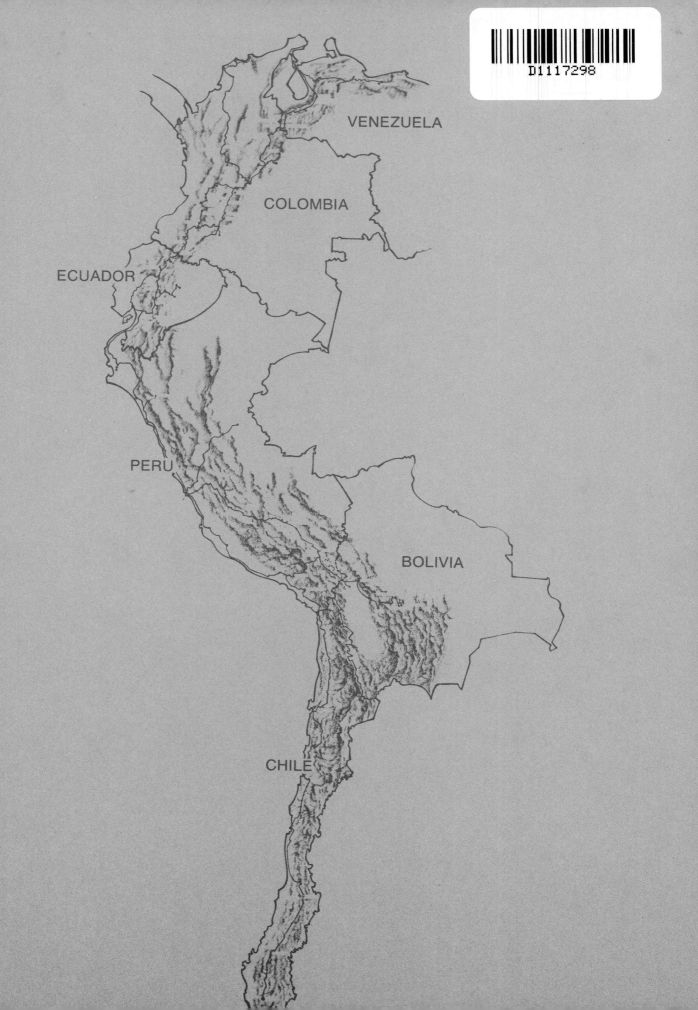

VENEZUELA

COLOMBIA

ECUADOR

PERU

BOLIVIA

CHILE

South American Folk Pottery

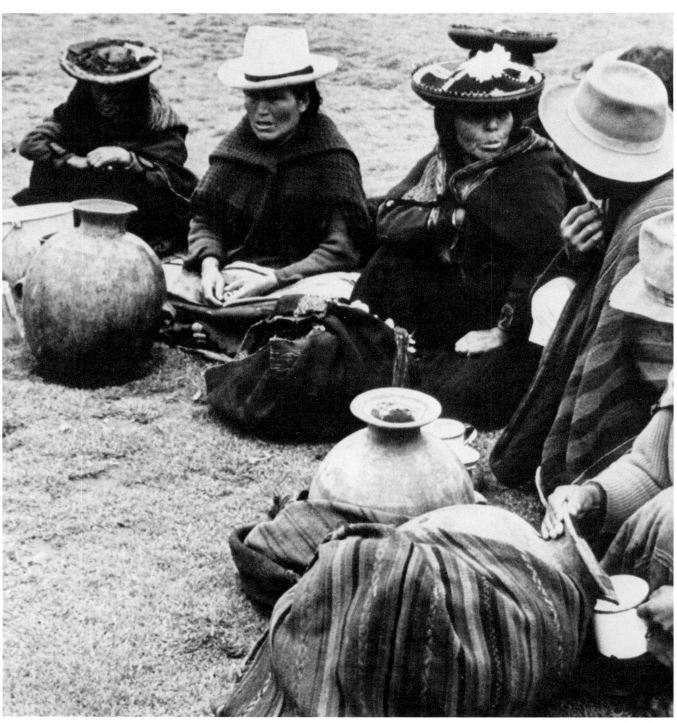

At Chinchero market, selling *chicha* is a social event. The Machacmara *cántaros*, often wrapped in colorful handwoven mantas, are used to bring the *chicha* to market.

South American Folk Pottery

by Gertrude Litto

STUDIO PHOTOGRAPHY BY ROBERT EMERSON WILLIS

ILLUSTRATIONS BY FRANK LITTO

WATSON-GUPTILL PUBLICATIONS/NEW YORK

To the Potters of South America

First published 1976 in New York by Watson-Guptill Publications,
a division of Billboard Publications, Inc.,
One Astor Plaza, New York, N.Y. 10036

Library of Congress Cataloging in Publication Data
Litto, Gertrude, 1929–
 South American folk pottery.
 Bibliography: p.
 Includes index.
 1. Pottery, Latin American. 2. Folk art—
Latin America. I. Litto, Frank. II. Title.
NK4002.L57 738.3'098 76-3644
ISBN 0-8230-4873-X

Manufactured in U.S.A.

First Printing, 1976

Contents

Acknowledgments

The extensive pioneering study necessary to produce this book could never have been undertaken or continued without the help of numerous people who actively encouraged and aided us.

The trip to South America was initially made possible by the Administration and Board of Education of a rural public school system in upstate New York, the Ravena, Coeymans, Selkirk Central School. Through a policy of granting sabbaticals, they encourage teachers to mature as both scholars and professionals. Elementary Principal John Prendergast; Supervising Principal Dr. Frank Filippone; and Board Members Dr. James Dougherty, Prescott Archibald, Howard Engel, Italo Frese, Joseph Pape, Kelton Vosburgh, John Willey, William Powers, and Robert Van Etten may have questioned the feasibility of a mission such as ours, but they showed their confidence by granting the sabbatical.

Leaving studios, home, financial affairs, and a son in his freshman year in college would have been difficult were it not for the administrative and counseling advice of our good friend John Collins. Working together as a family was essential in accomplishing both the physical voyage itself and the gathering of data. Frank's excellent driving kept our vehicle on the road during some treacherous mountain driving conditions. An automatic transmission on a heavily loaded motor home was foolhardy equipment for primitive mountainous roads. Our son Leo, a very able mechanic, has the outstanding record of having removed the transmission 14 times under incredible conditions and coaxing it back into working order. Once, when all else failed, a phone call was made to my mother, Henrietta Fine, who wrote out the parts numbers and ordered everything we needed. Our eldest son, Claude, on vacation between semesters, flew from the States with the parts and rescued us from our stranded position on the Peruvian desert. Another time, stranded on the *altiplano* near La Paz, it was necessary to call for a complete transmission replacement. We had to depend on the kind services of many ham radio operators, in both South America and the United States, to get messages to friends in the States who came to our rescue. Maradean and John Newton put in many frustrating hours searching for the proper equipment and then going through the hassle of transportation and customs to get it to us.

All of us, Frank, sons Leo and Corbin, and I, took the thousands of black-and-white and color photographs. During the evenings, while their parents wrote out the daily events, the boys processed black-and-white negatives and made the contact prints so necessary for immediate documentation. Also, their knowledge of the Spanish language, far more fluent than that of their parents, was a much appreciated asset.

Country by country—how can we acknowledge all the people who through their hospitality and interest in our project made our study more fruitful and enjoyable. First of all, the potters, hard working and intensely involved in their craft, are a special breed of people everywhere. Most of them were amazed to find that anyone, especially *gringos*, would be interested in what they were doing. When they understood our sincere admiration for their work and our desire to learn more about it, they went out of their way to help us.

In each country, we were lucky to find at least a few people whose enthusiasm for the craft enabled us to gain information and advice. Many anthropologists, archaeologists, museum directors, collectors, educators, and craftspeople helped. Here we list a few whose particular knowledge made our study more complete.

Our special thanks in Venezuela to:

Miguel Arroyo, director of the *Museo de Belles Artes* in Caracas, who showed us the museum collection of indigenous pottery, and his wife, Lourdes, who introduced us to several people knowledgeable about Venezuelan pottery, including Dr. Cruxent.

Dr. José Cruxent, anthropologist, who marked on our map the places he had investigated, where he thought pottery might still be made, and who gave us many good hints on how to go about finding pottery.

Sra. Masula Maníl, who opened her fine collection of pre-Hispanic Venezuelan pottery to us and gave us information about Guajira pottery.

Sr. Oscar D'Empaire, director of the *Museo de Belles Artes* in Maracaibo, who also gave us information and examples of pottery from the Guajira and from the Paraguana Peninsula.

Dr. Adrián Lucena Goyo, archaeologist, who explored the Quibor area with us.

In Colombia, we express our gratitude to:

Cecelia Duque Duque, director of the *Museo de Artes y Tradiciones Populares* in Bogotá, through whose fine collection of pottery and photographs, we learned where to look in Colombia.

Gerardo Reichel-Dolmatoff, Research Fellow of Anthropology at the University of the Andes in Bogotá, who gave us his opinions on the diminishing state of the craft today in Colombia. His insight on the subject influenced our thinking, probably more than he realizes.

Sra. Nubia de Bonilla, potter and teacher, who traveled with us in the Cali area to research the potters.

Señora Gambor, mayor of Caloto, who showed us her collection of pottery from the ancient Corinto culture and introduced us to the potters of El Guasimo.

In Ecuador, we thank:

Olga Fisch, famous weaver and authority on Ecuadorian handcrafts, for her valuable information on pottery areas.

In Peru, we are grateful for help from:

John Davis, former President of World Craft Council and authority on Peru's handcrafts, for his valuable information.

Martin Von Hildebrandt, a young sociologist who traveled in several areas of Peru with us and helped us gather information.

Kurt and Nilda Arens, who introduced us to Vicus pottery and helped us meet Simbilá potters.

In Bolivia, we are indebted to:

Dra. Julia Elena Fortún, anthropologist and authority on Bolivian folklore, who told us of the pottery in the Cochabamba area.

Hugo Daniel Ruíz, *Director of the Museo Nacional de Arte Popular y Artesanías* in La Paz, who opened its collection of colonial-era and contemporary pottery to us.

The Maryknoll Missionary fathers who got us to places that were inaccessible in our vehicle and who also introduced us to Sr. Florencio Rios, an enthusiastic guide, fluent in Quechua and Spanish.

In Chile, we thank:

Inge Dusi, Representative of the World Craft Council, who, regrettably, we could only meet through letters and telephone conversations. Nevertheless, she helped tremendously with information on pottery areas.

We met many members of the Peace Corps throughout South America who were able to introduce us to the potters in their areas or to people who knew about the pottery. We are grateful to these young people and those who came before them. Because of their enthusiastic interest in and love for the people, they were important ambassadors, dispelling the fear and suspicion of strangers found in so many rural people. We were greeted with enthusiasm wherever these Peace Corps people had founded sound friendships.

We also had the good fortune to meet many priests and missionaries who, because of their close ties with the local people, were able to introduce us to many rural craftspeople who otherwise would have been difficult to contact.

For the quality of technical darkroom magic needed to turn our negatives, often made and developed under adverse conditions, into superb photographs, we must thank an understanding, skilled friend, Robert Willis.

the reluctance of most rural people towards being photographed, this is a very real accomplishment indeed.

Gertrude Litto, presently an elementary art teacher, has worked in the fields of ceramics and education for over 20 years. She has developed an understanding of the problems of the potter, and her eye for the technical details involved will both fascinate and enlighten readers interested in the subject. In 1971–72 she made an extended trip to South America to explore in depth the contemporary ceramic scene. Accompanying her were her husband Frank and her sons Leo and Corbin, all of whom contributed to the photographic work, the truck driving, and the interpreting. Out of these 10 months has come a remarkable document which outlines the major types of pottery still being made, as well as a discussion of many of the problems relating to the craft. Some of these latter are unique, but others have difficulties in common with all the handcrafts still active throughout the world today.

This book combines an excellent travel account with a serious examination of ceramic design, technique, and practices. The author outlines her difficulties in getting at the information sought, thereby giving the reader the feeling of actually being along on the trip. As a journal, her observations bring to mind many of the "incidents of travel" made so dramatic by John Lloyd Stephens, world traveler and author of *Travel in Central America, Chiapas, and Yucatán*, 1841; she demonstrates the same enthusiasm, obliviousness to danger, and the capacity of knowing what to look for. However, anyone planning to follow in her footsteps should be well aware of the problems involved; not all travelers might emerge with similar good fortune. Time and time again she makes the point that fortuitous timing was all that made an encounter profitable—and one might add to that, the aid of a well-developed sense of purpose and resolute determination.

The people whose work she records are a vast mixture. Some are essentially pure-blooded American Indians—perhaps one-fourth of those in-

Foreword

In the field of Native American folk art, far too little attention has been given to contemporary pottery other than that from the Southwest United States. As the Bibliography reveals, those works of value can literally be counted on the fingers of one's hand, as against the huge quantity of pre-Columbian studies dealing with ceramics. Indeed, I suspect that the average person has little realization of the existence of aesthetically significant pottery in South America.

That this oversight is regrettable, and that it perpetuates the failure to record the work of many gifted artists, is well shown by *South American Folk Pottery*. That it is undeserved can be demonstrated by the delicate tracery of the Shipibo container (Color Plate 20), the powerful form of the *virque* (page 58), or the common-sense utility provided by the *olla* (Color Plates 12 and 35). Each superbly fills its own role. The author records this faithfully, writing in a straightforward manner; in so doing, she manages to bring together an overwhelming amount of detailed information concerning a little-explored subject. More remarkably, she has been able to document her notes with photographs—in view of

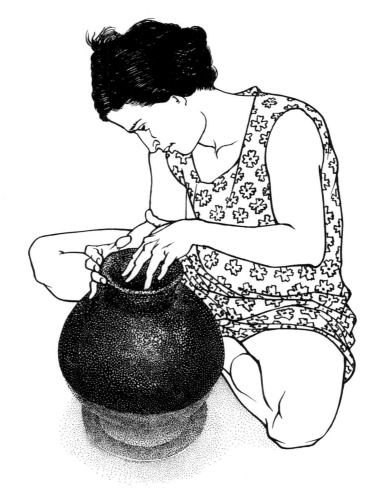

cluded. A small number are basically European in culture and background, perhaps best characterized as rural peasants. But by far the majority are "Ladinos," as the *mestizo* is called in Latin America: the mix in varying degrees of parents of Indian and non-Indian blood. This study, therefore, is not an examination of "Indian Art" *per se*; there are many European contributions, most particularly the wheel and the use of glazes, which place this work into the folk art category.

Most of the people, particularly the Indians, live in small bands, tribes or village groups, far removed from urban centers, each speaking a language which may or may not be related to a neighboring group. To penetrate such enclaves is a difficult task—and to obtain information relating to their daily lives is even more frustrating. The ever-present suspicion of the outsider, especially the Caucasian, is almost impossible to overcome. That Litto was able to accomplish this makes her work all the more valuable.

The excellent on-the-spot illustrations should make this volume useful to all potters interested in hand-produced ceramics. In a decade when more and more of our citizenry are turning to crafts as a hobby to escape from everyday pressures, such demonstrations are of great value in bringing home the delightful fact of man's relation to man through manual activity. And let there be no mistake about folk art as beauty *versus* the tired cliché of function: many of the vessels turned out by these potters have an esthetic merit which is deeply appreciated and prized by their makers. While it is true that most objects undoubtedly have value as containers, anyone who has ever traveled among native people has observed unusually fine vessels which have been placed in an unobtrusive spot for protection, to perform no other function than that of being an attractive *objet d'art*.

One of the merits of this book is the removal of the label of "anonymous art" from the product. Until recently, few native craftsworkers enjoyed any sense of identification with their work. It is quite true, of course, that in many cultures such individual elevation was not approved by the society; one was supposed to work for the benefit of the group, and striving for personal glory was not an accepted practice. Today, however, much of this has been changed, to the advantage of the craftsman, and signed pieces normally bring a higher price than those not so marked; this distinction has not been lost upon the artist. Litto has been careful to record the

names of those people with whom she worked, and the comments she makes, their own personalities, and the place they occupy in their own world make this an even more important document.

What is the future of this art? Can these people hold fast against the plastic bucket and the pop-top aluminum can? The answer, sadly, is probably not. If for no other reason than the growing scarcity of raw resources—pottery clay buried under paved macadam surface, wood for firing increasingly hard to find, and the inflated economics of the marketplace—all but the top-quality product destined for the high-grade tourist market will be driven out. And this tourist market will inevitably introduce its own dictums, thus slowly perverting the product. It is doubtful that this patronage, however well meaning, will be sufficient in most countries to allow more than a handful of artists to survive comfortably.

I believe that *South American Folk Pottery* is destined to be a classic record of one area of craft work and will singularly contribute to future needs for reference in the subject. It is strongly hoped that Gertude Litto will make other journeys and record similar observances—through the back country of Central America and the eastern sections of Latin America. Equally fascinating products await such attention there, are little known, and offer major aesthetic merit in their own right.

Frederick J. Dockstader

Introduction

The many pre-Columbian cultures of Peru, both before and during the Inca reign, are enticingly conjured up for us by the permanent ceramic displays and special exhibits held in museums throughout the world. We who seek further information about those ancient times, or who merely delight in the magnificent pottery that portrays so vividly the lives of those people, will find library bookshelves loaded with information. Fine photographic and written documentation of the potter's art in other areas of Latin America in precolonial times also exists, and is continually being augmented with bigger and better volumes. Detailed archaeological studies are less numerous but can be found in monographs, such as the *Yale University Publica-*

tions in Anthropology or the papers done for the American Museum of Natural History. As funding becomes available for more work in this field, new material is unearthed and more articles are published.

But what happened to the potter's art with the imposition of Spanish domination? What happened to the indigenous potter's craft? Was it completely wiped out with the Spanish conquest? If so, was it replaced by Spanish traditional work? Did any handbuilt-pottery methods survive, or had the Indians' need for this basic commodity disappeared? Only fragmentary accounts of the potter's craft in Spanish colonial times exist. Few examples of the work produced then exist to show the metamorphosis that must have taken place. Indeed, there is more known today about the ceramic work of prehistoric times than that which was done two to three hundred years ago. One would suppose, reading the accounts of the conquest in South America, that drastic changes must have occurred in the handcrafts as it did in everything else. Mexican craftwork, which today is fairly well known, displays an uncanny mixture of Indian and Spanish traditions.

We searched, trying to find information that might show this to be true of the potter's craft today in the land of the Incas and other strong Indian west-coast civilizations. Initially, our study would have led us to believe that there was nothing; that the craft, if not already dead, was indeed close to death. In written material, we found only a few skimpy articles on Peruvian handcrafts. The few people we were able to contact assured us that if we were to travel to South America, we would find no more than a dozen locations where pottery was being produced and that we would surely be disappointed.

Somehow, we theorized, there must be something more than we had learned so far. When the opportunity finally arrived for us to learn the truth firsthand, we expected to find little more than a dozen localities and felt that less than a year would be ample time for our investigation.

Because we would be traveling to remote areas, carrying a great amount of equipment, we felt we needed a vehicle. A 20-foot motor home provided us with independent transportation, living and working space, and storage facilities. An improvised darkroom built into the vehicle's bathroom enabled us to check the results of our black-and-white photography, while a refrigerator, convenient for our dietary needs, also kept

film and chemicals in working condition. This proved a wise way to travel and enabled us to comfortably visit some otherwise difficult sites.

The motor home was loaded on a freighter at Ft. Pierce, Florida, on October 16, 1971, and unloaded in La Guaira, Venezuela, 10 days later. From here we covered the western half of Venezuela, crossed the border into Colombia at Cucutta, explored the northeastern and central parts of Colombia, and then headed down through Ecuador to Peru. The *alto* of Peru and Bolivia was explored before we left the mountains for the coastal areas of southern Peru and Chile. After reaching our southernmost location, Temuco, Chile, on the 39th Parallel, beyond the southern extremity of the Inca empire, we followed the coastal Inca Highway, much of which is the present Pan American Highway, northward. We covered the northern Peruvian coast, some of the coastal area of Ecuador, and then took the Pan American Highway through the jungle region and the Cordillera of Ecuador. North to Colombia, both the Magdalena and Cauca valleys were studied before returning to the Bogotá Plateau and then northward to the Caribbean coast and our departure from Cartagena in August of 1972.

Once we arrived in South America, however, the few locations we expected to cover multiplied tenfold as we kept adding to our lists the information from museum directors, anthropologists, sociologists, Peace Corps personnel, and other craftspeople, and craft-oriented organizations in the different countries.

Just traveling with our eyes wide open helped us to locate some areas that were unknown to even some of the most knowledgeable people in their own countries. We might drive past a woman with a pot on her head and ask, "Where can we buy a pot like that?" and sometimes get a direct lead: "In the village just up the road; my sister knows the lady who makes them." Or, we might be fortunate enough to be in a village on the local market day and see the pottery there. Asking the vendors, we might find that some were selling their own ware. Others, being middlemen and sure that we wanted to buy out their source of supply, would become evasive or send us off on a wild-goose chase.

The *Padres* were also a source of local information in backward rural areas. They know the people in their parishes quite well and are able to obtain introductions to the most reticent, suspicious back-country peoples.

We watched avidly when driving past dwellings for the *chicha* pots airing in a doorway. A workman with his *chicha* pot strapped over his back on the way to his fields could be a lead. Archaeologists or anthropologists could be important sources of information. Often, for their own edification, they check the contemporary materials and methods used in the area whose ancient history they are unearthing.

In brief, our previously well-made plans, based on the scant information we were able to glean before our journey, changed constantly and turned our travels into a true pioneering adventure which became more enriched as we traveled from one discovery to the next.

Our time grew more limited as the number of localities continually grew. We found that in many instances we were able to do only partial surveys. In remote regions, travel took more time as we were challenged by roads that often became impassable because of avalanches, floods, or other natural disasters, common in such rugged geographical areas. We were hampered during carnival or fiesta time or national holidays, of if there was a lengthened rainy season, for it was often impossible to see work in progress unless we waited days, weeks, or months. In many places we discovered that potting is a seasonal occupation for people who make their main livelihood through farming. If we arrived at planting or harvesting time, no one was potting, no clay was prepared, and all the work had long since been sold.

Years of work would be necessary for trained people to thoroughly document what may be in many regions the end of centuries of pottery traditions. Tracing the similarities in work in widely separated areas, and learning how these similarities came about through the influence of relocated people before and during the colonial decades, for instance, would be a difficult study today, but far more easily done now than in 20 or a hundred years from now.

The potter's craft has started to go through traumatic changes in the past decade or so. For the first time in hundreds of years, new influences are entering the continent that will drastically change the work where it continues. More easily available aluminum and plastic are greatly diminishing the need for pottery. A look at the local markets shows how the commercial products are replacing the area craftsmen's ware. As potters' children become more urbanized, many see no reason for carrying on

the traditional family trade. Rural people, as consumers, are intrigued by the new, lightweight, colorful plastics and aluminum pots that will only dent rather than break in pieces if accidentally dropped. As Michael Cardew has aptly noted, the craft will not be missed immediately, but rather too late, when it has vanished. Then these people will realize that something warm, human, beautiful, and personal is missing from their lives.

Several things save the potter's craft in many areas at present. Economically, the impoverished potter still makes and sells his work for less than the price of the commercial ware, and there are many poor people who gladly take advantage of this. Secondly, we have heard the native homemakers declare that chicha will only be made in traditional ceramic vessels because of the distinctive flavor the clay ware gives the beverage. Others say that only clay water distillers and storage containers can keep their water pure-tasting and cool. The aficionado believes that such local dishes as *arepas* (Venezuela), *humintas* (Bolivia and Peru), fried bananas, rice, toasted corn, or *chicharrón* taste right only when prepared in the traditional vessel. Perhaps if *cerveza* does not completely replace *chicha*, and quickly prepared foods the traditional fare, there is a chance that the potter will still find his skills necessary.

We traveled the full length of the old Inca empire and almost its full width. We were able to explore areas known for their archeological wealth and to discover the potting activities as they exist there today.

As it is theorized that the Inca civilization began in Peru on the shores of Lake Titicaca and spread north and south from there, we will begin our recounting in Peru. Then we will move across the borders to Bolivia and south to Chile. From there we will head northward, recording our findings in Ecuador, Colombia, and Venezuela. We will conclude with the jungle areas that border the eastern slope of the Andes.

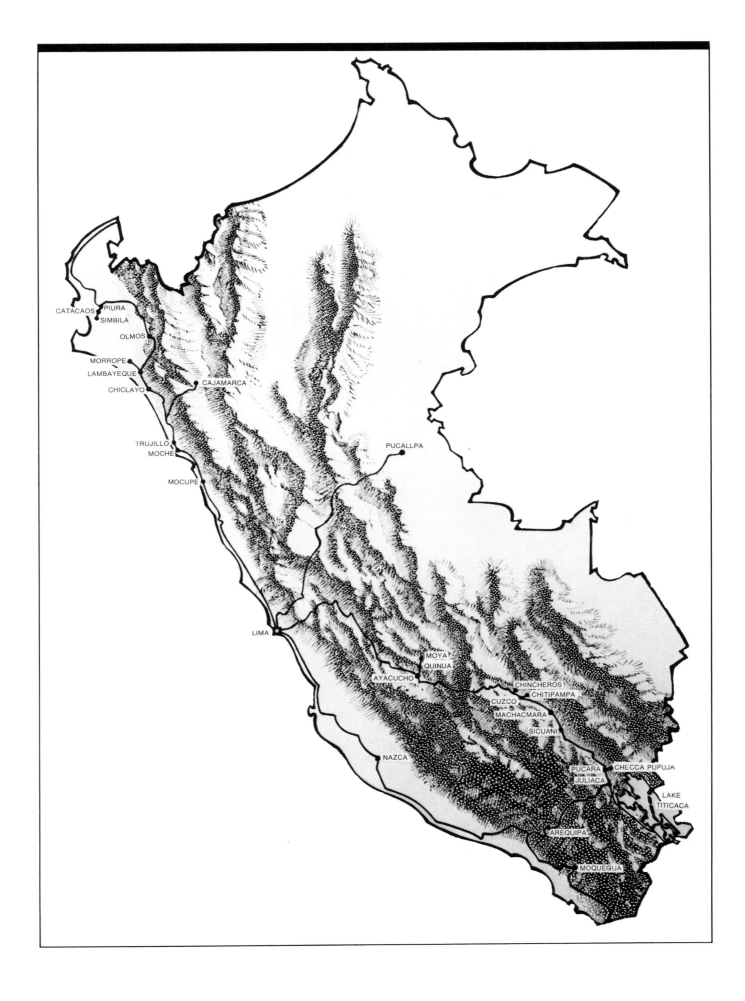

PERU

Driving from Ecuador into Peru, you would think that the border had been drawn where the lush green marshes end and the sandy dry lands begin. The change is startling. After driving through tall grasses that crowd onto the road and limit visibility, you find yourself suddenly in an open tan, pink, and golden expanse that stretches out toward distant hills and mountains to the east and the sparkling Pacific just a short walk down from the west bank of the road. This is only the beginning of that long, narrow strip of desert reaching almost 2,750 kilometers (1,600 miles) from the northern to the southern boundaries of the country and rarely exceeding 160 kilometers (100 miles) in width from Pacific waters to the foothills of the Andes.

The coastal desert is a geologist's handbook come to life. Crossing this inorganic, silica-dominated land-

scape are the rich deltas formed by the rivers that sweep down from the mountains and sluggishly silt down near the coast before trickling into the sea. In the sand beyond the green are the graveyards of ancient civilizations, dating from the earliest pre-Colombian cultures to the later, well-documented Inca era.

Stopping along the road at various arbitrary spots, you find pieces of ancient red or black pottery. Sometimes this pottery has been pushed along by a bulldozer that peeled the sand back from the road and left these pottery remnants in its wake. We had been told previously that no pottery was being made today anywhere in this coastal region. But we couldn't believe that this area, second to none in South America in its ceramic heritage, could be completely devoid of this art today.

North Coast: Simbilá

We had traveled less than 2 hours from the border when we saw one of several fishing villages, this one called Acapulco. Perhaps several hundred small shacks were here, with walls of vertical sticks and woven grass-mat roofs. These shacks were attached to each other in rows, as if for support. And near the stick wall of a shack we saw a group of five tall ceramic jars.

Excited, we stopped and walked down for a better look. The larger pots were some .76m (2½ feet) tall with swelling shoulders and small handles. Some had flaring necks and all had rounded bottoms nestled into the sand for support. They were handsomely proportioned, with the color and satiny sheen of hand-rubbed mahogany. This patina, we later learned, was produced by the *chicha*, a fermented beverage similar to beer, that had spilled down over the sides of the vessel during many years of use. The upper shoulders were embellished with rows of stamped designs: flowers (realistic or stylized), geometric swirls, or checkerboard patterns.

Several women came out of the shack, smiling at our interest. We asked, "Are these made here?" and were told ño, but we could buy them in the market at Piura. The pots were made near there somewhere. Driving farther, we saw many more pots of this type being used for water storage, as well as huge washbowl shapes up to .6m (2 feet) in diameter. We asked several people about the location of the potters who made them and were told Piura, Catacaos, or Simbilá, the last two being smaller villages just outside Piura proper.

Piura is the largest extremely northern city in Peru. It has a well preserved colonial atmosphere in spite of an increasing number of handsome modern buildings. We had the good fortune to meet an instructor in sociology at the university here. He was able to further inform us that the pottery we sought was made in Simbilá and that the principal markets for buying it were in Piura and Catacaos.

With our university friend acting as translator and guide, we drove to Simbilá, which sprawls out over low desert hills only a few kilometers away on the road from Catacaos. We turned off the main road onto a wide, sandy trail with groups of houses on either side.

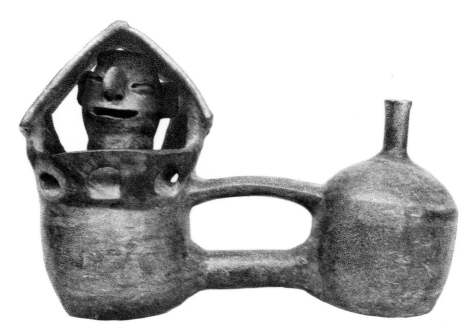

Recent grave excavations in the Piura Valley have revealed a wealth of imaginative Vicus, single- and double-type bottle forms. Designed for use, these pieces went beyond utilitarian concepts to depict a sculptural catalog of figures, architectural forms, animals, birds, and fish. This piece is in a private collection in Piura.

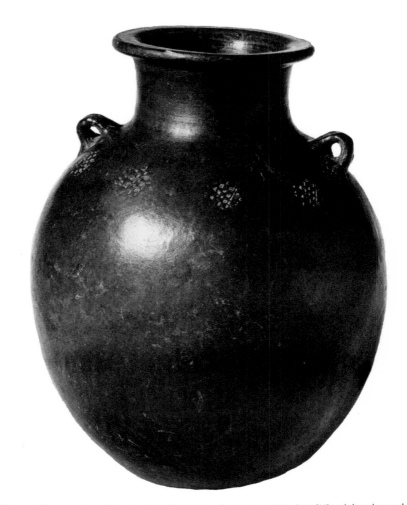

Chicha spilling over the sides of a Simbilá *cántaro* for many years gives it the rich color and patina common to fine old wood.

Simbilá Pottery Heritage

The pottery methods found in Simbilá are passed on from father to son. A 12-year-old boy can become quite proficient in the use of paddle and stone, the chief forming tools. All Simbilá pottery is handbuilt; no molds are ever used. Until the sons marry and establish homes of their own, they all work together producing large quantities of pots. Often brothers live near each other and cooperate in the production, firing their ware together. These men are primarily farmers and work the corn, sugarcane, and cotton fields during the growing season. Making pottery during the off-season augments their income.

These potters use the same basic techniques employed by the Incas. The large forms they make have not changed much since those ancient days, mainly because the uses for the pots are still the same today: *cántaros* store water and *chicha*, the local beverage; *tinajones* are still used to prepare *chicha*, and also as large wash basins.

Nowhere today can you see the fine, imaginative forms produced by the ancient Vicus and Chimu cultures that inhabited this river delta before the Inca period. Yet on the desecrated burial mounds between the Sun and Moon temples at Moche, some 320 kilometers (200 miles) south of Simbilá, the hills are red with shard remnants of huge ceramic containers. Their cross-sections are about 2.5 to 3cm (1″ to 1¼″) thick and reveal fine pebbles and sand blended with the clay mix. The rim treatment of these pots is similar to that of the Simbilá wash basins.

We were fortunate to be here during the potting season, which lasts only from August until December. The rainy season lasts from mid-December until March. Then the *garua*, a season of fog, misty air, and clouded skies, sets in, preventing the clay from drying. This *garua* clears away again in mid-August. We saw row upon row of damp pots drying in the sun and heard a rhythmic whacking sound echoing from the doorways. Visiting several households, we saw repeatedly the same basic forms, the same techniques, the same style of work, as if a master plan were being followed throughout the village. We were invited into several workshops where we photographed and took notes on the method of work.

Preparing Clay. Clay is brought in from the large haciendas in nearby La Legua; sand is brought in from the riverbanks. Both are dug with pick and shovel and transported in large burlap

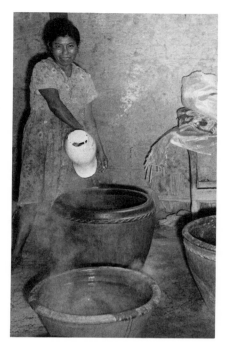

In Catacaos, Peru, a woman boils the local corn beverage, *chicha*, in the smaller vessel in the foreground called an *olla*. She then transfers it to the larger preparation container, called in Simbilá a *tinajón*. Thirty-six hours of constant stirring in this traditional vessel will bring the *chicha* to its proper state of fermentation.

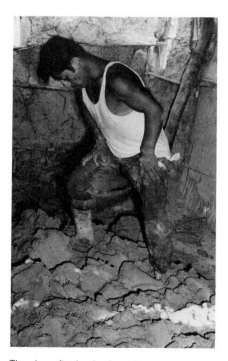

The clay, after having been broken into small chunks and soaked in water, is spread out on burlap. The Simbilá potter kneads the clay with his feet to bring it to proper working consistency. A great amount of time and energy are expended to produce the quantity of clay each Simbilá potter requires.

or plastic sacks by burros. Each person gathers the material he needs for his own use. The earthenware clay is remarkably free from impurities and is of a fine plastic quality, capable of being quickly built up and able to support itself well in large pieces.

The potter breaks up the clay into small chunks. Then he leaves the clay to soak in water in large, old clay pots sunk into the sandy floor of his workroom. This area is constructed in the same manner as the rest of the house and is an integral part of it.

After a couple of days, the clay and water have blended together into a slurried consistency. The potter scoops it out and spreads it on a large burlap cloth on the floor, along with a quantity of sand. This kneading process, done by foot, takes time and plenty of energy. More sand is added as needed, until the clay can be shaped with the hands into a ball of the size necessary for the forming process that follows. We were told that generally one part sand to three parts clay is the final working mix.

Forming the Tinajón. The Simbilá potter uses a method for forming his large pots that we will not see anywhere else in South America. For tools he uses a hand-sized paddle of algarroba wood and a smooth river stone as large as his fist. Kneeling on the floor, he holds the clay ball on his lap and begins the process of raising the pot's walls by pounding a depression in the ball (see illustrations).

Finishing the Pot. When the clay walls of the pots are firm enough, the work resumes. The potter adds thick coils of clay, presses them into the rim, and continues pounding with paddle and stone. To finish off the pot, another thick coil of clay is added to make the rim. The potter uses a wet rag to form a near-perfect flaring rim on a tall jar or a double-thick rounded rim with a decorative ridge on a wider-mouthed wash bowl. After the rim, the handles are formed and pressed into those vessels that need them. At this stage, the potter also presses designs into the receptive clay. The flat pounding stone is held inside the pot while the stamp is pressed onto the outside of the form.

Stamps and Designs. The artisans of Simbilá could not tell us the origin of the clay stamps they use. All through the village similar stamps are used with little variation. Many people make their own stamps, but there is one man in the village who makes very fine ones which he sells to other potters. The stamps themselves are made of fired clay and measure approximately 6 x 3cm and 1.3cm thick

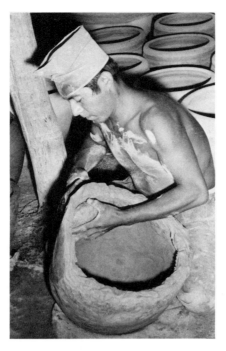

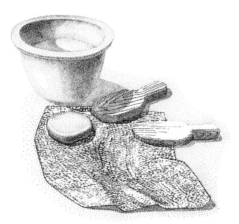

(Left) A flat, smooth stone and a paddle made of *algarroba* wood are the basic tools of the Simbilá potter. A basin of water, a rag, and a piece of burlap, which he uses to line a rounded depression in his studio floor, are all he needs to form his ware. (Right) The walls of a large *tinajón* are thinned and raised as the potter, using paddle outside and stone inside, rhythmically whacks the clay. As the form grows, it is transferred to a depression in the sandy floor lined with burlap. The pot is balanced against the potter's thigh as it is diagonally lifted and turned. The whole pot appears to be a shivering, gelatinous mass as it shudders under the blows. From time to time, the potter dips his paddle into a pot of water and rubs the stone to transfer the moisture, never seeming to interrupt the rhythm of his work.

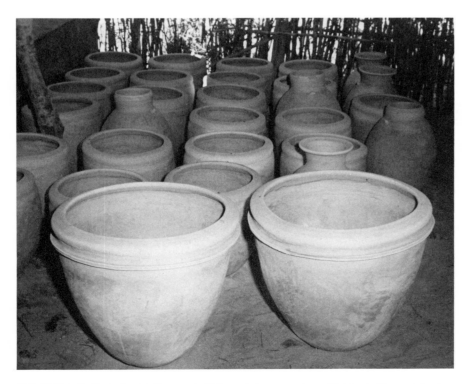

Simultaneously, in each workshop, up to 15 large pots are made and finished with a variety of rim treatments. When completed, the walls being about 1.5 to 2.5cm (½″ to 1″) thick, the round-bottomed pots are placed in scooped-out hollows in the sandy studio floor to dry.

(2¼″ x 1¼″ and ½″ thick). On one side of the stamp the design is usually a curvy stem with flowers and leaves. The other side has two designs, the upper half a stylized sun and the lower half a checkerboard. Sometimes a stylized bunch of grapes represented by a cluster of circles is used. Some stamps have only the checkerboard, others, just the sun design.

Forming the Bowls and Pitchers. The method used to form small bowls and pitchers for table use is quite different from the method just described. The potter takes a ball of clay and holds it in his left hand at face height. His fingers deftly turn the clay, while his right hand, holding a wet rag, hollows and forms the clockwise-turning shape. Often the women in the families help make these smaller pots.

Lustre Almagre. When the clay has reached the leatherhard stage, the bowls are put out in the sun to speed the drying. At this point, many potters cover their surfaces with a yellow-colored slip called *lustre almagre*. The women in the family are given this job. They dip rags in the thin slip and paint the entire inner and outer surfaces of the vessels with it. We are told that in firing the clay surface is often marred by an unsightly, blotchy lime fluorescence. The yellow slip, or *lustre almagre*, being rich in iron oxide, eliminates this condition, permitting the vessel to emerge from the fire with a uniform soft pink color.

Firing the Pots. Mounds rimmed with shards are raised near most of the houses in Simbilá. They may be 1 to 1.5m (4 or 5 feet) high and 3.5m (12 feet) in diameter, with a volcanolike depression at the top some .6m (2 feet) deep. These are the potters' firing sites.

Firing day for a family is every other Saturday during the pottery season. All the family, and often friendly neighbors, will help to stack the firing pit. A layer of wood is placed over the ashes of previous firings. Larger pots, with smaller pots inside them, are placed right-side up over the wood. Another layer of pots, mouths down, is placed over this. A covering of old shards is layered over the pots so that they are all concealed. Old straw, animal dung gathered from the corrals, rags, and any old refuse are thrown over the top of the shards.

The firing begins after the noonday meal. Kerosene is dripped through openings in the mound to ignite the wood at the bottom. The firing lasts up to 12 hours or until the ware is of a cookie consistency. To aid the concentration of heat, burlap sacks are

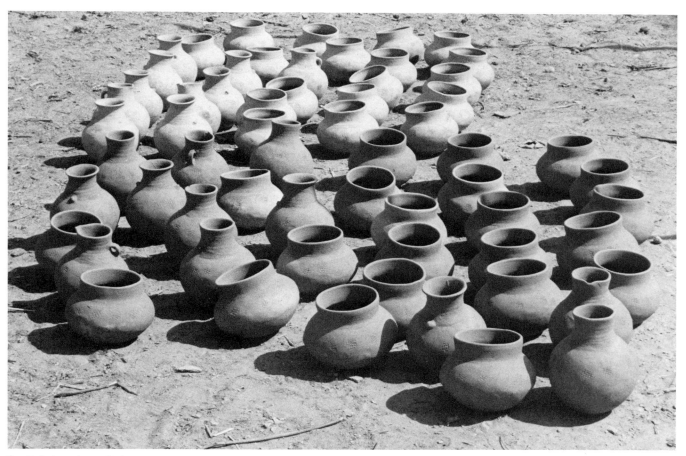

Small pitchers, jars called *cantaritos*, and small bowls called *ollas* are put out in the sun to dry. They must be continually turned so that they will dry evenly. When the pots are leatherhard, the *lustre almagre* is applied.

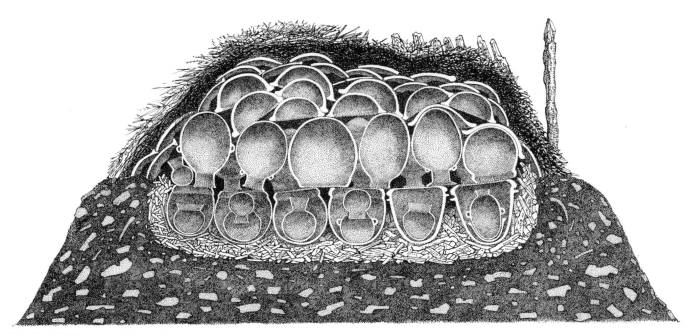

The Simbilá firing mound, shown here in cross-section, is generally 1.2 to 1.5m (4 to 5 feet) high and 3.6m (12 feet) in diameter, with a .6m (2 foot) depression scooped in the top. Over a layer of ashes from previous firings, a layer of wooden sticks is spread on which the pots are arranged. Shards of broken pottery, old straw, animal dung, and any old refuse are used to top the mound.

placed on upright sticks around the rim of the firing pit.

Anywhere from 50 to 100 pots of varying sizes are fired at one time. The amount of damaged ware in a firing depends on the heat of the fire. One potter told us that if it gets too hot, there is more breakage. The pots on the bottom layer of the firing pit are more vulnerable to breakage, and the bottom or middle sections of these pots can crack. Six or more of the larger pots may be lost during a firing.

The Future for Simbilá Pottery. In 1965, there were about 100 families living in Simbilá who made pottery. In 1972, only 50 men were still pursuing the craft. The Piura River basin has been subjected to drastic upheaval in the past decade due to natural causes and social changes. A six-year drought has caused unusual hardship to the potter-farmers of Simbilá, who depend mainly on agriculture for their existence. The majority of men work at the large haciendas of the wealthy landowners, and the drought has decreased the landowners' profits. This loss is passed on to the Simbilá community, where life has never been much more than marginal.

Marcel Paz, one of the community's finest potters and a man who shows great concern for his community, told us of the changes imminent in Simbilá. For some time he has tried to convince the community that they should form a cooperative and become eligible for government aid. At present, each potter contributes his share of money to pay a set fee for the village's right to dig clay and sand from the landowner's property. Each person digs and transports his own raw materials and this is very costly in effort and time. With a government loan, the village cooperative could buy a truck to transport the clay and also bring their wares to many markets, thus eliminating the middleman who makes a great profit for his part in the sale of the Simbilá product.

The villagers have resisted the cooperative movement because they have always worked as individuals and have no mutual trust. The landowners also, fearing the efforts of a cooperative, have threatened not to sell the villagers any more clay if they form a cooperative. This adds to the villagers' fears.

Marcel urges the people to seek more government support. The large land holdings are being broken up by the present government and turned over to farming cooperatives. Marcel is worried that if all the land is turned to farming, the villagers will lose their clay beds. He estimates that one

square kilometer (.4 square mile) would provide enough clay to supply the village for several years. He would like the government to give the villagers the land, when it is turned over to agrarian reform, so that they may continue their life as farmers and potters.

Moving South down the Pan Am

There are scattered families throughout the countryside who produce pottery in the same manner as those of Simbilá. In San Jacinto, a nearby village, several potters are producing molded ware in imitation of the Mochica, Chimu, and Inca pots. You can see a variety of their pieces, such as animals, portrait vases, and erotic pieces, offered as "originals" in many of the marketplaces.

Traveling farther south along the Pan American Highway, you can see the work of other potting communities in the markets at Chiclayo, Lambayeque, Guadalupe, and Trujillo. There, the communities of Moche, Cajamarca, Mocupe, Morrope, and Olmos are represented. You find the same type of ware in all these markets, the same basic shapes as in Simbilá. The practical needs common to these communities cause the potters to produce quantities of pots with the same basic shapes but often with distinctive variations.

A form not seen in the Simbilá repertoire is the large, flat frying platter with upturned rim and handles called a *perol*. It is found here in these markets, sometimes with a splash of plumbate in a glistening swish painted in the center of the platter. These are said to come from Morrope.

Olmos: Molded Ware. The number of potters in many of these Northern coastal pottery villages is steadily dwindling. We stopped at Olmos, a small community on the Pan American Highway. We were attracted by two pottery stands in front of houses along the road. The woman tending one stand told us that she could remember when there were many more potters in the area. Now two men still make the Olmos pottery in El Imperial, a hamlet 2 kilometers' (1.2 miles) walk back from the highway.

The two men who make the pottery from August through December were tending cornfields when we visited in May. The great bulk of the ware is formed in one- and two-piece molds. Wet clay is plastered over the inner surface of the molds. If a two-piece mold is used, the two pieces are immediately pressed together and the joint rubbed smooth. The work is roughly finished and very low-fired, producing a coarse, sometimes crumbly sur-

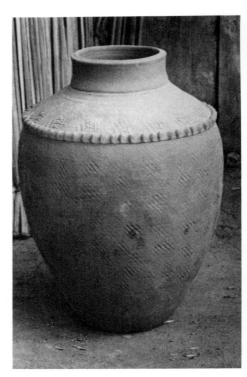

This *cántaro* from Morrope has a basic form similar to those made in Simbilá. On this *cántaro*, however, the stamp design is used as an allover pattern and a fluted clay band has been added at the shoulder.

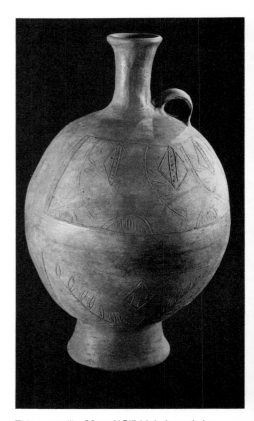

This *cantarillo*, 38cm (15") high, is made in a two-piece press mold. Lines etched into the molds are transferred as relief designs onto the finished ware. The handle and high foot are handbuilt additions to the molded form.

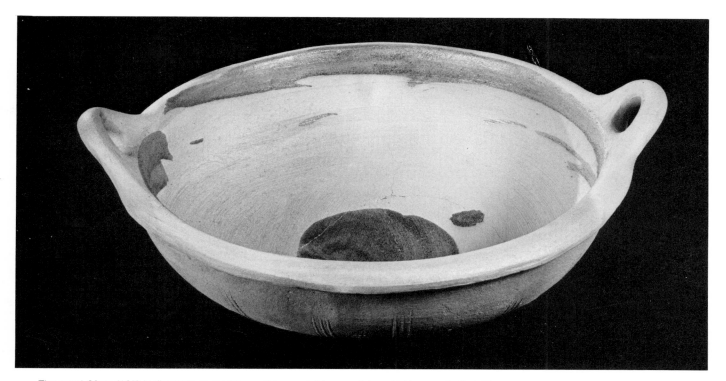

The *perol*, 33cm (13") in diameter, is used for washing such things as fish and tableware. In Simbilá, the *perol* is made by hand with lines incised around the rim. This *perol* from Morrope is made in a press mold with the rim and handles formed above the edge of the mold proper. Inside, a few swirls of lead glaze, and outside, the incised lines from the press mold, decorate this vessel.

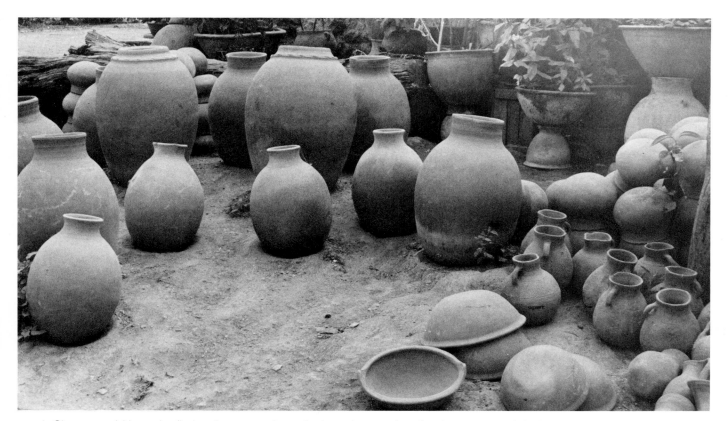

In Olmas, a roadside vendor displays the ware made nearby. Large forms such as the *cántaros* are made by the same techniques employed in Simbilá, but without stamp designs. All the smaller forms, such as *ollas, cantaritos*, and *perols*, are made in press molds. All have round bottoms that sit firmly in the sandy ground.

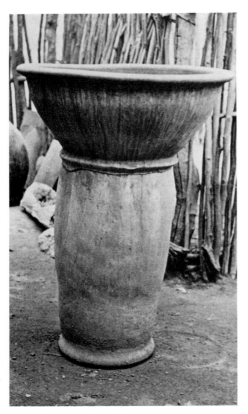

The wife of an Olmos potter uses this wash basin made especially for her by her husband. Years of use have patinated the surface to a satiny smoothness.

Nazca pottery is notable for its fine thin-walled shapes and a smoothly polished, many-toned decorative surface. In Nazca and other well known pre-Columbian south-coast pottery sites, the pottery heritage terminated long ago and no pottery is being made today. This Nazca piece, measuring 20.3cm (8″) in diameter, is in a private collection.

face. The line where two-mold pieces come together is clearly visible. Line designs are often incised in the molds and appear as raised decoration on the finished ware.

Neither the techniques nor the fine finish of Simbilá pottery are found here, although the Olmos firing mound is similar to that in Simbilá. The Olmos forms are well proportioned, and the older pieces are quite handsome because with use a deeper-colored, smoother surface is produced.

Olmos molded ware appears in many markets, along with the molded pieces made in the mountain town of Cajamarca. These northern-area potters today, then, are carrying on the tradition of molded ware as begun in this area by pre-Columbian cultures such as the Chimu and Mochica peoples.

Continuing Southward. These northern desert communities contain the last remaining ceramic activity that you are likely to encounter along the length of the coast. Fewer ceramics are found in the markets as you travel south, and these are brought down over rudimentary roads from eastern communities high in the Sierras. In the rich delta communities such as Santa, Chancay, Rimac, Ica, and Nazca, which once had a rich ceramic heritage, no pottery is made today.

South Coast: Moquegua

Moquegua was founded by the Spaniards in 1626 on the Rio Osmore in the extreme southern part of Peru as a center for processing wine and brandy. In the rich valley above the city, avocados, wheat, maize, potatoes, and fruits are grown. Below the city, the slopes are covered with vineyards, the flatland with sugarcane. Fifteen wineries located here trace their origins back to Spanish colonial times. Just beyond the fields, on the dry sandy ridges, stand the crumbling, roofless remnants of numerous adobe buildings. These were storage rooms for the wineries.

Colonial Wine Jars

Inside what is left of the old winery walls, buried up to their shoulders, are rows of narrow clay jars called ti-najas. These jars were used to store wine and vinegar. The dry fill has eroded away from some of the pots, revealing their full height, measuring as much as 2.5m (8½ feet) tall. Some tinajas have tumbled out of their settings and rolled down the steep banks. Others are being carelessly excavated with machinery, too often with disastrous results. In some places the old jars are covered with large, flat stones and still serve as storage for vinegar. However, most are gradually being removed, trucked to Lima, and sold for garden ornaments.

The shape, quality, and size of these jars make them very impressive. The bottom of their elongated form has a softly rounded point. The surface is smooth and the profile lines are clean and full. A strong shoulder curves into a short neck, ending with a doubly thickened lip. The shoulders are incised with a simple design, often a cross, and an inscription, "En la Asunta Año" ("in the business year") with the date. The earliest date we saw is 1702 and the latest 1895.

The Collapse of the Clay Industry. The end of the 19th century saw the changeover from clay tinajas to wooden casks and barrels. The local pottery industry disappeared with the replacement of the tinajas. We were shown several colonial bowls and pitchers made in the area, which the local women are still using. However, today, in the local markets, the utilitarian pottery sold to the householders is trucked down the rough roads from highland villages between Pucará and Puno. One sees the same type of ware found in the small altiplano village markets.

All along the coast south of Lima, it is the same story: we found no pottery being made today. All the markets have small pottery sections displaying ware made in the highlands and brought down whenever the rugged roads are passable.

Altiplano

The altiplano, or highlands, of Peru south and east of Lima can be reached by several treacherous roads running up across the rugged Andean chain that lies between the coast and the great high plateau. You cross passes that range from 4,200 to 4,800m (14,000 to 16,000 feet), through areas of seemingly perpetual fog, snow, and hail storms, and over tortuous, pitted,

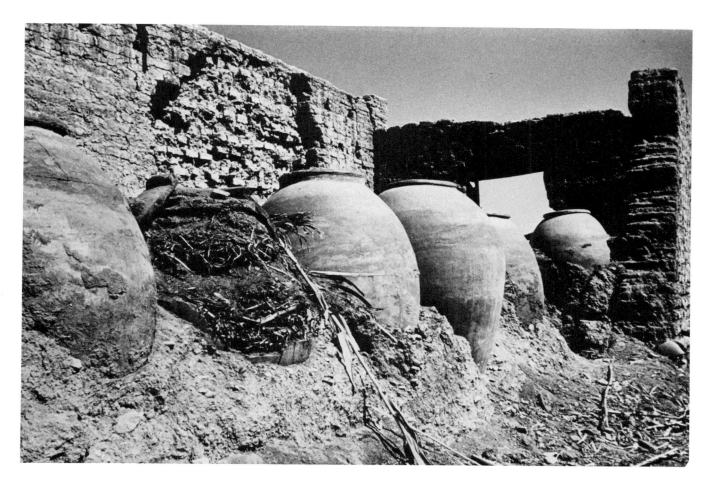

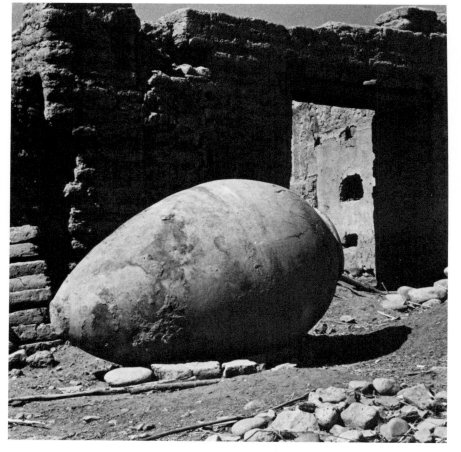

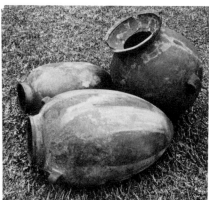

(Top) Inside the ruins of a colonial winery, large clay *tinajas*, that were once buried to their necks, are now visible due to the erosion of their hillside site. Some of the vessels measure 2.7m (9 feet) in height.

(Left) One of the *tinajas*, pulled from the old winery site, which has the date 1702 incised into its shoulder. This elongated form is comparable to those made in the Inca period as shown above. These Inca *amphoras* were recently excavated on the grounds of the Pachacamac ruins just south of Lima. The strong influence of these early Inca forms can be seen in the south coast colonial wine jars and in the northern potting community *cántaros*, such as those from Simbilá.

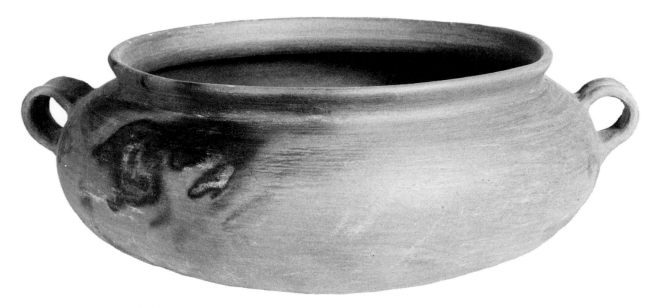

This *olla* is handbuilt, slip coated, then burnished and ground fired. It is 40.6cm (16″) in diameter.

washboard roads. Severe landslides may close off roads for weeks at a time. You drive for hours in first gear, both because of the steep ascents on curvy, precarious roads, and in an effort to minimize the battering punishment to tires and vehicle. The abrupt change in altitude, temperature, and atmosphere produces what is known as *siroche*, an uncomfortable condition of nausea requiring several days of physical readjustment.

You are rewarded for making the journey via land by the beauty of the ever-changing landscape. The road up through Arequipa provides an unusual view of saline lakes teeming with pink flamingos, abundant herds of alpaca and llama, and fields of blue lupine. From the rosy-hued, rocky sandstone vistas below you travel to the higher ranges above, where the predominating mountain colors change to grays, blues, and vivid greens until you drive past the timberline and drive between snow-covered peaks. Beyond Arequipa looms Mt. Misty with its almost perfect volcanic cone and graceful slopes. Though not the tallest of the three peaks in the area, the ever-present plume of vapors above its summit, makes it the dominating landmark from countless viewpoints.

Physical Characteristics

On reaching the great plateau, the aspects of road and vista change very little. There are still mountain passes that cross over this high valley formed along the Ayaviri, Santa Rosa, and Urubamba rivers. The really flat characteristics of a plain are found toward Lake Titicaca and south around the lake into Bolivia. The entire highland valley ranges from 3,000 to 4,200m (10,000 to 14,000 feet), surrounded by still higher snow-covered mountain peaks on all sides.

Stony fields, rough terrain, and sweeping, cold winds make this a difficult place in which to live. Stands of eucalyptus trees give some protection from the wind and provide a fast-growing supply of lumber and fuel for the inhabitants.

The rural people are mainly Quechua-speaking, with some pockets near the lake where Aymara is the prevalent tongue. Spanish, where spoken, is merely a second language used primarily in commerce within the larger towns and mastered by the Indians who have had to learn the language for their business activities. At home the Indian language is used.

Agricultural Communities

The main subsistence activity is farming. Grains, corn, potatoes, and yuca are coaxed from the poor soil. Fruit trees and the more tender vegetables are cultivated in the sheltered, more fertile valley areas. The Urubamba valley is especially famous for these. The jungle is not far away, and the markets offer citrus and other warm-climate produce to the urban dwellers. The other major sources of livelihood for the rural Indians and urban processors are the heards of alpaca, sheep, and llama. Wool, fur, and meat from these animals are an important part of the *alto* economy.

Many rural families are fairly self-sufficient. They raise their own food, and prepare and weave their own yarn into fabric for clothing. Many, seasonally, make their own family pottery. They sell excess produce, meat, and skins in order to buy the things they cannot produce, such as sugar or needles. They build their own homes from available stone or adobe and thatch them with grasses unless they can afford tile or corrugated sheet iron. Small home industries spring up to supply such community needs as leather, yarns, woven goods, crude tools, and pottery. Some have expanded into larger operations that provide the big cities of the nation with handcrafts from the Andes for tourists and for export.

Alto Handcrafts

Driving from Puno to Cuzco and on to Huancayo, you pass through the great handcraft area of Peru. The richest patterned weavings, woven on backstrap looms, come from this area. Here also, the *retablos*, which are small chests with carved or modeled religious scenes inside, devil masks, rooftop good-luck symbols, and so many more fine crafts flourish.

In many households either the man or the woman will take time during one month of the dry season to fabricate enough pottery for the family to use in the next year. Others produce more ambitious amounts for sale. You see large shards from pots cracked in the firing placed on the roof ridges of potters' houses to secure the straw thatch. In this way, even the pots lost during the firing are utilized. Broken-bottomed pots, serving as improvised chimneys, stick up through the straw roofs. An old ash-strewn circle on the ground near a house and a few remaining cracked pieces add to the evidence that a potter lives there.

Chita Pampa

The *chicha* of the *alto* regions is made with a blend of the locally grown corn and another grain known as *quinua*. The *quinua* plant is a variety of the common North American edible weed called "lamb's quarters." *Quinua* yields an abundant growth of high-protein grain. It is often used in soups. Most housewives make more *chicha* than their households can consume, and since it does not keep, they sell the remainder. When the *chicha* is ready, a sign is posted. Traditionally, this sign was a bouquet of red flowers, such as geraniums, tied to a pole stuck in the wall of the house. Today, red, magenta, or blue plastic bunched at the end of the pole is used for the sign.

On market day in Pisac, we stopped at a house near the main plaza to sample the *chicha*. We noticed that it was stored in a large, cylindrical clay vessel about 75cm (2½ feet) tall and 50cm (20″) in diameter. On inquiry, we were told that across the Urubamba River and along the long, winding road that leads to Cuzco, we would have to search and ask for the small community of Chita Pampa where these vessels are made.

The Village

As we came nearer to the village, we passed several of the large vessels sitting outside houses drying in the sun. Chita Pampa was set back from the road, and to get to it, we had to jump from stepping stone to stepping stone across a stream swollen by abundant rain. Walls of beige adobe, topped with thatch held down by pink pottery shards, surrounded yards where *quinua* and blue lupine were thickly planted. We were there in January. Everything was muddy and wet.

The Pottery Work

Years ago, we were told, there were many more people here involved in pottery making. Now perhaps a dozen men, working only in the month of August, produce pottery. The rest of the year they tend their farms.

The clay, and the slate which is ground up and added to the clay to temper it, are found on the villagers' own land and therefore cost them nothing. A month or two before they begin their pottery work, they prepare the clay and let it age. The procedures for building their ware are similar to those used in all of the *altiplano*, and are as described in detail in the following chapter on Machacmarca. The same turntable and wooden tools are employed. Their production includes most of the *alto's* basic cooking pots, as well as the unique storage containers for food stuffs and beverages.

Making the Storage Containers. These large earthenware jars are formed in three stages, taking 3 successive days, in order to give the clay a chance to set before additional weight is added. The 20cm (8″) flat base has flaring sides added that slant outward at a curved 45° angle to a height of about 20cm (8″). At this point the vessel's straight-sided, cylindrical walls rise until they terminate at the thickened rim. This rim and two handles placed low on the vertical wall section are the only details found on these pots. When completed, the vessel's entire surface is dampened and then burnished with a wooden tool to produce a smooth surface.

The pieces are set outside in the sun for at least two days before they can be fired. As many as 15 large containers, with smaller pieces inside, are fired at once at the end of each week's work.

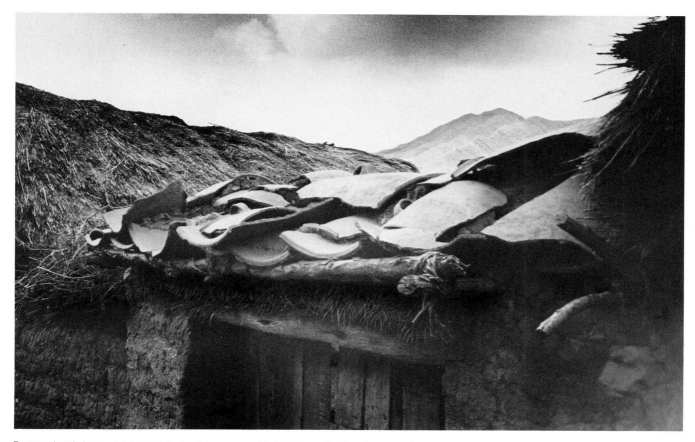

Pottery shards from ware broken during firing are used to hold down the thatch on top of walls and rooftops in Chita Pampa. This is often the only indication that pottery is made nearby.

A ground firing similar to the procedure used in Machacmarca is followed, where cow dung and hay are burned for fuel. Firing takes place at night and we are told that 2 days elapse before the ware is removed from the firing site.

Sale of the Ware. People in the surrounding area between Cuzco and Pisac depend on the potters of Chita Pampa for these large storage containers. After each firing they flock to the village to get the containers, which are used not only for *chicha* but also to store dry grain and cereals. Sculptors from Cuzco also use them to store their clay, plaster, and other sculpting materials. Some containers are used to store water, and the smaller ones are used for cooking.

Besides selling their pottery out of their homes to people who come from the surrounding communities, the Chita Pampa potters barter pottery with their neighbors. After this, only a few containers remain for the families' own use. None of their pottery is sold at the markets.

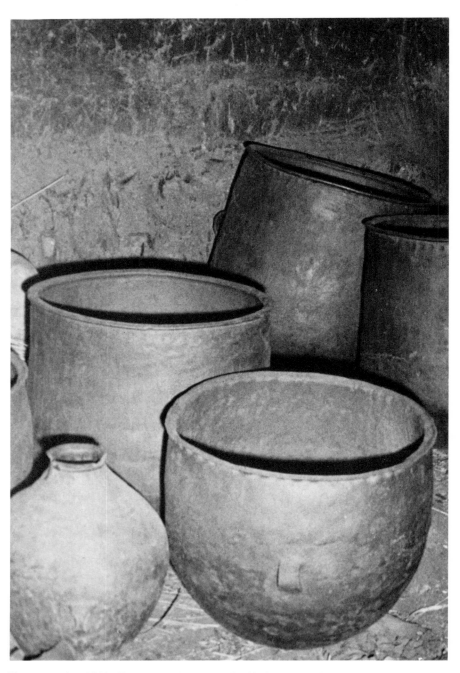

These completed Chita Pampa vessels were not fired before the brief pottery season ended and had to be sheltered until the next season. The closest counterparts to these unique, large, straight-sided vessels are the *virques* found in the Cochabamba area of Bolivia.

Machacmara

In the great pottery market at Cuzco and in scattered markets between Cuzco and Puno, we found many crudely fashioned braziers, stoves, pitchers, and small cooking pots. This common ware is made throughout the *alto* region as part of the housewives' seasonal work. Mixed in with these are the glazed tableware pieces from the Pucará area. Whether stacked in the pottery section of the Cuzco market or in use to serve *chicha* at the more distant market of Chincheros, one product was easily recognized because of its unusual pale cream color and red-slip line decoration. These were clearly the largest and most elegantly proportioned pots in the market.

The Search for the Cream-Colored Pots

No one seemed to know where the cream-colored pots were made. The pottery vendors at the markets mentioned San Pedro, San Pablo, Sicuani, and other villages strung along the highroad south of Cuzco. Men walking to work with the water-filled cream-colored jars hung on their backs by alpaca wool ropes could only tell us the names of the markets where they had bought them. We traveled the road between Sicuani and Cuzco several times without result, until late one summer afternoon when we came upon a sprawling, unnamed cluster of adobe houses. From at least a dozen places great billows of gray smoke were being blown across the road, burning our eyes and making us cough. We knew they had to be firing clay. We learned later that many fortuitous signs, which we could not ascertain, had indicated to the villagers that this day would be a good one for firing.

The Village. We walked through the village down narrow, twisting paths of grass and packed earth. On either side, solid walls of adobe, often over 2m (6 feet) high, hid houses and yards from view. The one-room houses and storage buildings were incorporated into these courtyard walls. Usually, a gateway was used to enter from street to courtyard, but some buildings were accessible by doors which opened directly from the street. The overall impression of the village was that of secretive dwellings hidden from view behind tan rubble and adobe walls, topped with pink, Spanish tile roofs.

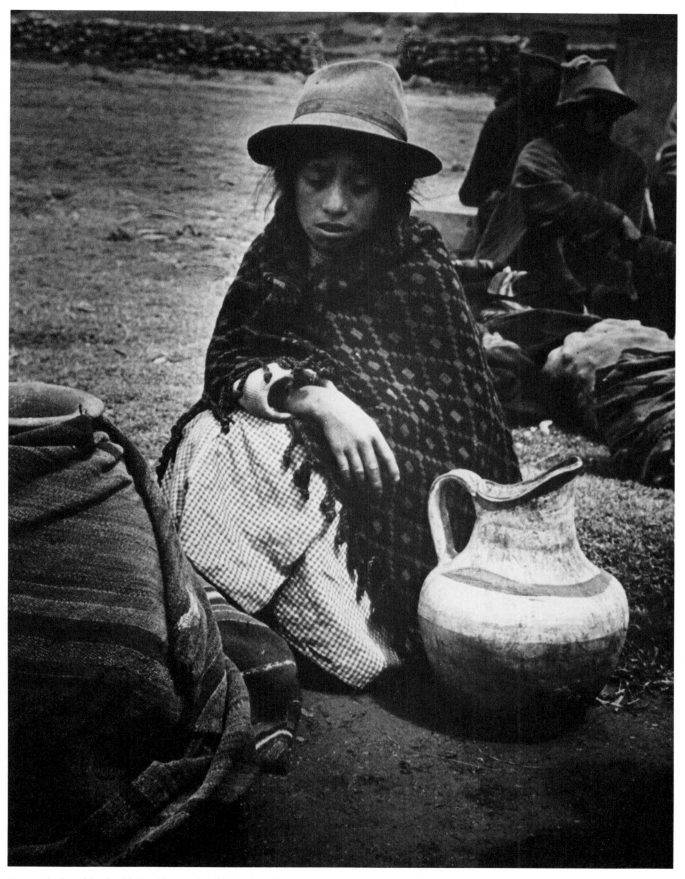

A young Indian girl sells *chicha* at the market. It is kept cool in a wrapped Machacmara *cántaro* and poured into glasses from a Machacmara pitcher.

In piles, side by side, one finds the slip- and glaze-decorated wheel-made bowls from Pucará and the handbuilt, undecorated *tostadoras* and *ollas* made and used by Indian householders.

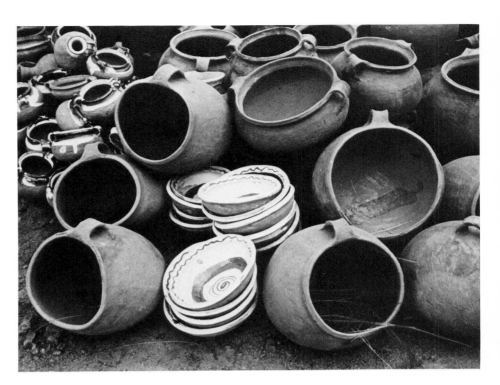

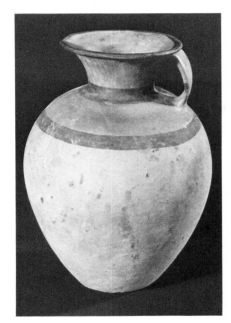

(Above) Machacmara pottery is easily recognized by its cream color, its billowing, rounded form, and the strongly applied slip designs. The most popular form of pottery made in Machacmara is the *cántaro,* a name given to pitchers of all sizes and forms. Some have no spout and have two opposing handles. This one has a slight dip in the rim to pour from, with a gracefully pulled handle opposite. It measures 45.7cm (18″) high and is meant to tip and pour from, rather than to lift and pour.

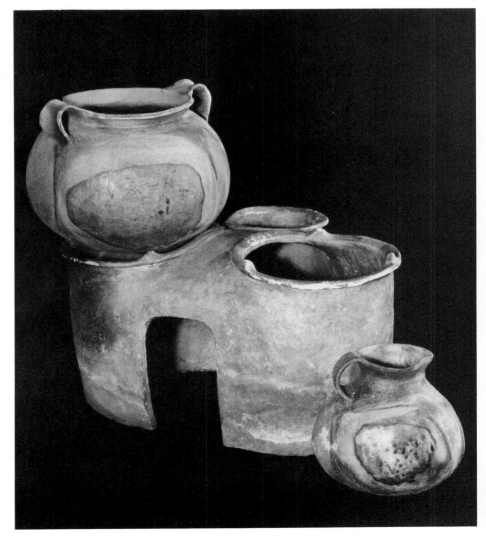

(Right) Many householders make these crude cooking pots and pitchers. The strong firemarks on the pots are caused by the firing methods used. The two-burner, 30.5cm (12″) high clay stove is used in most of the *alto* home kitchens. The stove is partially buried in a dirt mound on the earthen floor of the cooking area. Only the top and the arched opening at the front, where the fuel is fed, would be visible above the dirt.

The People. The people, like their houses, are of a basic Indian foundation with a Spanish overlay. The very young, who learn Spanish in school, and those who are in commercial contact with the outside world are the only ones who speak Spanish; everyone else speaks only Quechua. Those who did not speak Spanish were suspicious and shy and would not even come to their doors, preferring to remain hidden from strangers. Others indicated that they would not permit us to take pictures. Some had photographic taboos about the kilns, others were concerned for themselves.

Almost 300 people live in this small village. In the fields surrounding their homes, they raise their own animals and crops. Almost every family makes pottery, as this is their principal means of support. Making pottery is mainly the work of the men, although many of the women, too, do make pottery.

The Kiln

We arrived at the village during a firing day and knocked on gates where firings were in progress. Some families either did not understand us or gestured for us to go away. Other families smiled and invited us in. The kilns were constructed either in the center of the yard or along a rubble-stone wall bordering neighboring fields. A semicircular or oval wall of stones, about .5m (1½ feet) high, is the base and sole form of this rudimentary kiln.

Kiln Stacking. For firing, the bottom of this stone-formed site is covered with a layer of wood and dried cow manure. Mixed with this are piles of a dry, coarse grass called *pacha*, an Indian derivation of the Spanish word *paja*, or straw. The pottery is stacked over this and more of the grass is stuffed between and around it. The pottery and grass layering rises over the stone wall to a height of about 1.5m (4½ feet). Great heaps of grass are placed over the top, completely concealing the pots. Old pot shards finally cap the mound, with more straw thrown over all.

Firing Ritual. We watched particularly closely the firing at Rosa Ashla's house. Rosa is a widow, and her younger brother Miguel works with her, making the pottery and firing the ware. Roberta, Rosa's teenage daughter, took care of her baby sibling who was kept in the house away from the smoke. As she spoke both Quechua and Spanish, Roberta shyly translated for us. Their yard was large and, being located along open fields,

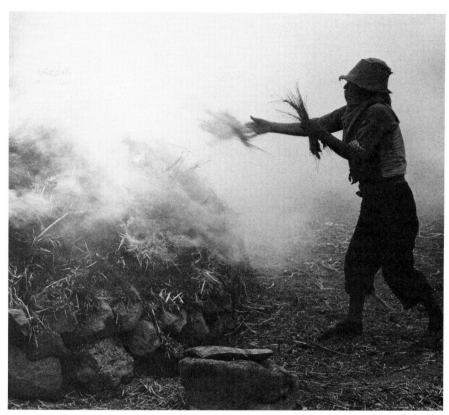

Miguel sprints through the billowing smoke to toss handfuls of *ichu* grass on the fire. Both this native grass and *pacha*, or straw, are continuously added throughout the three-hour firing.

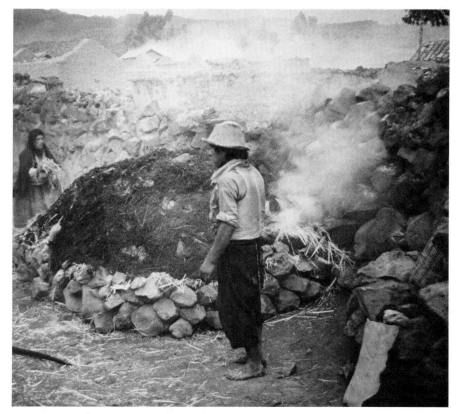

Rosa and Miguel each tend a side of the firing mound, replacing straw as pottery appears through the smoldering mass of the nearly completed firing.

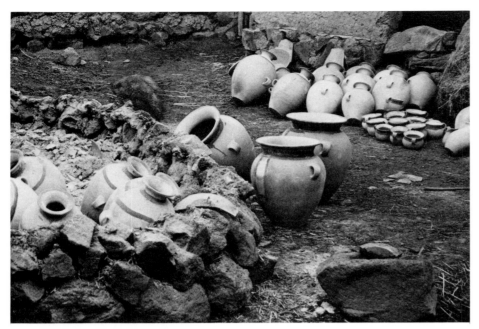

The kiln site is a base of rough fieldstones set in a semicircle against the rubble wall of the yard. At the unloading, approximately 180 pieces are taken from the firing, among them 42 jars of varying sizes, 80 pitchers, and 39 bowls. Only 3 pieces were broken.

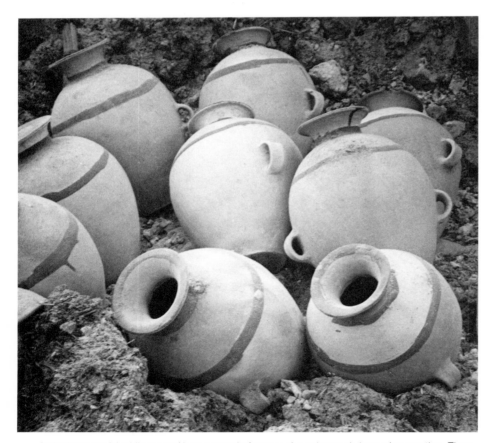

At the bottom of the kiln mound is a group of *cántaros* of nearly equal size and proportion. They are decorated in the most general manner, with bands of white and dark brown slips around lip and shoulders. The two handles are placed low enough so that the pot may be carried on a person's back by means of a rope passed through the handles and over the shoulders of the carrier.

was less smoky than many of the others. Their kiln was built along one of these field walls. Still, both potters protected their faces from the constantly shifting smoke—Rosa with her manta, and Miguel with a handkerchief tied bandit-fashion over the lower part of his face.

The fire was tended and fed constantly during its 2- to 3-hour period of combustion. As the straw blackened, great clouds of dark smoke belched out, blanketing yard, people, and even main highway, where it become a temporary hazard to motorists. As pots and shards appeared through the smoke and straw, more grass was added from a nearby pile. This resembled a rather nervous ritual dance. Rosa took care of her side of the fire and Miguel his. They circled through billowing, wind-driven smoke, tossing handfuls of straw at blackened open patches, backing up as these burst into flame. From time to time, they threw handfuls of salt over the straw or poked holes through the mass and tossed salt into them, causing a crackling, hissing series of small explosions. Roberta could tell me no other reason for the salt, except that it "makes it better." Again, it appeared to be a ritual act whose original meaning was lost. About half an hour before the firing terminated, Miguel tossed some old rags onto his side of the flaming mound and added more old shards. They were both still tossing salt on. Rosa continued to throw dry grass onto her side of the pile. At this point, Miguel was putting only fresh yellow straw over his portion of the firing.

As the fire died down, both of them pushed bits of straw and shards aside and tapped the top pots with a stick to test their hardness by sound. When they sounded hard, the blackened straw was poked back into place, and the process was repeated in other parts of the mound. Perhaps Miguel was not satisfied with the sound he received from the top center of the mound, for he rushed out of the yard, returning with an armful of dry dung. This he placed on the middle of the mound. Roberta helped at this culminating point, by tapping the pots and placing a few more handfuls of straw here and there. The final touch was Miguel's. He took the last armload of fresh straw and threw it over the manure. As it began to smolder, he placed a large pot with a broken-out bottom on the very top, like a chimney pot, out of which smoke billowed.

It was growing dark. Rosa retreated to the house to comfort the baby and make dinner while Roberta and Miguel swept up the scattered straw around the base of the kiln. They paused now and then to pat the black-

ened, smoldering straw and to rear-
range it.

Unpacking the Kiln. At 6:30 the next
morning, when we arrived at Rosa
Ashla's house to see how the firing
came out, we found the happy family
busily unloading the last pots from
the pit. These pots, like almost all the
pottery we have seen in Peru's coastal
or mountain areas, were purely utili-
tarian.

It had been a very successful firing,
with only three pitchers and one bowl
broken. Several pieces had chipped
rims, but these would sell.

Marketing the Pottery

At 7:00 on the morning after the firing,
several families had already bundled
their smaller pots in alpaca rope nets
and dried grass and were waiting at
the side of the road for the trucks.
Dressed in their best clothes, the
women were spinning and chatting.
Some women would ride to market
with the pottery to supervise its sale.
Most pottery, however, was sold to
the truckers who buy up work from
various communities and sell it in lots
to the market vendors.

The larger pots were carried down
to the waiting trucks, two by two, and
the largest were carried one at a time
by means of alpaca rope and strong
backs. These larger pots were loaded
on top of the bundles of smaller ware.
Because of the roughness of the roads
and inadequate packing, more pots
are lost during transportation and
handling than in the firing process.
This amount of breakage affects the
market price of the remaining pots;
the more breakage, the higher the
prices.

A Working Potter in His Outdoor Studio

Having witnessed the pottery firings
and having seen the work sent off to
market, we returned to the village pot-
ters to see how the pottery was made.
We stopped at the house of a potter
who allowed us to photograph any-
thing we liked, for a fee. He would
demonstrate his technique of building
a pot and show us all his ware in prep-
aration. He would not, however, tell
us his name, as he considered that to
be bad luck. The potter told us that in
his family he alone made all the pot-
tery, as his children were very small
and his wife did not do it. The yard
was set up for work, with areas ar-
ranged for building the ware, prepar-
ing the clay, drying the pottery, and
firing. The cow-dung cakes to be used
as fuel were thrown against the build-
ings to dry and piled along the edge of
the tile roofs.

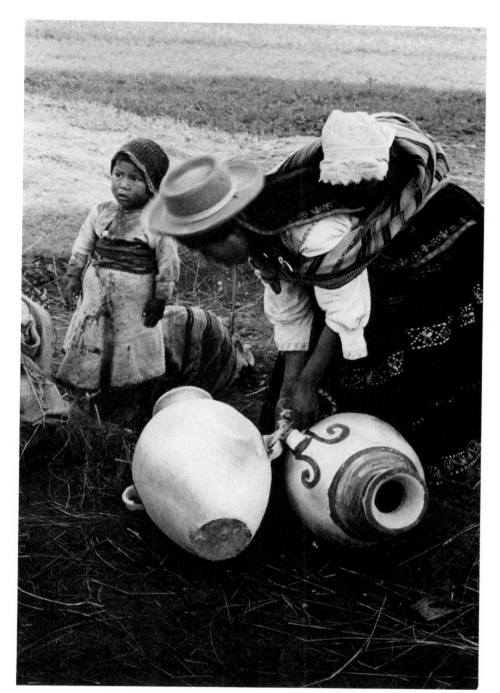

A Machacmara woman ties several smaller *cántaros* together to carry them from her home to the waiting trucks. She wears her best clothes, as she will accompany her pottery to market to supervise its sale.

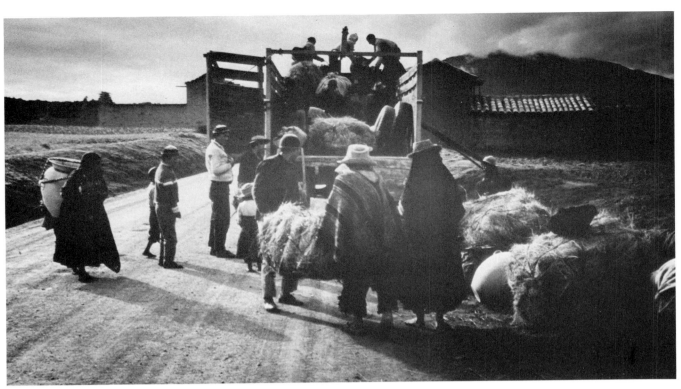

Early in the morning after a village firing, trucks arrive to carry Machacmara pottery to market. Smaller pots are bundled in *ichu* grass and alpaca rope nets.

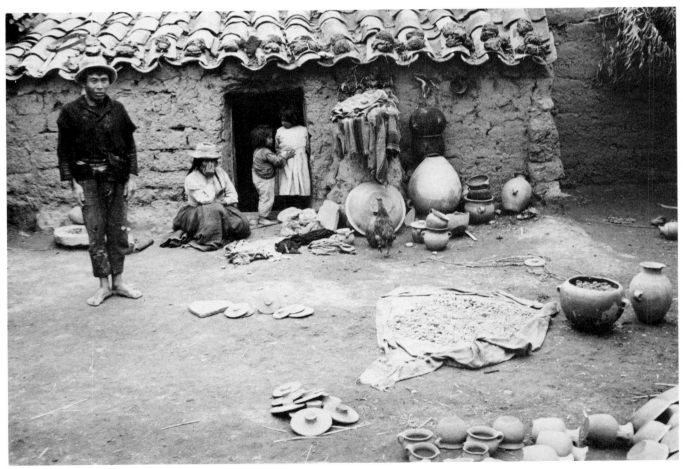

A potter poses with his family in front of his home. The dung drying on the tile roof will be used in his next firing. In the foreground can be seen a pile of *pocos*, or turntables, his crushed clay, and the pot he uses to soak it in.

Machacmara Forming Process. Whether a pot is to be a small bowl or an amply proportioned *tinajón*, the building procedure is the same.

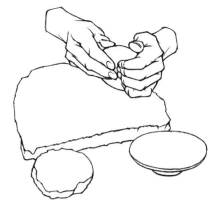

1. With his hands the potter forms a smoothly shaped disk.

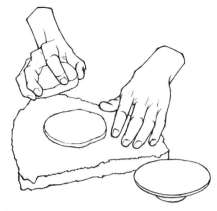

2. He sprinkles some crushed sandstone on the flat rock he uses as a worktable and with a smaller flat stone he taps the clay disk to thin and enlarge it.

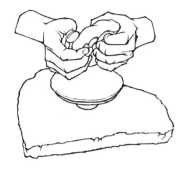

3. Selecting a *poco*, he places the clay disk on it. Then he takes another lump of clay and forms it into a doughnut shape.

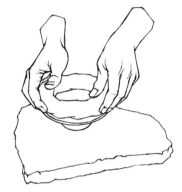

4. The potter places the doughnut shape on the clay disk.

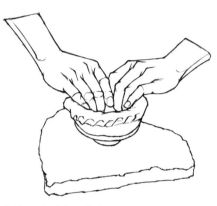

5. Using both hands, he turns and pinches the forms, joining the ring to the disk and gradually thinning the beginning pot's walls.

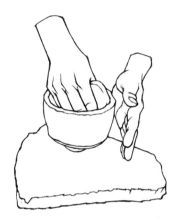

6. The potter uses his left hand to propel the pot. With his right hand and a wooden rib, he raises and thins the wall from the inside.

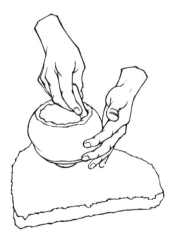

7. He uses a curved wooden rib on the inside to round out the curved walls of the pot.

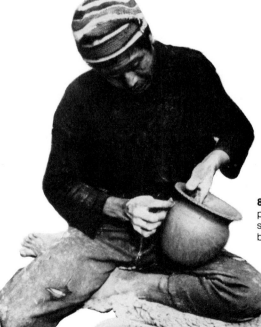

8. After the clay has been allowed to set, the potter adds a rim. When the pot is uniformly stiff, the potter rests it on his thigh while he burnishes the surface with a small stone.

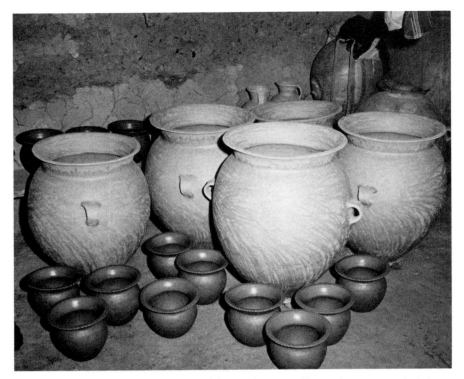

Marks left by the burnishing process are evident on the group of large, vigorous vessels drying in the potter's shed. The smaller pots, still glistening from the water used to smooth them, have been decorated with serrated rims.

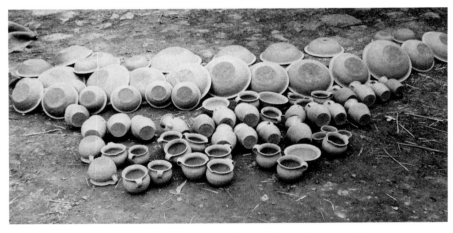

The small pitchers and basins are turned often to insure uniform drying outside.

Clay Preparation. The clay is mined from beds in the nearby hills. Each family goes out to dig its own clay as needed. The clay is dried out on a burlap cloth and ground into small pieces on the same stone used to grind the family corn. The red sandstone used to temper the clay is purchased from people in the nearby community of San Pedro. The clay is mixed with water in an old clay cooking pot. To work it into usable consistency, the sieved sandstone is kneaded into the clay.

Forming Tools. The most important tool is a series of turntables made of fired clay. The potter uses these to support and turn the pots during the forming process. The turntable, called a *poco*, is made in two parts. The upper section is a flat clay disk 2cm (¾″) thick and anywhere from 10 cm (4″) to 30.5 cm (1 foot) in diameter. This is fused to a short, flaring cylinder that measures about 2.5 cm (1″) high and 7.5 cm (3″) in diameter. With this, the potter uses a few wooden ribs, which he carves himself, to smooth and form the contour of his pots. (See illustration for forming process.)

Drying the Ware. The weather is unpredictable—showers or hailstones can fall with little warning—but because the air is generally damp, the pottery must be placed in the sun to dry. This potter had three storage rooms that contained pottery of all sizes and in all stages of drying. From these storage rooms, only as much pottery as could be quickly moved back indoors was carried outside to dry in the sunshine.

Decorating the Ware. When the pot is almost dry, two slips, one a darker brown and the other a lighter, orangey brown or white, are used to decorate it. Wide bands are applied around the neck and rim. Often crosses and swirly circles are used to decorate the inside of the wide-lipped rim; two opposite or four on quarter-points are usual. Circular or swirling dark line designs are often painted around the handles that are placed on the low, swelling shoulders of the larger pots. Some applied clay decoration is also used. We found applied rope patterns between neck and shoulders of some pots. Also, button-sized rosettes and sprig-molded pieces are applied at quarter-points on the wide, flaring lips of some pots. These rosettes are similar to the ones used more lavishly in the community of Checca Pupuja (see the following section).

Spanish Influence

Some shapes used are swelling, rounded forms, usually with wide, flaring rims, reminiscent of the Inca aryballoid jars. Pitchers come in a variety of forms, from the tall, elegant ones to a more squat, rounded shape. Handles are pulled and gracefully curved. These pots are completely unlike the more crude, earthy local ware and reflect the Spanish influence seen in other aspects of these peoples' lives; i.e., dress, tile roofs, colonial looms. The decorative motifs seem to empha-size this cultural borrowing. Stylized leaf and flower patterns, crosses painted on the ware, and the slightly fluted rims and rosettes used in Machacmara are used more discreetly here than in the more strongly Spanish-influenced community of Pucará, 170 kilometers (106 miles) southeast of Machacmara.

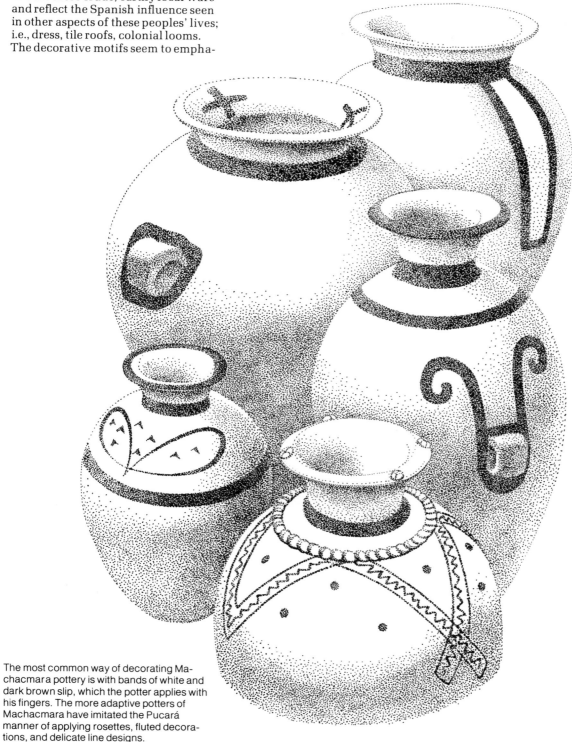

The most common way of decorating Machacmara pottery is with bands of white and dark brown slip, which the potter applies with his fingers. The more adaptive potters of Machacmara have imitated the Pucará manner of applying rosettes, fluted decorations, and delicate line designs.

Checca Pupuja

In all displays of *artesanías* from Peru, one finds a sturdy, rounded bull with a huge neck, the head seemingly pushed back into the body and the tip of its tongue thrust into one nostril. He is generally painted with a white slip and further decorated with painted swirls of slip or glaze and applied flowers and leaves. He is known as the Pucará bull. He can be found in sizes from a 5cm (2″) long whistle for children to a vessel measuring as much as .9m (3 feet) in length. His fame began with the building of the Cuzco-Puno railway. People riding the train are plied at each station with offerings for sale of foods or the crafts of the area. People returning to the cities with the handsome bull would describe his purchase at the Pucará station. Also, tourists traveling the *altiplano* main road, which passes through Pucará, could purchase the animal sculptures at the crossroads there. This is how it came to be known as the Pucará bull (see Color Plate 14).

Ceramic ware is made in Pucará, but it bears little resemblance to the products made in the nearby community of Checca Pupuja. The potters who live in this village, which is the true birthplace of the bull, take great pride in their work and are quick to let you know the distinction of their pieces.

A Secluded Village

Checca Pupuja, some 5 kilometers (3 miles) from Pucará, is a community of small farms with low adobe and straw-thatched homes. You approach the houses by walking over the fields in this village, surrounded by low, steep-sided hills. Some houses are perched precariously on these steep inclines. Dry cow dung is neatly stacked near the houses. New felt hats are drying on rooftops. Herds of llama graze nearby. Rounded grass-covered mounds used as ground firing sites and several adobe kilns dot the landscape.

Self-Sufficient Potters

Pablo Condore, born here, is a ceramics teacher in a nearby government school and is considered the authority on local folklore, crafts, and especially ceramics. He introduced us to his family and to several other families of potters. Everyone, he told us, is a potter here—the mayor, the priest, men, women, youths—almost 200 families. Their chief occupation is farming. The principal crops are *quinua* and potatoes. There is never a lucrative crop, as cultivation is difficult in this poor, rocky soil at an elevation of 3,900m (13,000 feet). Some livestock, chickens, sheep, and llama are also raised.

The self-sufficiency of the people is extraordinary. Besides raising most of their food, they also make most of their own tools and clothing. Even the town leader and head of the co-op has a colonial four-heddle, foot-pedal loom set up in his home. He spins the wool from his own sheep and weaves cloth on this rustic loom.

Use of Natural Materials. All the clay-colored slips and glazing materials are found nearby. The clay, which is dug from the banks of the Pucará River, has a fine plastic quality. The potters merely have to wet it down in their clay-preparation containers and add some crushed shale to it, after which it can be used right away.

Decorated Ware

The decorative pieces, which include the bull, horses, other animals, figures, and churches (made in the manner of those from Quinua, but nowhere near as elaborate), all are made from hand-modeled strips of clay that are joined together. Of the sculptured figures, you see ladies in bonnets and long dresses playing musical instruments most often. Their faces are made in clay sprig molds. Thin coils of clay are also rolled and applied. These decorative methods carry over to some of the other animal sculptures as well.

All the cooking utensils, candleholders, animals, figures of farmers, plows, buildings, and such, are also made in miniature to be sold as children's toys.

Sprig Molds. This decorative method was brought to South America by the Spanish. The technique has taken hold strongly in two areas that we visited. One is here in the Pucará area and the other is Huayculí, Bolivia. We will note many other similarities in the ware here and in the Bolivian village. Sprig molding is a technique whereby a small, shallow mold is made by pressing a wad of clay onto a small sculptured form, such as a carved rosette or leaf, a doll face, or other small image. This hollow, molded impression is allowed to dry. It is then used as is or else fired to obtain permanency. To make a positive, the process is simply to take a small ball of clay, press it in the mold, and then remove it. Clay slip is smeared on the back of the sprigged design and it is then applied to the ware.

Slip Glazes. All pieces are allowed to dry for several days before the slips or glazes are applied. The work is fired only once, after decorating, so the potter must work quickly and spontaneously on the greenware forms.

The whole piece is generally coated with white slip. Splotches of green or brown glaze are loosely splashed over this white base, as well as swirled-line patterns of brown slip. The glaze and slip are applied in a seemingly casual manner.

Lead Glazes. On some of the older pieces more of the bright lead glazes were used. You find the bulls and lady musicians, especially modeled in the same fashion and then covered with a deep green, rich plumbate glaze with blendings of dark browns. The lead glaze, which they call *escoria,* or slag, is made from the slag left over from depleted silver mines after they were abandoned by the Spanish. This material, as well as the oxides of copper, iron, and manganese, is found in impure but workable form nearby.

Molde-Formed Ware

The tableware, as in Machacmarca, is made using the same rudimentary wheel of a clay disk with a small foot, called a *molde,* or its diminutive, *moldecito,* on the flat stone. Señora Condore demonstrated making a small bowl, using the same process as the Machacmarca potters.

Pitchers and shallow bowls made on the *molde,* destined for table use, are also decorated with white slip and linear design motifs using a series of parallel or wavy lines painted with brown slip or glazes.

Typical Alto Kitchenware

Rougher, undecorated ceramics are also made with the *molde.* Storage vessels holding many gallons and cooking pots of all sizes and rounded shapes are made here. They are distributed widely to points at least as far away as Cuzco, Desaguadero, and even coastal towns where they are sought and bargained for by marketing housewives.

Two Kinds of Kilns

The original kilns used in Checca are made much like those in Machacmarca. The main difference is that here a shallow hole is scooped in the top of a manmade mound, sometimes ringed about with a wall of stones .45m (1½ feet) high. The combustible

The body of the horse is made first, using handpressed strips of clay joined together and rubbed smooth inside and out. The head is made in the same way as the body. Lastly, the legs and small details are applied.

Sprig molds are an important decorative device used on many Checca Pupuja figures. The sprig-molded pieces on this bull represent the flowers and coca leaves which adorned the ritual bulls for special festivals.

material is the dry cow dung that one sees in high conical piles placed in the fields. The ware is placed directly over this. Then everything is covered with dry llama dung, while old, calcined llama dung from previous firings is spread over the top to temper the fire. Because the wind can pick up suddenly and cause the fire to flare up too quickly, a wooden plank is kept nearby to deflect the gusts. This type of firing is planned for the afternoon and lasts from 2 to 3 hours.

Because of Pablo Condore's influence, his family—and several others besides—are trying smaller versions of the Spanish-style Pucará kiln with great success. This type of kiln is described in detail in the next chapter.

The Pucará Bull

Because of its widespread fame, more should be said of the Pucará bull. It was not until the mid-1500s, when the Spaniards colonized the *altiplano,* that bulls and oxen were introduced into Peru. They made a tremendous impression on the Indians because of their great size and strength and the work they could do. Previously, the llama had been the only work animal they knew. Prized for its ability to carry loads, his wool, and his meat, it was the central sacrificial animal in many ceremonies. The bull was destined to take its place. Because of his greater strength, he became a symbol of life and virility here, as in various other ancient cultures. The clay bull is a record in miniature of how, on some feast days, a prime young bull was actually painted with whitewash over which symbolic designs were applied in ochre earth. The skin around his neck was pierced and the drops of blood collected and flung to the four winds to appease the goddess of the earth, *Pachac Mama.* Flowers were thrown on him and coca leaves pressed on the small wounds to ease his pain. Then, to stir him up and set him prancing, a few drops of *chicha* were poured into his nostrils, where he thrust his tongue to ease the sting. Thus the young men of the village could dance around the snorting, prancing beast to test their bravery. The bull was never really hurt, however.

That the bull is made as a hollow vessel with an opening and a handle is certain. We have been told of several uses for him as a container. One is that the cavity is filled with oil which is burned as a votive offering. A similar explanation is that the opening is meant to support a candle. We were also told that a young man is tested to prove he is a "man" by handing him the bull filled with *chicha.* To pass the test, he grasps the container by its rump and chest, lifting it to his lips and not lowering it until the contents are drained.

The Wedding Cup

Another special vessel made in the usual decorative manner, and hard to find now as it generally is made-to-order for the occasion, is the wedding cup. Made for the bride and groom to drink their *chicha* from, it is a full-rounded form with a wide neck. Around this neck are modeled the members of the wedding party and the band of musicians. Centrally located and opposite the handle are the head and front hoofs of the bull. A hole is pierced through the wall of the cup and through the bull's mouth, which makes it possible to pour liquid from the bull's mouth.

Marketing Ware

The government has put up a building for the artisans' cooperative in Checca. It is an L-shaped building with large glass windows lined with hundreds of plants all growing in tin cans. The floor is concrete. The structure is much more substantial than any of the houses. The building serves as a school; provides space for offices and for the collecting, displaying and selling of work; and is a community meeting place. Much of the best decorative work is gathered here for *Artesanía del Perú,* an organization co-sponsored by the government and the Industrial Bank of Peru. The work is trucked from this point to showrooms and shops in the cities. Export is also encouraged, and indeed, the Pucará bull is better known throughout the world than any other folk art of South America.

Traveling merchants also drive through these communities buying work from individuals and selling it in markets and tourist shops.

Some of the potters still bundle up their own ware and take it to the markets. On the 16th of July, a festival day is held in Pucará. Many of the people save a large amount of their ware to sell then.

To pack their ware, a clever method is used. A hole is dug in the ground and then lined with a net made of llama wool. The ceramic pieces are placed in the hole, with straw between the pieces, and then the net is secured. The bundles are loaded on the donkeys to be taken to Pucará or to waiting trucks.

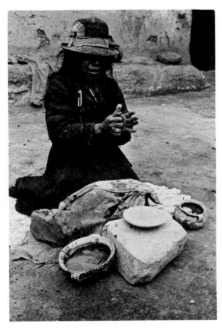

Sra. Condore uses the same techniques to build her ware that are practiced in Machacmarca. Her tools, too, are the same, except that she has added several wooden ribs, a rib made of a rubber tire which she keeps in a pot of water beside her, and a chamoislike piece of sheepskin to smooth her ware.

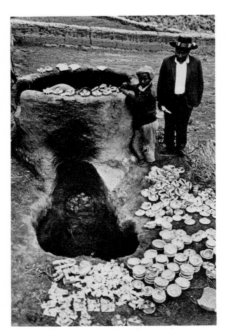

Sr. Condore has convinced many Checca Pupuja potters that this simple kiln will fire their ware more easily than a mound firing. All of these small pieces, designed for the tourist market, are the product of one firing.

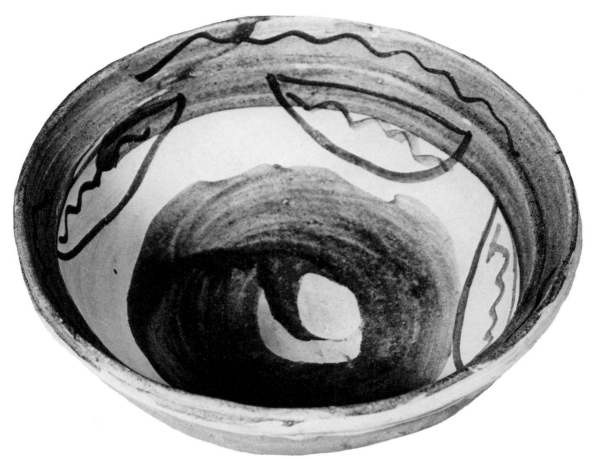

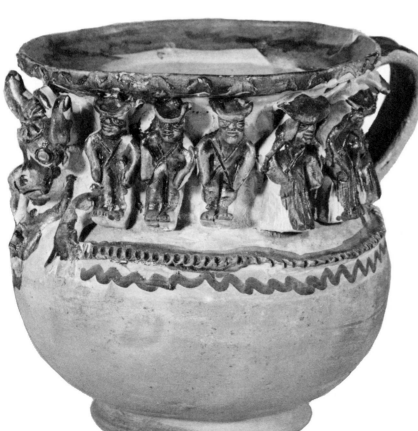

(Above) The Checca Pupuja soup bowl called a *chua*, is covered with white slip when leatherhard. Dark-brown narrow slip lines, similar to the painting on the Pucará bull and thinly applied light-brown glaze lines are painted on the bowl.

(Left) The body of the wedding cup is made on a *molde*. The bull, a symbol of virility, is centrally located.

Pucará

The trip along the main highland road from Puno to Cuzco is slow and adventurous. Only a fraction of the road is paved, and the remainder allows slow, uncomfortable travel at best. Pucará is built at a crossroad on this artery. Stores selling beverages, food, and *artesanías* flank the corners. To the east is Santiago de Pupuja and Checca. To the west is the main concentration of Pucará: the plaza, churches, government offices, a small museum, and further up, where the road ends, a rising hill at the foot of stone cliffs.

A Historic Site

Here stand what is left of the ruins which date from 500 to 200 B.C. and relate in time and style to the early Bolivian Tiahuanaco culture. "Pucará" in the Aymara Indian language means "fortress." What is left of the fortress complex is a series of polished, rectangular cut stones set in an intriguing layout of sunken courts and corridors. Little is left in place. One sees the pink cut stones from the site which were used during the Spanish occupation as building blocks for the huge colonial church, for street paving, door sills, and as foundation stones for humble adobe dwellings.

The few ancient ceramic pieces and shards found here bear a close resemblance to the Tiahuanaco style, as do the carved stone stelae, or columns. The old ceramics are finely made, with beautifully polished slip designs in reds, creams, and tans painted within incised lines depicting animal, human, and anthropomorphic figures in abstract patterns.

The Village Work Today

About 300 families live in the close-knit village itself. The people here, too, support themselves through agriculture, by working on the large surrounding farms, or by raising animals. The majority of families also work with clay. Weaving and knitting are done in some quantity here, as in almost all the localities along this route.

The Potters' Yards

There are large yards behind every house, some communal, where one or more kilns are located. Each yard contains pits or large earthenware containers for clay preparation. Depending on the type of work produced, you see walls piled high with plaster

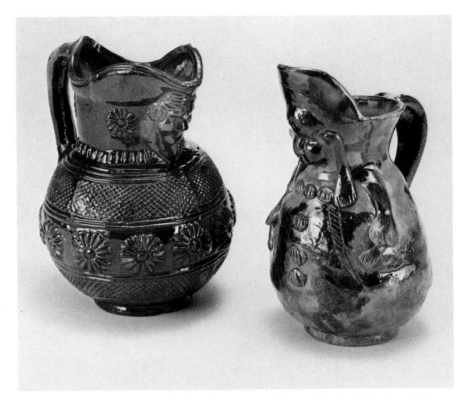

The pitcher on the left is an example of mold ware made in Pucará. The lead glaze is a deep glossy brown. All the relief embellishments are formed within the two-piece mold. The similar pitcher on the right is from Huayculí, Bolivia. The body of the pitcher is built of flattened and joined strips of clay. The hat, sprig-molded face, and other details are then applied. A green glaze covers the piece.

molds or glimpse a potter's wheel through a courtyard doorway. Other rooms may be stocked with a variety of drying greenware. Huge mounds of dry llama pellets or cow manure piled against a courtyard wall predict an impending firing. Some handwork is done; however, the great quantity of work produced here is done in molds or on crude kick wheels. Production methods are poor.

The Clay and Glaze Materials. The clay is dug from the banks of the Pucará River. One bed produces a very greasy plastic clay, under which is a rather sandy clay deposit. The two clays are mixed in the proportion of three parts plastic to one part sandy clay. The mix is soaked in water and passed through a cotton-cloth screen for use in the molds. All the finished ware is covered with bright, shiny green, yellow, or brown plumbate glazes, using the same sources for materials as the potters of Checka, but with truly garish effects on most of the pottery.

The Mold Ware

The molds used are of plaster, mainly two-piece, and are held together with llama-hair rope or rubber innertube. Some of the molds are made from

what we were told are original design models, but what we saw was a variety of pitchers, flower pots, bowls, and such items that appeared to be molded from other commercial ware. Molds are also made of the bulls and other animals and figures. Some of the artisans were making molds of copies of Inca vessels and hand painting slip designs on these. Much of the ware is obviously tourist-oriented, of the Indian-on-ashtray variety, and it can be seen all over Peru. There is a market for this molded utilitarian ware, and it is sold in cities, village stores, and markets along with other commercial tableware.

Wheelthrown Ware

Pucará is the only community in Peru where the Spaniards were able to introduce the use of the potter's wheel. We visited several families where crude wheels were set up in the dark corners of ill-lit rooms on simple wood supports built into the adobe walls of the house. A rough wooden post supports the wooden wheelhead, and a wooden kicking platform worked by bare feet supplies the power. Throwing off the hump, the potters produce great quantities of skillfully formed, small, shallow

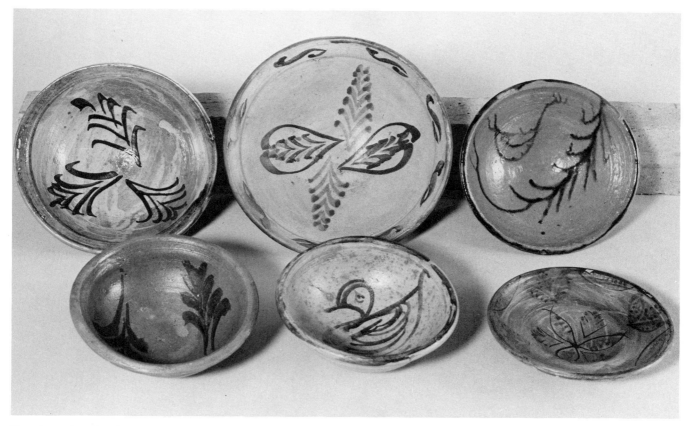

There is a variety of traditional patterns painted by all the Pucará potters on their *chuas*. Flowers, leaves, birds, or fish are rapidly brush designed in shades of brown and green. Thin washes of glaze in pale greens, golden tans, and yellows are brushed over the linear designs.

bowls called *chuas*. These are the table plates most commonly used by country people in the Peruvian highlands. One sees piles of these beautifully decorated, thinly glazed bowls in all the markets, often extending down to markets on the southern coast. A variety of designs is freely painted with oxides of manganese, iron, and copper. One sees curving fish motifs resembling those on ancient ware but more loosely designed than the precise forms of the pre-Columbian ceramics. Bird, flower, and foliage motifs are done in what appears to be a prescribed, symbolic manner with minor variations. Geometric patterns or straight and wavy lines are also employed. The *chua* is also made in Checca Pupuja, but not very many are made and they are therefore harder to find. Those of Checca are decorated mostly in white, red, and brown slip and only occasionally painted with green and brown glaze lines over white slip. Checca *chuas*, however, are not covered with glaze (see illustration on page 35).

Glazing and Firing. All the ware is fired twice in Pucará. Both wheel and mold ware are often dipped entirely into or partially painted with a white

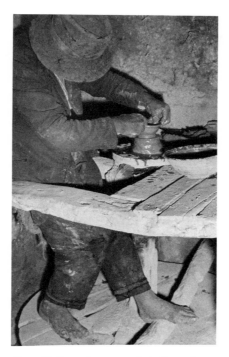

Pucará is the only community in Peru where the wheel is generally employed. Here, a Pucará potter forms a *chua* by throwing off the hump. The potter's wheel is made entirely of wood, the framework being built into the adobe walls of the room. The potter sits to one side of the wheelhead, throwing at his left side.

slip before the bisque fire. This gives the glazed ware a more brilliant color, as the lead glazes are quite transparent. In the glaze firing, the pieces are stacked one on top of another. Crude setting stilts are used to place plate on plate; wads of sandy clay are placed between other pieces. This, of course, causes glaze to be pulled off parts of each piece, especially where the glaze is thickly applied. Perfect pieces are unknown.

The bisque firing takes 3 to 4 hours and the glaze firing 4 to 5. Firings are generally planned for evening hours, as the wind is less violent then and the color of the fire and appearance of the gloss on the ware can be more easily seen in the dark.

Kilns

The kilns are of two types. The most common is a round chamber of adobe which often is lined with bricks made by the potter. This cylinder is of varying heights and diameters, the most common being about 1.5m (5 feet) tall and 1.2m (4 feet) in diameter. The floor of the chamber is an arched-brick grill. Pottery is loaded from the top. The firing chamber section of the cylinder beneath the grill is either at ground level or below, where it is

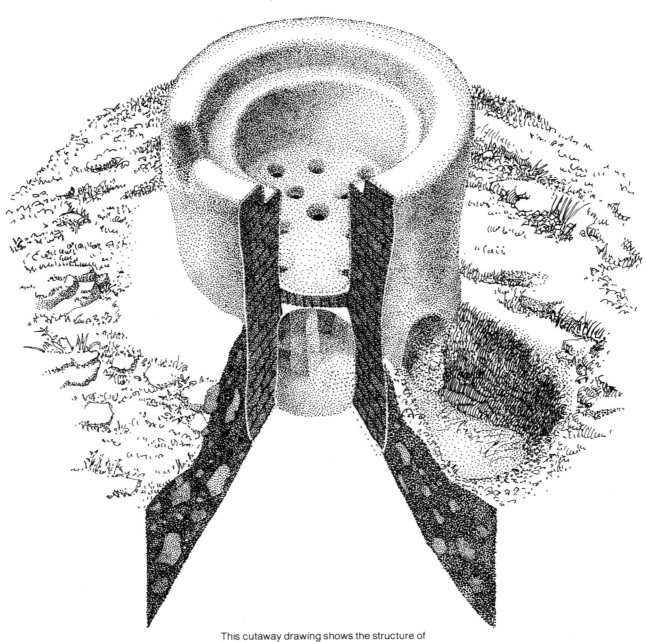

This cutaway drawing shows the structure of a simple updraft Pucará kiln. It is made of adobe bricks and covered with more adobe. Columns of bricks support a perforated brick floor arched on its underside. The combustion chamber is sunk .5 to 1m (2 to 3 feet) below ground level. A large pit is dug in front of the fire port to permit access during firing. Ware is loaded through the top. A niche in the wall provides easier access to the firing chamber, which measures about 1.2m (4 feet) in diameter and about 1m (3 feet) deep.

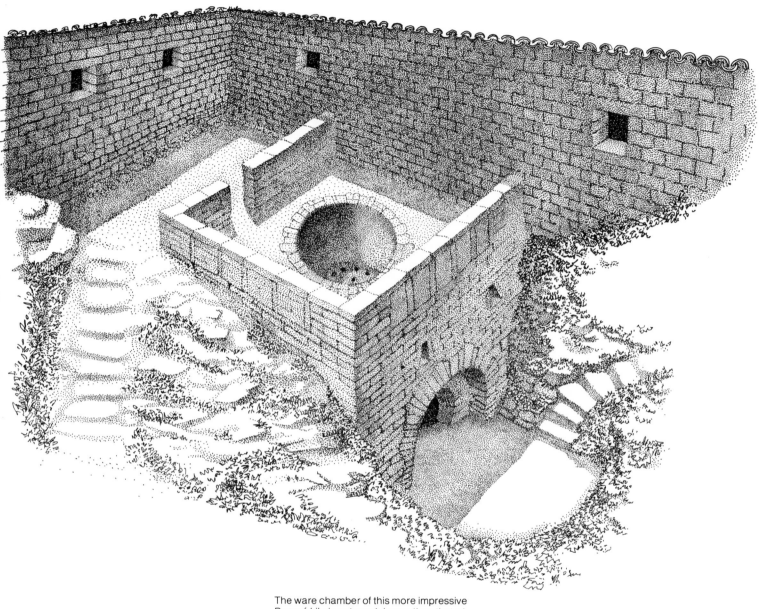

The ware chamber of this more impressive Pucará kiln is not much larger than that of the more simple kiln. The average ware chamber is about 1.5m (5 feet) in diameter and 1.5m deep. The rectangular structure around the chamber is made of adobe brick with rubble fill. The large fire pit sometimes provides a sheltered area for combustibles. The fire port is made of a double wall of arched brick. The firing chamber is about 1m (3 feet) high and built like the one on the smaller kiln.

reached through a small pit dug in front. This is the same type of Spanish-inspired kiln we saw in Checca and were to find in Bolivia and Ecuador as well.

The more impressive kiln is a large rectangle with a cylindrical chamber within. This type of kiln is constructed of the same materials, but is much larger—it looks like a miniature fortress. One climbs a stairway to the square-top platform to load the ware. Llama dung and old shards are used to top off the pile. A few steps lead down to an anteroom from which the fuel is loaded into the arched entrance of the fire chamber. Wood from the countryside, often augmented with grasses, cow dung, and llama dung, are the combustibles.

Government Ceramic Schools

Two *artesania* centers are sponsored by the Minister of Education in the Pucará area. One is in the town center, and the other is set up, boarding-school style, south of Pucará. Ceramics is one of the disciplines taught in these centers; mold-making, wheel work, glaze decoration, and firing techniques are included. It is difficult to tell what influence the centers have, except by looking at the ware produced. One could wish that the teaching of design were better. Unfortunately, outside of the *chuas* and other related wheel work, the molded pieces show little influence of good design, originality, or integrity.

Ayacucho

The road from Cuzco to Ayacucho crosses three mountain ranges. It is 600 kilometers (375 miles) of extremely slow, difficult driving. From Lima to Ayacucho is 550 kilometers (340 miles). The road to Huancayo is mostly paved, except where it crosses the 4,767m (15,889 feet) Anticona Pass. From Huancayo to Ayacucho is some of the worst road encountered in the entire Andean highway system: rough dirt, stony, narrow, and tortuous. In one 110 kilometer (70 mile) stretch of river gorge, the road is so narrow that traffic is allowed in a southbound direction on Monday, Wednesday, and Friday and northbound Tuesday, Thursday, and Saturday. On Sunday it is a free-for-all. Landslides are frequent in this area and can be expected to cause long delays.

At last count, 24,374 people lived in this somewhat secluded city, which is the capital of the Ayacucho Department, a city which has retained most of its colonial characteristics. The city is famous for its 33 churches, either in use or abandoned. A religious city, its most notable festival is the *Semana Santa*. During a full week, starting with Palm Sunday's procession of fantastically woven palm towers tha are paraded through the street, each successive day sees a different procession of saints and *Cristos*. At night, candle-lit processions pack the streets, and the sounds of mournful bands, singing, and fireworks echo through the town.

A Handcraft Center

Ayacucho is one of the largest Peruvian handcraft centers. Here one sees the *retablos*, painted boxes whose double doors open to reveal nativity or other religious scenes packed with tiny, brightly colored modeled figures. It is said that traveling priests first carried these to the indigenous people to teach them religion. Other crafts include elaborate tin crosses, weaving, gold-and-silver filigree work, carved gourds, and carvings made of the "stone of Huamonga," a soft translucent alabaster.

Inca-Spanish Heritage

The fame of Ayacucho's artisans goes back to colonial times when the Spaniards brought their traditional arts to the area. The carved saints and *Cristos*, and old *retablos* from that era, are prized collectors' items today. The architectural and ceramic remains of pre-Inca times attest to the great early culture that grew and spread from this locality. Several notable ruins are located in the department, the most noteworthy being Vilcashuaman, where one sees the remaining elegant trapezoidal doorways and beautifully fitted cut-stone walls and stairways. Again, the Spanish colonists, while bringing their own strong culture, did great harm to the existing one. Vilcashuaman and other ruins here have been torn apart for their stones, which were used, as in Pucará, for church construction and for the colonists' homes and courtyard walls. Regrettably, the earlier heritage was neither valued nor respected. Judging by the painted political slogans and carved initials seen on these and other great ruins, this is true even today. What remains in the lives of the people is a mixture of both heritages. In religious festivals and pageants, and in the many religious handcrafted artifacts, you see a mixture of Christian mysticism humanized by Indian sentiment and augmented by Indian beliefs in magic, nature dieties, and witchcraft.

Quinua

The famous ceramic "Ayacucho churches" and other figures that are said to be from Ayacucho are not made here. As at Pucará, you must travel outside the city to see the people who make the most famous ceramics. About 30 kilometers (18 miles) out of Ayacucho, on the road toward Huamonga, you travel through gently rolling hills at 2,400m (8,000 feet) to arrive at Quinua. The village is noted as the site of the memorable 1824 Battle of Ayacucho, which marked the end of Spanish rule in Peru. Six thousand people live in the district, either in the village of Quinua itself or in small groups of houses called *barrios* that surround it.

As is usual in the highlands, the livelihood of the village is based on agriculture, each family working its own small parcel of land. The climate there is more mild than it is around Pucará, making living easier for both the people and their crops, which consist of fruit trees, corn, wheat, *quinua,* potatoes, beets, etc. Cactus grows abundantly in the sandy hills surrounding the area, and the people harvest the extremely seedy, sweet fruit called *tuna*. Communal pasture land is set aside for small herds of all the usual *alto* animals, plus cows and horses.

The Potters. About 100 families here augment their farm incomes by the serious production of quantities of ceramics. Where previously they only made what their own local communities could use, they now have become so well known that they have had to increase production in order to supply the growing demands from local, national, and international markets. As the market has grown, the potters have increased not only the quantity of work, but also the variety of types of figures and ware.

The Clay Work

The techniques of working in clay have changed little, even with the increase in production. The warm, tan-colored clay used by the potters for hand modeling is dug from beds located on their farms. Digging below the top-soil, the potters encounter two kinds of clay. One is a slippery, plastic type of clay; the other is more coarse and sandy. The two types complement each other well when mixed as two-parts plastic and one-part sandy clay. The potter dries, crushes, and mixes the two clays together and sifts them through a coarse cloth screen.

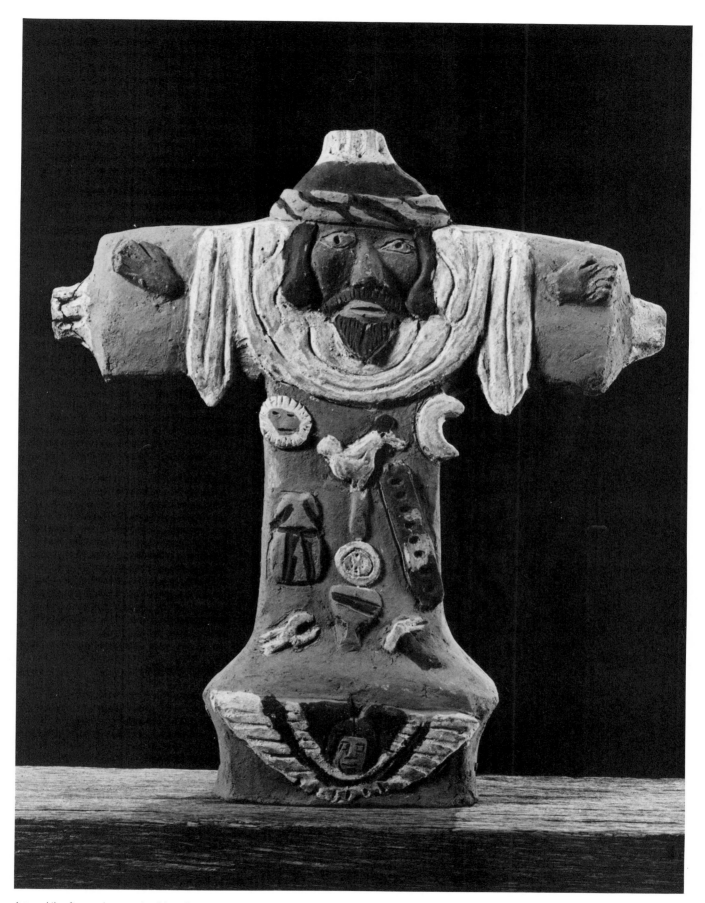

Around the Ayacucho countryside, tall wooden crosses are decorated with a twist of white cloth representing Christ. This clay crucifix goes a little further by using cloth head and hands. On the cross upright is a mixture of Indian and Christian religious symbols.

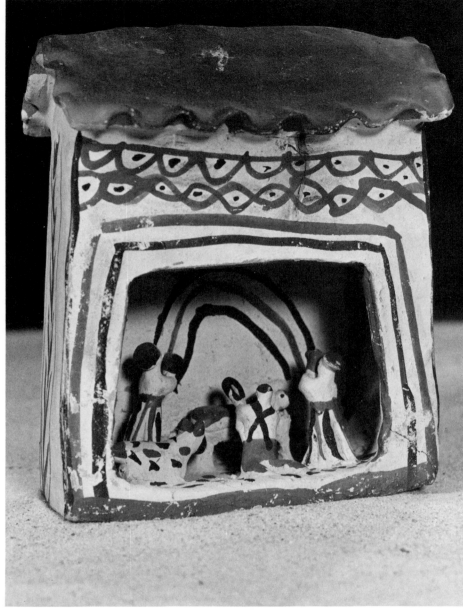

A nativity scene is placed in a 21.5cm (8½") high clay shed. It is coated with white slip that looks like the whitewashed adobe walls of the Quinua houses. Light- and dark-brown slips are used to paint the decorative details.

Next, he wets the clay down and kneads it with his bare feet on a piece of goatskin.

Everything is handbuilt, from architectural pieces to figurative work. Just as the hand-modelers did in Checca, the potter in Quinua seats himself before a flat stone. On top of this, he uses a disk of either plaster or fired clay to support his work in progress. The sculptural forms are built of small, hand-pressed slabs of clay, joined and rubbed together. The main section is formed first and then the subsidiary shapes are added. A footed animal would have the legs added last. Small details, such as eyes, mouth, nostrils, etc., are pressed into the clay with a sharpened stick or a thin tube of cane.

The potter's tools, besides these already mentioned, are like those of Checca, varishaped wooden ribs which are used wet. A small, smooth stone is another important tool which is also used wet to burnish the surface of the leatherhard sculptural pieces.

Slip Decorating. All the decorating is done with white and brown slips, again found in special beds in the Quinua area. To make the fine-textured, colored slips, the potters today use a system that must have been used by the pre-Inca Huari Indians of the area to obtain their smooth, polished surfaces. Quinua is the only place in Peru where this method, so commonly used throughout ancient Peru, is still practiced today. The slip clays are ground fine with the same mortar used for corn. The potter mixes the finely ground slip clay in water to soak for a few days. When it has settled in definite layers, the water is decanted, and then only the top layer of sediment containing the finest particles of clay is used. The surface of the present Quinua ware is not as brilliantly polished as the old pieces. It is possible that the early potters decanted the liquid slip several times to produce there characteristic sheen, similar to that of the *terra sigillata* of the Romans.

The practice used on many pieces is to coat the piece with an orange-brown or white slip after the modeled clay has become leatherhard. Then a smooth, wet stone is used again to polish the surface. This produces only a very slight sheen. Over this is painted an assortment of designs—branches, leaves, flowers, decorative bands, or architectural and facial details. Painting is done with brushes, chicken feathers, or a bit of rag tied to a small stick. Some potters will then again use the wet stone over the design, but this is not commonly done.

Rooftop Good-Luck Symbols

Many inhabitants of Quechua communities place various types of *suertes* (good-luck symbols) on their roofs to ensure good fortune for the people who dwell within. Around Ayacucho and Huancayo, especially, you can see elaborately cut and soldered tin crosses on rooftops, reminiscent of the colonial silver crosses carried in processions. Over many other rooftops in various communities you see crosses of straw and thin wooden slivers, more crudely done than the Scandinavian work with similar materials. In Quinua, and stretching out to other communities, notably Ayacucho, you find the roofs topped with a great variety of ceramic churches placed there to disperse evil. Their forms are silhouetted against the sky in all sizes and designs, and more fancifully put together and embellished than the great number of colonial churches that abound here.

Clay Churches

The simplest unit in the clay structures is a rectangular shed with fluted roof. Inside a large doorway you can see a scene, perhaps of the nativity, with simply modeled figures. The more complex churches are as much as 61cm (2 feet) high, often with attached building segments, wings, and one or two towers, domes, vaults, columns, or Romanesque arches. These are further embellished with turrets around and on top of towers, belfries with bells, clocks, niches with saints, crosses, saints on rooftop balconies, stairs, and again through large doorways, you glimpse a priest who may be leading a mass, a procession, or a baptism (see Color Plate 29).

The potter generally coats the churches with white slip, over which the modeled ornamentation is painted with two or more shades of brown slip. Doorways and windows are outlined with a series of thin and thick lines in varying shades. On the flat building surfaces, giant branches with leaves, huge flowers, or a series of decorative dots may be painted. The surface of this particular item is like rough whitewash, which is in harmony with the architectural concept.

Another Rooftop Ornament

A drinking vessel, originally in the form of a bull or llama, was also made here before Quinua became famous. These vessels are also seen on rooftops, where they are placed on either side of the ceramic churches, as if guarding them. When it rains, these fill with water and are used by birds

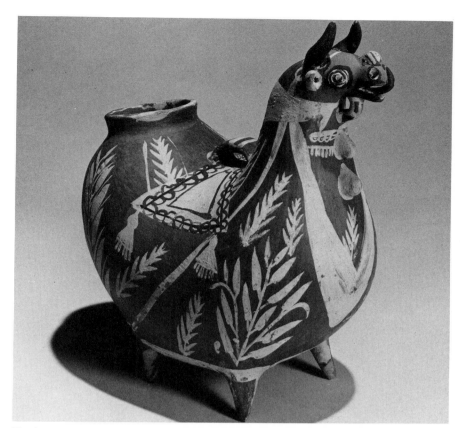

The Ayacucho bull is used both as a drinking vessel and as a rooftop ornament, where it is often placed beside the clay church, as if to guard it. The bull's brown slip-coated body is decorated with white slip designs representing plants and trappings. This bull is 30.5cm (12″) high.

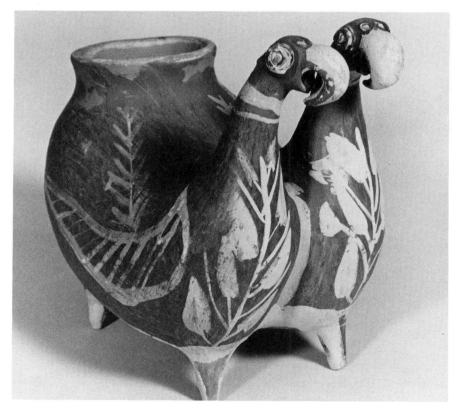

The Quinua potter's creative and good-humored personality is evident in most of his work. Here, a mythical two-headed parrot is formed on the same basic sausage shape used for the bull. This rooftop ornament is 30.5cm (12″) long.

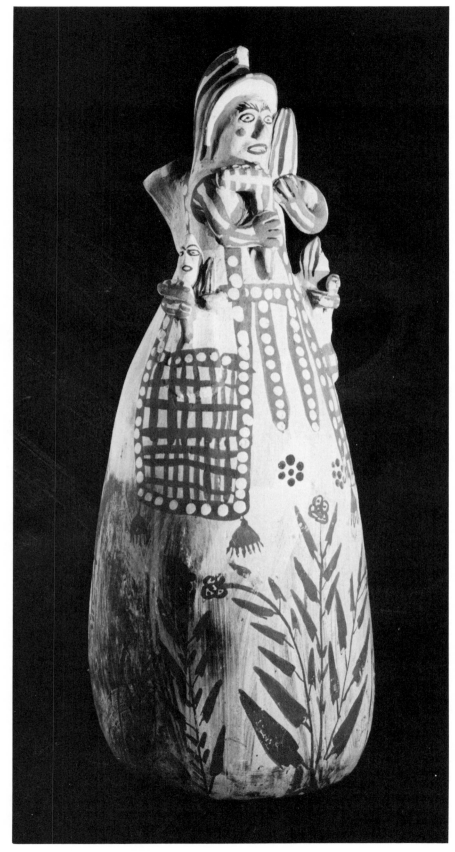

This Quinua *Bruja* or witch doctor bottle is larger than usual, measuring 50.8cm (20") tall. The bottle is coated with white slip and the decorative details are brown slip. Over her shoulders are woven bags which hold small figures and witchcraft paraphernalia. In her arms she holds a loaf of bread and a panpipe. The drinking spout protrudes from her back.

as water fountains, the rims serving as handy perches.

Because of its popularity in the national marketplace, the rooftop "bull" vessel has been expanded to greater proportions, some attaining a length of 91cm (36"). Smaller ones have also been modeled to make it easier for tourists to pack in a suitcase.

Figure Bottles

Drinking bottles made in the shape of specific personages are another Quinua tradition. These bottles are fashioned for special family occasions, such as weddings or feast days. If a band is invited to play, each one of the members is presented with a figure in uniform playing that musician's instrument—drums, horns, guitars, etc. The top of the hat is the opening for this bottle figure. Often, in lieu of payment, the band is content to play in return for these figures, filled and refilled with *chicha*. Humorous "mother" and "mother-in-law" pots are also made for these partygoers, represented with appropriate expressions, cooking utensils, baby-on-back, or pouring a bottle into a cup. The variety seems to fit the occasion (see Color Plate 2).

Magic Figures. The other commonly made figure bottle is that of the *bruja* or *chuncha*. This represents the professional witchdoctor who comes from a tribe that lives in a town near the border where Peru and Bolivia meet, to the northeast of Lake Titicaca. The people from that village are famous for their magical potions, incantations, and various performances with symbolic apparatus. It is best to be on the good side of the *chuncha*, so she too is invited to parties and handed a good-sized container of *chicha* made in her likeness.

Cucumaris and Crucifixes. Belief in magic still persists. The *cucumari*, an ancient nature diety, is represented in clay in the form of a round vessel with a decorative face-body, arms appearing where ears would be, clutching figures, birds, or animals. He can be made in various forms, such as a lidded container with a condor for a handle, or as the base of a candelabrum which rises from his head and may even be surmounted by a small church.

A crucifix is made in the same manner—a hollow cross upon which is suspended a modeled Christ figure. Sometimes small *campesino* figures stand below, and symbols of the crucifixtion are placed upon the cross. All these forms are decorated with the same slips and designs mentioned be-

fore, with some noticeable variations made by each potter.

The Wedding Cup. Another special drinking vessel is the wedding cup. This two-chambered cup is used so that the bride and groom may drink together. It is very rarely found on the market, as it is made only for the occasion and seldom sold. Two cups, one a little larger, are joined at the bowl by a wad of clay. They are also joined by a handle going from one to the other. This article is crudely made and simply decorated with a band of white slip and a few dark lines.

A School That Helps

Under the guidance of an admirably effective *artesanías* center in Quinua, set up by the Ministry of Education, the artisans are given instruction. The teachers encourage new ideas and good design. With the increase in production, unfortunately, the general quality of the work has been lowered. This problem has permeated all the areas where demand has risen. The school is attempting to counteract the decline in quality by teaching the potters improved techniques in the use of available materials.

Solving Firing Problems. An example of this innovation is the kiln used. The traditional kiln is made of adobe brick in the shape of a barrel about 2m (6 feet) high and 1.4m (4 feet) in diameter. It is fired with wood. As is the case with so many of these open-topped kilns, they do not fire efficiently, and a certain amount of loss through ware cracking is expected. Through the efforts of the school, and with the help of sympathetic experts in the fields of ceramics and *artesanías*, such as John Davis of Lima, experimentation has been done to improve firing procedures. As wood becomes more and more scarce in this region, the substitution of kerosene as a fuel is being encouraged. Also, the artisans are learning how to build larger, more efficient catenary-arch downdraft kilns.

New Imaginative Ware

Inspired by the staff of the *artesanías* center and by success in the marketplace, the area potters have been encouraged to invent a new set of figures that have no apparent use except to delight the beholder. These are decorative animal figures—each one painted in patterns of reds, browns, or cream and decorated with outlined patterns of fine lines. Large, rounded pots made in the shape of animals are treated in the same imaginative way, with such humorous devices as fat,

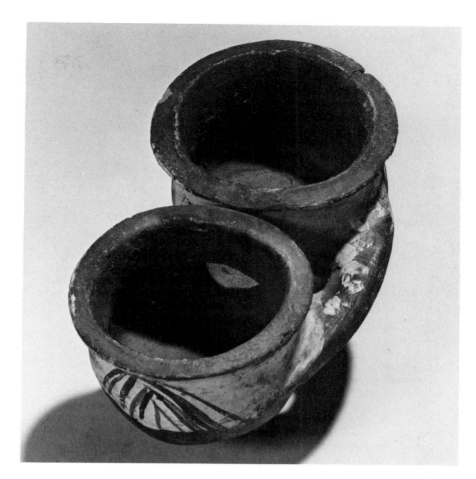

(Above) The wedding cup in Quinua is made on order for the occasion. There is a traditional significance that requires the bride and groom to drink together from these two joined cups. A connecting passage links the interiors of the two vessels, allowing the liquid contents to flow together.

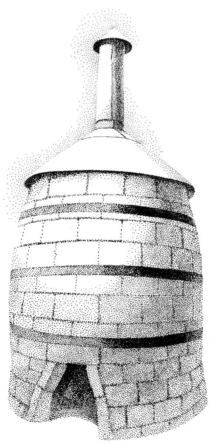

(Left) This barrel-shaped updraft kiln is typical of the type used in Quinua. The ware is loaded through the top. The metal funnel top and stack are then put on, improving the burning efficiency of the wood-fired kiln.

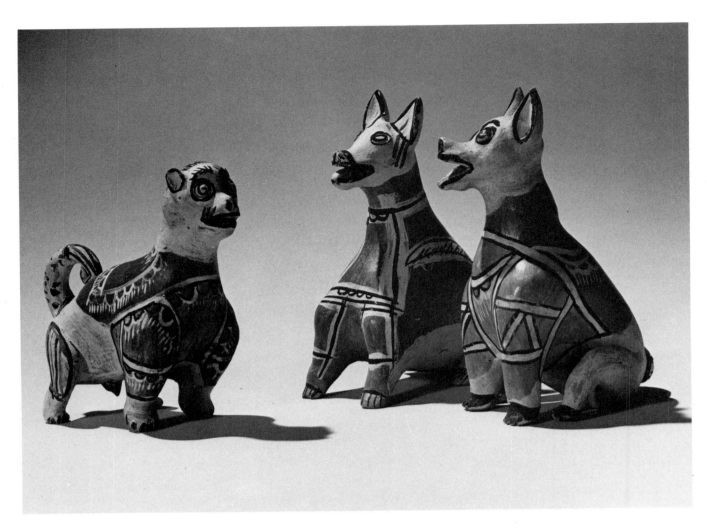

These ceramic dogs from Quinua are a new venture for the potters in this innovative community. Unlike the more traditional pieces, these serve no utilitarian purpose. They are a tourist-oriented product, well decorated, finely burnished, with amusing likenesses of the countless small mongrels seen in many South American towns.

smiling inchworms forming handles on a clipped-winged bird pot.

Inspiration of Pre-Hispanic Ware

Recently, another group of potters has made simulated Nazca- (see Glossary) and Inca-styled animal forms. The shapes, such as an aryballoid (see Glossary) representation, the surface texture, and the painted designs on the surface are not so much copies of Nazca, but instead appear to be individual interpretations of that era imposed on the Quinua style. The rounded, full joinings of necks and legs to body are typically Quinuan. The surface, however, is far smoother and more lustrous. The designs are stylized geometrical animals, birds, and figures with the addition of derivations from Inca band and step designs. More varicolored slips are used on these pieces than on the more traditional ware made here, and the surface is more finely burnished.

Tableware

Quinua is not known for utilitarian pottery. In fact, no cooking ware is made here. Only some tableware is

produced, such as a cup and a strange kind of closed-form lidless teapot that has three handles and a spout placed around its belly, and a fourth handle on top. It is filled from the bottom by means of a clever device, a tube that goes up the center and ends just before the top. Thus it holds its water when turned right side up again. We bought a bird pot, made in the previously mentioned Nazca-Inca style, that had the same internal construction. The bird's neck and beak become the pouring spout.

Tinéo de Ayacucho

One sees individual artists emerging from the general folkcraft group, such as Tinéo de Ayacucho. He models sympathetic, mildly expressive little figures. Tinéo is best known for a series of nativity figures depicting local townspeople as the actors in the religious scenes. Everything is hand-modeled—sensitive faces with pensive expressions, simple hands, feet, and clothing, with the underlying form well realized.

He also makes humorous *campesinos* riding burros, seated, playing

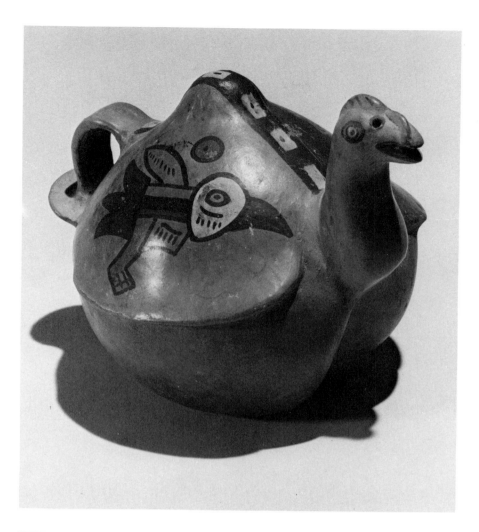

Several potters in Quinua are producing pottery on which the surface polish and design closely resemble the slip coating on ancient Nazca ware. This 20.3cm (8'') tall bird pitcher has a handle at the tail and a spout hole in the beak.

A cross-sectional diagram shows how the interiors of the bird pitcher and one-piece teapot are constructed. The pitcher is turned upside down and filled through the bottom tube. On being turned rightside up, liquid can be easily poured, as the filling tube acts as an air vent.

Tineo of Ayacucho makes these nativity figures, the tallest of which is 20.3cm (8") high. The figures are simply modeled. The surface clay and slip are left in the soft, natural, unburnished finish.

a guitar, etc. Many of these are whistles, the orifice for the whistle placed not too discreetly at the rear of the figure or animal. A group of clay figures standing in a row, all attached to each other, is played like a harmonious pipe. One orifice suffices to sound all the individual whistle people.

Moya

In Moya, one of the *barrios* of Quinua, lives a group of families who do produce pottery for use. The pots are made and decorated using the same techniques as in Quinua. Some pieces are burnished with red slip before being decorated and others are coated with cream-colored slip and decorated sparingly with wide bands of red. Their cooking pot is a squat, rounded form with four handles

around the rim. They make a variety of pitchers in different sizes that are well decorated in the Quinua manner. Bowls, which are used as we would use dinner plates, are decorated, often both inside and out. Large, wide-mouthed jars, and tall, thinner jars, both with handles at their middles, are made to store *chicha* and grains. The potters also make several styles of wash basins. Those used to wash clothing are oval shaped, have two handles, and rest on small, cone-shaped feet. For personal hygiene, round bowls are made in two styles: one has a single handle and looks like a chamber pot, the other has flaring sides and no handle. With the increase in sales of the Quinua product, these people too are inventing and selling new forms.

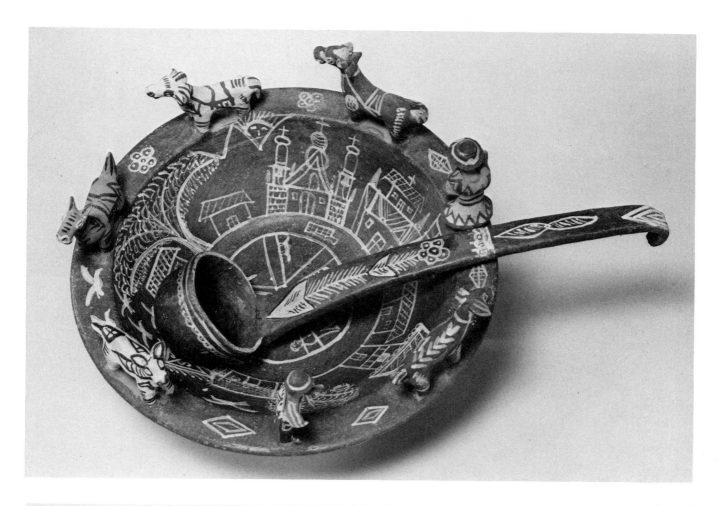

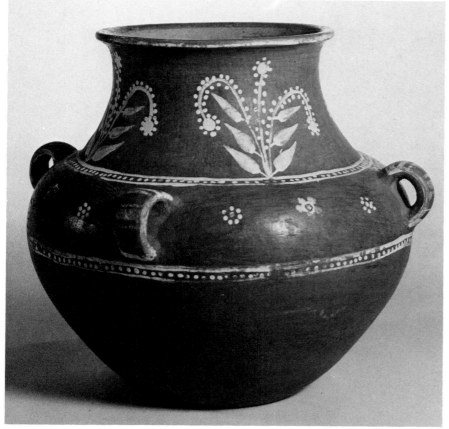

(Above) Because their pottery is selling well on the national market, Moya potters are trying more innovative ware. This 28cm (11″) diameter punch bowl has a village scene decorating the interior and a herd of llamas and attendants sculptured on the rim.

(Left) A 34.3cm (13½″) tall *cántaro* made in Moya is used to store *chicha* or grains. Its brown slip-covered surface is smoothly burnished, and decorative floral designs are applied in white slip.

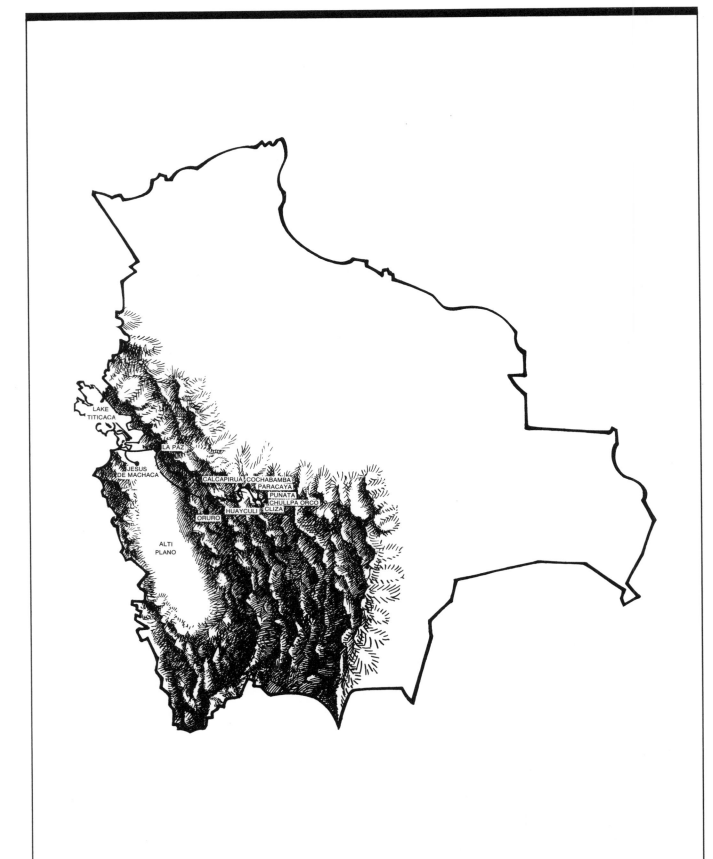

LAKE
TITICACA

LA PAZ

JESUS
DE MACHACA

CALCAPIRUA COCHABAMBA
PARACAYA
PUNATA
CHULLPA ORCO
HUAYCULI CLIZA
ORURO

ALTI
PLANO

BOLIVIA

Prior to our journey, we corresponded both with people in Bolivia and with people who had recently returned from there. They all led us to believe that we would find no pottery being produced there. We were told that it would hardly be worth the risk of venturing into this forbidding country whose relations with the United States at that time were not very good. The Peace Corps had recently been evicted. The schools and universities were closed. American missions generally were suspect and not too secure. The roads were so bad that it would be impossible to drive our vehicle beyond La Paz. By the time we arrived, it would be the middle of the rainy season. Carnival preparations would be in full swing, and no one would be working.

La Paz

In spite of the admonitions, when we found ourselves in Puno on Lake Titicaca, looking over the Peruvian highlands only a day's journey from La Paz, we decided to make a short visit to Bolivia. La Paz had been pictured to us as the most dramatically located capital city in the world. We took the risk of going, both to view this marvel and to try to obtain further information on the state of current pottery-making there.

From the border crossing at Desaguadero to the airport on the *altiplano* just outside the city, the road was deplorably potholed, dusty, hilly, and narrow, with streams that had to be forded. There are more military checkpoints along this stretch of road than we have seen in any other country. All of this causes the journey to be long and annoying, when in reality the distance covered is only a short 105 kilometers (65 miles).

The road curves along the *altiplano* between 3,750 and 4,050m (12,500 and 13,500 feet), moving away from Lake Titicaca after skimming its tip at the border crossing. A bad series of steep hills begins just beyond the town that bears the name of the famous pre-Inca culture and ruins, Tiahuanaco, and continues to within a short distance of La Paz. The *alto* is a vast, flat plain with a view of rolling hills and a chain of snowclad mountains to the north.

A View of the City

No matter how well people may describe the city of La Paz for you, the first view down into this vast bowl set below the level plain comes as a breathtaking surprise. The city is completely hidden from the approach. Then, all of a sudden, you are thrust upon the rim of the plain and can gaze down at the entire complex. From there the road winds down the incline of the building-encrusted canyon—a half-hour's trip down to the heart of the city.

New buildings stand out strangely in this city because there are so few of them. The old predominates. A few wide thoroughfares flanked by narrow, winding streets eventually climb up the canyon or narrow down to the pass that continues downward to the wealthy residential district. Markets are located in large building complexes in the downtown area, but the largest and most interesting market is up Sagarnaga Street behind the colonial Iglesia de San Francisco.

You follow the narrow, cobbled

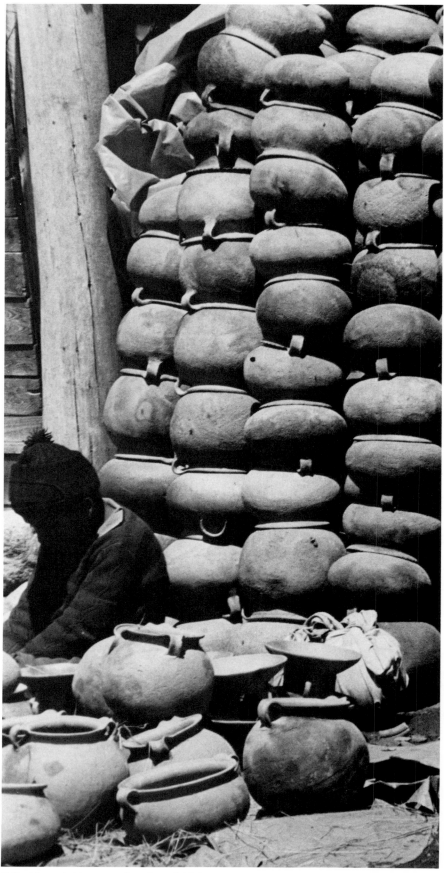

At the Mercado Uruguay, piles of rough kitchen-type pottery can be found. In this stack are mainly round-bottomed *ollas* in various sizes, some offset *tostadoras*, and a few braziers and pitchers.

street past shops where many varieties of *artesanías* can be bought, from baubles made for tourists to fine old weavings. Further along is the street where the witchcraft shops display their fantastic assortment of animal paws, dried flower buds, herbs, spices, an endless variety of seeds and nuts, dried llama fetuses, multicolored powders, bones, and the countless essentials of their trade. Pungent aromas pervade the entire area.

Markets. The *famous Mercado Negro*, or Black Market, is farther up the steep street. Here all sorts of illegally imported items are on display. On the way to the market, the streets are lined with women sitting on the sidewalks with piles of fruit, vegetables, dried potatoes, meat, bread, etc., spread out for sale. In some places men are leaning against the buildings, bundles of cane and wood beside them which they are carving into various types of musical wind instruments.

This scene is repeated along the approach to the *Mercado Uruguay*, famous for its fresh produce from the *llanos* and its meats from the *altiplano*. Across the street, in a diagonal lot, a space is set aside for the pottery market. Stacks of pottery in several distinct groups are the responsibility of the various vendors who watch over and sell the ware. At the time we were there, four vendors were selling. The pottery is brought by the truckload to be sold here. We were not able to get much information from these people regarding where the pottery was made. We were told either "Coroico" or "up on the *alto*" in answer to our questions.

One vendor was finally able to identify the location of the majority of the ware he had piled about him as being from Jesus de Machaca, a small village not far from the border town of Guaqui. But he told us that the recent rains had so badly eroded the road to Jesus that only a few trucks with large wheels and very high clearance were able to get through. So it was not possible to go there, and we had to content ourselves with the pottery and information available at the market.

Pottery from Jesus de Machaca

The ware is made entirely by hand. The surface is scraped and burnished, with metallic, gold-colored flecks glistening against the deep-colored umber and black, fire-darkened clay.

On display were globular *ollas*, round-bottomed and with a short neck, the rim flat, flaring, scooped out, and then slightly raised. Two handles loop gracefully up from this rim and

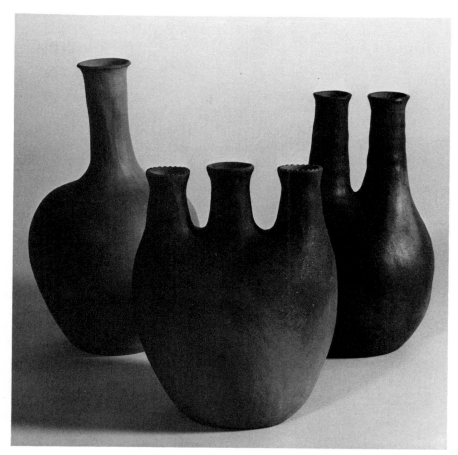

Many one-, two-, and three-necked *floreos* come from Jesus de Machaca to the pottery market in La Paz. The deep orangy brown burnished surface glitters with specks of mica. On all the three-necked pieces, the rims on the outer two necks are notched, but not the central one. We could not get an explanation for this. The tallest *florero* is 35.6cm (14″) high.

curve down to the shoulder. These range from a liter (about a quart) to several liters in capacity. There are taller *cántaros* and pitchers in all sizes (see Color Plate 5) and *tostadoras* made in a boot shape. Half-liter (pint) sized, teardrop-shaped flasks, braziers with disk-shaped tops, small bowls, and plates are also stacked up in quantity, but the most unusual shapes are the *floreros*. The potters also make a vessel starting with the tall, oval form, with a chicken or bull head at one end of the shoulder and a slightly flared rim opening at the other end. A wide handle arches between the two high shapes.

We saw no evidence of slip decoration, glazing, or incised or applied designs on the ware from Jesus de Machaca at the market. The only other place we were to see or hear of ware from that village was in the small town of Laja, once the capital of Bolivia, 40 kilometers (24.8 miles) northwest of La Paz. On the plaza, in the courtyard of a little shopkeeper, we saw a water container about 1.5m (5 feet) tall and .9m (3 feet) in diameter. This, the lady told us, belonged to her

grandmother and came from Jesus de Machaca. There are two similar to it in the courtyard of the Casa de Murillo in La Paz, made in the early 1800s.

Pottery from Huayculí

Another type of ware we saw piled in the market was wheelthrown and covered with brilliant glazes or decorated merely with red, white, and brown slip designs on the natural clay. This ware, we discovered, came from La Paz itself, made by a man from Huayculí, a town we would be visiting later.

The Indian Population

Eighty percent of the population of La Paz is Indian. The men dress in the manner of the whites, according to their economic situation. Dark jackets or suits are favored; very few wear hand-woven ponchos. Sweaters are frequently worn by men and women, and unlike the people out in the *campo*, or rural area, everyone wears shoes or sandals. The women are dressed in multiple-layered, full, mid-calf-length skirts of wool or cotton. A

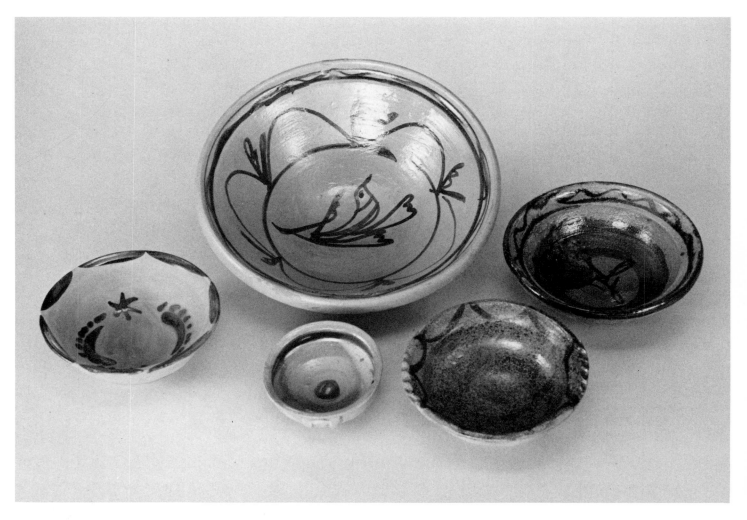

The smaller wheelthrown bowls are made by a Huayculí potter now working in La Paz. His pieces, like the larger bowl in the background from Huayculí, are painted with deep-brown glaze designs and left plain or coated with a clear yellow or golden-brown glaze.

full blouse of cotton, sometimes with a gathered peplum over the skirt top, is again covered with layers of sweaters, wool shawls, and hand-woven, red-striped mantas, secured with decorative pins, often a silver fish and chain. The *aguayu*, or carrying shawl, also hand-woven in colorful stripes with red predominating, is worn over the back as in Peru, to carry babies, food purchases, and anything else. The women's hair is neatly plaited in two braids, which are tied back with a black woven device called a *tullma*, which hangs between both braids. Topping all, the women wear a brown felt, bowler-type hat which they are very careful to protect with a plastic bag when it rains.

They speak Spanish, but are more likely to speak among themselves in Quechua. Very suspicious of foreigners, and with a great fear of the camera's ability to steal their souls, the Indian women cover their faces with their hats or try to hide when confronted with this "danger." One irate woman pottery vendor screamed at us and threatened to stone us if we dared even take pictures of her pottery. Their fear is real and alarming and

one feels ashamed to provoke them, knowing how upset they get. We found this fear and resentment among the Indian population far stronger in La Paz than anywhere else in the *alto*, although we did encounter some strange taboos against picture-taking in other areas.

Museo Nacional de Arte Popular y Artesanías

It was through a well-informed young lady at the Instituto Boliviano Americano that we learned of the existence of this small museum. The associate cultural affairs officer of the American Embassy also worked here, and advised us to get in touch with Doctora Fortún, who, he said, was an anthropologist and might be able to provide us with information.

The museum's collection is housed in a French-baroque-style, yellow stone building. Carved stone arches over doorways and stair entrances are supported by round columns. The collection includes costumes, hats, weavings, various artifacts, and pottery, but is most notable for its historical collection of carnival masks. The

group of intricate *diablada* masks is especially fine. The collection is an attempt to provide something where nothing has previously been available. Although one may be disappointed in the small quantity of items and the poor manner of displaying it, one must realize that the space, funding, and present national interest in the popular arts are not sufficient to make it any better. A poor country, Bolivia has not yet realized that her artisans are one of her greatest treasures—a source of national pride and worthy of encouragement.

Among the few people interested in documenting Bolivian Folk Arts is Doctora Fortún. Under the Ministerio de Education y Belles Artes she has produced several books, including one documenting the music, dance, and costuming of the *diablada*. Two volumes on Bolivian folklore, which include information on such things as language, indigenous dress, weaving, musical instruments, and folk festivals, have been produced under her direction. In process is a book that will have information on current ceramics. Lack of funds has caused delays in finishing this book, which should contain valuable information, considering the careful accounting given in her other writing. The manuscript is largely the work of Hugo Daniel Ruíz, who is working on the book with Doctora Fortún's help. As Señor Ruíz is presently director of the museum and a ceramist himself, he is well able to record the technical aspects of the work, as well as its cultural values.

Doctora Fortún informed us that there is a great amount of popular ceramics being produced throughout the country. Nearly every village has a local potter who makes the ware needed in his area. It is generally of a crude, utilitarian quality, she told us. In some communities, everyone makes pottery for his own needs and some extra for sale or barter.

She advised us that we were here during the rainy season, a time when we were unlikely to find anyone working with clay. Roads, too, were in bad shape and might hinder our research. Also, carnival time makes travel hazardous. Dancers, carrying glasses of *chicha*, take to the roads, snake dancing along it with their instrumental accompanists. Those who have reached the limit of their celebrating capacity are stretched out along the roads or wander unsteadily onto the roadway.

Since we were still anxious to see something of the Bolivian potters' craft, Doctora Fortún suggested we go to the Cochabamba area where the country's best pottery can be found.

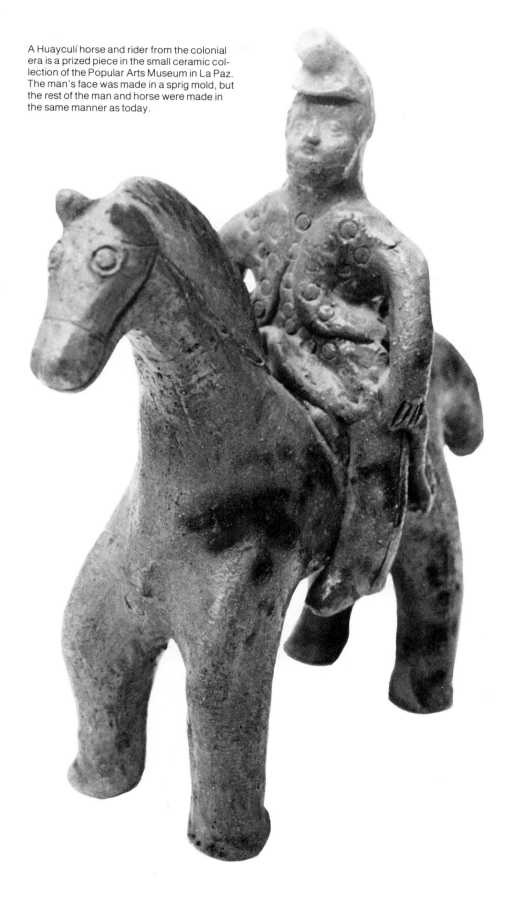

A Huayculí horse and rider from the colonial era is a prized piece in the small ceramic collection of the Popular Arts Museum in La Paz. The man's face was made in a sprig mold, but the rest of the man and horse were made in the same manner as today.

Cochabamba

All that Doctora Fortún had foretold was true, including road hazards, revelers, rain, and fine work. We drove to Oruru over a beautifully paved highway, one of two in the whole country. It was a trip through long, flat stretches of fields with mountains rising in the distance. We drove through storm clouds which could be seen many miles ahead across the plateau, scattering patches of rain. Indians in their wool *chulo* hats were frequently seen guiding teams of oxen pulling ancient wooden plows through the fields. We watched a long line of mourners crossing the fields behind a wooden box, many men laden with standards in the form of crosses and *mandalas* loaded with flowers. And, as Doctora Fortún predicted, we were stopped many times and surrounded by dancers and musicians as a party wound out onto the pavement somberly carrying out the dance formations.

From Oruru the highway deteriorates to a narrow, two-lane, dusty, stony road that cuts through high, barren mountain passes, rising precipitately from the *alto's* base of 3,600m (12,000 feet) and reaching over 4,500m (15,000 feet). We were frequently above the clouds or lost in them only to come out again looking down over precipices best left unobserved. We peered down through clouds, past flying condors, to see tiny llama herds wending their way down the precipitous slopes toward an incredibly distant valley below. Blind curves, avalanches, narrowing of the road, and fast-moving vehicles appearing suddenly make the way treacherous to those who do not hug the hill side of the road. About 10 hours of strenuous driving is needed to cover the distance from Oruru to Cochabamba, a trip filled with a combination of the worst driving conditions and the most beautiful panoramas in the Andes.

Cochabamba Markets

Cochabamba is the reward—a beautiful colonial city set in a rich, tropical valley at 2,400m (8,000 feet), a welcome change from the frigid atmosphere of the *altiplano*. The market here, called La Concha, has, besides its large spread of fruit, vegetables, and meats, numerous wooden-roofed booths where it is possible to buy many types of hand-woven, knitted, or crocheted articles of hand-spun wool, either lamb or alpaca. Ponchos,

(Above) A group of *puñus* from Paracaya glisten in the sun at the Cochabamba pottery market. Among them is a four-handled wash basin called a *chchillame* from Calcaphirua.

(Right) This Paracaya *olla* carries the strange number of seven handles, which are formed from a wide rim when the piece is on the wheel. The rim is then cut out between the handles, which are curved over onto the walls of the pot and pressed firmly in place.

rugs, blankets, and a variety of local handbags peculiar to the area predominate.

One side of a street leading to La Concha is the pottery display area. The women sit beneath sunshades on the grassy "sidewalks" with their ware spread out between the walls of the buildings and the curb, sometimes spilling over onto the street itself. They have ware from Huayculí and Calcapirhua and another village which we were later to learn is called Paracaya. None of the really large vessels were on display at this market (see Color Plate 9).

All the highly glazed, wheelthrown pieces, we were told, were from Huayculí, as were the baskets of small sculptured animals. The darker clay pieces came from nearby Calcapirhua. We received mixed answers concerning the origin of some more primitively formed, lustrously glazed ware and some light-buff ware, slip-painted with dark, curvilinear designs.

The Seven-Handled Pot: Paracaya

There were nests of *ollas* of whose place of origin we are still uncertain. Several people claimed that they were from Paracaya. These are wheel-thrown *ollas* with very thin walls, rounded bottoms, obviously wheel-trimmed. The chatter marks of the trimming tool are clearly visible over

the rough, pebbly mixture in the clay. Paracaya appears to have a great variety of work methods and at least three distinct styles of ware which we were to see later. The unusual feature of these *ollas* is that the number of handles can be two or four on otherwise similar pots. A few had the magical number of seven handles evenly spaced around the rim! We were certain, and still are, that there is some special significance in the number seven, as this is not the easiest number of handles to attach at even intervals. On questioning the amiable lady selling the pottery, her laughing answer was that the handles were "*por repuestos*" (for spares), in case you broke some.

Necessary Aid

With the help of the Maryknoll Fathers at the Cochabamba Language School, who were kind enough to let us park on their grounds, lend us a jeep, and obtain a guide for us, we were able to visit two of the pottery villages. Sr. Florencio Rios de Mercado, a retired gentleman who spoke Quechua and Spanish and knew the area well, guided us to places of seeming inaccessibility. He was able to help us become acquainted with people who might not have been so receptive, being involved in fiesta activities. But this kindly, soft-spoken man knew their language and the best way to approach them.

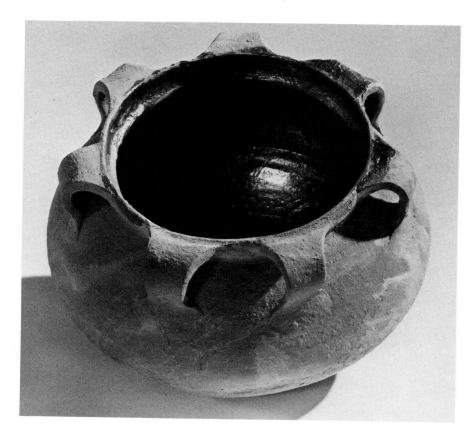

Calcapirhua

Calcapirhua is on the western end of the 14.5 kilometer (9 mile) long paved approach to Cochabamba. Lines of adobe house with tile roofs, surrounded by yards with high adobe walls, are set back on either side of the highway. One wall was partially constructed of tall orange *cántaros*. The top of the 2.5m (8 feet) high wall was composed of a row of these .6m (2 feet) high jars, some right side up, others upside-down, set into the adobe. The spaces between were filled with an adobe-rubble mixture that has largely washed out to reveal more of the jars than had been originally intended. Dirt roads were cut back from the main road to allow a greater village development. Farmland spreads out where the houses stop, climbing steadily up steeper hills as the land rises higher from the main valley highway.

Potter, for the Season

We visited families of potters, the first being Señor Donato Vargas. He was not making pottery then. He works the clay only four months of the year, during the dry season. The rest of the year he farms his land. He enjoys making pottery, having learned from his father. His sons, who are grown up, do not care to make pottery; however, his wife, Rosa, makes all the pottery she can.

Giant Pots

Our first look at the covered storage areas around his yard gave us quite a shock. We had had no previous idea of the size of the pottery made here and were astonished to find these monsters, some measuring over 1.5m (5 feet) high and 1.4m (4½ feet) at their widest dimensions! These, Sr. Vargas told us, were not the biggest ones that he and his neighbors had made.

Four main shapes are fashioned here, there being little variation in the four basic traditional forms except for size. The largest and most impressive form, because of its dimensions, is given the local name *virque*. The *virque* is used for storage of water and *chicha* and for brewing the latter. The second, the *cántaro*, appears smaller than the *virque* because of its restricted neck, but in reality it can measure as tall and as wide at its greatest width as the largest *virque*. Its dimensions are robust and elegant. Walking through the streets of Cochabamba, we saw a pair of impres-

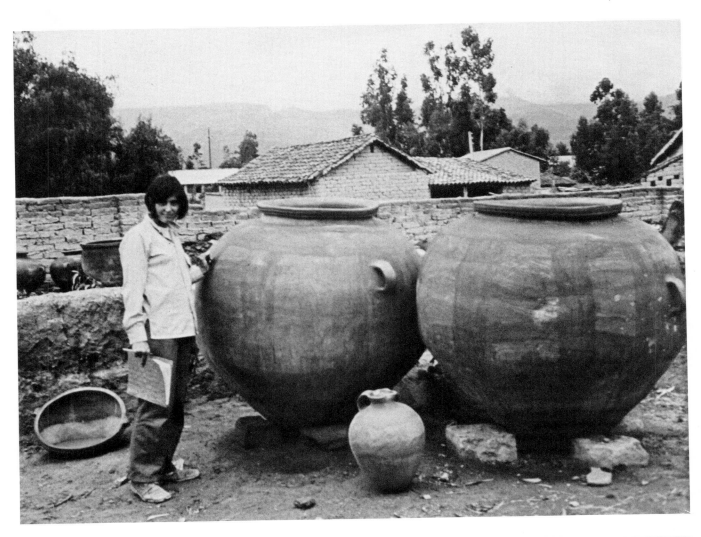

(Above) These giant *cántaros* are over 1.5m (5 feet) high and about 1.3m (4½ feet) in diameter. They are often partially sunk into the ground and are used primarily to store water. A 45.7cm (18″) pitcher is dwarfed by the large vessels.

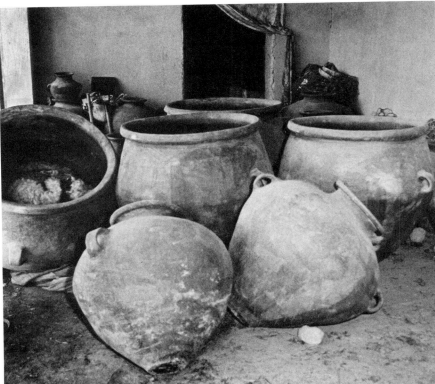

(Right) *Virques* and *cántaros* are stored under a porch roof in Calcapirhua. All of these containers are used to make and store *chicha*, which is boiled and stirred in the wide-mouthed, 7.6cm (3″) high *virques* and served from the *cántaros*. Ropes used to transport the *virque* are passed through the loops in its handles.

sive *cántaros* lying on their sides, airing outside a doorway. Years of use as *chicha* containers had glossed and polished the outsides to the color and sheen of old, hand-rubbed wood. Draped with snippings of confetti and a swatch of corn husk, they were testimonials to their festive importance (see Color Plate 9). The third vertical form is a pitcher, locally called a *yuru*. It is of more modest proportions than the previous two. The last major form is a wash basin, called in Spanish a *fuente de baño*, the local Quechua word *chchillami* being more popularly used here. This bowl is used for cleaning, washing dishes, vegetables, and clothing, or personal hygiene.

Another shape sometimes seen in Calcapirhua is the *puñu*. It is made like the *cántaro* but is of more modest proportions, and is identifiable by an added body bulge between handles and neck that gives this form its special character. Its use is the same as that of the pitchers or *cántaros*.

The Clay

Sr. Vargas told us that clay is easy to get in Calcapirhua. He goes outside the village and digs it just below the topsoil. At the K1 (kilometer marker) on the road toward Santa Cruz is a pit where the villagers go to get the red shale they use. The black clay used for slip painting is also found nearby.

The clay body is a mixture of pulverized clay, crushed shale, and coarse sand, all mixed with water and used as needed. We saw that many potters store their dry pulverized clay under the patio roofs or even in their houses to keep it dry.

Forming the Ware

Sr. Vargas works on a large, flat stone sprinkled with sand, set directly on the ground. He works in the sun so that the clay can dry after each section is added to the piece. The only tools he uses are two 30.5cm (1 foot) sections of 2.5 by 5cm (1″ by 2″) boards with rounded edges, and a variety of oval clay platter shapes and oval clay "stones," all used to smooth the insides and outsides of the pieces as he walks around them. Four people working together build four of the giant *virques* at a time, so that they can work on one while the clay stiffens on the others.

The Slip Coating. When the pieces are finished, they are all covered with a red slip made by crushing the soft red shale and mixing it with water to a pasty consistency. On the *virques*, a wide, purplish band of slip is painted around the body just under the rim. Wide vertical bands of this same color

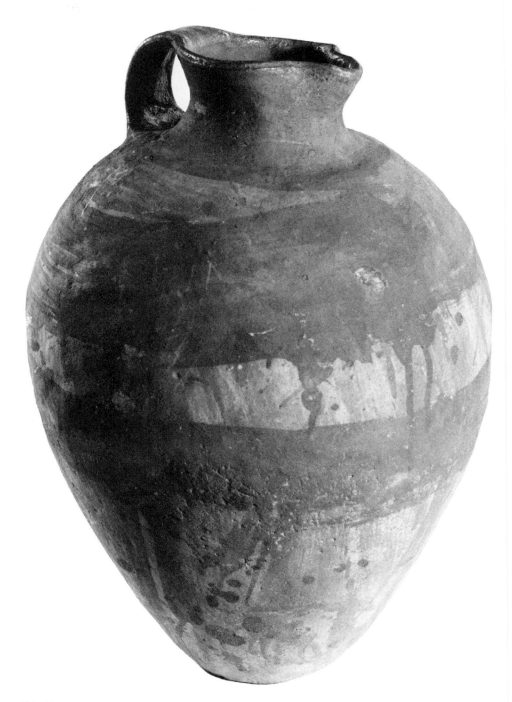

This 47cm (18½″) high *yuru* is meant to be tilted and poured from, rather than lifted, as it is very heavy when filled with *chicha* or water. Unlike the vertical, red slip-painted bands common to all *virques* and *cántaros*, the *yuru*'s bands are applied horizontally.

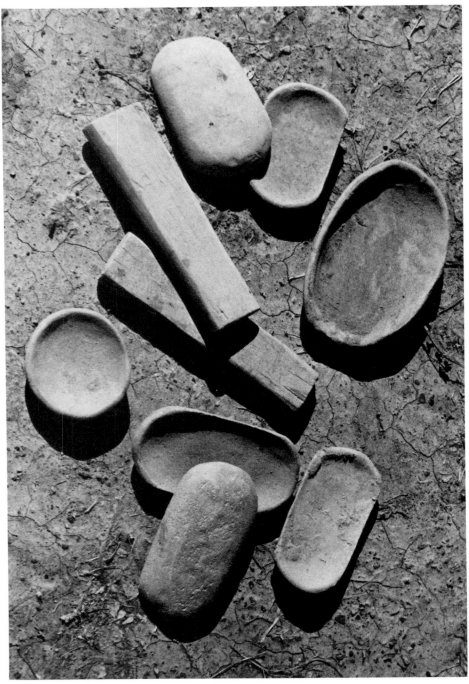

The primary tools used in Calcapirhua to make large pottery are the hand-sized implements shown here. Two rounded wooden boards are used for thinning and smoothing. Clay platter shapes and clay stone shapes are also made with contours that will conform to the inner and outer profiles of the pottery.

are then painted from rim to base, all around the form. On the *cántaros*, two horizontal bands are painted just before the fullest shoulder section and around the neck. Six wide, vertical stripes are usually made. The *fuente de baño* has wide bands painted around the rim and in a cross on the inside.

Firing

For firing, the pots are stacked on the ground, sometimes in a hollow depression lined with stones. Smaller pots are nested inside the big ones. The only fuel used is dry cow dung, which is piled inside, between, and over the pots. The firing, Sr. Vargas tells us, lasts for 6 days during which time fuel is continuously replenished.

A Vist with Emelerio

We were introduced to a neighbor named Emelerio, who makes the same forms in the same manner. He is a younger man with a young wife and three small children. We had the feeling that Emelerio had difficulties with his firings, as we saw many more cracked pieces and shards in his yard than elsewhere. Many large, broken pieces lay near his clearly delineated firing site. Sand, shale, and clay were neatly piled along the walls of his house. His family lives in a three-sided house opening onto a courtyard. Workshop and beds share the same area.

Protected by the roof and walls were piles of greenware. We were allowed to photograph all of the courtyard and whatever was in it. His gray-haired mother asked us to take her picture as she posed severely with a pitcher balanced on her outstretched hand. However, when we approached the area where the greenware was stacked, Emelerio blocked our way and asked us not to look at the greenware or take pictures of it because that would cause it to crack during firing.

Pottery in Use

Walking through the village we saw many of the large pots in use. Sr. Vargas has a wheelbarrow especially constructed to carry a *cántaro* for water. Some *virques* were half-buried in the ground, where they were used for storing water; chickens were eating and drinking from others; plants were growing in old broken ones. We saw a *virque* on its side with earth built up around it being used as a stove. Wood was pushed inside and cooking pots balanced on top. While we were there, Señora Vargas was washing the

greens in a *chchillami* before preparing the daily soup.

Carnival Time at Sr. Espinoza's

We stopped at another house, after peering over the wall and seeing the largest *virques* and *cántaros* of all. A party was in progress and everyone was laughing and joking. The 17-year-old daughter, Feliza Espinoza, greeted us at the door. When we told her we would like to buy a *cántaro*, we were invited in. Feliza showed us the *cántaros*, and when we explained that we were also interested in how they were made, she took us to the large work court which is separate from the family patio. Their firing pit is sunk 1m (3 feet) into the ground and is lined with stone. Sheets of corrugated tin lay nearby to be used to confine the heat of the fire. People wandered out from the party and added information, but there was so much laughing and joking that even Sr. Rios found it difficult to understand them.

The Work Cycle. Sr. Espinoza told us that five people work together to make the biggest pots, and that it sometimes takes a month, working on six at a time, to complete them. One of the potters told us that the men and women work together on the big ones, but one of the men, teasing Feliza, said that the women can only make the littlest ones. This caused a mock chase around the yard. Señora Espinoza corroborated the facts that 6 days and nights go into firing the ware and that cow dung is the only fuel.

While they are making the large pots, they are also making medium- and small-sized ones. They fire four times a year. The work starts with gathering materials in March. The first firing takes place in May and the last in October, when the last of the clay work is done for that year.

The Chicha. Sr. Espinoza told us that since we had seen the pots the *chicha* is made in and had seen where they are made, the final step was for us to sample their *chicha*. We were invited into the dining room. A long table with many chairs ranged along it dominated the room. In one corner a pile of clay was kept dry, and along one wall four greenware *virques* were holding each other up. Here we had permission to photograph anything with the exception of the pot full of *chicha*, as this would ruin it! *Chicha* varies greatly in palatability as well as flavor. That which we sampled rather cautiously here had the sweet freshness of orange juice with a flavor reminiscent of apple cider. It was delicious, and one would not suspect its insidious potency.

We left by way of the main family patio, carrying our *cántaro* and a pitcher past a cage of guinea pigs and a laden fig tree. Under the branches of the grapevine, we said thank you and goodbye to one of the warmest, friendliest families we had met, and promised to come again.

A Historical Note

Wendell Bennett headed an archaeological expedition to Bolivia in 1934. Calcapirhua was one of the areas in which he worked. He unearthed a thin layer of small, colored, slip-decorated pottery, with Inca-inspired designs not too dissimilar to those found at Arani, which we will describe later. Under this layer and from an earlier culture was another layer of what he describes as large U-shaped burial urns that were not decorated. We feel that the *virques* of today are related to that early form. The burial urns had an inverted bowl in place of a cover. This combination of bowl forms is similar in appearance to the strange-shaped *puñu* of today which does look like a small bowl inverted on a tall one. Of more interest is that potters have lived in this spot for such a long time. The huge pots made here today bear a close relationship in size and form to the early indigenous ware, with little evidence of Spanish influence. The *yuru* form seems to be the only one leaning in that direction.

Cochabamba Area: Punata, Paracaya

In the Peace Corps offices in Bogotá, we had met a young man who, with the rest of the Corps, had recently been expelled from Bolivia. He drew us a map of he Cochabamba Valley showing interesting areas for weaving, an ancient burial site, and small towns, in particular one called Huayculí where, he said, the pottery for the valley was made. He also told us of another young Peace Corps volunteer named Mike Hirsh who, although expelled with the rest of them, had, he believed, returned to the Cochabamba area to set up a commercial venture for exporting weavings.

At the time we were uncertain as to whether or not we would make the trip, but we kept the notes. Only after talking to Doctora Fortún did we realize the value of this chance encounter.

Punata

Mike was difficult to contact, as he was traveling about, and it wasn't until we had been to Huayculí with Sr. Rios de Mercado, and two days before our scheduled departure from the area, that we were finally able to meet him. We were surprised to find that after traveling halfway around the globe, here in this remote spot we were to meet a man whose home was less than 30 kilometers (20 miles) from our own back in the United States.

Mike took us to his village of Punata. We saw the good rapport that this Peace Corps volunteer had developed with the villagers. He is highly regarded by the thriving community which now has an electrical system due to his efforts in setting up a cooperative for it. Electricity has greatly changed the lives of the people who have found a great advantage in being able to "light the night" and therefore extend activities that previously ended when the sun went down.

A Typical Household. We visited the home of one of Mike's closest friends in Punata. It was the best possible opportunity we could have had to see how the typical household makes use of the local pottery, and why there will be a need for the *alto* clay products for a long time to come.

The adobe-walled kitchen had openings for light and air placed high in the wall, casting a Rembrandt-like light on the interior. In one corner stood two Paracaya *cántaros*, .9m (3 feet) high, filled with grain. A large *fuente de baño* half full of water was on the floor nearby. The open shelves bore, along with several aluminum pots, many *ollas* of various sizes, smaller *cántaros*, and pitchers—all unglazed—and a variety of bowls from Huayculí. An iron charcoal-burning stove with an open top stood in the middle of the room ready to receive the round-bottomed cooking pots or the aluminum pans. The family dishes and coffee cups are commercial white china (these would be replaced by Huayculí tableware in a poorer home). All the traditional foods that are prepared in this household are cooked in the traditional pottery ware.

A *virque* from Paracaya 1.2m (4 feet) in diameter and several lesser *fuentes de baño*, some smaller *virques*, pitchers, and *puñus* are kept out in the patio. The large *virque* is settled in a slightly tilted position and three-quarters filled with a fermenting mash used for starting the *chicha*.

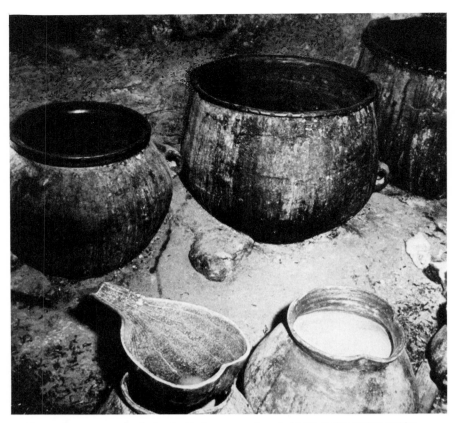

In a Punata home, one room is devoted to the preparation of *chicha*. In one corner are the large *virques* used to hold the *chicha*, where it is stirred for 36 hours. The smaller pitchers and gourds, in the foreground, are used for ladling and serving.

Across the patio is a small, dark room built especially for preparation of the *chicha*. An adobe oven, measuring about 1.2m (4 feet) square and .6m (2 feet) high, is built into one wall. A large earthenware *fuente de baño* is built into the top of it, and an arched opening is left in the front through which fuel is loaded. Three large *virques* are set into the floor up to their vertical walls. The *chicha* is cooked for 36 hours, carefully tended all the time, and then ladeled with pitchers and *tapara* spoons into the larger *virques*. Other smaller *virques* sit around on the floor, along with the pitchers and *puñus* that will be used to serve the beverage. In both this room and the kitchen, freshly cut green grass is piled on the earth floor for the numerous guinea pigs that are both pets and eventually the main course at festive dinners, when they are served with a peanut sauce.

A Chichería. We also visited with Mike, a *chichería*, one of many in Punata which display a white flag and a wooden fish at the door to advertise that the brew is ready. The owner boasted to us that there are reportedly so many *chicherías* in Punata that the taxes they pay support the University of Cochabamba. *Chicharron*, which is a local dish made of fried pork chunks, sections of large-kerneled corn on the cob, and rice are cooked outside the door in Huayculí pottery and served in the inner court on commercial china plates along with tall glasses of what is reported to be the best *chicha* in South America, prepared in Paracaya pottery containers.

Punata Market

It was a Tuesday, market day, and our main reason for coming to Punata was to see the pottery that Mike knew would be there. This is a typically Indian market. One would not expect to find such a large, well-attended market in such a small town. The typical hat worn by the Indian women here is an extremely high-crowned, starched, white-painted straw, prized for its whiteness and height. We had seen similar hats around Cochabamba, but here the height is more exaggerated.

We walked through the vegetable market along rows of women sitting on the grass under the trees of the plaza. Poles rigged with four spokes supported white and green plastic, which shaded the vendors and bathed them in a soft, diffuse light. The pottery market is located on a side street of this main plaza. Along one side of the dirt road a group of women sat, leaning against the adobe walls of the buildings, their ware spread out in front of them. These women sold mainly wheelthrown bowls in varying sizes, from Huayculí, some highly glazed *maceteras*, and a few globular vases with thin necks.

The same women who were selling the smaller glazed ware were also selling the *galena* crystals that are used as the main ingredient for the lead glazes in both Paracaya and Huayculí. We were told that it is mined locally.

Glazed Pitchers. Among all these Huayculí pots, there were several wheel-formed globular pitchers with a well-turned foot and with glazes much like Huayculí pots. We were told that these pitchers came from Paracaya. I found it hard to believe, as all the evidence we had seen would deny it. However, we had been in potting villages, such as Lomas Bajas, Venezuela, where two distinctly different types of pots are made.

Virques. Farther down the street, we were again astonished by the size of the *virques* we saw. These were lined up, lying on their sides in front of the vendor's house. These *virques* were not as large as those in Calcapirhua, but that might only mean that the largest ones were not at the market.

We watched a man bend under one side of a large *virque* as another man passed a rope from the first man's chest and back through the handles of the pot, and handed the ends to the stooping man. Then the helper aided the carrier to lift the monumental pot as he struggled to his feet and prepared to stagger down the street with it on his back.

Other Glazed Ware. In the courtyard in back of the vendor's house, we looked at the storehouse filled with piles of Paracaya ware. There is a strong Spanish influence in this work. Even the *virques* show evidence of it in their fluted rims and the glaze on the inside, as well as on the lowest section of the outside. Paracaya *cántaros* are full-bodied and coated in a brilliant yellow or green glaze. They vary from liter (quart) capacity to those that would hold many gallons.

Ollas, pitchers, and *fuentes de baño* without glaze are also piled in this courtyard. We also saw a few *virques* and other smaller ware from Calcapirhua piled here. However, the *puñus* we saw here were identified as being from Paracaya. The *puñu* seems to be made in two sections that are

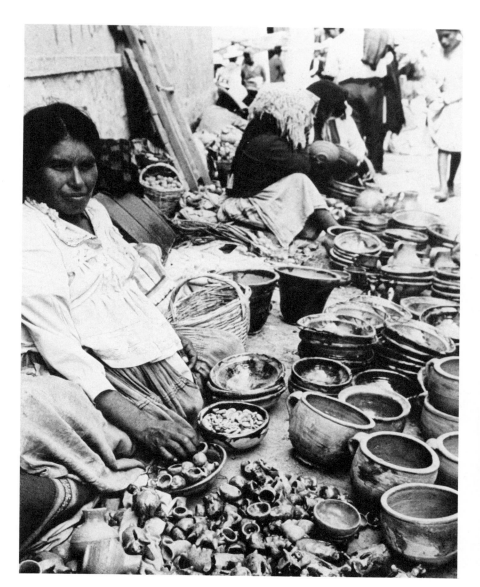

A vendor of Huayculí ware specializes in selling soup bowls, chamber pots, and countless toy banks and doll dishes. All are highly glazed in shades of yellows, greens, and browns.

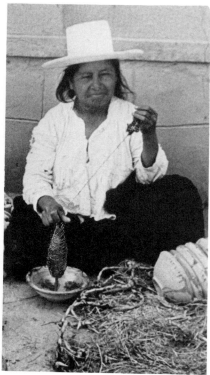

(Above) This woman sells only Huayculí bowls and globular glazed pitchers, which she says are made in Paracaya. Between sales she spins alpaca yarn, using a Huayculí bowl in which she whirls the point of her spinning *rueka*.

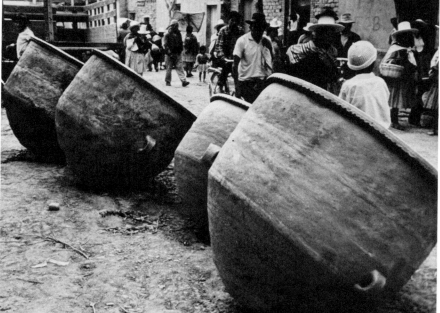

(Left) Paracaya *virques* line the street in front of a vendor's shop in Punata. These containers measure over 1.2m (4 feet) tall. The handles are placed so that rope can be passed through them, enabling a man to balance one on his back for carrying.

This 20cm (8″) tall pitcher, reputedly made in Paracaya, is wheelformed and footed with a well-turned flat bottom. The base lead glaze is a clear yellow, decorated with bands and splashes of deep green.

joined later. The upper section is coated with the same shiny glaze seen on the *cántaros*, washed on with the same thin-thick application, which in the sunlight appears almost iridescent. You can feel a sharp ridge on the inside where the two sections are joined together (see Color Plate 28).

Back at the Cochabamba market, we had seen an entirely different style of pottery that several people insisted was from Paracaya, but we saw none of this style of work at the Punata market. In this handsome work, the clay is much more orange than the browner clay in the other Paracaya pieces we saw (see Color Plate 6).

The actual village of Paracaya was to remain a mystery to us. The roads up into the nearby hills where the potters live are very bad, we were told. And again, it being carnival time, there would be no pottery around, no one would be working, and it would be an inconvenient time to talk to the people. Our experience at Huayculí, discussed in the next section, will bear this out.

Chullpa Orco: Another Historic Site

One road leading out of Punata goes to Arani and another to Villa Rivera. The latter is a rug-weaving center where many families, using floor-to-ceiling looms, make rugs of sheep, llama, and alpaca wools in derivative Tiahuanaco designs. Between Arani and Villa Rivera is Chullpa Orco, an ancient burial site which Wendell Bennett excavated in 1935. Even at that date, Bennett found the hillside pitted with holes left by *huaqueros* who had ravaged the area. The ground is scattered with fragments of broken pottery and bones. An elongated, boulder-strewn hill surrounded by cultivated fields, this huge burial site has only recently given up its ultimate treasures. Local farmers, in their spare time, have hacked their way into the numerous graves, breaking as many pots as they have salvaged to sell to a newly interested group of collectors in Cochabamba. The pieces they have dug out are described by Bennett as being of a style derived from Tiahuanaco, having many similarities to Tiahuanaco ware, but containing enough of its own particular variations in form and decoration to make it a style in itself.

The scope of work dug at this site dates from 2,000 years ago through the Inca period.

It is interesting to note that in all cases the ware found here is of a distinctive type, all of it being small, thin, delicate slip-decorated pieces. Each

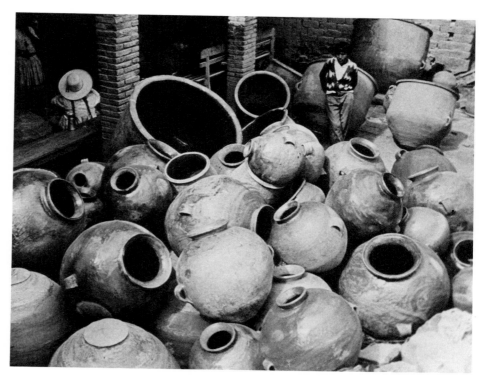

A storage area at the Punata market in Bolivia is filled with partially glazed *cántaros*, *puñus*, and *virques* from Paracaya. These handformed three-quarter globes rise from a flattened, slant-sided base.

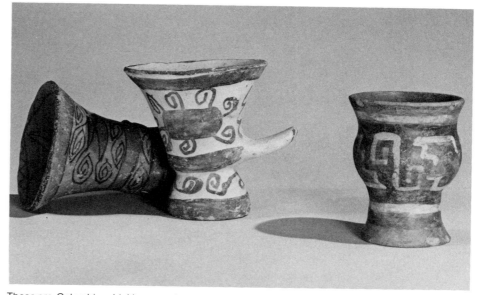

These pre-Columbian drinking vessels are excavated from an extensive burial site near Punata. The cup on the right is older, its designs similar to early Tiahuanaco step and wave motifs. The other two show early Inca influences, with strong mandala and band designs.

grave contains up to four of these small pieces, which vary greatly in quality. Among the ware are found small, flat-bottomed bowls with outward flaring sides, a two-handled cup, a *keru*-shaped cup with a projecting hornlike handle, and many anthropomorphic types of vessels showing a great variety of design. Some graves contain decorated as well as undecorated cooking-type *ollas*.

This site is very different from that of Calcapirhua, which is in the same valley, and where only the U-shaped urns or larger undecorated pottery forms were found in the pre-Inca diggings.

Today, too, the division of labor in the valley seems clearly marked. Calcapirhua keeps to its pre-Hispanic pottery traditions and makes only its massive utilitarian ware. Huayculí has been greatly influenced by the Spanish but continues the nearby Chullpa Orco tradition with its small decorative ware and figurative pieces.

Paracaya is the mystery lying somewhere between the other two in both location and influence. All these communities buy from each other the ceramic products that they themselves do not make. Thus, one is likely to find Huayculí families brewing their *chicha* in *virques* from Paracaya or Calcapirhua, while people in Calcapirhua would be eating their soup from Huayculí bowls.

Huayculí

Because it was carnival time, we learned about the pottery village of Huayculí in three different ways. First, we visited the village itself to see the locality and the working equipment as it existed. Second, we visited two potters from the village who had established a productive pottery-dominated existence for themselves away from Huayculí. Our third way of learning was through the ware itself that we encountered at the marketplace.

The Road to Huayculí

We had to drive over terribly pitted or muddy roads at that time of the year to traverse the area from Cochabamba through either the town of Tarata or Cliza, which both have roads leading to Huayculí. The main road into Tarata's central plaza is a dry riverbed most of the year, but now it was like driving up a shallow

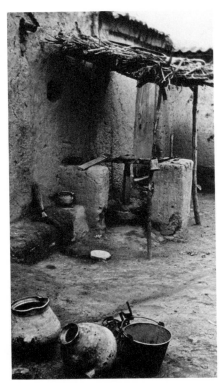

Sheltered under a roof of twigs, a potter's wheel made entirely of wood is built into the adobe walls of the house.

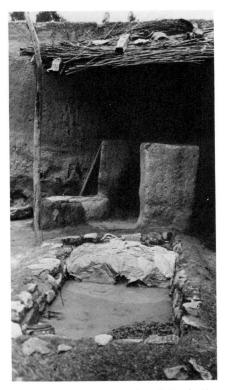

The Huayculí clay-preparation pit, lined with stones, is similar to the type used in Chordeleg, Ecuador. The clay is soaked, then kneaded, formed into blocks, and stored at one end of the pit, protected by plastic.

Venetian canal, as walls of houses border the ⅓m (1 foot) deep torrent that the roadway has become. Leading out of the plaza toward the potting village, the road becomes a morass of mud. Pedestrians have set stones along the edge for walking.

With the help of the Language Institute's four-wheel-drive jeep and the company of Sr. Rios, we were able to make the trip. Several times the jeep settled into axle-deep mud and we had to push and lever the vehicle onto adjacent fields that were higher and harder. We would drive on the high shoulder, rather than on the road itself.

We forded a torrential stream just before climbing a rise into Huayculí. Carnival time, Water Day, saw families splashing water on themselves and throwing relatives and friends into the streams as a symbol of fertility, virility, and good luck. In the cities and villages on this day, children and even adults run through the streets dousing friends and strangers and throwing water-filled balloons through open car windows. Meantime, revelers pour from the houses with *chicha* cups in hand.

Of course, no one was working, but we went to several potters' houses to see wheels, kilns, and work areas. No completed work was to be seen. All had been finished and sold before carnival time to pay for new clothes and carnival food and drink. A broken clay horse and rider with a string around its neck lay where some child had dropped it, and mounds of broken green and yellow shards lay at the road's edge, but this was the only evidence we saw from the road that this was a pottery village.

The Potter's Yard

The houses are all made of adobe blocks with tile roofs. Adobe walls or dense planting of long-spined cactus, often 3m (10 feet) high, separate one yard from another. The earthen patios are clean and bare, having the appearance of a stage set where the action is about to take place. In one yard we saw a potter's wheel whose horizontal wooden support was built into the wall of the house on one side and was held up on the other side by a thick, low wall which also acted as a counter for the potter's supplies. Another low adobe wall protruding at right angles to the house, functioned as the potter's seat and workbench. A square, 10cm x 10cm (4″ x 4″), upright supported a 30cm (12″) diameter wooden head, which went through a 10cm thick, 76cm (30″) diameter wooden kick wheel and down to a wooden pivot base below. The roof of

this improvised pottery studio was made of tied bundles of sticks. In the center of the yard was a rectangular pit lined with stones. At one end a block of prepared clay was covered with plastic sheeting. The rest of the pit was full of water and soaking clay.

The Kilns

A separate walled yard contained the kiln and the bundles of wood, dry grasses, and eucalyptus branches used as fuel here, neatly stacked along one wall. The kiln is a cylinder 2.5m (8 feet) high and 1.5m (5 feet) in diameter. It is made of field stones and bricks plastered over with adobe. To help overcome the problem of the kiln walls cracking, the potter simply binds the parts together with wire. The kiln here has a circular adobe-and-field-stone ramp built around it which serves two purposes. It buttresses the kiln, helping hold it together, and it provides a ramp up which the ware can be carried to be loaded through the top. A perforated brick-and-adobe floor, upon which the ware is placed, is raised about .5m (2 feet) from ground level. The fire chamber below it is fed through an arched opening on one side. It is very much like the kilns of Pucará and of Chordeleg, Ecuador.

Another house we stopped at was set in the midst of a cornfield on a hill above the river. The elderly lady who was the only one left home on this festival day showed us a wheel similar to the first one we saw. Her kiln was set in a forest of prickly cactus. We walked through the opening in the cactus hedge to the kiln enclosure. The kiln was set into a slope in the ground, the fire-chamber entrance being on the low side of the hill. A notch in the kiln wall on the upper hillside made it easier to load the ware. Piles of broken bowls and figures were scattered around the enclosure.

Carnival Mood

It was impossible to talk to the people. They were at fiestas or drunk, and were in no humor to talk about work. One woman did not want us to photograph the kiln, although it was all right if we photographed anything else. Her husband then invited us to take pictures of the kiln, which set off a family argument in Quechua.

We had reached our information-gathering limits in a short time, and we left the village realizing that our quest for knowledge was out of keeping with the present festival spirit. No pottery was left in the village to sell, and the long-anticipated holiday was all the villagers were interested in.

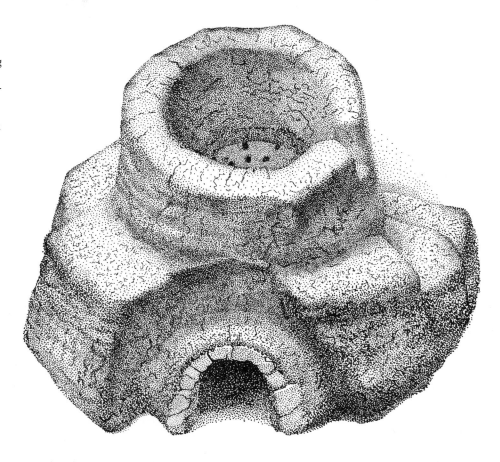

This Huayculí kiln, cracked and patched many times, is made of fieldstone and adobe. The buttressing forms a ramp which also serves to make loading the kiln easier. The perforated adobe kiln floor is raised about .6m (2 feet) from the ground. The wood and grasses used as combustibles here are fed into an arched opening at ground level.

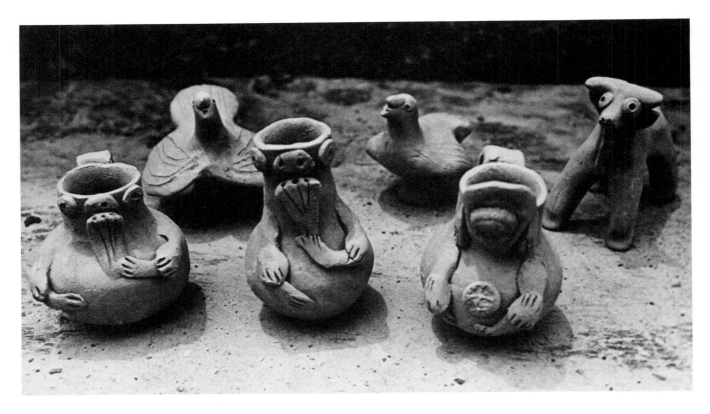

(Above) Handformed pots and figures, no more than 5 to 7.6cm (2" to 3") tall, are decorated with applied appendages and facial features and incised lines. Two of the pot figures are blowing *quena*, or panpipes.

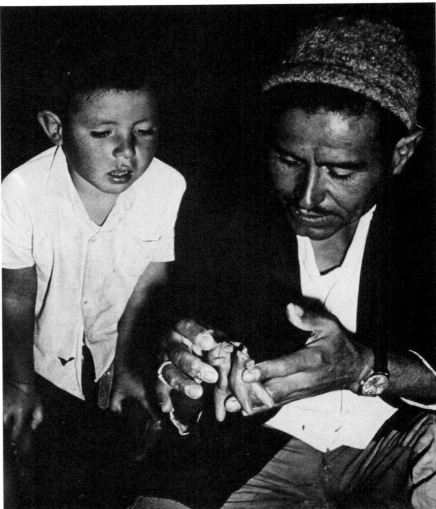

(Right) This typical Huayculí horse and rider, with incised lines and applied details, took Sr. Nogalez less than five minutes to complete.

Sr. Nogalez

Back in Cochabamba, we met Señor Alberto Nogalez, who is a teacher of ceramics in the Industrial School of Cochabamba. He was born in Tarata and grew up there and in Huayculí, where his mother still lives. His mother had told him of seeing us there. As a small boy, he learned pottery-making from his parents.

He told us that he had heard that the potter's wheel first came to Tarata a century ago. His grandparents were some of the first people who learned to use it. If the wheel came to that area earlier, or how people worked before its arrival, he did not know. It would take a great amount of research to learn the colonial and precolonial pottery history of this area. We had heard that evidence of a large Spanish colonial kiln remains somewhere at Chullpa Orco. Sr. Nogalez went away to school to learn the technical aspects of his trade. He takes great pride in being a potter and has tried to tell his fellow potters that they are not just *alfareros* (men who work with clay—including brick and tile markers) but *ceramistas*, a term with connotations of dignity.

The Technical School. Sr. Nogalez specializes in teaching the theory and practice of clay mixing, but at the school many aspects of clay work are taught, including glaze preparation and forming the clay by wheel, mold, or hand modeling. Firing practices are also taught, but he is upset because they have no refractory materials and cannot make kiln furniture. Stacking in the old way, they lose too many pieces and there is nothing they can do about it at present.

About 26 students graduate each year in the field of ceramics from the school. The government pays for building maintenance, materials, and salaries, and the students are not charged anything. On graduation, most go to commercial businesses to make brick, tile, or commercial tableware. Some go to Argentina or the United States for further study. Although many students come from the Huayculí area, they never go back there. They want to earn more money than a village potter could ever make.

A Trained Potter. Sr. Nogalez makes pottery on his own time. He has a wheel similar to those in Huayculí but better constructed, with a concrete flywheel, a metal head, and an excellent bearing arrangement. His kiln is the same as used in his hometown.

The room where he keeps his wheel is piled high with greenware, waiting for the good weather when he can fire

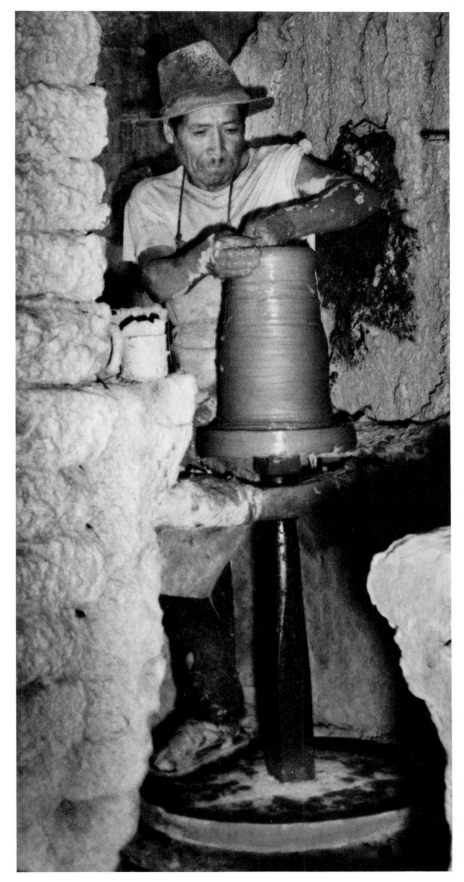

One of the three potters working for Sr. Savedra forms a large cylinder from which a *macetera* will be made. The wheel he used is similar in construction to those in Huayculí, even to the way it employs the adobe walls for support.

it. There are stacks of similar wheel-thrown *maceteras*, flower vases, and bowls, all well-thrown production pieces.

His glazing, as in Huayculí, is all *galena*, silica, and colorants of red iron oxide obtained near Santa Cruz; copper and manganese oxides are imported from Argentina as colorants.

As for the traditional hand-modeled figures from Huayculí, he can make them all. While his 6-year-old son watched intently, he modeled a traditional horse and rider. A stick picked up from the ground becomes the tool adding the tiny details to the hand-sized figure that took form in less than 5 minutes while he was talking to us.

A City Potter from Huayculí

It was back in La Paz that we were to meet a potter who could provide answers to the remaining questions we had about the kind of ware produced in Huayculí. Two different people told us we must visit both a man from Huayculí who had set up a pottery here in the city and a woman from Cliza, who might or might not still make pottery, but lived in the city. We were given two different complicated sets of directions to find the two people, but strangely enough, both sets of directions, approaching from opposite sides, led to the same house; the two just happened to be husband and wife!

Pedro Savedra told us he had left Huayculí 28 years ago. He acknowledged that he knew Alberto Nogalez. His wife used to make pottery but does not anymore. He learned to make pottery from his mother and father and did not have the benefit of a technical school. He has lived and worked as a potter in La Paz since he left his village.

A City Pottery Site. Sr. Savedra's home is up several hills from the sunken plaza in front of the city stadium. This plaza is famous for its duplication of the Tiahuanaco sunken-temple court. Here are all the major stelae and sculptures that you miss seeing at the original site. They were brought here only a few years after they were excavated but have been badly mutilated and defaced with spray paint.

Perched atop a sheer cliff, Sr. Savedra's home has a room and a gateway on the street. One climbs several flights of stairs up the cliff to his house and workshop. From there, one walks up hilly alleyways between one set of buildings and the next to yet another platform where another path leads still higher. All the raw materials must be carried up those stairs, and all the finished ware carried back down them. His perch commands a grand view over the rooftops of the city and out to the mountains beyond.

The Clay. Sr. Savedra tells us he has no trouble getting clay because a fine throwing clay is dug near here in a section of the city called Potopacachi. It is hauled here in a truck and is prepared simply by breaking it up and soaking it. Nothing has to be added to the clay. He uses the same rectangular stone-lined preparation pit that we saw in Huayculí and in Chordeleg, Ecuador. His kiln is no different, but for fuel he uses wood shavings bought from a local carpenter's shop.

The Wheel Work. He has a good-sized business here and hires three men to help him with the work. Two of the men are from Huayculí, but say that they learned most of their pottery skills from Sr. Savedra. The third man is from La Paz and was also trained here. Three Huayculí-type wheels are set up, all under a shed roof, and the work goes on, rain or shine. All the men are good production potters and turn out stacks of *maceteras, floreros,* bowls, or plates each day. The work is set out in the alleyway between workshop and building to dry. The corrugated sheet-metal shop roof is also used to dry the fresh ware. The glazing operation takes place here too, with large *fuentes de baño* being used to dip and pour the lead glaze over the greenware. Bowls are decorated with the same linear patterns as those in Huayculí. All the ware is fired only once.

Mold Work. Besides the wheel work, Sr. Savedra makes a lot of poorly designed mold pieces. Psuedo-Tiahuanaco faces are modeled and then cast in plaster to be molds for *maceteras.* Another favorite of his is a horizontal planter in the shape of a log with strong bark texture and little log feet. It gets glazed in garish browns and greens. He will try anything, even molds of Disney-type rubber toys. And yet this man is a fine potter and does the typical Huayculí figures with an added humor and flair of his own.

Marketing the Ware. Sr. Savedra's work is sold in the many city markets. His older daughter manages the pottery stall in Camacho market, not too far from his home. Once a year, he makes a selection of special pieces to be sold at the *artesanías* fair held in the city. *The National Museum of Popular Arts* owns several of his pieces, which are on permanent display there.

Hand-Modeled Ware We particularly admired a 23cm (9″) tall sculpture of an Indian girl sitting on a chair holding her baby, a cup with a frisky dragon for a handle, and a *diablada* with a wicked grin. A few days earlier we had bought several figure groups at a stall on Sagarnaga Street. They included a woman feeding pigs, two

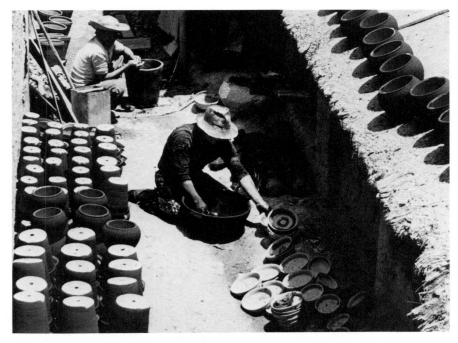

A 2.4m (8 feet) wide passageway between the potting shed and a solid wall is the area used both to sun dry the ware and as a glazing. Even the shed roof is used so that more pieces can be exposed to the sun's heat in this rarified and atmosphere at 3,600m (12,000 feet) altitude.

men playing instruments by a *chicha* pot, and a woman pouring *chicha* from the pot on a stove into a *cántaro*. These, too, Pedro Savedra had made.

Since we expected to be in the city for at least a few weeks because of transmission trouble, we asked Sr. Savedra if he could make up several of the figures we had seen in the museum, a traditional horse and rider and anything else that struck his fancy. Did we want them glazed or unglazed? We thought some of each would be good and he decided to make each item both with and without and we could pick out whichever ones appealed to us. Sr. Savedra would not let us watch him work, and we have some notion that his cheerful wife might have helped with some, especially after speaking with her on the day we went to pick them up. The pieces made for us are buoyant and humorous and depict typical scenes of village life.

A Trick Cup. Sr. Savedra's pride, however, was a cup with a fused cover and a hairy, four-legged creature with a bird's head as its handle. The cup has a series of trick holes. You fill it from a hole in the bottom, with *chicha*, of course, we were told. To drink from it, you must hold your thumb over the bottom hole and fingers over two holes on the side of the lid. Then you can suck the liquid from a hole in the front edge of the lid. When you hand the cup to a friend, warning him to hold his thumb over the bottom hole, but not telling him about covering the side holes, nothing comes out of the front hole. As he tips the cup up, four lower holes pour the *chicha* down his chin and neck. The museum cup was fashioned on the same principle, but with an open top!

A Cup for Semana Santa. A more traditional cup made in Huayculí is a strange drinking vessel to be used on the day before *Semana Santa*. This cup is really an arrangement of six cups or goblets fastened to each other around a central cup with a spout. Tiny horizontal handles join the six cups to each other with little oval patches of clay. Two vertical handles go from the rims of the cups next to the end ones, down to their sides. These are big enough for the drinker to put his fingers in as he drinks from the spout. Liquids are poured into the six surrounding cups, and, as they have holes near the base that go through to the central cup, all the liquids merge together.

On the day before *Semana Santa*, any family who has had a death during the year sits on the floor of its main room, around a cloth-covered table

Most of the Huayculí clay tableaus are scenes of typical village life. Sr. Savedra makes a dome-shaped oven with a couple of people removing the small rolls. In this one, a dog begs for food, while in others, a small child sits in the scene eating a roll. This piece is unglazed, but would usually be coated with a shiny deep green. The oven is only 10cm (4″) high.

The present-day Huayculí horse and rider wears a large-brimmed hat and strums a guitar. Sr. Savedras humorously shows the contemporary counterpart with the man carrying a transistor radio. The piece is 19cm (7½″) high.

A further development shows the rider on a motorbike with transistor radio strapped behind. The hat is changed, but the same method of applied designs with incised lines is still employed. This piece, measuring 14cm (5½") high, is glazed a pale yellow.

set up as an altar in the center of the room. Candles, holy pictures, sometimes clay figures, the favorite foods of the departed, and bread cookies shaped in the figure of the deceased are placed on the table. Visitors come and sit with the family for a while, and this cup, filled with *chicha* or other alcoholic beverages, is sipped and passed among the guests.

Other Figurative Vessels. Sr. Savedra knows of, and makes, all the traditional forms from Huayculí. Another interesting vessel is a small, hand-modeled or wheel-shaped pitcher with sprig-molded parts, such as baby-doll faces and rosettes for buttons, added. The hand-formed pitcher spout becomes the hat from which coil braids fall. Skinny coil arms are added with incised line designs for details on the sleeve and fingers. This piece is reminiscent of ware seen in Checca and Pucará (see the illustration on page 42).

A long-legged bull with a small head is made with coil ribbons of clay decorating his sides and the back of his neck. Like the Pucará bull, he has a raised rim on his rump to drink from and a handle with incised branch design arching from neck to spout. His open mouth has a hole through it so that air can enter the vessel while one drinks.

Decorated Tableware. The large bowls made in Huayculí are the same shapes and colors as those from Chordeleg, Ecuador, but the designs are different. The main decorative motifs are linear bands in brown, done with iron oxide. Between parallel bands, wavy lines are drawn. Oval clusters of leaflike shapes and simply drawn birds are popular. Copper-oxide green is used for wide stripes, controlled splotches, and exuberant swirls. All this is done on a yellow background (see Color Plate 27).

The smaller bowls are simpler versions of the larger ones and reminiscent of the *chuas* of Pucará, Peru. Some bear ropelike sections of applied coils on the rim or small handles with the ends folded back. On the smaller bowls, there is sometimes a yellow glaze with fine brown speckles. Some of the bowls are left crude, with green or brown glazed lines and designs. All of the bowls are set upon sturdy, wheel-trimmed feet. The outside of the bowl is always unglazed.

Sr. Savedra supplies all these traditional Huayculí pieces to the local city markets, where they are avidly bought for use in the urban households, just as they are in the rural areas around Huayculí itself.

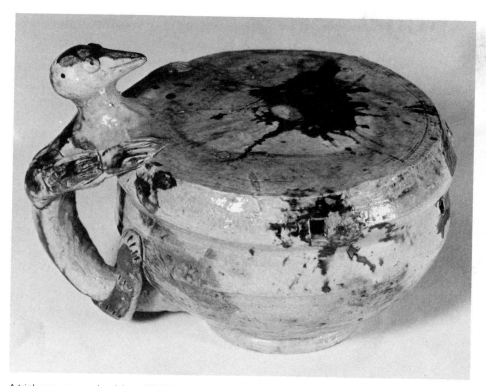

A trick cup, measuring 14cm (5½") in diameter, is glazed a shiny yellow with splashes of brown and green. The interior of the vessel is a very complex structure, allowing liquid to be drunk from the front hole only when the two side holes are covered. The cup is filled through a hole in the bottom. A series of low holes on the front will douse the unwary drinker.

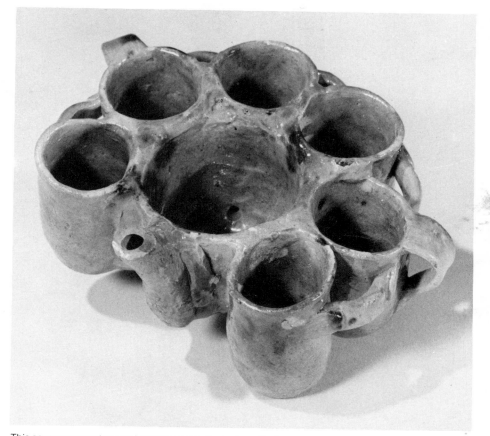

This seven-compartmented drinking vessel is designed to be passed around during *Semana Santa*, when friends visit the homes where someone has died during the year. Liquids poured into the outer cups mingle in the center through connecting holes.

CHILE

We were advised that there were two flourishing, productive pottery communities in Chile. Besides these, we would find little or nothing. It is estimated that 50,000 Araucanian Indians are living in the central area south of Santiago. These people are known principally as weavers, but some produce crude utilitarian pottery. We did visit markets where their work is weaving and pottery is sold.

The coastal area north of Santiago is barren desert. Unlike the Peruvian

coast, here there are few oasis towns, this being one of the driest, most desolate areas on earth. However, as you approach Santiago the scene changes to one of flat, rich farmland and vegetation. We arrived during the South American autumn to see pumpkins, grapes, and squash ripening in fields bordered by palms and banana trees. Parks have the strange combination of tropical plantings in full bloom backed by the autumn foliage coloring of deciduous trees.

Santiago

The capital, Santiago, has the most European atmosphere of any South American city on the west coast and is the fourth largest city on the continent. European-style cafés, bookshops, and art galleries are abundant. The architecture is as middle European as you will find in Latin America. The Spanish colonial influence is minimal in this cosmopolitan city.

Promotion of Folk Craft

In the past year, COCIMA, a women's organization, has been established in an old building on Calle Nataniel, just a few blocks from the Plaza Bulnes. The organization's inception was prompted by the interest of a group of craft-oriented people, who felt that Chile's crafts needed greater encouragement and publicity. COCIMA exhibits a permanent collection of rural folk craft alongside the work of individual craftsmen who maintain their own studios in the city. The work is attractively displayed on whitewashed walls, rough wooden shelves, and tables. Work is labeled to show where it originates. As in the Bogotá *Museo de Artes Popular y Tradicional*, guides are provided to tell you about the work and to help you make purchases, if you wish, of the craft work for sale. The prices are maintained at reasonable rates. The shop pays the artisans good prices but has a very low markup. Their aim is to publicize the crafts and to make a market for them, thus encouraging the craftsmen. The shop is able to sell everything that the craftsmen can produce. Quality is kept high, as shoddy or poorly designed items are not accepted.

Although folk craft is featured, the majority of work is from the individual city craftsmen. It is readily admitted that there is no great quantity of folk art in Chile, but what remains is of good quality, distinctive, and worth retaining. The greater part of the work is in weaving, whether wool, cotton, reed, grasses, hemp, or straw. Only two folk-pottery communities are represented in the exhibit here. One of them, Pomaire, is only an hour's drive due west of the capital.

Pomarie

We had heard conflicting stories about Pomaire. Some people told us that it is a very commercial enterprise, that you see row after row of ugly faces on pots and an abundance of clay chains. They told us that the famed "blackware" is nothing more than shoe polish painted on. Others told us that the place is a phenomenon, that we must see it. We were told of an interesting blackware process. People spoke of the great amount of work being done there and said that some of it was very good. All the conflicting stories are true. Pomaire is all of these.

From Santiago to Pomaire

The bus travels through rich farmland. At harvest time in April we saw corn shocks and piles of squash. Yellowing poplar trees and palms, both festooned with clusters of red flowering parasitic plants, added to the colorful fall landscape.

In several front yards we saw *cántaros* similar to those in Calcapirhua. Whole ones lay on their sides as ornaments. Broken ones were planted with petunias. They attest to a time when the area potters must have made many of these for local use.

Hopping off the bus at a crossroad, we waited in a concrete bus stop for the bus that goes the 2.5 kilometers (1.5 miles) north to Pomaire. We waited 45 minutes and then saw why. When the bus came, it was loaded—top, back seats, and halfway down the aisle—with sacks of potatoes. Some of. the bus was taken over by cases of empty Coca-Cola bottles. Little room was left for the passengers, many of whom stood for the short trip. Nearing the town, we asked the passengers where to go to see pottery being made. A chorus unanimously answered "everywhere," which turned out to be no exaggeration.

The Potter's Town

The town of 1,000 families has two long main streets of dusty, pulverized clay. One street comes and the other goes, laced between with numerous short blocks. All the streets are lined with houses of adobe or wood. Wood fences, signs, and display shelves proclaim that here lives another potter. We arrived at a busy time. Everyone was working. A cheerful joviality reigned as people hauled carts of clay and wood down the streets. In every yard, people were handbuilding,

working at wheels, firing kilns, polishing crude ware, or carrying ware to one of the kilns that dot the yards. The rhythmic banging of clay wedging echoed from all sides. We passed two neighbors who were putting up a wood fence between their yards so that each of them would have more room to display his ware. There was a great spirit of community cooperation and camaraderie. Obviously, everyone is able to make a good living from his work and has no fear of competition due to lack of buyers.

The Fall Tourist Season. The town is always busy, but in the fall especially everyone wanted to be sure to have a lot of work ready. Pomaire is noted also for its *chicha* and pork dishes. Now, with the new grape *chicha* just about ready, scores of people would be driving down from Santiago to eat and drink and to buy pottery.

Pomaire has long been known for its production of utilitarian cooking ware. The traditional foods such as *caldilla de congreo colorado,* made with conger eel, *pasteles de chorlo,* a corn-and-sugar cake, and many others, depend on the clay *paella* dishes for their authentic flavor. Pomaire's *chicha* could not be made correctly without the proper clay vessel.

Modernization Brings Changes. The town is steadily modernizing—buses every 20 minutes to the capital, fire hydrants all along the main streets, schools, offices, stores, and restaurants. Television antennas top the most primitive structures. Tractors have replaced horses. Transistor radios carry music and news to remote workroom areas. All this is reflected in the changes in Pomaire's ware. The potters now cater to the tourist and knickknack collector as well as to the connoisseur of fine cooking.

The Clay

Pomaire has been a center of ceramic production for a long time. The town sits on top of, and is surrounded by, miles of pure, fine plastic clay. The inhabitants have only to go outside the village to the hills that are not being farmed to find their supply. Some potters told us that they use it just as they find it. Others tell us that after it has been dried and pulverized it is mixed with water and foot-kneaded, and that at this stage sand and grog are mixed in.

A Duality of Work Styles

We visited several potters' workshops and found a great variety of work being done. From house to house we would often see the same kinds of

ware being produced with only minor variations. Previously only the women made the pottery, while the men were solely involved in agriculture. Today, the men find time to make pottery along with their farming. Some people specialize in hand-building, others in wheel work, and still others do both. Some families make a little of everything, others specialize in one particular type of ware.

Wheel work here is not considered "handwork," and handwork is of greater value. Two identical-sized *paella* dishes of similar quality were being sold in a shop. One was made on the wheel, but with all traces of the wheel work removed. The other was made strictly by hand, and it sold for twice as much as the wheel-formed piece.

Wheel-Formed Work. The kick wheels used here are of a very sturdy contemporary construction. A heavy wooden frame supports table, wheel, and bench. The flywheel is a large, heavy wooden platform. The shaft and metal head are supported with metal bearings. These wheels, unlike the unsteady wobbly variety we saw in Peru and Bolivia, are a smooth-running mechanism. The potters are equally skillful.

At one studio where we stopped, the specialties were large *floreros* and *maceteras*. Some were 1.2m (4 feet) tall. These were thrown on the wheel in one or more sections, depending on the size. The potter here could easily throw a thin-walled cylinder 30cm (12″) in diameter and 50cm (20″) high. When the pieces are leatherhard, they are burnished with a smooth agate. This stone, found in the nearby Pacific, is dipped into water and rubbed on the surface of a pot until it produces a deep chocolate sheen, completely eradicating every trace of wheel-made finger ridges from the work.

Kilns

There are many kilns in Pomaire. We saw them in almost every yard. Some yards contained two. They remind you of the kilns in Checca, Peru. Most are cylindrical, but there are many square and rectangular ones. All are of updraft-type construction. A fire box is built below ground level with a tunnellike protruding section through which the combustibles are fed. The kilns are made of brick covered with adobe. The floor is of pierced clay construction on brick supports. Some we saw had floor supports of several twisted and warped railroad-track sections that protruded from either end of the kiln! On these are piled shards over which the ware is

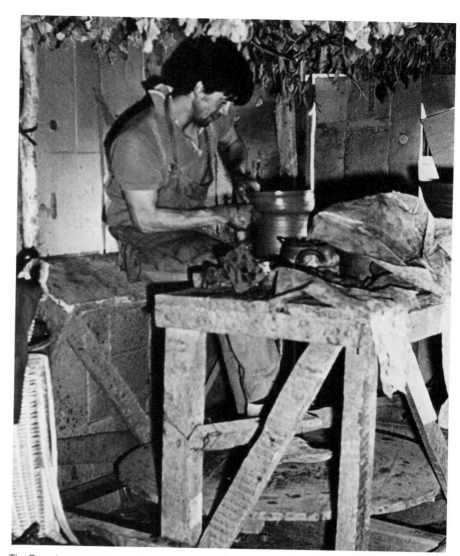

The Pomaire potter has a wheel with a wooden frame and flywheel. The metal shaft and head are set into metal bearings. A skilled potter here can easily throw a thin-walled cylinder 30.5cm (12″) in diameter and 50.8cm (20″) high.

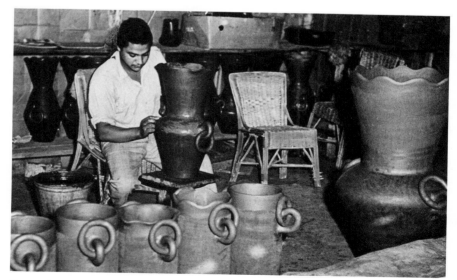

These wheelthrown *maceteras* and *floreros* are being polished to remove all trace of throwing ridges. To do this, the craftsman dips a smooth stone called an *agata* into water and rubs the surface of the leatherhard ware until it shines.

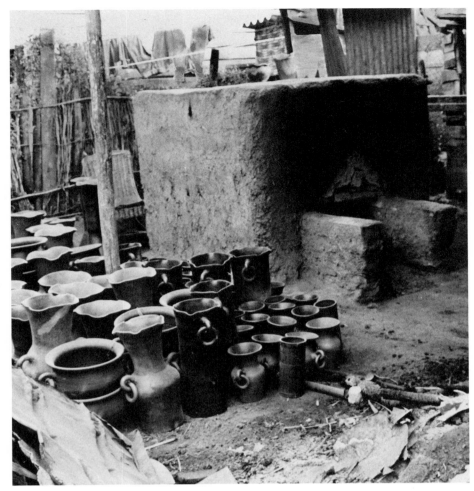

Kilns in Pomaire are either cylindrical or rectangular, but basically, they are the same updraft-type construction encountered in Peru and Bolivia.

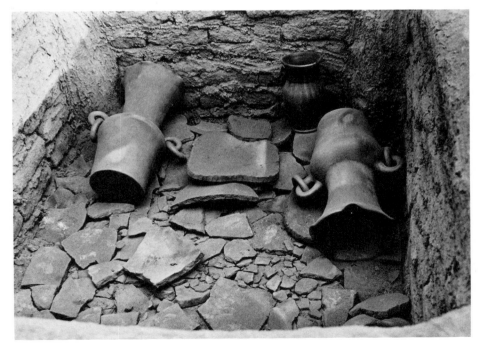

The ware chamber of the kiln shown above has a brick floor supported on brick columns. Shards are spread over the brick floor before the ware is loaded, and more shards are used to cover the top.

stacked. On top of the ware load another layer of shards is stacked. A corrugated metal covering is often placed over this for the reduction part of the firing.

Blackware Firing. Split logs are the main combustible; they are shoved farther into the fire box as they burn down. For more heat and a smoky atmosphere, the top of the kiln is covered with more twigs, leaves, grasses, old papers, and trash. For a really strong reduction, dry cow dung is thrown in. The amount added determines the darkness of the ware. The reduction part of the firing often does not last long enough for the blackness to penetrate very far into the body of the clay pieces, which results in a variegated surface of rich, deep browns with tawny shadings. The entire firing lasts 10 hours, and it is often dark when the final stages are reached (see Color Plate 19).

Because Pomaire has become known for its blackware, many tourists, expecting a jet-black ware, are not impressed with the handsome deep-brown tones that the ware sometimes exhibits. Some Pomaire potters have compensated for this by using black shoe stain to darken the ware for the approval of the buyers who see no distinction between natural black and applied black.

Traditional Kitchen Ware. The best pieces here are the traditional cooking pots. The *paella* dishes come in sizes from individual to those that could feed 24 people! The surface, as is true of most of the ware, bears the crosshatched texture of the agate polishing stone, and the fired ware retains the softly highlighted sheen.

Some of the individual-sized bowls have incised lines into which white clay has been rubbed, similar to the traditional design motifs practiced in Quinchamali, a community to be described later.

Oval platters and oval bowls have clay fish tails and fins added to the rims, similar to those in La Chamba, Colombia. One handsome bowl is a semioval rectangle with a broad, flat rim.

Stoves. Señor Castro Torreo specializes in making large stoves about 1 to 1.2m (3⅓ to 4 feet) high. The bases are cylindrical, about 30cm in diameter and 25cm high (12"x10"). Above this, the body swells out to allow a full-bellied form for the fire. The ashes fall into the cylinder below.

These fireplaces are made to ward off winter chill in rural areas, but city people often cart them off as containers for flowers in their apartments. Sr. Torreo says that these fireplaces are

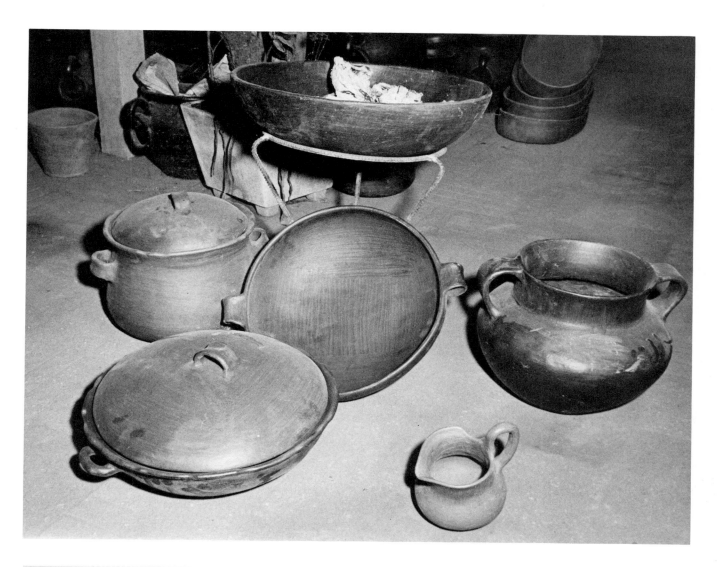

(Above) Traditional cooking pots are the most successful ware produced in Pomaire. *Paella* dishes and *ollas* are made with and without lids. The brazier in the background holds hot coals and can be used for cooking or to warm a room on a chilly day.

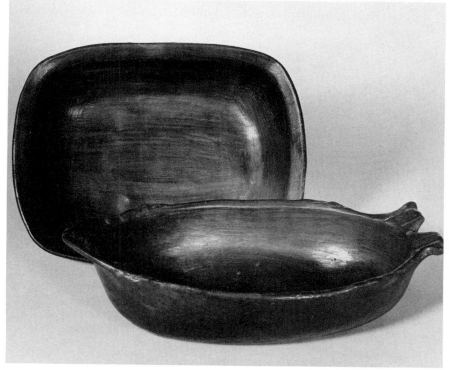

(Left) These baking platters are made by hand and burnished with an *agata* to bring out the luster of the clay. They are a deep rich-brown color, having undergone a reduction firing. The platter in front has a stylized head and tail, to resemble a fish. It is 38cm (15″) long.

(Above) Sr. Torreo's large, handmade stoves are often purchased by apartment dwellers to be used as decorative pieces, usually to hold large bouquets of artificial flowers.

(Right) Decorative *floreros* are a popular item in Pomaire. This one, which is 48.3cm (19″) high, was made by hand. Long, wide slabs of clay were built up in horizontal layers. Each layer is smoothed into the one below it. The handles with rings are a common contemporary decorative device. The piece is burnished to a fine sheen and reduction fired.

original, but we have seen similar forms in places such as Cartago, Colombia, and Acatlán, Mexico. However, it is always surprising to find a clay with few, if any, additives that will sustain the thermal shock that these large pieces will withstand.

Another form of fireplace/cook stove is a large, shallow basin shape that is set on an iron-ring tripod. Charcoal is burned directly in it. It is used both to keep a room warm and to heat a *paella* dish for cooking native foods (see the illustration on page 79).

Contemporary Decorative Ware. A host of semiutilitarian decorative pieces abound. Among these we saw quantities of *floreros* and pitchers in many sizes and varying proportions. Coffeepots and teapots, cups, three-legged fruit bowls, and countless other forms fill the majority of shops.

Some of the new work is handsome and well designed, but in many workshops the philosophy is to make anything if it will sell, the craftsman making no commitment to good design if poor design and poor taste will sell, and it does. The latest innovation we saw was to paint the clay with metallic enamels, to simulate metal. We saw a young couple heading for the bus back to Santiago with their new purchase, a .6m (2 feet) tall *florero* painted an antique copper tone.

Pomaire has become well known for making small copies of old-fashioned cast-iron four-legged cook stoves in clay. These are made from 15 to 46cm (5″ to 18″) tall, and many come complete with stovepipe and cookpots. Minute details of burners, doors, and ornamentation are carefully added. The clay chains we had been warned of are in great abundance, with anything from rosary beads, crosses, imitation clocks, or anchors added. These are hung on walls or from ceilings. Many types of vases are made with rings hanging from their handles, like those we would see glutting the market in Ráquira, Colombia. A profusion of clay turtles, ducks, and other animal sculptures look too much like rubber baby-toy counterparts to be taken seriously. There are, however, several people who specialize in religious figures, especially those for crèches.

Julieta Vera, Religious Sculptor

Julieta Vera is acknowledged by the townspeople, and by many outsiders who know her work, to be the finest folk sculptor of figures here and throughout Chile. A devoutly religious woman, she is dressed usually in a long black skirt and a black nunlike headcloth, with a silver rosary hung around her neck. She is very modest

and soft-spoken and considers her skill of sculpting a precious gift. That she is able to transform "humble clay from the ground into something with a beautiful religious significance" she takes as a sign that she should devote her life to it. She told us all of this in an honest, sincere tone, and was happy to show us her latest work and set it up so that we might photograph some of it.

There was nothing she could sell us. The greenware figures that she set up for us were part of an order from a church in Italy. All her work is done to order and she never lacks work, just keeping up with what is ordered. The figures she models are Italianate in style with faces and hands as delicately modeled as her own. Rich textures of garments are drawn into the clay, which is draped softly and simply to suggest the underlying form. All her work is left in the terra-cotta state.

She believes that her modeling skill is unique in the village. She had no special training in it, but taught herself with the help that "descended from above." Both her parents were potters, but they did no modeling, only making the traditional forms that everyone else in the village used to make. In her yard is evidence of her family heritage. A 1.2m (4 feet) diameter, thick-walled water jar, about 1m (3½ feet) high catches the water fed to it from roof spouts. She told us it has been in her family for a long time, at least since her grandmother's day.

Continuing Heritage

The Indian tribe that originally populated this area was working with clay when the Incas conquered them, and gave the place the Quechua name of Pomaire. Everyone is aware of his pottery heritage, each having learned the pottery skills from his parents. Pottery is taken for granted as a good thing, so the children are learning all the skills and will continue the craft.

They feel that new traditions will be made. There is a danger of Pomaire losing its remote country atmosphere and turning into a "Woodstock"-type arts and crafts center, where fad merchandise will be made and sold. We hear that copper embossers, wood engravers, weavers, and other craftspeople are planning to set up shop in this area, since it has become so profitable for the potters.

There is a strong dualism in the community between those traditionalists who resist the changes and the fadists who welcome them. Both groups, however, have profited by Pomaire's attraction for tourists, as even the traditional pottery is sold at inflated prices. The average Chilean woman going to her domestic market to buy food and the pots to cook it in could not afford to pay half the price that is charged for the cooking ware here in Pomaire.

Quinchamalí

Chillán, a city of 97,000, is an agricultural center set in gentle hills and fertile farmland 565 kilometers (350 miles) south of Santiago. It has an impressive, large, high-ceilinged market building with parking areas for the trucks and buses that supply it.

Having found that the crafts made in the area were being sought by many people, the local administration moved them out of the general market and set up a special plaza across the streets for them. Modern booths set in a crosswalk pattern with diagonal walls that offer large display areas and invite people to enter line either side of the crossed paths. There are many handsome baskets, some weaving, and the local Quinchamalí pottery. The Quinchamalí blackware displayed is humorous and imaginative. The ware we saw on the market was mainly decorative, although a few styles of bowls and vases were also on display.

However, to fill this extravagant exhibit space, the booths are always stocked with woven goods from Temuco and pottery from Pomaire. Other poorly designed woodwork and commercial products pad out the displays. Flower vendors, balloon men, and ice-cream wagons give a fairlike atmosphere to the plaza. On Sunday, it is a place where the townspeople stroll and make purchases.

A Potting/Farming Community

On a Sunday, the only way we could get to Quinchamalí was by taxi. A 20-minute drive and we were there. Unlike Pomaire, the village is no tourist mecca. The wooden houses, built like small American farmhouses, are spread out over the farming community. Apple orchards, wheatfields, cornfields, and other assorted garden plots and pastures fill in the spaces between the houses. Small, wooden, handpainted signs are hung on some houses and fence posts advertising the fact that here ceramics are made.

Today, about 125 women make the clay ware. The women have always been the potters here. The men are employed in agriculture and other occupations. Many men commute to Chillán for work, but the women still

This nativity set was made by Julieta Vera, who the villagers feel is the finest sculptor in Pomaire. She works only on order, doing only religious figures. Her work is delicately draped and sculpted in an Italianate style.

Figurative ware is outstanding in Quinchamalí. A traditional series of *borrachos* on horseback is made with the drunk depicted in progressive stages of inebriation. Facial details are the simplest, with a ball for the nose and holes for eyes and mouth. Arms and legs are smoothed coils of clay.

This four-legged turkey is the most delicate, flamboyant piece we saw made in Quinchamalí. The thin wings and tail are decorated with an abundance of feather lines which give the figure a light appearance despite the pudgy body.

carry on the traditional work in clay. Their homes are modern, with running city water and electricity, and many have propane or electric stoves. However, their ceramic techniques are timeless.

An Ancient Heritage Changes with the Times

The villagers claim to be descended from the earliest pre-Columbian, pre-Inca people who lived in this area, and that their ceramic heritage goes back that far. In the more recent past, they made all the storage vessels for the people who lived for many miles around the area. Containers for such things as grain, water, and wine-making were formed from the local clay, which was left its natural red color rather than being subjected to the reduction techniques which were used even then for smaller items. We mentioned that we had seen several flat-bottomed, amphora-shaped, .6m (2 feet) high jars lying in several yards, and yes, we were told, these were examples of the earlier utilitarian ware.

Since there no longer is a local need for the utilitarian pottery once made here, the people have switched their emphasis to decorative ware that has found a good market in Chillán, Temuco, and Santiago itself. They declare that the Quinchamalí figure work is directly related to the pre-Columbian indigenous people's work, but there seems to be no evidence of this. The figures, however, are unique to this area and bear little resemblance to that from anywhere else. Perhaps one can see a slight resemblance to some of the blackware figures done in Mexico, but no one who has seen the Quinchamalí work would confuse it with that of any other locality.

The Clay

Quinchamalí potters buy their highly plastic, pink-colored clay from people in the nearby countryside. There it is found in great abundance. In order for the clay to withstand the Quinchamalí firing technique, a high percentage of sand must be added.

All the pieces are covered with a very fine-textured yellow slip which is called *greda*. This is also found nearby.

The Work

We had picked a poor time to see work in process in Quinchamalí. It was April, and the harvest season was in full swing. There was grain to reap and fruit to pick. No one had the time then to work with clay. Besides, in the fall, which lasts from April to July, the

Doña Silvia's Sculptural Process. A sculptural process is used to form both figures and tableware.

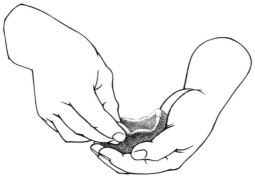

1. Wads of clay are pressed and smoothed together where needed.

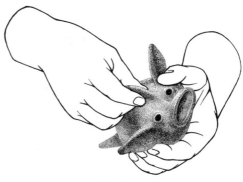

2. More wads of clay are added for sculptural details and modeled into place.

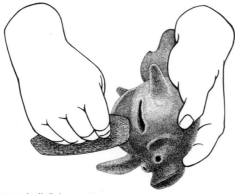

3.A *tapara*-shell rib is used to scrape and smooth the surface of the piece.

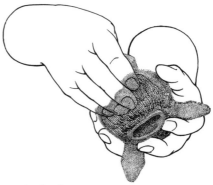

4. A fine, mustard-yellow *greda* is mixed with a little fine sand and water to a pasty consistency and then stuccoed thinly with the fingertips over the entire surface when the ware is leatherhard.

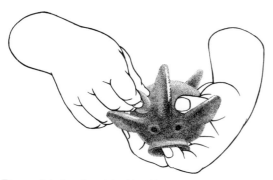

5. The *greda* is then burnished to a high polish by lightly rubbing with a smooth stone called an *agata*.

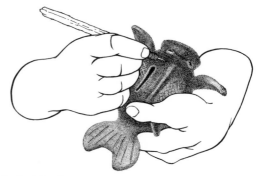

6. The final details before firing are fine lines etched into the surface of the fish with an old Victrola needle embedded in the end of a stick. After firing, white clay is rubbed into the lines.

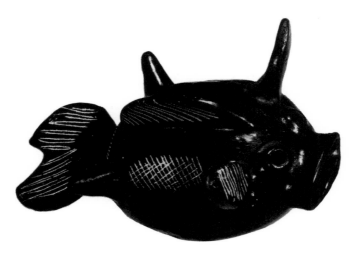

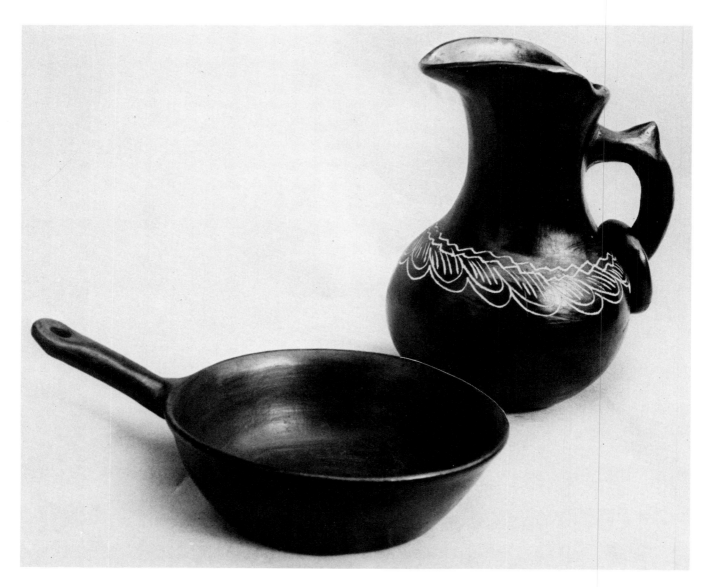

A few utilitarian pieces are still produced in Quinchamalí. Here, a *sarten*, or fry pan, is highly polished and given a long handle with a hole for hanging it. The pitcher shows strong Spanish influence in its form. The ring around the handle is one of the examples of an exchange of influences carried between Pomaire and this community.

air is so damp and it rains so much that they could not dry either the ware or the combustibles sufficiently for their firing techniques.

We had stopped at the workshop-home of Doña Silvia Moskoso, who had been recommended to us as one of the finest potters in the area. She greeted us warmly and invited us into her workroom where shelves and tables held displays of her ware. Doña Silvia apologized for the fact that she had no clay prepared and therefore could not show us the process. But she agreed to simulate it for us as best she could.

"It is all very simple," she assured us, holding out her hands. "These are the only machines that form the clay here." All the potters of Quinchamalí are very proud of the fact that unlike "that other pottery community," no wheels, molds, or kilns were ever employed here.

Firing

The firing process is really a form of raku. Everything (air, combustibles, and clay) must be dry to insure success and a minimum amount of loss. Where the Oriental potter would fire his raku ware in a kiln, the Quinchamalí potter subjects his pieces to an intensely hot fire, built on the ground and using wheat straw as fuel. He places one piece at a time into the fire and leaves it there until it is red-hot, which takes from 5 to 15 minutes, depending on the heat of the fire and the size of the piece. It is removed from the fire with a long pair of tongs and immediately plunged into a mixed pile of dry cow dung and wheat straw. Flame shoots up and smoke billows up. When the piece is lifted out, it emerges a brilliant, shiny black. Some pieces are not subjected to the dung treatment and remain a deep, soft orange with a few dark fire marks.

Large vases and bowls are also fired using this process, but many are cracked because of the difficulty in removing them from the fire and settling them in the straw and dung heap. When the piece is cool enough to handle, a white clay is rubbed into the etched line designs. We were assured that it becomes a permanent part of the piece and will not wash off.

Kitchen and Decorative Ware

Ware for use is no longer needed in this community. A few *paella* dishes are made whose thermal resistance, like those in Pomaire, enables them to withstand even the direct flame of a gas burner. Large fluted vases and jar shapes, also like those in Pomaire, are made, and many are festooned with the same ring-chain attachments. Another bit of evidence showing the cross-fertilizing influences between the two area's are the cook stoves, teakettles, and other Pomaire forms that these people are also making.

Temuco Market

Our South American pottery explorations took us to Temuco, 676 kilometers (420 miles) south of Santiago and as far south as we were to journey. We were advised to go here, as this is in the heart of Araucanian Indian country and the Indians bring their handcrafts here to sell to tourists, either in the market itself or around the railway station.

The 110,000 people in Temuco, a thoroughly modern city, support a large central market building which is in the heart of the downtown shopping district in the center of a whole block of small shops. Arcaded entries lead to it from the center of the four side streets. The market is a high-ceilinged building with glass skylights that flood the interior with light. We were there on a dark, rainy day, but the displays of fruits, vegetables, and flowers gave a bright air to the building. It was crowded with shoppers buying produce, meat, and fresh fish. Piles of sea urchins, shellfish, abalone, and a seemingly endless variety of fish attest to its proximity to the sea.

Handcrafts at Temuco Market

The handcraft stalls are concentrated in the central part of the market. Here are large displays of the handsome woolen rugs with intricate, diamond-shaped designs woven on vertical looms by the Araucanian women. Belts, ponchos, and blankets in profusion from the Araucanian household crafts load down tables and racks.

Hand-woven baskets in a variety of reed and grass materials, coarse or fine weave, and many shapes fill other stalls. A few vendors show small displays of the scarce, Araucanian handcrafted silver necklaces, which all the Indian women wear, bib-fashion, on their chests.

The rest of the crafts are, for the most part, the tourist-type gadgets of wood and paint and feathers with *Recuerdo de Temuco* clearly printed on them. Some native instruments, such as the *trutruka*, a 1.2m (4 feet) long cane with a cow horn fastened on one end with wool weaving and braiding, were also on display. We purchased one, and a delighted Indian, seeing us with it at the railway station, insisted on giving us a demonstration of how it was played. He raised it to his lips and played a staccato tune in strict rhythm with his shuffling feet. It was surprising to hear the number of tones he could produce, all in a minor key, a haunting, sad-sounding song.

Araucanian Pottery

Looking for pottery, we found more shelves and tables loaded with the ware from Quinchamalí and Pomaire. Among the piles of junk in one small stall we did find several examples of Araucanian pottery. The proprietor of the stall seemed quite knowledgeable about this Indian craft. He told us that the women make pottery as part of their household chores, and that many of them make enough to be able to barter with their neighbors or bring them to the Indian markets. Not as much is made today, he told us, and all that comes to the Temuco market now are small pieces made especially for tourists. These are animal-shaped pitchers, small bowls, and vases. He had only a few examples and said he would not have more for quite a while as the rainy winter season prohibited the making of pottery and it would be next summer before the Araucanians could again do their ground firing.

He told us that Indian communities were broken up and scattered over hundreds of miles of countryside. The people were farmers and the craft work was a diminishing occupation. Less and less found its way to market.

So, our only evidence of how Araucanian pottery is made comes from the book *Native People of South America*, by Julian Steward and Louis Faron. Here Mr. Faron shows a photograph of an Araucanian woman kneeling on the ground and rolling a coil of clay to make a pot. On the ground in front of her is a flat stone on which she has already formed the round base of her pot.

Several small pitchers, similar to the ones we found in the Temuco market, are in the photo. A .6m (2 feet) tall water jar, crudely formed from its bellied body to its irregular, flaring rim, is also pictured. A pair of vertical handles where the body slants inward toward the neck seem to be awkwardly placed for use.

Two Examples

The pieces we bought at the market are thick-walled, made of a clay that fires from a yellow tone to a more orange shade and is flecked with large spots of golden-toned mica. A horizontal, oval-shaped pitcher, with a neck at one end, has a pair of rudimentary wings and tail suggesting a headless bird, with a handle going from rim to midbody. It sits on the suggestion of a foot. The other pitcher is taller, 20cm (8″) high, and has a globular base. The neck of this pitcher is wide, set to one side, and has a flared base, like a ridged collar where it joins the globe. The spout is just suggested. The handle is strong from lip to body. Both forms show a strong sculptural concept. The ware is irregular and heavy (see Color Plate 21).

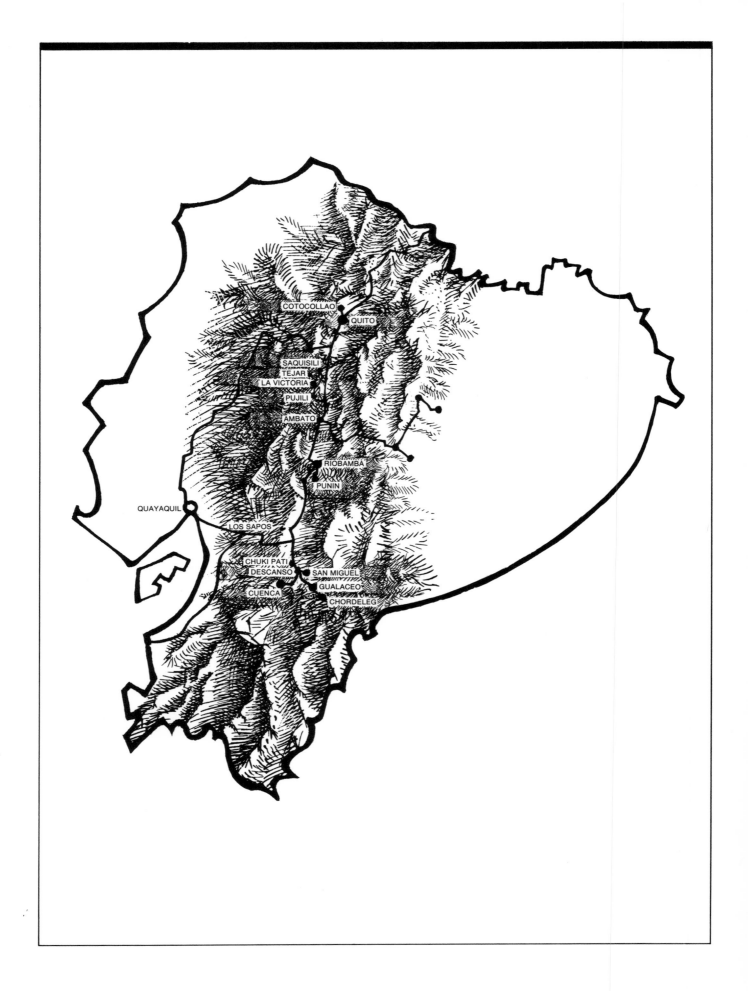

COTOCOLLAO

QUITO

SAQUISILI

TEJAR

LA VICTORIA

PUJILI

AMBATO

RIOBAMBA

PUNIN

QUAYAQUIL

LOS SAPOS

CHUKI PATI

DESCANSO

SAN MIGUEL

GUALACEO

CUENCA

CHORDELEG

ECUADOR

Ecuador, like its neighbors to the north and south, is divided into three distinct regions. First, the Pacific coastal lowland region, except for Guayaquil and the area surrounding it, is sparsely populated. In crafts, it is best known for *jipi japa*, the plant from which "Panama" hats are made. Second, the central Andean valley lies between two high mountain ranges. This is where the majority of the population lives, and where, except for the port of Guayaquil, all the major cities are located. It is this central valley which contains the greatest variety of the country's crafts, including ceramics, and which will be the main area studied here. The third region is east of the mountain range, the great Amazon Basin, the Oriente, which from Colombia to Peru has only political boundaries, and for its crafts should be considered as an area complete in itself.

The mountain valley is divided into ten pocketlike basins running north and south. Lower in altitude from 2,100 to 2,700m (7,000 to 9,000 feet) than the peaks that surround them, these hollows contain the cities, separated from each other by transverse mountain ranges. This stretch through the Andes was nicknamed the "Avenue of Volcanos" by the great naturalist Alexander von Humboldt, as no less than 30 volcanic cones flank its length, adding an incredible beauty to the snow-capped mountain panorama.

Inca and Spanish Heritage

The Incas built the great highway from their capital, Cuzco, in Peru, to their more distant conquests, establishing their northern capital at Quito. By means of this highway they spread their culture and language north to the indigenous Indian peoples inhabiting this chain of valleys.

For the majority of the Indian population, subsistence living conditions have remained the same here as they have on the Peruvian *altiplano* today.

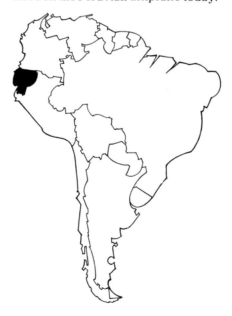

One sees pockets of indigenous people speaking a variety of Quechua and wearing variations in costume of the Peruvian hand-woven woolen fabrics and hard felt hats or other related head coverings.

The Spaniards used this *camino real* to facilitate their conquests so successfully that Spanish techniques and style all but obliterated what was left of the Inca influence in the handcrafts. One sees this at the craft centers located in the cities in the heart of these basins. But venture out to the passes between them and off in the remote areas east and west, and you find that the indigenous population is living about as remotely as it did in centuries past. From these areas hand-fashioned, ground-fired, slip-coated, and burnished ware makes its way to market.

Since the Spanish conquest, various Catholic orders have taught, along with religion, painting, sculpture, carpentry, weaving, and other handcrafts. In some instances, Spanish looms and potter's wheels have completely replaced the old Indian methods. In other areas, the Indians have held fast to their own language, music, and craft traditions. Therefore the most interesting phenomenon that you find along the Avenue of Volcanos is the strange variety of cross-cultural combinations of working methods and styles.

Cuenca Valley: Cuenca

On Thursday, the big market day here, you find a fine assortment of weaving, embroidery, and ceramics brought in from the surrounding countryside. A special section in one plaza is set up for clothing and fabrics. Racks of colorful long skirts with brilliantly hued machine-embroidered borders, stalls full of special knotted and dyed shawls, piles of woven ponchos, and hammocks vie with stacks of factory-made dresses and sweaters, often of synthetic fibers.

In another plaza are piles of herringbone-weave baskets in a unique form—square and tall with an hourglass waist. Women shopping in the area explain the baskets' strange shape by the way they carry it. A shawl is wrapped around the basket's waist and its ends are passed up over the carrier's shoulders and held or tied in front. Other types of baskets, handcarved wooden bowls and spoons, and mounds of ceramics are also displayed at this plaza.

The Pottery Market

Three different pottery areas are represented at the Cuenca market. Corazón de Jesus, a crowded *barrio* on the edge of the city, is one of them. Chordeleg, a town about an hour's drive north, is another. The third, San Miguel, where impressive handbuilt pieces are made, is still farther north. At first observation, it is difficult to tell the difference between the ceramics of the first two places. Both are brilliantly glazed and similarly designed wheelthrown forms. On closer scrutiny, you notice that the Chordeleg pots at the market are represented by fewer types of forms, mostly bowls in all sizes.

The women of Chordeleg and Corazón de Jesus sit on either side of a narrow pathway which winds through their piles of pots. They have set up shades over their wares and sit on stools or chairs. They are chatty and friendly and seem to enjoy the market day. The women from San Miguel are serious and quiet except among themselves. For the most part, the San Miguel women are reticent to discuss their work, and many resent the presence of people with cameras. The younger men, who stand around

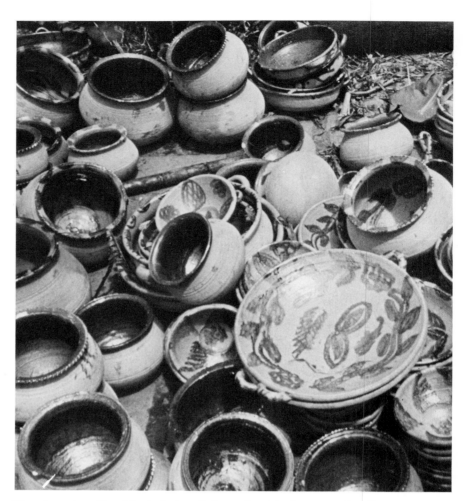

Glazed ware from Chordeleg is displayed in large piles at the Cuenca market. Plates are painted in green glaze, with the traditional leaf, geometric crosshatch, and bird designs, which show through a clear yellow glaze. Glaze inside the *ollas* is a deep green.

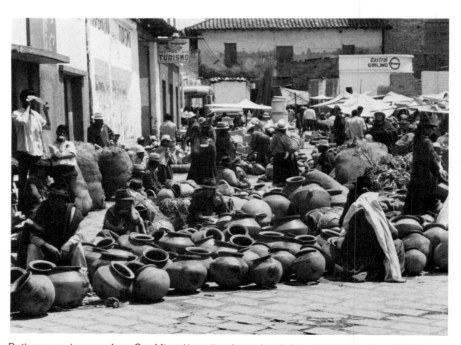

Both men and women from San Miguel in native dress sit quietly beside their pottery. *Cántaros* in all sizes and dimensions, up to .6m (2 feet) tall, and as great in diameter, are spread over a large section of the Cuenca market.

laughing and enjoying their camaraderie, tease the women for their shyness. The Indian women squat on the ground or sit on bundles. Unlike the mestizo potters, who are more apt to be wearing machine-made cotton clothing and sweaters, they dress in hand-woven skirts and mantas.

Chordeleg

Heading north out of the market town of Cuenca on a beautifully paved road, we soon arrived at Descanso. A sharp turn east led us back over a narrow, winding dirt road that follows along the Rio Paute. After crossing it several times, we came to the community of Gualaceo. In almost every house of this village there are craftsmen working. We passed doorways and open windows through which we glimpsed shoemakers, furniture makers, and women seated at stretchers embroidering dress-length fabrics or shawls. Other women sat weaving Panama hats or knotting the famous *flaco de macana* panels on shawls dyed with the *ikat* technique of tie-dye. Others were weaving hammocks on backstrap looms. We drove through the narrow streets of this cheerful little town to find the narrow dirt road bearing left and over a covered bridge which winds uphill to the smaller community of Chordeleg.

Filigree jewelers, as well as ceramists, practice their trade along this road. Balconied, tile-roofed, two-story adobe homes set among eucalyptus trees display signs proclaiming their wares. First floors have showrooms to accommodate the bus tours from Quito that sometimes make a side trip here on their way to Cuenca. We saw pottery set out to dry in the sun on concrete or stone porches that bridge the narrow space between house and road.

A Potter's Home

Before entering the village proper, we stopped at the first house where we saw pots. A young couple lived on the street level. The land dipped down sharply from the road here. We entered the simple home from street level and walked through to a balcony that overlooks the yard and kiln, then down a flight of stairs to a lower-story room that was open to the yard on one side. In this room was a rough wooden counter the length of the room, into which was built a potter's wheel. Clay

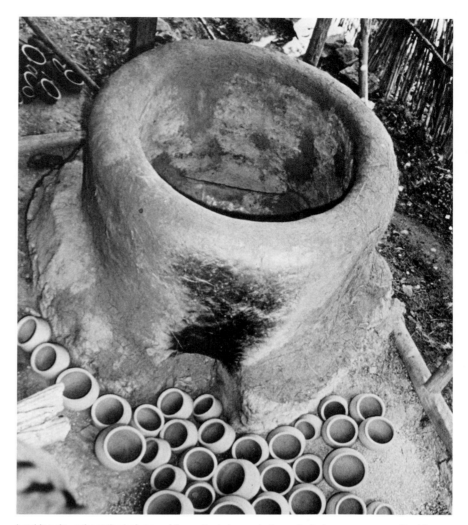

Looking down from the balcony of the potter's house to the patio below, you can see the kiln and the pots put out to dry. Ware is placed in the kiln on a grill of horizontal brick arches, which are leveled at the top and covered with adobe. An adobe wall encircles the base of the kiln, except in front of the fire-chamber entrance.

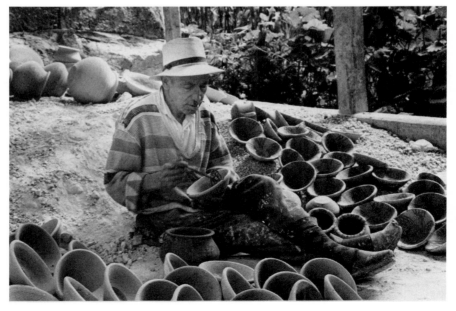

An older potter in Chordeleg sits on a pile of crushed clay and leisurely paints a series of traditional designs in green glaze on bowls and *ollas*.

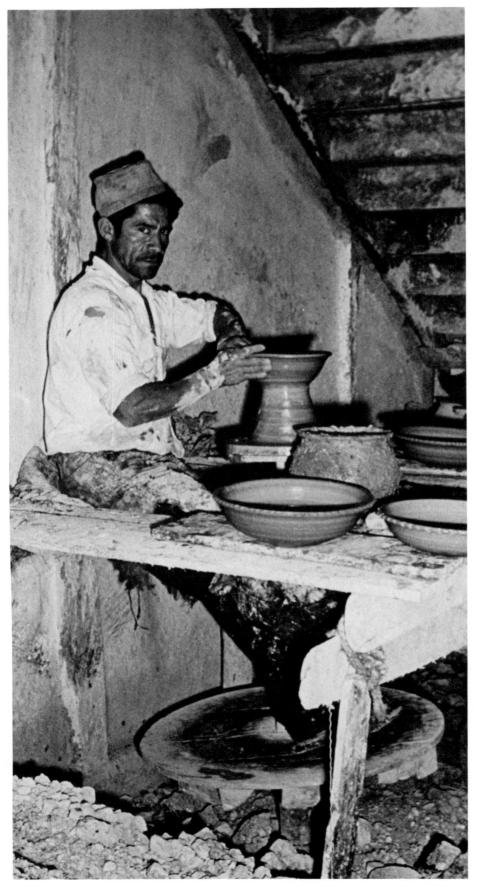

Another potter in Chordeleg shows great proficiency throwing off the hump to produce all his ware. Chordeleg potters sit to the right of the wheel shaft and work at their left sides.

was piled all around and there was a large screen used to sieve the clay before it is wet down. Ware in all stages of drying was piled around the kiln in the yard, exposed to the sun.

The Clay

Everyone buys his clay by the truckload from a man out in the *campo* who owns a large clay pit. Looking at the leatherhard pots, we noticed chunks of chalk-white clay and smears of greasy black clay distributed through the medium-gray body. We could see by the way the clay worked that it was a good, plastic wheel clay. It is soaked in pits dug into the ground and can be used without aging.

A Potting Family

The people in Chordeleg were hospitable and friendly. Most were receptive to the questions we asked and eager to show us their equipment and work. They are very proud of their craftsmanship and were quick to tell us that they are the finest potters in all Ecuador.

We were invited to visit a young girl's grandfather. Her *abuelito*, as she called him, is one of the oldest potters here, and one of the best, she added. We found him in the shade under the porch roof, seated comfortably on a pile of crushed, dry clay. Surrounding him were dozens of greenware soup bowls and more piles of the smaller, round *ollas*, the common cook pots with small handles at the rim. He was dexterously painting "net"-patterned leaves, winding vines with leaf patterns, concentric half-circles on the inner rim, and a calligraphic swirl at the center.

He put down his brush, rose to greet us, and led us around the yard explaining his working methods.

Wheel Proficiency. The potter's wheel here is a wobbly, off-center contrivance with head, shaft, and flywheel all of wood. A metal spike driven into the lower end of the shaft turns in a hole in the stone base. It is amazing that these people can produce such fine work on this primitive equipment. Throwing off the hump seems to offset the eccentricity of the wheel. The elderly potter demonstrated his facility by throwing bowls and vases off the hump and deftly cutting each piece loose with a length of string. On several pieces he demonstrated a few wheel decorating techniques such as wiggling his finger near the rim as the pot turned to produce a wavy double rim, or slowly forming a fluted ridge decoration with the fingers of both hands.

Glaze Techniques. A mill for grinding glaze ingredients, an idea brought by the Spanish colonists, is commonly found in a number of potting communities in Ecuador and southern Colombia. Most of the potters in Chordeleg use this, too. It consists of a stone-lined cylindrical pit, in which a large stone block rotates by means of a hand crank. Hours of back-breaking work are needed to prepare glazes in this manner. Our friend showed us how this works and explained that this, too, along with clay preparation, is the man's work. The women paint and glaze the ware and assist with the stacking and firing. It is the woman's task, also to market the ware.

As is true with all the wheel-made ware we will see in Chordeleg, plumbate glazes are used with manganese, iron oxide, and copper oxide as the colorants. The designs are painted on either greenware or bisque, each potter firing once or twice as he prefers. After the design is made, the piece is dipped sideways, first one side and then the other, into a bath of clear, yellowish glaze.

Adobe Kilns

We were next shown the kilns. There are two in this yard, both about 1.2m (4 feet) in diameter and about as high. One was empty and we could see that the grate is composed of three adobe arches, upon which the ware is piled. Through an opening in the kiln wall wood is shoved into the combustion chamber under the arches. The other kiln had been recently fired. The top was open and we saw the ware stacked inside, still hot. Bowls are fired upside down, one on top of another, with smaller objects in between, in this case many three-necked candelabra. Where one piece touches another, a small wad of clay is set to slightly separate them. Of course, this mars the surface.

We noticed a very rough texture on the glazed pieces opposite the firing hole where the glazes had not matured. We were told that this happens now and then, and that if the glaze is too rough, the pieces will be refired. That this firing difficulty happens with some frequency is born out by the fact that we saw several other potters who had stacks of rough-glazed pieces set aside to be refired.

A Family of Craftspeople

The granddaughter led us across the road to introduce us to other members of her family. Her mother and aunts were sitting in one doorway weaving intricate open patterns into two-toned Panama hats. Next door, an uncle had

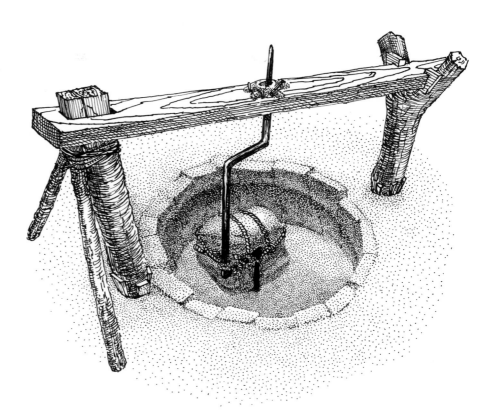

The Chordeleg glaze mill is a cruder contrivance than those we encountered in more northern parts of Ecuador and in Colombia. Several stones are tied by means of a rope to an iron crank-shaft. The stones that line the pit are well worn by the action of the turning stone.

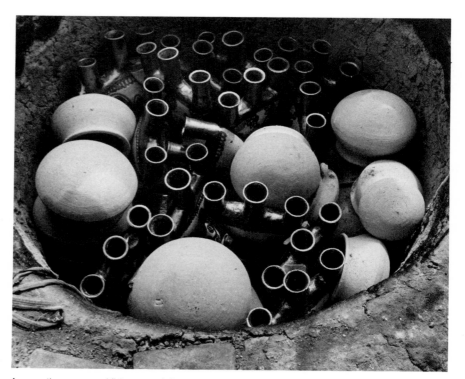

A recently uncovered firing reveals how pottery is stacked in the Chordeleg kiln. *Ollas* are fired upside down, and glazed pieces touch each other or are separated by small wads of clay, which of course will mar the glazed surface. The candelabra stacked in this load were inspired by a Peace Corps volunteer.

his backstrap loom neatly arranged with his other weaving tools, waiting for the wool for his next poncho commission. At the next house, another uncle was working at a wheel, the duplicate of all the others in Chordeleg. Rows of large *ollas* sat glistening on the workshop floor. He was trimming feet on the bottom of the pots. A clay mound was centered on the wheel and covered with a cotton cloth. Each bowl was inverted on the mound for the brief trimming process.

Spanish-Influenced Traditional Work

They have been potting here since the Spanish introduced the wheel. Each father passes the potting techniques on to his sons. Only the men use the wheel.

We are told that a dozen or so families in Chordeleg still are producing pottery. These few have a large output. The markets of the entire valley are well stocked with their traditional ware, which consists mainly of cooking pots and tableware, all of Spanish design, and glazed and fired using traditional Spanish techniques.

Some is bought by merchants who take it to markets in the neighboring valleys north and south; some even goes to market in Quito occasionally. You see the colorful platters being used directly on hot-coal braziers to cook the local soup and meat dishes in markets and squares throughout the valley. Deeper, decorated bowls are filled with water and used to wash the soup bowls in which the meals are served. These bowls, too, are recognized not only by their typical green line designs, but because of the customary depression measuring about 2.5cm (1″) deep and 7.5cm (3″) wide in the center of the bowl.

Newer Influences

People in the town told us of a Peace Corps worker who spent some time with them several years ago. We were invited to go to the cooperative store near the village square. The shop is well stocked with all the woven crafts of Chordeleg and Gualaceo, as well as embroidered goods, filigree jewelry, and a vast display of Chordeleg ceramics. We saw many of the traditional market forms and a great variety of other, newer forms, having nothing in common with the traditional except the materials used.

The strangest items are wall plaques in the form of sun, moon, and stars strung as a mobile, or flat bowls set one against another pyramid fashion. One wonders what the local people thought when it was suggested

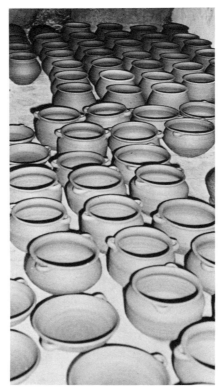

This Chordeleg craftsman is a production potter. These *ollas* and platters, thrown off the hump, are the result of one morning's work. They show the potter's skill in the perfection and similarity of size for each form.

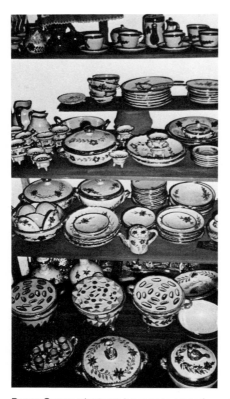

Peace Corps volunteers have encouraged Chordeleg potters to try many new ideas including the blue-glazed dish sets displayed here in a co-op store. The traditional painted designs are not used on these sets.

that they make these! There are double-bowled pitchers with handles joining them, braziers with gaily painted perforated set-in tops in larger and smaller versions, ash trays, perforated lamp shades, small crèche figures on a plaque, and much more.

Probably the most successful design is a dish set using the basic flower-and-leaf patterns for decoration, but done with a much tighter, self-conscious line. Casseroles with cone-shaped lids would have been better designed in the rounder shapes that are more naturally seen in Chordeleg ware, but in total, the shapes are pleasing and make a commercially feasible product. These ceramics of foreign influence stand apart from the traditional work, because of a naiveté in conception and a lack of understanding of the new forms. A cobalt-blue colorant was also introduced in the new work and it stands out, strongly alien, against the customary earth colors.

Another Peace Corps store set up in Cuenca stocks this low-fire ware and sells it locally, but because of its fragility, it could not profitably compete in an international market. Also, the plumbate glaze would violate safety regulations.

It would be of greater value for the potters of Chordeleg to receive technical assistance in improving clay body, glazes, and firing techniques, than to introduce too-hastily improvised forms. Someone is needed who has a very sensitive understanding of good design to help the people adapt their own good design forms to the contemporary market.

Corazón de Jesus

The *barrio* of Corazón de Jesus is only ten blocks from the center of Cuenca. The narrow, cobbled city streets are faced on either side with pastel-painted wood and adobe one- and two-story buildings, topped with ceramic tile roofs. No one would suspect that there is a pottery community here just by walking down the street. When you are invited into the buildings and are taken to the large inner court, the scene becomes more familiar. Several families share a court and you see piles of crude and prepared clay, kilns, wheels, and stacks of ware in all stages of production. A grand-

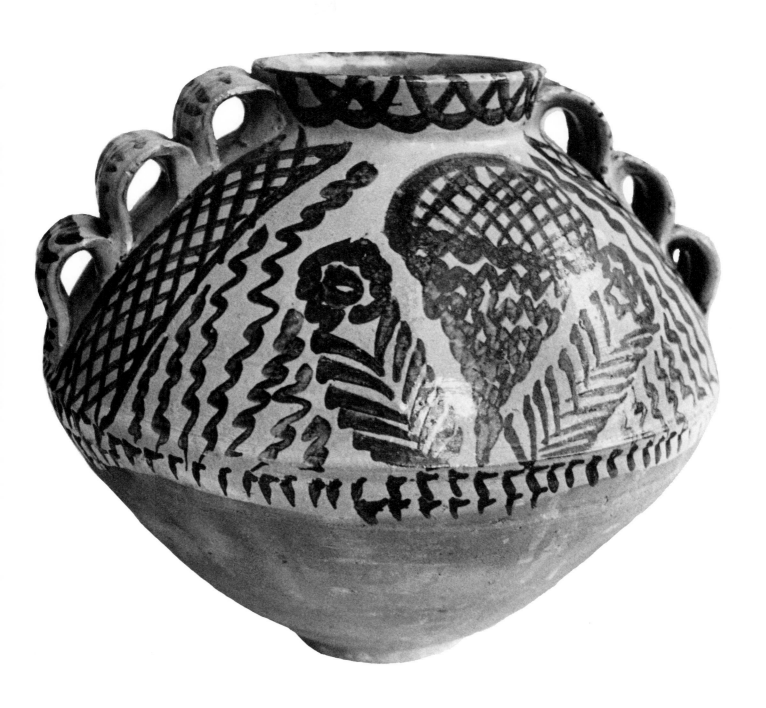

This *florero* is flamboyantly decorated with both glazed line designs and a triple-handle treatment on either side of the neck. Only the top half and inside are covered with the clear yellow glaze. Collection of Olga Fisch.

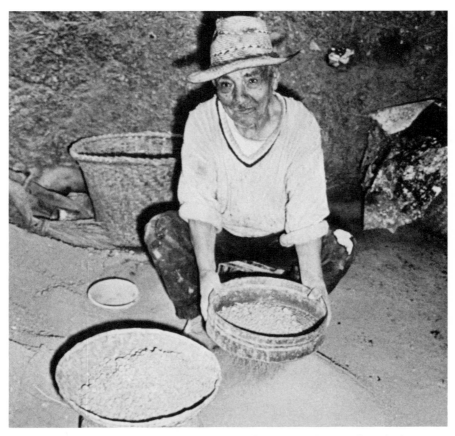

Clay is pounded and sifted before it is soaked, both in Chordeleg and here in Corazón de Jesus.

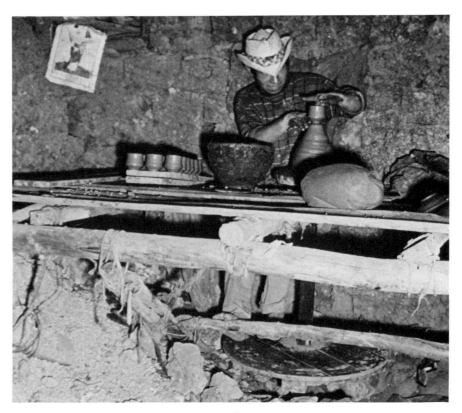

Like their counterparts in Chordeleg, the potters here sit to the right of their wheelshafts and throw at the left. They, too, are proficient production potters, throwing off the hump with great uniformity.

father is sifting clay, his grandson turning out trayfuls of cups made by throwing off the hump. The man on the other side of the court is stacking roof tiles for shipment, while his wife sweeps up the debris around the kiln from the last firing. No more than 10 potter families are working here, but, again, they are proficient production potters and turn out a lot of work rapidly.

All the equipment and techniques that one sees in Chordeleg are found here—the same wheels, kilns, glazes, and similar forms and decorative motifs.

Kilns

The Corazón de Jesus kilns appear to be somewhat more efficient. Some of the kilns we saw had the same basic cylindrical structure as those in Chordeleg, with a square form built around them for greater insulation and support. Some were built with common brick. Besides tableware, these people make roof tiles, both plain and glazed. The varying shades of golden brown or olive green make for a very handsome product. For these, they need larger kilns and the potters have had to develop greater firing skills than those in Chordeleg.

The Pottery Pieces

The Corazón de Jesus potters are quick to pick up new ideas and to incorporate them into their own style. Perforated tea strainers, and pitchers decorated with applied rolls of clay in rooster or flower design, are among their innovations; also, pots with finger-poked-out bumps all over. They will try anything, and they often succeed. Many of their pieces show a great deal of humor, that delights adults as well as the children. Wheel-turned closed forms are made into brilliantly glazed piggy banks with a variety of facial expressions. Again we were told of the Peace Corps volunteer who came and demonstrated many different ideas on the wheel. As in Chordeleg, with generations of basic skills and understanding behind them, a knowledge of more acceptable, durable materials could greatly expand their market and the demand for their product.

All the ceramics and other handcrafts of the Cuenca region have a colorful buoyancy about them, from the small clay whistle birds to the large, freely decorated wash bowls. A delight in detail marks even the utilitarian ware, whether it is in the exuberantly painted line designs or a triple-looped handle where one loop would be adequate. The glazes are

also richer and more heavily applied.

One can hope that these communities will receive more recognition and the encouragement to grow and improve.

Commercial Ware

In the Cuenca area a commercial factory is producing rather ordinary molded and jiggered dinnerware and decorative objects. It also produces hand-size pigeons that are cast out of clay. These become outstanding craft objects when painted in enamels, very much like the Mexican decorative painted ware. The difference is that these birds are painted meticulously with delicate flowers and linear patterns in shades somewhat resembling the fine embroidered cloth of the area (see Color Plate 25).

San Miguel

This community is up a series of long, winding dirt roads from the small town of Chuki Pati at the northern end of the Cuenca Valley. The Indians carry their ware down to the main road on their backs in rope nets. The bundles are so large one wonders how they could have been lifted into place and carried by these small-framed people.

Unlike the other pottery of the area, shouts its Spanish colonial heritage, this pottery reflects the people who live more secluded and self-sufficient lives in the remote hills.

As noted, their dress and manner reflect the cold, hard life of hill people. The pottery, too, has a no-nonsense air about it. It is sturdy, with powerful forms directed to its purpose, with no extras added.

The Pottery Forms

The forms themselves are sharply stylized with each piece being elegantly conceived in two major planes with a strong break in direction between them. Handles are placed at the junction of the two planes only when needed.

Only three basic utilitarian shapes are used, and these are made in a variety of sizes. The *cántaro*, a taller jar form with a small mouth, is used for water and *chicha*. The *olla* for cooking is not too different, except that it has a more squat shape and a wider mouth to accommodate bulky ingredients and to allow easier stirring and

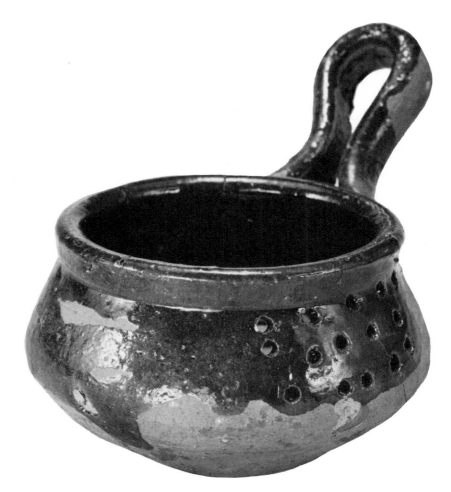

A tea strainer from Corazón de Jesús is a good example of the well-designed utilitarian ware made here. It has been dipped in a deep-brown manganese-lead glaze.

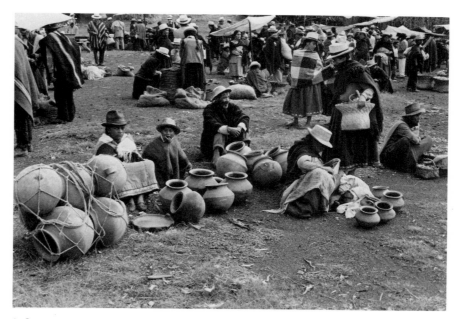

At Chuki Pati, Sunday is market day. The potters from San Miguel carry their pottery here in rope nets. The large bundle shown would be carried on a man's back from the village to the market, a distance of several kilometers. Chuki Pati market is patronized mainly by the Indians of the area.

ladling out of the soups (see Color Plate 4).

The third shape is the flatter *tostadora*, a platter used for toasting the corn that is the main staple of the people's diet. Their version has a slightly rounded bottom and a shallow rim on which sit two vertical handles. These are difficult to bring to market in good condition, due to the fragility of the flat shape. This is the reason that so few of them are seen.

Construction of the Pottery. The rich, deep-red clay is worked completely by hand, the larger forms appearing to have been made in three successive stages: first, the rounded lower part; then the inward-moving upper section growing from an almost horizontal plane; third, the neck, which rises and flares out, sometimes repeating the horizontal plane with its broad lip. The lip treatment is varied in either size or direction or sometimes with the adornment of a slight beading or cleft along the edge. Handles are made with the idea that they must be sturdy and able to bear the weight of a heavy pot, fully loaded.

The Surface of the Ware. Over the upper surface, and sometimes with a slosh around the handles, is painted an even redder smooth clay slip that shows the marks of having been burnished in all directions with a small stone.

The handsome black patterning that enhances the surface appearance of the pottery is caused by a smoky firing on the ground.

The cross-section of a typical San Miguel pot. Holes are poked through the body of the pot where the handles are to be applied. The handle is literally plugged into these holes, and its smooth swell flows over the plugs, melting into the body. Inside you can feel the plugs where they are thrust through the wall of the vessel.

Riobamba Valley

The next important mountain basin and the largest north of Cuenca is the Riobamba Valley. A long, thin valley with several of the larger Sierra cities located within it, it extends from Riobamba at its southern end to Saquisilí in the north. The center of the valley provides the easiest descent from the eastern range of the Cordilleras into the Oriente, or jungle area, in the Rio Napo and Rio Pastaza basins.

Early Ceramic Evidence

Like the Cuenca basin to the south and the Quito basin to the north, the climate here is a favorable, springlike temperature all year round. Because of this and the fertile soil, the valley is known to have supported a sizable population long before the Inca invasion. Although the archaeological investigation in this area has not been too extensive, ceramic pieces dating back to 500 B.C. have been unearthed. The Sierra ceramics of Ecuador, unlike those of the alto region of Peru, never attained as great a stylization and sophistication as the Ecuadorian coastal culture did. But, whereas ceramics are no longer being produced along the coastal sites of Ecuador, the pottery tradition still continues in several parts of the Sierras including the Riobamba basin.

Around the city of Riobamba itself are several communities where local people, who have a great interest in the area, have conducted informal digs, some prompted by seeing exposed ware as much as 2.7m (9 feet) deep along eroded riverbeds. According to the authorities, they have found work dating back 800 years. Small fragments of figures, large anthropomorphic jars with symbolic faces applied at the jar neck, and many small, simply made utilitarian pots were found from what is called the "integration period." The digs were conducted around the tiny communities of Punín, Chambo, and Guallabamba. There still are people producing pottery here on a very small scale. One sees it occasionally on the big market day in Riobamba, where it is overshadowed by the pottery brought in from the Cuenca area and from the more productive pottery villages of the northern part of the valley.

Punín Ceramics

One woman from Punín displayed a pile of ware made by using the same materials and techniques employed by her long-vanished ancestors. The same brown-toned clay is formed into thin-walled vessels, coated with a red slip and burnished with a small, smooth stone. You see the identical color and sheen in both the new and ancient work. Where the ancients indicated nose and eye slightly by adding clay, the features on her pots are more emphatically accented. Among her forms are several well-developed, fully rounded sculptural birds and sheep, all with the ubiquitous coin slot on the back. A humorous pig, with a serene, human-looking face, a most realistic nose, and a body shaped like an elongated head on three legs, seems incongruous in its surreal implications among the more complacent animal shapes and small, fluted, three-legged vases that complete her assortment of wares. Shortly after the potter had set up her display, the local people had bought almost all her work, showing that she does not have to depend on a strictly tourist market, as one might suspect.

Ambato

Heading north, one comes to Ambato. Here an important road from the jungle area connects with the main highway. This road brings the Salasaca Indians to market, where they display a beautiful assortment of tapestries woven in traditional designs of birds, frogs, and people. At Ambato, you see the best selection of woven belts, wooden bowls and spoons, and brass cooking ware—in short, it is one of the most extensive markets in the country. The pottery market is second only to that at Saquisilí.

Traveling further north from Ambato, the highway passes between the perfect volcanic cones and snow-topped peaks that make this beautifully paved and graded road one of the most appealing highways to travel over in all of South America.

Saquisilí Market

On Thursday one must arrive before 6:00 A.M. at the Saquisilí market in order to see the tremendous volume of pottery that arrives here. All of the market, the commercial clothing, gadgets, food, and weavings are gathered in the main plaza and radiate from it through the streets. About three blocks from this main plaza is a huge open field, and it is here that the pottery is laid out. Row upon row,

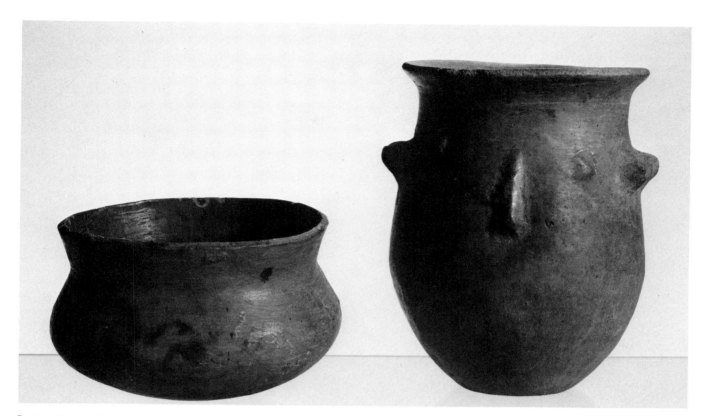

Pottery dug near the small community of Punín is estimated to be about 800 years old. Both of these pieces are coated with slip and burnished to a fine sheen. The anthropomorphic vessel on the right, measuring only 13.3 cm (5¼") tall has only the suggestion of a face. Two nubbed finger holds are on either side of the pot.

Where the ancient potters only suggested facial features, this contemporary potter makes strongly delineated mouths and noses on these clay banks. The surrealistic three-legged pig has a human face.

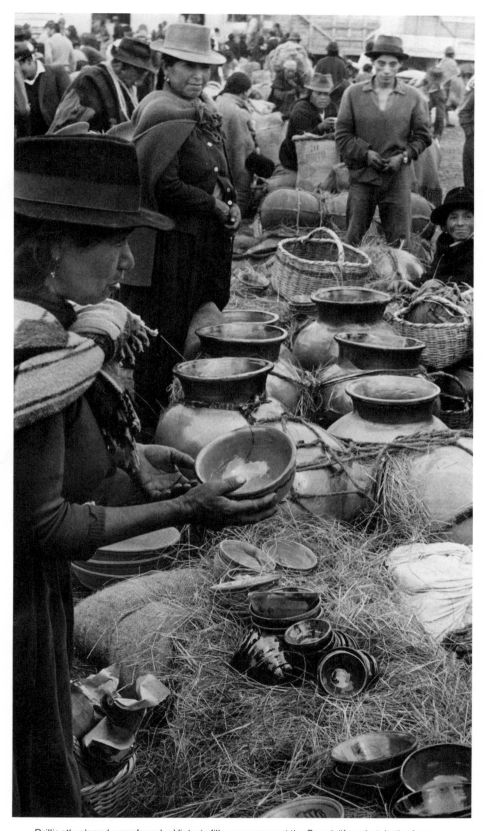

Brilliantly glazed ware from La Victoria fills many rows at the Saquisilí market. In the foreground, a woman bargains for several of the popular soup bowls. In the back are the large, fully glazed *cántaros.*

hundreds of pots are spread in aisles on the ground. Behind these pots are groups of the same kind of pottery wrapped in coarse straw and bundled in a netlike arrangement of ropes. Commercial vendors walk up and down these rows checking out the pottery and haggling over prices. Then the huge bundles of pots are lifted by several men and hauled over to waiting trucks that are soon filled to capacity. In an hour, the rows dwindle down to the work that has been left open on display and this too thins out rapidly as hundreds of individual buyers purchase for their needs.

The variety of pottery is tremendous. Three pottery villages bring their ware here and each has its own distinct techniques, styles, and products. All are located within an hour's drive of Saquisilí and Latacunga, two large cities surrounded by a combination of lush farmland, desert sand area, eucalyptus forests, and lofty snow-capped mountains (see Color Plate 33).

Tejar

The largest pots produced in Ecuador come from Tejar. The village is best known for these huge containers, some measuring 1.2m (4 feet) tall, that are reminiscent in form of the famous aryballoid Inca storage vessels and to the amphora-shaped anthropomorphic pots that were produced 1,000 years before the Inca invasion.

Amphoras

These basically utilitarian pots are decorated only with a wavy, irregular line that is incised just under the lip and also along the high, full shoulder. However, one does see the burnishing marks left on the surface where a stone has been used to polish the form. Again we saw ample demonstrations of how this pot shape is designed to be carried full of liquid: The pot is suspended on a man's back by means of hemp rope. This rope encircles the pot and extends over the man's shoulders. Because of the lower angle of the vessel, he can walk along with a very slight forward bend and still support the vessel in a vertical position.

The pot may vary in height, width, and neck opening, but this is the basic Tejar form. Although the majority of

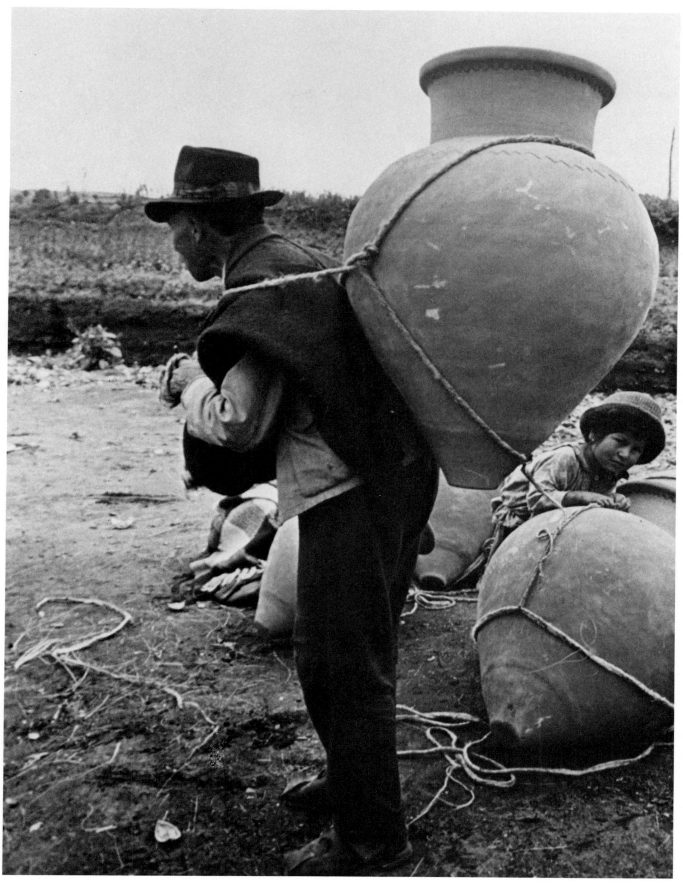

The slanted side of the Tejar amphora is designed so that a man can easily carry the vessel upright. An intricate arrangement of ropes is used for carrying, as the Tejar potters do not provide handles on their ware.

potters here specialize in this huge form, we also found rounder cooking pots, smaller amphoras, and large *tostadora* which other people specialize in making (see Color Plate 13).

The Clay Work

The men are the potters in Tejar. We were told by a teenaged boy that his father works all day every Monday, Tuesday, Wednesday, and Friday. On Thursday morning he takes his ware to the Saquisilí market and on Saturday morning to the Latacunga market, but by afternoon he is home working the clay. Even the tallest pots are started in a small clay *moldecito* which conforms to the base section of the pot. Coils of clay are added as the work progresses. The potter circles his pot rather than turning it. He pinches and raises the wall, smoothing it with a wet chamois. Firing is done on the ground.

Pujilí

Great mounds of ware sold at the Saquisilí market represent the utilitarian product that comes from this village in Ecuador. Pujilí is noted, however, primarily for its painted figures. The day of *Corpus Cristi* is celebrated in Pujilí with long processions winding through the altar-lined streets. Afterwards there is great festivity. Bazaars are set up and the potters sell their painted, molded clay sculptures to the crowds of people who journey from other parts of the country to be in Pujilí on this day.

Molded Ware

Among the molded figures are many animals—roosters, bulls, and pigs—decorated in imaginative, colorful designs. Also prominent is the figure of an Indian with a large headdress (see Color Plate 1). He holds a dove in one hand, and wears a skirt, pantaloons, and a full cape. His large, flat, stepedged headdress has three holders that contain bunches of colored feathers. This figure is said to represent the returning Inca god, Viracocha. You also see this figure placed among a group of figurines in festive local native dress. There are musicians, and people drinking beer around a table loaded with beer bottles, beer kegs, and food. All the parts of the figure are made individually or in small press molds and assembled on a clay

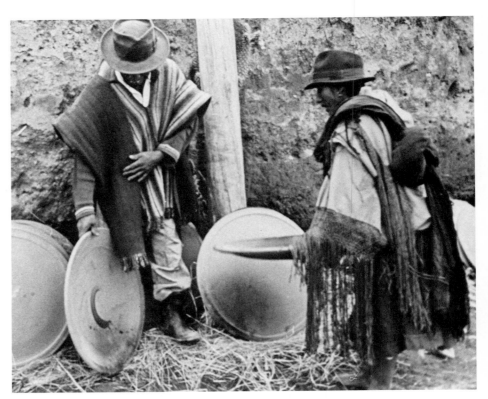

Tostadoras are made in large, flat platterlike *moldes*. At Saquisilí market, a potter who specializes in this ware displays it for a prospective buyer, who will use it for roasting corn.

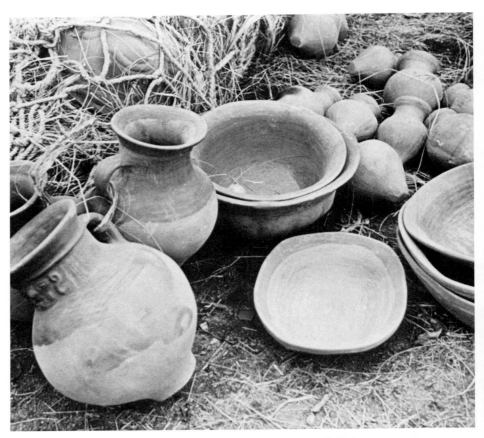

Pujilí potters bring mostly their utilitarian ware to the market in Saquisilí. All the work, amphorashaped jars, pitchers, and round and oval bowls, are made in molds. Some of the pieces are painted with a swish of red slip on upper areas or rims.

The painted animals from Pujilí have been compared to the Mexican Metepec figures. This rooster is made in a two-piece mold and painted in bright, shiny enamel colors. Collection of Olga Fisch.

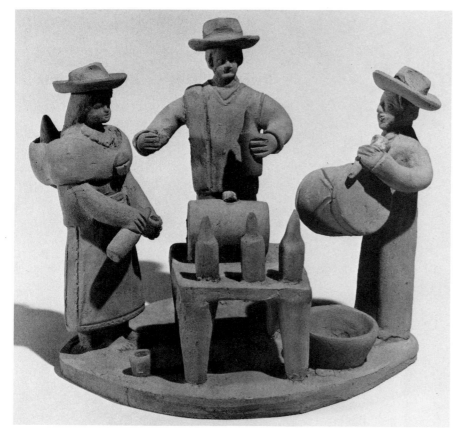

This unpainted group of molded and handmodeled pieces is put together to depict a festive celebration. Many combinations of figures are possible in these tableaus, which may include villagers drinking, musicians, and even the god Viracocha himself.

plaque. Sometimes these groups are left unpainted, but generally they are first coated with a base of white, over which enamel, acrylic, or casein paints are used to add color in meticulously delineated decorations.

Everything in Pujilí is formed in molds. One- and two-piece clay molds are piled high on the potters' porches.

Clay Preparation

The potters live on the outskirts of this large community. They haul their clay on muleback from fields that are several kilometers from the village. The clay is black when wet; it tends to be sticky and nonplastic but is suited to their methods of mold work. A part of each yard is paved with stones as a clay-preparation area. A pot of water for clay preparation is sunk into the ground to its rim. A sufficient quantity is mixed for each day's work.

Mold-forming

A typical Pujilí potter, Señor Chicorza does most of the family pottery, although his two sons and wife share in the work. Their method is to roll a ball of clay on a large, flat work-stone. Dry clay is dusted over the stone to keep the wet clay from sticking while it is turned and patted into a large pancake. Molds are used for making everything. To make a bowl, a complete mold of the outside of the shape is used, and the clay pancake is flopped into the mold. More dry clay is sprinkled on the flat stone. The mold is spun slowly on this with one hand, while the other hand presses the clay to make it conform to the contour of the mold. The clay remains in the mold until it shrinks from it and can be removed without warping the shape. The rim edge is usually raised slightly from the mold to permit it to be rounded and smoothed.

Large circular, oval, and elongated bowls are all made in this manner. Often a line design is engraved into the mold, producing a raised design on the outside of the bowl. If the bowl is to be painted, which is the manner of decoration the Pujilí potters enjoy most, then the raised line is incorporated into the painted design.

Slip Decoration At the Saquisilí market, many unpainted pots have red slip applied to the rims. The 76cm (30″) diameter Pujilí *tostadora* used throughout the whole valley is often decorated with a swirl of this red slip at its center as well as along the rim.

Tostadoras. The *tostadora* is basic to the Ecuadorian kitchen. Without it, the natives could not roast the corn kernels which, along with a gruel or

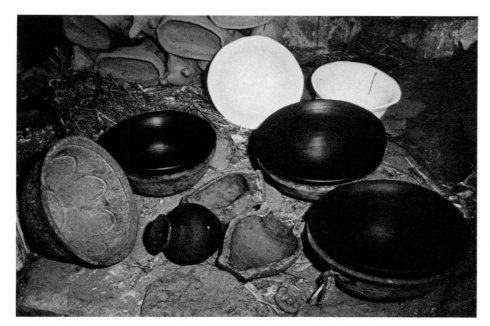

On Sr. Chicorza's porch, bowls and small jars are formed. On the left is a bowl mold with lines incised around it. Formed bowls stay in the molds until they dry enough to be easily removed. A two-piece mold and the pot removed from it are in the center. Two fired bowls have been primed with a white paint before they are further painted with bright enamels.

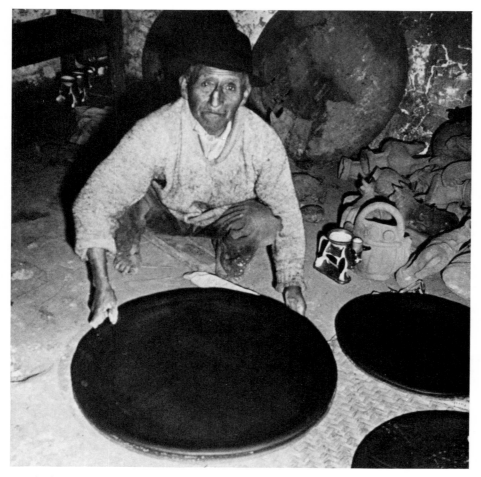

Sr. Chicorza makes the same platters, called *tostadoras*, that are made in Tejar. He forms a huge pancake of clay and flops it in the *molde*. The *molde* is then turned while he smooths the surface and forms the rim.

soup, constitute the main diet, day after day, for most of the Sierra people. For toasting, the *tostadora* is supported by three stones which are pushed apart to accommodate its large diameter; the fire burns between the stones. The corn is rolled over and pushed about on this platter until every kernel is evenly roasted. One imagines that this cookie-textured platter gains in durability through its daily use and that the tensile strength of the clay must be particularly high.

Kilns

Sr. Chicorza's rectangular kiln is built of stone and brick. The floor is a few upended bricks with other bricks set across in a grill pattern upon which he piles his ware. Wood is fed through an opening just below ground level. Straw is also fed through here and piled all over the ware to completely cover it. The straw often leaves interesting black crisscross fire patterns on the ware. A sloping wooden roof rests on the back wall of the kiln and is elevated at the front on two rough posts and a crossbeam. He tells us that because his kiln is small, he fires often. It takes only 2 or 3 hours to complete a firing.

In an adjacent yard a woman showed us her kiln. It consists of two parallel walls of brick 1.5m (5 feet) long, one brick high, and 1m (3½ feet) apart. Over this, an iron reinforcing rod bridges the gap and serves as a platform for her ware. Her firing procedure is to pile quantities of straw on top of the pottery and feed wood through both ends under the rods. The two firing techniques are basically the same, only slightly removed from a ground firing.

Marketing the Ware

With these simple techniques, using a clay that is difficult to work with, all the potters of Pujilí are able to supply a large market with small amphoras, *tostadoras*, flower pots, wash basins, cooking pots, pitchers, bowls for fruit, and painted sculptural ornaments. Their utilitarian pottery is found at every market in the Riobamba valley. Often in Pujilí, as at the Saquisilí market, jobbers buy the pottery in huge lots to sell at other markets where the Pujilí potters themselves do not take their ware.

Their decorative painted figures and bowls are sold at fiestas and markets and often can be found in craft shops in Quito.

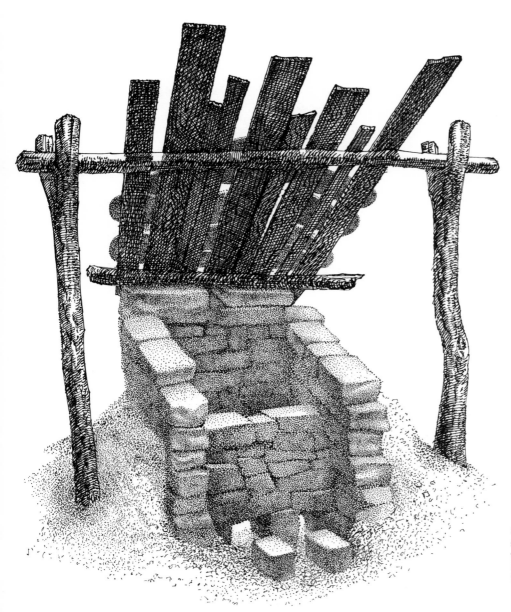

Sr. Chichorza's kiln is built of field- and cut stone with a brick grid to hold the ware. A wooden roof is raised over it. The two stones in front are plugged into the fire ports when the firing is terminated.

This simple kiln is only slightly removed from a ground firing. Two rows of common brick with concrete reinforcing rod bridging them support the ware. This is covered with shards, then straw. Wood will be fed underneath the rods.

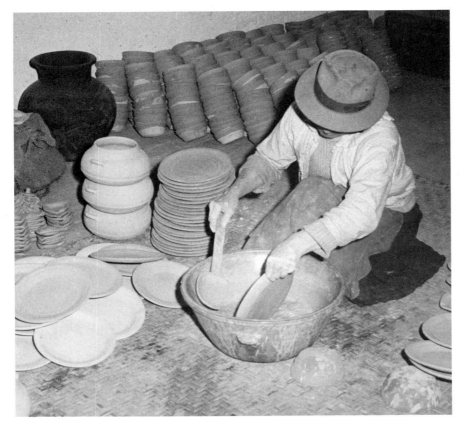

Seated on a reed mat, Sra. Segorra uses a clear lead glaze to coat the bisqued plates beside her. With the help of a ladle, she dips each plate, top and bottom alike, up to her hand. Then she holds the plate by the glazed end and dips the unglazed portion.

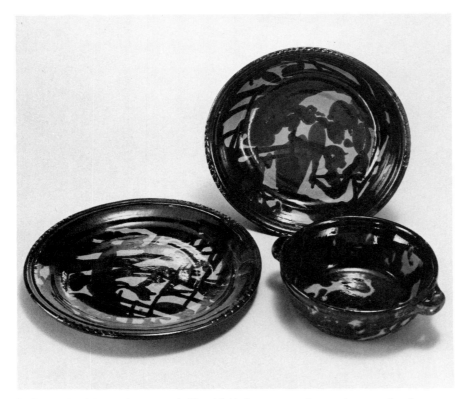

Sr. Segorra's tableware is patterned with a dribbled manganese brown glaze over the clear base glaze. He makes small three-pronged clay stilts on which he stacks his ware during firing. These leave marks on the upper and lower surfaces of each piece.

La Victoria

Only 8 kilometers (4.9 miles), from Pujilí is a potting community with entirely different objectives, as can be seen in their products. La Victoria is a tiny community that boasts a spacious plaza with a broad sweeping view of the volcano Cotopaxi. At one side of the plaza is the home of Señor Gonzalo Segorra, whom the community considers the finest potter in the area. We were told that his dishes are used in many of the finest restaurants of Ecuador, and that even the Hotel Quito in the capital has ordered plates from him.

Lead Glazes

Apparently the worry about lead glazes has not affected his market, and much of his output is made to fill the orders he receives.

From what we had heard, we expected to see a large setup with a production potter busy at the wheel. Sr. Segorra is an amicable man with a twinkling smile and great enthusiasm. He led us to the main room of his house, a combination bedroom, living room, and workshop. His wife was seated on a large woven-reed mat glazing plates.

Tableware Production

One side of the room was piled with pottery in all stages of completion: bisqued, glaze-coated, unfired, and stacks of finished ware. All forms of tableware—casseroles with lids, soup tureens, soup bowls, platters, individual casseroles, cups, teapots, ashtrays, small vases—enough for many complete services.

Sr. Segorra proudly showed us the various forms he had created and put into production. He is the one who made popular, he told us, the clear glaze with the deep brown or green random spattered designs that are used by all the Victoria potters now. Around his walls are many framed documents, a tribute to the number of awards he has received for his original designs.

Forming the Ware

We asked him if we could see his wheel, and we were answered by a bright laugh and asked to follow. Across his courtyard was another, larger building of whitewashed adobe. We peered into the high-ceilinged, windowless room. It was so dark that it took a while before our

Senor Segorra's Production Methods. Although this ware appears to be wheelthrown, the forming process is done entirely by hand and *molde*.

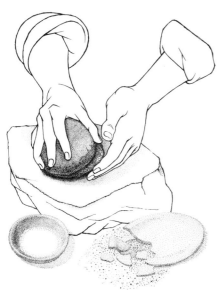 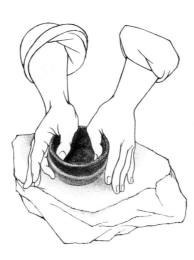 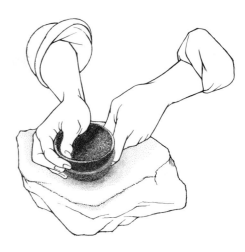

1. With a small stone in her right hand, the potter taps and turns a disk of clay, forming it into a smooth, even "pancake." Grog made from a broken bisqued plate is used to keep the clay from sticking to the stone. In the foreground is the *molde*.

2. Using her thumbs inside and other fingers outside to support, smooth, and turn the piece, the potter presses the clay pancake into the *molde*.

3. The potter keeps her fingers wet as she thins and raises the wall of the pot above the *molde*. She spins the *molde* clockwise with her left hand and sprinkles more grog under it to help it spin more easily.

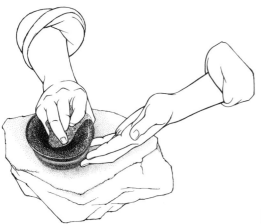

4. A wet chamois is used to flare the rim and give the surface a final smoothing; all the while the form is kept rapidly spinning.

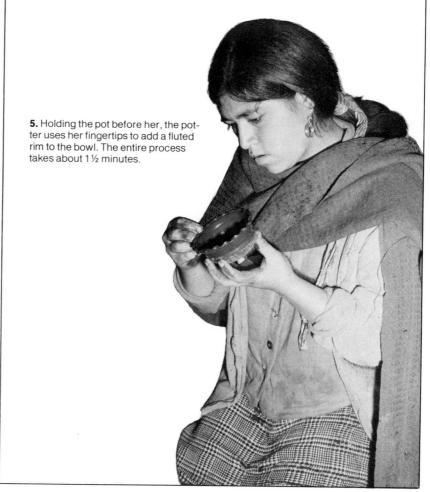

5. Holding the pot before her, the potter uses her fingertips to add a fluted rim to the bowl. The entire process takes about 1½ minutes.

Sr. Segorra demonstrates how his glaze mill is used. This is a more sophisticated mill than the ones we saw in Chordeleg, as this one is made of poured concrete. The "stone" itself is made of concrete poured inside an iron ring.

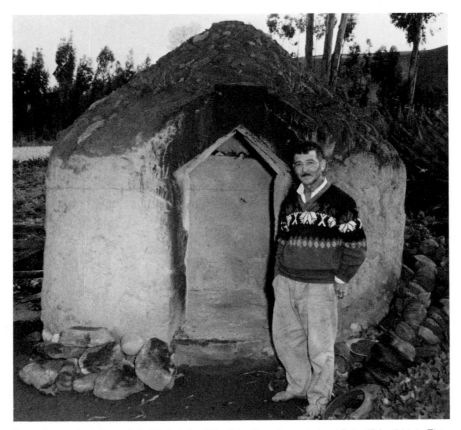

This brick-and-adobe walk-in kiln is 1.8m (6 feet) in diameter and about 2.4m (8 feet) high. The fire port is in back to the left. The roof is covered with earth and stones for added insulation. There is no flue and gases must escape through chinks in the bricked-up door.

eyes adjusted and we could see all that the room contained. Directly opposite the door was a large mound of unprepared clay beside a clay-preparation area. In front of this were rows of hundreds of black, glistening soup bowls, still wet from having been recently formed. Rows upon rows of dryer bowls stretched out across the floor. We could not distinguish a potter's wheel in this dim light.

Señor Segorra introduced us to his attractive teenaged daughter, who demonstrated their production methods (see illustration on previous page). This clay is not plastic enough to be thrown on the wheel and one wonders how the method was developed to create a production piece that looks so much like wheelthrown work, even to the interior finger ridges! Platters, cups, and even the large pieces are all made using the same method. A taller piece is made by adding coils of clay to the base form as it sets and continuing the turning process.

Glaze Mill

There is much Hispanic influence evident in La Victoria, even to this adaptation of throwing techniques. Sr. Segorra grinds his own materials for his plumbate glaze. His mill is a more sophisticated version of the basic mill we saw in Chordeleg. It is made of concrete, set into a concrete platform built between a three-walled section of his patio, a platform just big enough for the mill, the structure for the turning arm, the potter, and his materials.

A Walk-in Kiln

His kiln, too, is an impressive cylindrical brick structure with a doorway as tall as the potter. The roof is a cone of brick. All is covered with adobe, and the roof, for added insulation, has a topping of earth and stone. Between the cracks grow plants and moss. The fire box is in back, to the left. There is no flue. Gases escape through chinks in the bricked-up door. Eucalyptus branches are used for fuel. The family makes all the three-pronged kiln furniture, and since there are no kiln shelves, again each piece bears the mark inside and out of the supports.

Common Market Ware

Sr. Segorra's ware is not often found at the markets, but at the Saquisilí market the pottery of La Victoria is very well represented, and you can see the great range of ware produced in this small community. Many large platters glazed in deep greens or browns are displayed.

Soup bowls are seen most often and range in size from 240ml (1 cup) to

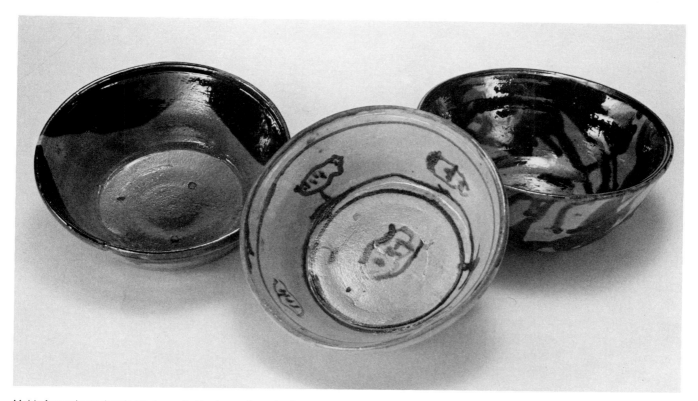

Molde-formed soup bowls are decorated in glaze colors of yellows, greens, and browns. The glaze patterns may be dipped, dribbled, or painted.

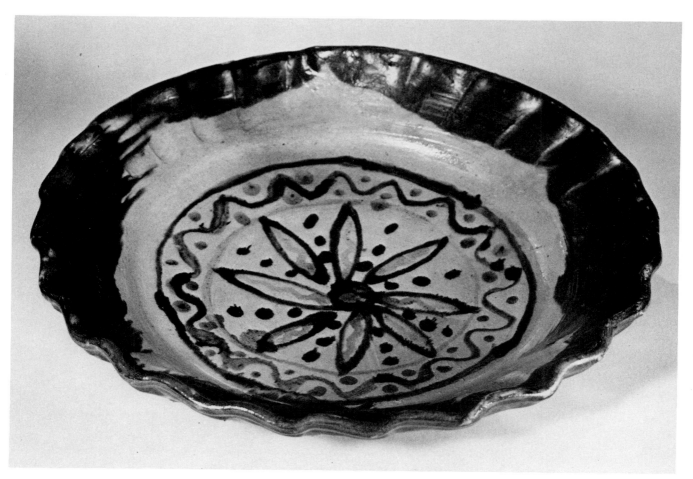

A platter, 38cm (15″) in diameter, was made in a *molde*, the fluting being done on the wide rim protruding from the top of the *molde*. It is clear glazed and decorated in shades of green.

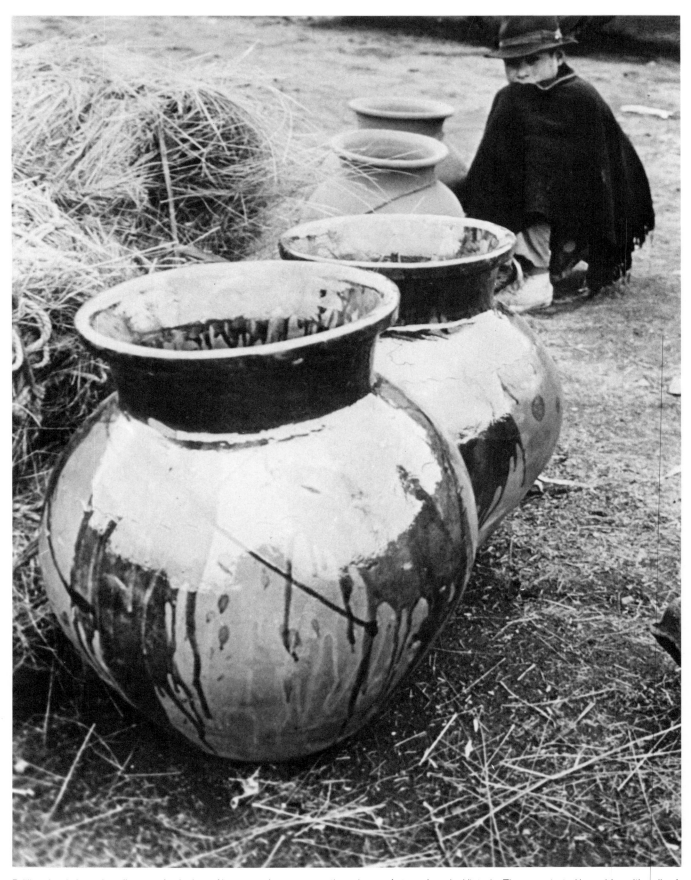

Brilliant lead glazes in yellows and splashes of brown and green cover these large *cántaros* from La Victoria. They are started in *moldes* with coils of clay being added and shaped into the forming pot as it grows.

720ml (3 cups) capacity. Decoration on these is always in clear, green, and brown glazes. The spatter pattern is most common, but some pots bear a delicately patterned design of lines and a leafy pattern.

Another common shape is a spherical bowl that rolls around on its curved bottom. At the shoulder is a band of lines between which are other curvy, overlapping lines or a branch motif (see Color Plate 26).

The taller, round jar is glazed only on the inside, the outside being adorned with only a few drips from the green rim of the pot or by the natural marks of the fire. There are many other varieties of forms, including brilliantly glazed flower pots with fluted rims, basket-shaped casseroles with two basket-type handles, and other wide, flaring bowls.

The glaze on these pots varies in quality from brilliant to dull and sandy-textured, but on the whole, probably because of the more controlled heat possible in the closed kilns used in La Victoria, it is more likely to have a fine sheen. It also appears to be a far more durable glaze than we have seen in Chordeleg or in Pucará, Peru, again possibly because of the closed kiln.

Technical Aid

The Andean Mission, originally under the International Labor Organization and the United Nations, is now run by the Ecuadorian government with various missions aimed at aiding the Indians of the highlands. At Tejar, a school has been set up which teaches ceramics as one of its major courses. It has several large American electric kilns, well-constructed potter's wheels, and more American-made pottery machinery. At present, a Russian technician is there to advise the school's director on equipment and materials. The program there now, as we saw it, is one of teaching commercial mold production. In a somewhat autocratic system, the instructor was teaching the young people how to make and fill molds, how to prepare clay and glazes, and how to apply the glaze. He designed all the forms, and they made up his designs. The work we saw was not unlike that produced in many adult education mold-oriented programs in the United States. It will be interesting to see what effect this school will have on the area. At present, the people are very proud of the school, its clean, cement building, and all its modern machinery. They feel that a lot is being taught, but we saw no immediate effects mirrored in the three surrounding pottery communities.

Quito Valley: Cotocollao

Quito, the capital of Ecuador since its colonization by the Spaniards, has had the reputation of being a great cultural and craft center. During the 17th century, its only peer in ceramic production was Mexico.

The "Quito School" was famed for its wood carving, painting, and architecture, all taught and inspired by various Spanish religious orders in the 16th and 17th centuries. Since this era of artistic greatness, all the arts have deteriorated. One looks in vain for worthwhile remnants of the painterly or plastic crafts in the Quito Valley.

Cotocollao, just a few kilometers north of Quito, was mentioned as a place where we might find some people who make *maceteras*, clay flowerpots. We took the road from the center of the capital out just past the airport to reach this surburban settlement. Cotocollao could claim that its pottery is made closer to the center of the world than any other pottery, the famous equatorial marker being only a few kilometers farther along the road.

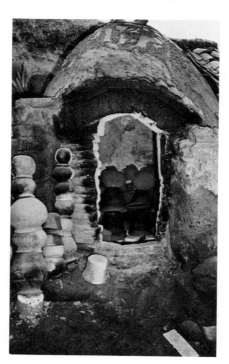

The kiln in Cotocollao is similar to the one in La Victoria. This one is built into the side of a long shed and buttressed against a hill. The firing pit is on the right end. The pots stacked in and around the kiln are meant primarily to serve as *maceteras*.

We passed several houses where flowerpots covered with bright enamel paint stood in doorways or courtyards. We were directed to several people who only painted these flowerpots, until we found someone who showed us where the pottery was made. Looking through the crack between two huge doors that opened onto a large dirt courtyard, we saw a man kneading clay with his bare feet on a large, woven grass mat. He was just finishing up the last batch of clay. Around him were piled eight cubes of prepared clay about 50cm (20") square. While we watched, he rolled up the last batch and slapped it onto another clay cube.

The Potter's Tools

We told the man of our interest in the work, and although it was Saturday afternoon and the week's work was long finished, we were invited in to see the setup. Directly opposite the doors from the road and against the opposite wall of the court stood a duplicate of the kiln in La Victoria. The only difference was that this one was more evenly constructed, and the rooftop was covered with cement instead of earth and plants. A long shed contained rows of flower pots 15 to 46cm (6" to 18") high in all stages of drying. Stacked in the kiln were many more, almost ready for firing. Beside the kiln was a pile of cut eucalyptus. In a small room next to the drying shed were four wooden potter's wheels, and we surmised we had found some wheel-production potters. Looking at the floor in front of the wheels, we were surprised to see a 6m (2 feet) square, smooth, flat stone with a palm-sized, smooth, flat stone on top of it. A pot of water and a bowl of fine grog beside the flat work surface, and a burlap pad behind it, told us a familiar story.

The Work Process

Three generations of potters are working here and all use the wheels. The grandmother offered to show us how they work (see illustration next page). Several styles of bowls were made, granddaughter and grandmother making a perfect team who could quickly turn out as great a variety of bowls as we saw in La Victoria. We were shown the techniques for delicately fluting an edge and attaching a simple casserole handle to the rim. A rolled coil of clay is notched at both ends, bent and fitted over the rim before the bowl is removed from the wheel.

For the larger flowerpots the same technique is used. In the first step, the

Bowl Production in Cotocollao. Grandmother and granddaughter work as a team to form several styles of bowls.

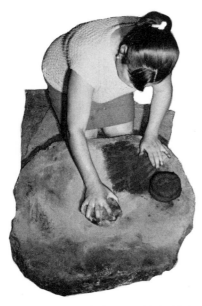

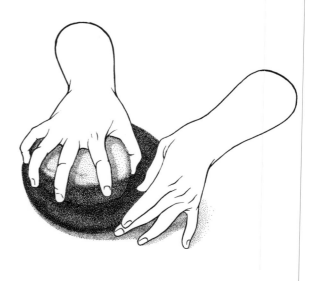

1. Starting with the same technique used in La Victoria, grog is crushed on the large table stone to prevent the clay from sticking.

2. A large, even "pancake" is formed by tapping the clay with the flat stone held in one hand, while the rim of the clay disk is turned and smoothed with the other hand.

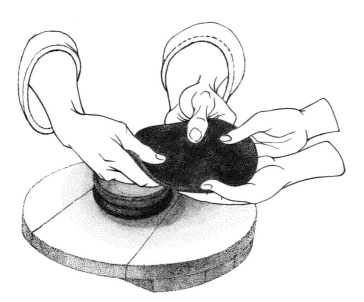

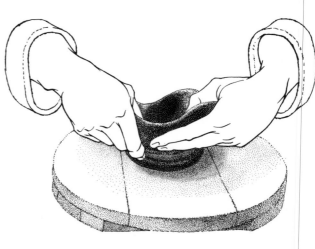

5. Here the clay pancake is transferred from stone to wheel.

6. The clay is carefully centered over the *molde* and pressed into it, and the wheel is turned, enabling the potter to smooth and even the clay to the inner contour of the *molde*. Uneven edges are trimmed with a sharpened piece of metal.

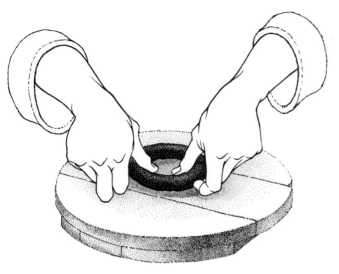

3. While the clay disk is being prepared, the older woman forms a clay ring which she adheres to the center of the potter's wheel.

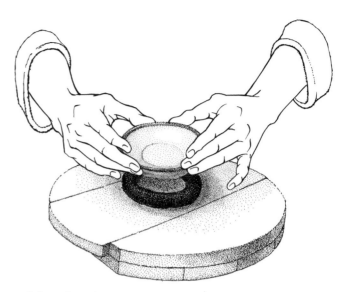

4. Sometimes the clay pancake is put in a *molde* first, and sometimes the *molde* is positioned on the wheel first.

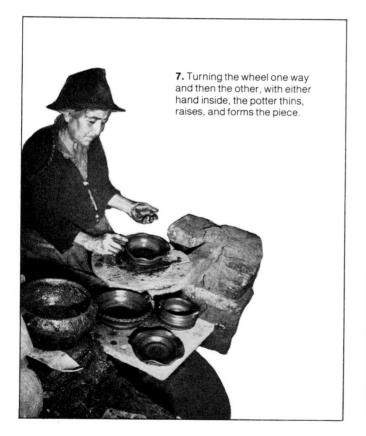

7. Turning the wheel one way and then the other, with either hand inside, the potter thins, raises, and forms the piece.

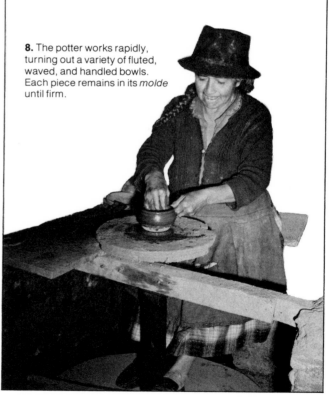

8. The potter works rapidly, turning out a variety of fluted, waved, and handled bowls. Each piece remains in its *molde* until firm.

pot is raised 13cm (5″) or 15cm (6″) in the *molde* and then allowed to set until firm. Coils of clay are added and turned on the wheel, the coil being formed, brought up, and thinned with the aid of clay ribs and fingertips. This process is continued in several steps, depending on the size of the pot.

Flowerpots

Their greatest output here is *maceteras*, flowerpots, which they sell by the hundreds. While we were there, several families from Quito arrived in pickup trucks with newly acquired nursery plants, looking for flowerpots. Our hosts explained that they were all sold out except for a few poorly glazed leftovers, which were quickly purchased. They do glaze the ware here, with the same splashy combinations of clear, yellow, greens, and browns. What about blues, we asked. "Too expensive," we were told. "Blue is painted on pots for those who want it."

The majority of their pots are sold to the villagers, who specialize in painting them with bright enamel colors. The rest of their flowerpots and the variety of plates, bowls, platters, and vases that they make are sold all over Quito.

An Unknown Heritage

We tried to find a link between these people and the potters of La Victoria, who have the same kilns and grinding mills, and similar forming methods, and whose work is so similar in appearance. They do not know of the potters working in La Victoria or anywhere else in Ecuador. The grandmother told us she learned from her mother who learned from her mother before her. Her daughter and her granddaughter have learned in the same way. They all come from Cotocollao.

The clay they use is hauled in by truck from a pit only 1 kilometer (.6 miles) away. It is a fairly pure clay and needs no additives. Its color and texture are similar to the clay in the Saquisilí area, but unlike it in that this is a good plastic clay and would throw well. I asked them if they ever worked directly on the wheel. They had never heard of this and were amazed when I described the process used by many potters for throwing on the wheel and opening up the form. They found it difficult to believe that such a thing could be done.

This is the only family still making pottery in Cotocollao. They told us that there were other families making pottery here before, but that they are the only ones working the clay here now. Where the family originally came from or how their strange combination of hand and wheel work came about is completely unknown to them. Their isolation and their lack of knowledge about the clay work that goes on outside their neighborhood is incredible considering the proximity of Cotocollao to the center of Quito. It is equally surprising that no one has discovered their methods or researched what must be an unusual history.

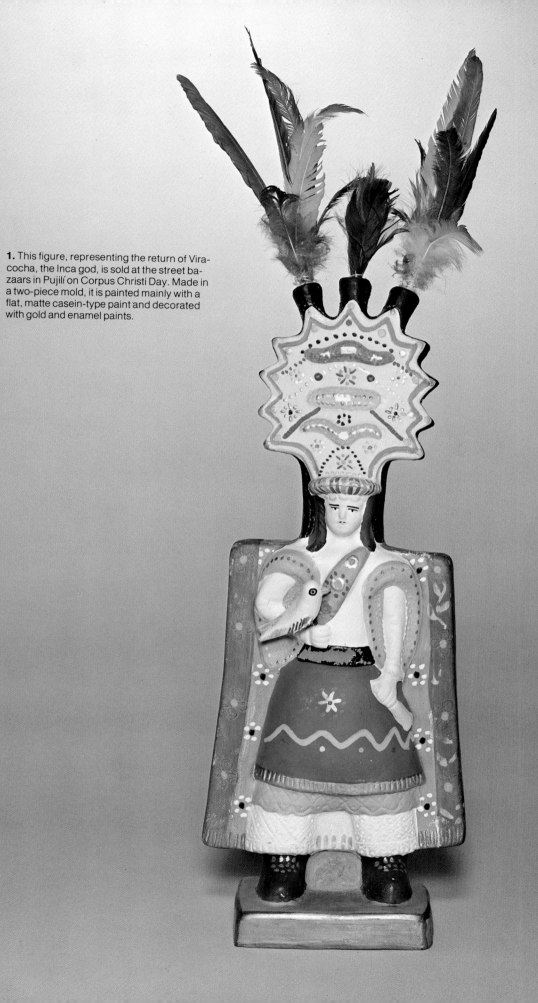

1. This figure, representing the return of Viracocha, the Inca god, is sold at the street bazaars in Pujilí on Corpus Christi Day. Made in a two-piece mold, it is painted mainly with a flat, matte casein-type paint and decorated with gold and enamel paints.

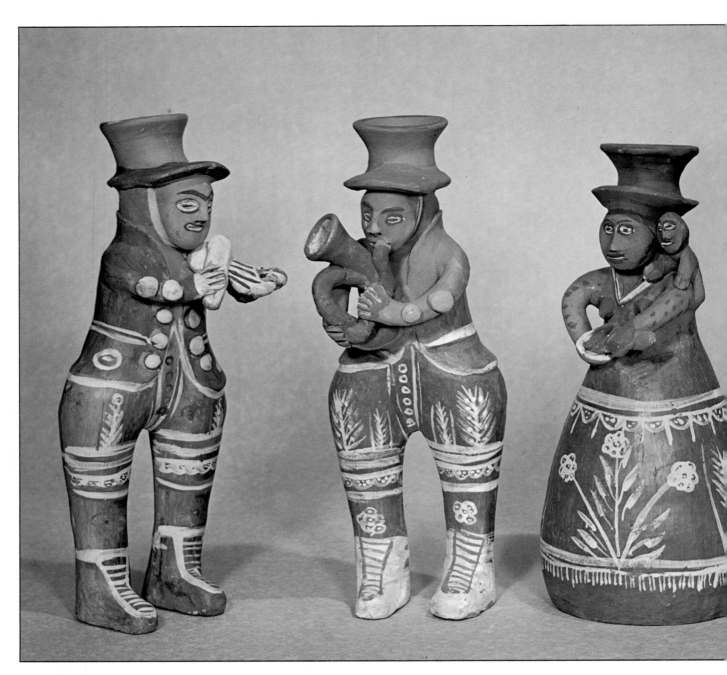

2. (Above) Figure bottles made in Quinua, Peru, are used as festive *chicha*-drinking vessels. For special occasions, a container is made for each important member of the party. Here are three ''band-member'' bottles and a ''mother'' bottle. The brown-slip base under the white-slip decoration is sometimes burnished and other times left rough.

3. (Left) This flaring bowl was coil built by the Tucano Indians, who live in the Vaupes area of Colombia. The interior is coated with a black resin, while the naturally light-colored clay displays strong, dark patterns caused by the fire.

4. (Top right) This *cántaro* from San Miguel, Ecuador, measures 48.3cm (19'') in diameter. The upper section is coated with slip and burnished. The piece shows strong, dark marks from the ground firing.

5. (Bottom right) Bolivian Jesús de Machaca ware is distinguished by its deep-orange, fire-darkened surface, irregularly burnished and flecked with mica. This *cántaro*, 45.7cm (18'') tall, has an oval cross-section that becomes fully round at neck and rim.

6. (Right) This unusual handbuilt pitcher from Paracaya, Bolivia is decorated with a band of stylized leaves, painted with fine lines in brown slip.

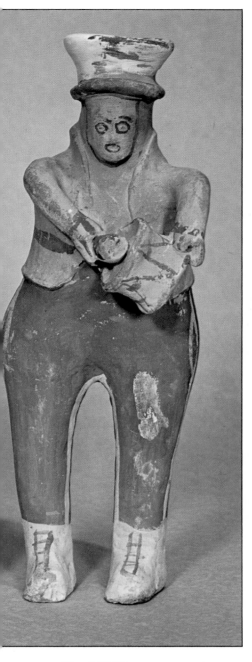

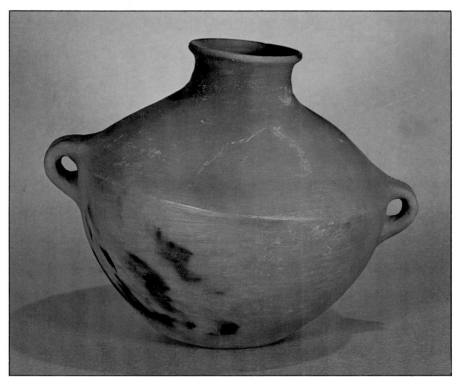

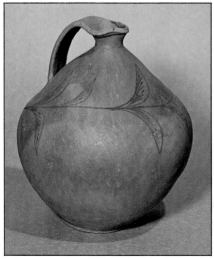

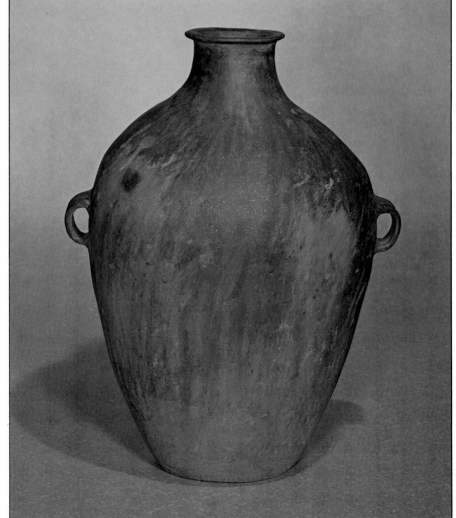

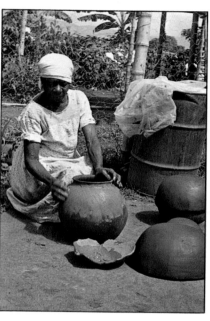

7. (Opposite page) The molded horse from Ráquira, Colombia was the first form that brought Ráquira national fame. Facial details and textured lines of mane and tail are added by hand. This horse has a saddle, but other models have water jars hung on either side of the horse's back.

8. (Left) The unglazed pottery from Lomas Bajas, Venezuela, is decorated either with slip before firing or with enamel paints after firing. Several pieces here show typical painted designs while others show a new form of decoration, having been painted with a base color and then sprayed in blotches of enamel colors from aerosol cans.

9. (Left) A *cántaro* made in Calcapirhua, Bolivia, has been washed and set out in the sunlight to air. Its smooth, dark sheen is caused by years of use as a *chicha* container. The decorating sheaf of corn and dusting of confetti attest to the container's importance during festival time.

10. (Above) A potter from Caloto, Colombia, uses her fingertips to apply red *greda* over the entire surface of her pottery. When the *greda* is no longer sticky, it will be burnished with a *totuma* rib.

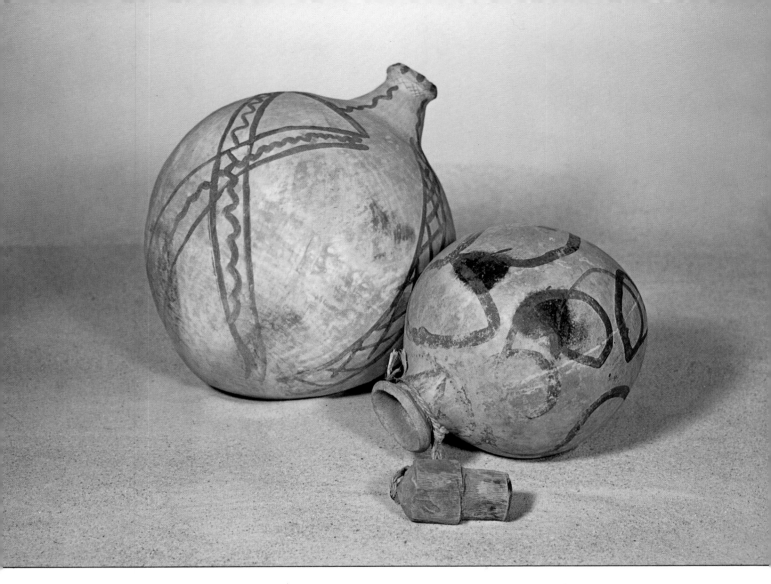

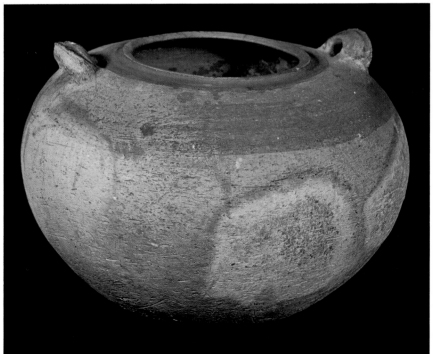

11. (Above) Water containers from the Guajira Peninsula, Venezuela, are made with coils in rounded gourd shapes. The clay, a natural buff color, has dark marks caused by the uneven burning of the ground firing. Slip decorations vary from calligraphic line squiggles to more rigid parallel-line patterns. The larger container is 39.4cm (15½″) tall.

12. (Left) An impressive *olla* from Pueblo Viejo, just outside Ráquira, Colombia, is 58.4cm (23″) in diameter. The slip-decorated form also bears marked differentiations in coloring caused by the firing.

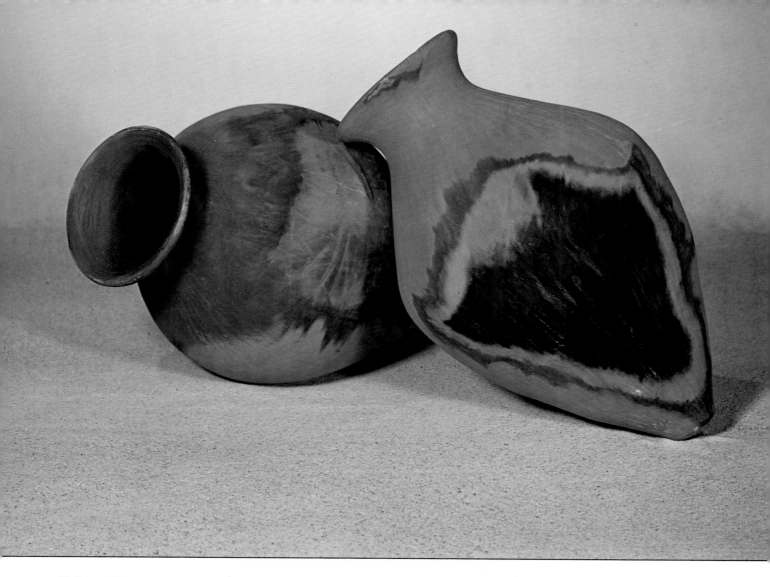

13. (Above) Pottery from Tejar, Ecuador, is never glazed; however, handsome fire marks decorate these pieces. The ware is ground fired with wood as the main combustible. Straw covering the ware during firing adds its own mark to the surface.

14. (Right) The slip- and glaze-decorated bull from Checca-Pupuja, 33cm (13″) long, is the best known contemporary piece of Peruvian folkcraft. The clay bull is a facsimile of the one used in ritual practices that were transferred from the Inca llama to the Spanish bull.

15. (Below) In Venezuela, the Capacho countryside is dotted with dozens of abandoned brick-firing kilns. This kiln, with water flooding its arched firing port, looks like a decaying castle.

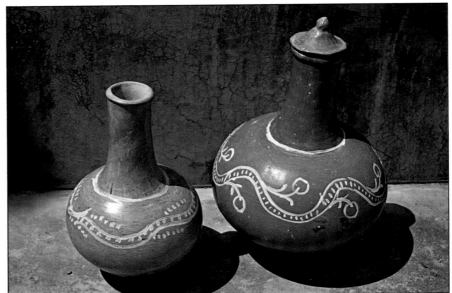

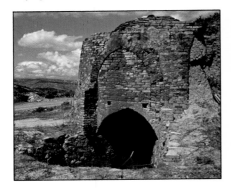

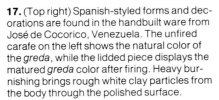

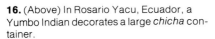

16. (Above) In Rosario Yacu, Ecuador, a Yumbo Indian decorates a large *chicha* container.

17. (Top right) Spanish-styled forms and decorations are found in the handbuilt ware from José de Cocorico, Venezuela. The unfired carafe on the left shows the natural color of the *greda*, while the lidded piece displays the matured *greda* color after firing. Heavy burnishing brings rough white clay particles from the body through the polished surface.

18. (Right) This flower vase from Patía, Colombia, is displayed with dried flowers in the *Oficina de Taurismo* in Popoyán. The red *greda* applied on the surface of the piece, has been burnished to produce a soft luster.

19. (Opposite page) The ware from Pomaire, Chile, varies in color from an orange-brown to deeper, more tawny shades of brown and near-black. The darker-toned ware is the product of reduction firing: the stronger the reduction, the darker the ware. The large *paella* dish is 33cm (13'') in diameter.

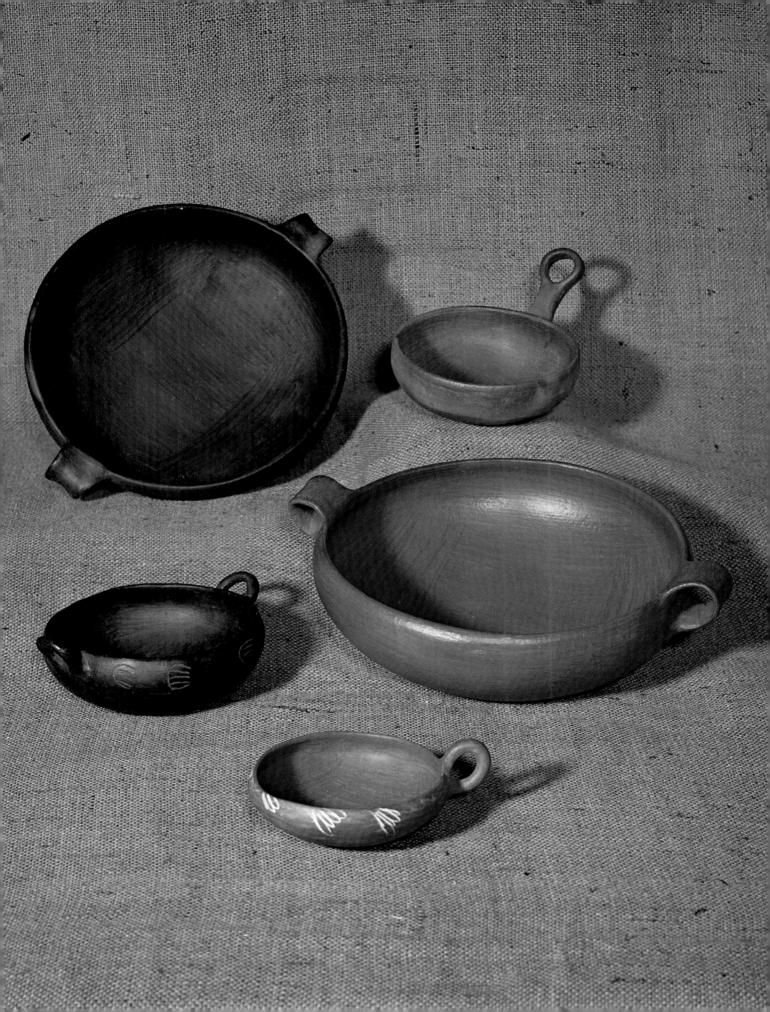

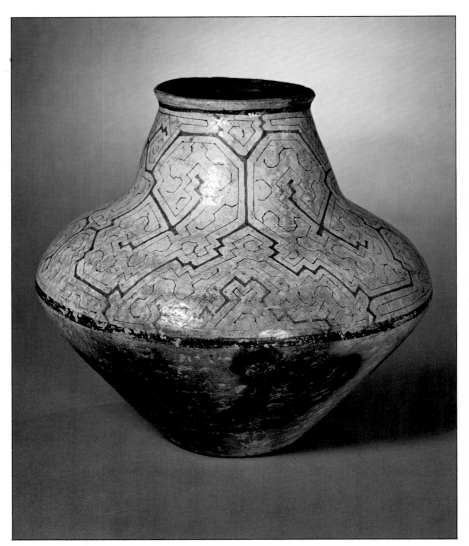

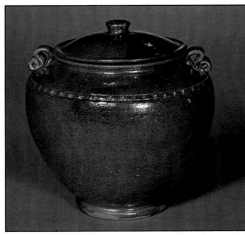

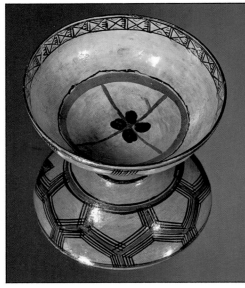

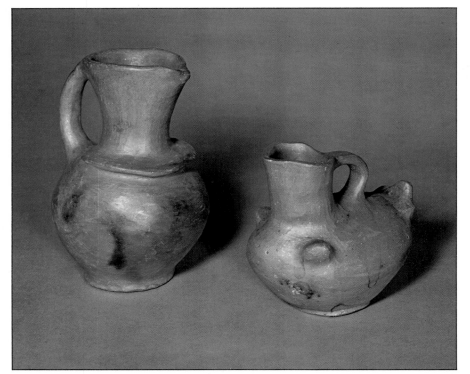

20. (Top left) This Shipibo Indian *chicha* container, measuring 45.7cm (18'') high, comes from the Selva area of Peru. The angular design repeats almost mirror-image motifs around the form. No two pots are decorated the same, although common motifs are repeatedly used.

21. (Left) The Araucanian women of Chile make their utilitarian pottery with coils of clay. The pieces are thick walled and sculptural in feeling. The pitcher on the right has wings and tail to emphasize its bird shape. The taller pitcher measures only 20.3cm (8'') high.

22. (Top) This 25.4cm (10'') tall, lidded pot is from Acevedo, Colombia. The lead glaze gets its color from salvaged copper wire covered with sulfur and heated in the potter's kiln to produce copper sulfate.

23. (Above) This 19cm (7½'') diameter *chicha* drinking bowl is from Rosario Yacu, Ecuador. The potter uses her fingers and brushes made of human hair to paint slip designs over the burnished slip coating on the bowl.

24. (Above) Sr. Terrawa of Buga, Colombia, uses a basic borax glaze with nontoxic frits to produce a rich assortment of variegated yellows and browns. These slip-molded pieces are part of a set of dishes.

25. (Right) A small factory in Cuenca, Ecuador, produces these molded clay birds. After bisque firing, the birds are painted with enamel in intricate flowery designs. The designs are similar to the colorful embroidery work done in the area.

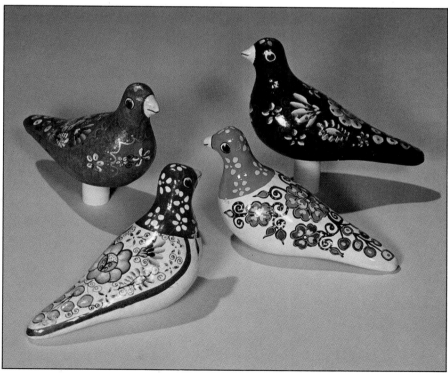

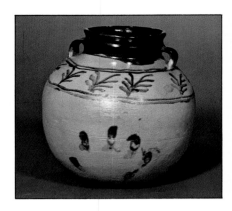

26. (Top) One of the most popular pieces from La Victoria, Ecuador, is this glazed *olla*. It may vary in size, but it always has the same proportions, handles, and glaze patterns. Often the potter's glazed handprint becomes part of the pattern.

27. (Above) A 35.6cm (14″) diameter bowl from Huayculí, Bolivia, is formed on the wheel. The freely drawn and splashed green and brown decorations vary only slightly from bowl to bowl.

28. (Below) In the Cochabamba area of Bolivia, an unusual form called a *puñu* bears strong similarities to pre-Columbian two-piece burial urns excavated in the vicinity. The *puñu* is made in two sections, one turned upside down over the other, and joined. The ridges of the two pieces are strongly apparent on the interior. Even the glaze demarcates the two sections, being restricted to the upper part.

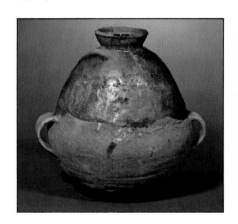

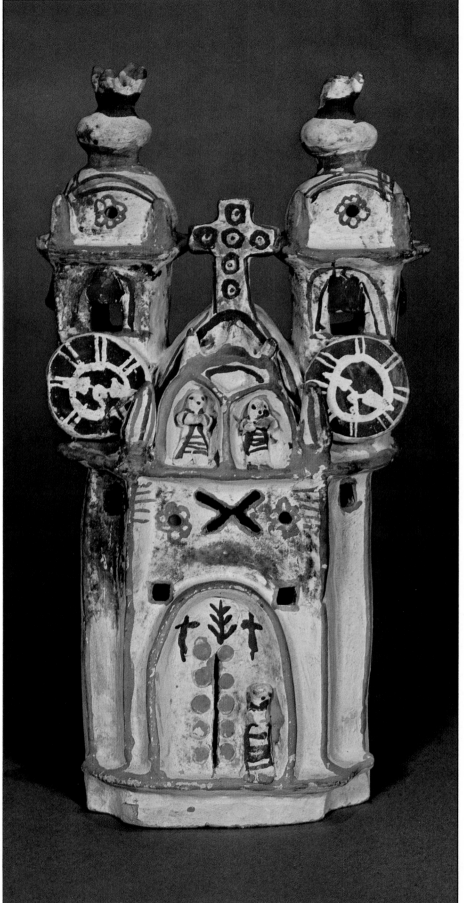

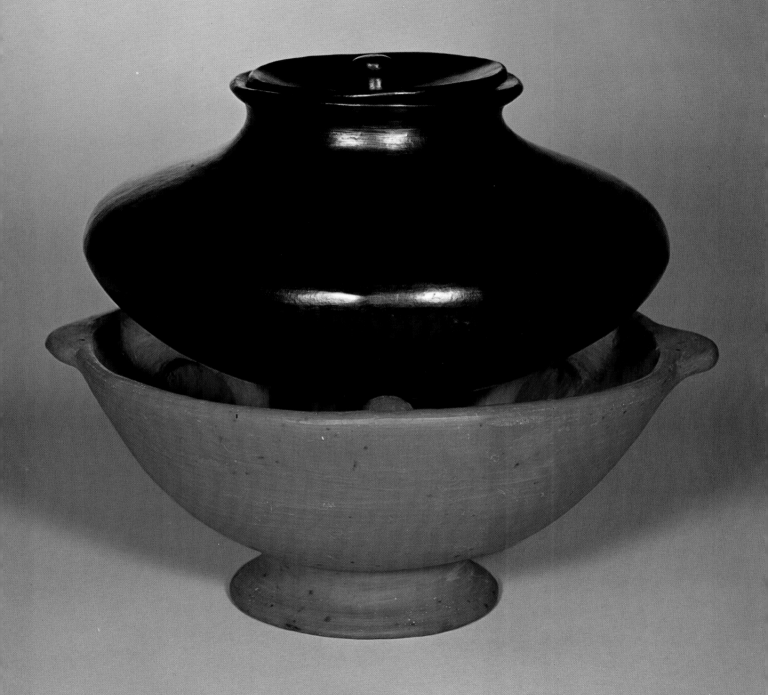

29. (Left) The clay church, 44.5cm (17½")
tall, made in Quinua, Peru, is secured to a
householder's rooftop to ward off evil spirits.
Using the numerous area churches as inspi-
ration, the potter enriches the clay counter-
parts with a complex variety of architectural
embellishments such as belfries, clocks,
niches, sculptures, turrets, and so on.

30. (Above) La Chamba, Colombia, pro-
duces finely burnished red- and blackware.
The brazier, 35.6cm (14") in diameter, has
three strong loops inside to support cook-
ware. The covered *olla* resting inside the bra-
zier is a distinctive traditional shape found
only in La Chamba.

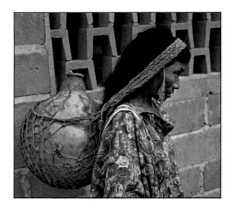

31. (Top) A woman from the Guajira Peninsula carries a clay water jar in a sisal net made with a headband which divides the heavy weight between her back and neck muscles.

32. (Above) In La Chamba, Colombia, an 11-year-old girl helps her mother by brushing *greda* on the leatherhard ware.

33. (Right) The potters from Tejar, Ecuador, sit together at one end of the Saquisilí market. Their amphora-shaped *cántaros* are started in small *moldes*, the impression of which can be seen clearly on the base of the vessel in the foreground.

34. (Opposite page, top) The color and texture on these large jars from Caloto, Colombia, are the result of surface treatment and firing. Red *greda* is rubbed on and polished, while the ground firing produces the blackened areas.

35. (Opposite page, bottom) These three pots from Lomas Bajas, Venezuela, are thrown on the wheel. The one on the left shows strong Spanish influence by the obvious fingermarks from the throwing process, the added wheel-turned foot, its basic proportions, and handle placement. The two round *ollas* bear closer resemblance to earlier indigenous ware. All traces of the wheel have been removed with a *tapara* rib used to scrape and smooth the surface. The darker *olla* shows evidence of a reduction atmosphere during firing.

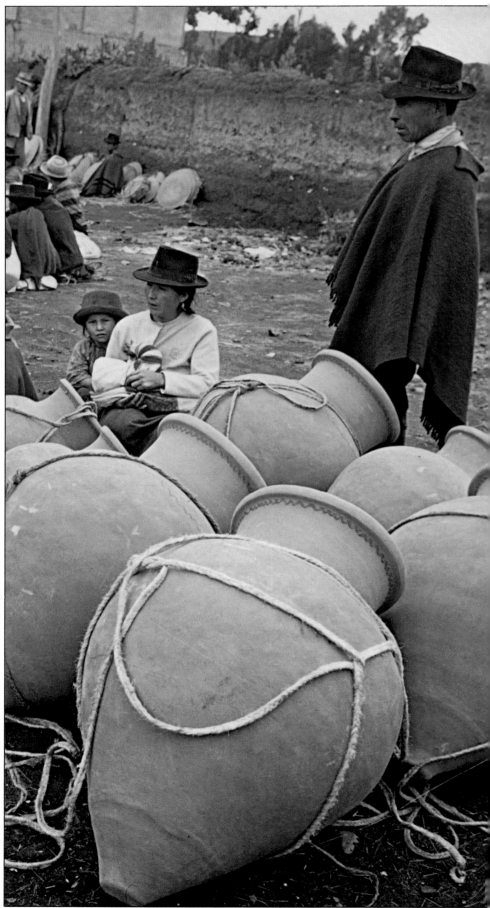

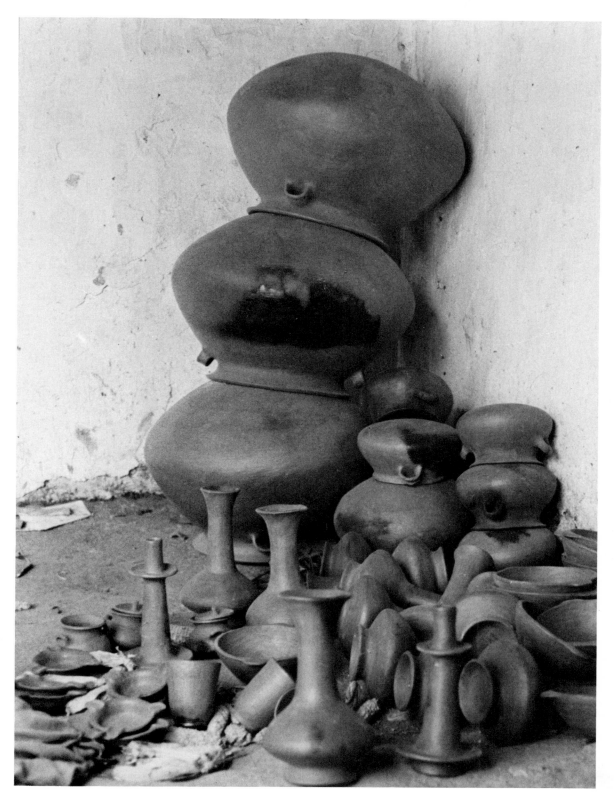

36. (Left) Ware decorators at Carmen de Viboral, Colombia, are encouraged by the owners of the tableware factories to develop new designs. These examples have proven popular and are handpainted on the factory-produced dinnerware.

(Above) This pile of ware on one potter's porch shows only a small selection of the great variety made in Tuaté, Colombia. The larger *ollas* are 45.7cm (18'') in diameter.

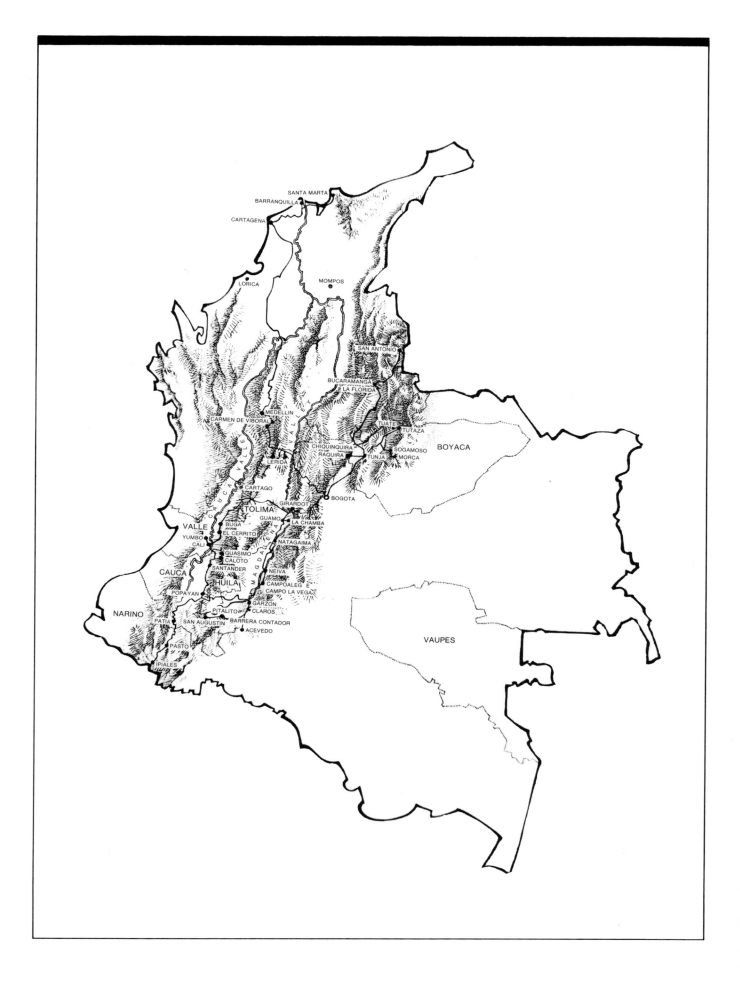

SANTA MARTA

BARRANQUILLA

CARTAGENA

LORICA

MOMPOS

SAN ANTONIO

BUCARAMANGA
LA FLORIDA

MEDELLIN

CARMEN DE VIBORAL

TUATE
TUTAZA

CHIQUINQUIRA
RAQUIRA
SOGAMOSO
MORCA
TUNJA

LERIDA

BOYACA

CARTAGO

GIRARDOT

BOGOTA

TOLIMA

GUAMO
LA CHAMBA
BUGA
EL CERRITO

VALLE

YUMBO
CALI

NATAGAIMA

GUASIMO
CALOTO
SANTANDER

NEIVA

CAUCA

HUILA

CAMPOALEGRE
CAMPO LA VEGA

POPAYAN

GARZON
PITALITO
CLAROS

NARINO

PATIA

SAN AUGUSTIN

BARRERA CONTADOR

ACEVEDO

PASTO

IPIALES

VAUPES

COLOMBIA

Colombia is a vast country, but because of its geographical extremes, it is only habitable in a few areas. These populated regions are separated from each other by high mountain ranges or vast expanses of sparsely settled, marshy grasslands. Travel between these areas is difficult and further complicated by rainy-season hazards in the form of huge landslides or washed-out roads. In spite of this, and because of a strong regionalistic feeling, the spread of similar pottery techniques found in greatly separated regions is noteworthy.

We explored the pottery villages that are located in the great valleys of the Cauca and Magdalena rivers. These rivers parallel each other, running from the south, north to the Caribbean. Ceramics have been made in these two valleys for thousands of years. Another area we covered quite extensively was the northern part of the Bogotá plateau, in the province of Boyacá. Many other pottery areas are scattered through the jungle basin east of the Cordilleras, and several isolated communities do exist in the north.

Of all the countries we visited, Colombia seemed to be the richest in handcrafts. This is due in part to the fact that the crafts are keeping pace with the needs of the people, and also because the country is waking up to the values of its handcrafts. There are several organizations devoted to the promotion of *artesanías* that provide incentives for craftsmen in all fields.

A Folk-Art Museum

In Bogotá there is a unique *Museum of Popular and Traditional Arts*. It is housed in an old colonial building, originally built as a seminary, with a colonnaded inner court. Faithful restoration has made it an admirable place to display the impressive collection of regional costumes and craftwork gathered from the entire country. Its founder, curator, and director, Señorita Cecelia Duque Duque, has gathered together, and is continuing to gather, specimens from all parts of the country. She is responsible for the highly effective displays of craftwork accompanied by excellent mural-sized photographs, many taken by her, which show the artisans and their techniques as background to the actual work. Large, high-ceilinged rooms opening off the central court are devoted to fabric crafts—rooms for woodcraft, textile weaving, basketry, etc. But the largest rooms are filled with an impressive collection of contemporary pottery and ceramics.

It is a new museum, opened in November, 1971, and has not yet received the publicity it deserves, both for its educational value to the Colombian people and for acquainting foreign visitors with Colombia's rich diversity of crafts. An illustrated monograph on this collection would be welcome.

Proarte, an organization dedicated to the promotion of quality *artesanías,* is closely associated with the museum. Throughout the country, its members act as delegates and collectors for the museum's *artesanías* shop. They select the best crafts of each region for display and sale at the museum. Their selection is based on good, original, well-executed design. In the capacity of constructive, selective critics, these delegates can contribute to improving the quality of the craft work. Many of the members are instrumental in setting up cooperatives to oranize the craftsmen into groups. They also help set up standards of quality for materials, finished work, and fair-price scales, as well as social-security funds, banking and savings, systems, and other necessities for the general welfare and education of the craftsmen.

Government and Industrial Aid

Artesanías de Colombia, a government agency with industrial backing, is also concerned with the handcrafts. It emphasizes marketing both within the country and abroad. This organization is also a new one and has made mistakes in promoting salable items of dubious quality and design. On the whole, however, with the proper directorship, it should prove to be important in expanding the market for Colombia's fine crafts. The same types of organizations have been tried in the other South American countries we visited but with less success. This organization maintains handsome shops in key cities all over Colombia. The crafts are well displayed and offered at reasonable prices, so that the work is sold out rapidly. This is very encouraging to the craftsmen who are enjoying a better life and new identity through their success on the country's markets.

Southern Cauca Valley: Popayán

The Rio Cauca, which extends south to Popoyán, is the most southerly Colombian pottery area in our study. However, we know that pottery is produced in the southernmost district, Nariño, near the city of Pasto, which is close to the Ecuadorian border. Pasto, once the northern extremity of the Inca Empire, is famous for leather- and woodcrafts.

Popoyán, a large, handsome city of white buildings that has retained its colonial atmosphere, has a very active, friendly goverment tourist bureau. The bureau, located in the center of the city, has an extensive display, not only from the better known crafts centers, but also from Colombia's southeastern jungle territory, the Vaupes. This includes a large array of weavings, weapons, woodcrafts, canoes, painted-bark textiles, pottery, and *chicha* containers in the shape of human figures with a smooth, varnished surface decorated with thin, dark lines (see Color Plate 18).

Patía Pottery

This collection also contains numerous examples of the strongly formed pots from Patía, a town halfway between Popoyán and Pasto on what is conceded to be the worst road on the entire west coast of South America. Patía ceramics have a smooth, sensuous, carefully finished surface, even though the work is intended almost exclusively for cooking and storage.

There are *tostadoras* as well as large, rounded cooking pots and taller, rounded water containers. All of the ware is made by hand, coated with a red *greda*, or slip, and burnished with small, smooth stones, not unlike the process and results found in La Chamba—a center which we will discuss later. Two other popular forms made in Patía are a flower vase and a beverage container.

A Bead Maker

The tourist office has a few glass cases full of pre-Columbian ceramics and examples of work by one of the local ceramists, Señor Campo. The office offers free guided trips around the city, and we were happy to have a

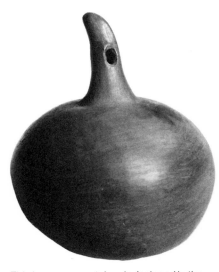

This beverage container is designed in the shape of the gourd that is used for the same purpose in Patía. Boiled sugarcane syrup is poured through the small hole in the stem. The brew is allowed to ferment and then is drunk from the same hole. Its taste is allegedly "as bubbly and delicious as champagne."

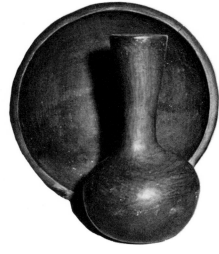

These three pots from Patía, a *tostadora*, a *florera*, and an *olla* (below), are all coated with red *greda* and burnished.

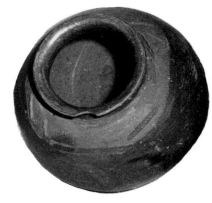

This *olla* uses a design technique found on pre-Columbian tomb ware excavated in the Cauca district: the shoulder area is left free of *greda* and decorated with applied, incised coils.

young man from the University come with us to the home of this ceramist and another local potter, whose work at the time was not displayed in the tourist office. Whatever craft you are interested in, the office personnel, with great enthusiasm, can supply information on the local craftsmen.

Señor Campo, like so many other ceramists in South America, does not depend on his craft for a living. But, unlike the majority who work the land, Sr. Campo is an urbanite in this beautiful colonial city. He owns one of the largest gasoline service stations and is one of the town's best-known citizens. He lives in a community of new, contemporary homes, with split-level interiors, very different from the tile-roofed, balconied colonial architecture the city is famous for.

He first became interested in ceramics because of his involvement in pre-Columbian history. As a young man, he went with several groups to Inza, a famous archaeological site, and helped excavate 85 graves. He personally dug up a number of ceramic and metal objects, many of which he now has displayed in glass cases in his dining room. Local people, aware of his interest, have given him many other pre-Columbian artifacts found around the Popoyán area when new roadsways and the new airport were excavated.

Ten years ago, while visiting a friend in Barranquilla who owns a ceramics factory, Sr. Campo became convinced that he could work in clay. He began with mold work but was more interested in the variety of decorations he could make with line designs. While rolling clay in his hands, he came up with the idea of beads. He got his friend to help him concoct some brilliant glazes. Another friend in Bogotá helped him build a small electric kiln that operates on only 110 volts. This friend also helped him solve the problem of wire armatures for firing beads.

Clay and Glazes. He uses two clays: a white one with a high kaolin content from near La Chamba, and a red clay from a village called Las Piedras. His glaze base is made of red-lead oxide, borax, and two frits, to which he adds oxides of cobalt, iron, copper and vanadium for colorants. He buys all the glaze chemicals in Bogotá from a firm that imports them from Mexico. Over the white clay, the colors are brilliant and strong, while over the red clay, more muted shades are produced.

For firing the glazed beads at 800°C., Sr. Campo's friend devised refractory metal frames with holes to receive refractory wires. The red

glazed beads, are fired separately at a lower temperature.

A Family Enterprise. His wife and children enjoy the work, and it has become a family enterprise with Sr. Campo, his wife, daughters, and one son making, glazing, and stringing the beads together. All the beads are made by hand in a variety of geometric shapes—spheres, cylinders, ovals, flattened pendants, and diamonds. The process is simple and effective, but the product does not yet show great imagination beyond the initial project. However, one daughter has been experimenting with tiny beads in the shapes of heads, birds, and fish which are spaced between the geometric beads when strung.

The son is studying at the *Instituto de Cultura Popular* at the University of Cauca, where he is learning to use the wheel as well as studying drawing, painting, history of art, etc. He is just beginning and has made some small ceramic pieces intricately decorated with natural-colored slips and incised designs.

National Success. From this small home workshop, Sr. Campo's beads have become well known all over Colombia. *Artesanías de Colombia* sells his necklaces in their many shops and cannot keep them in stock because of Sr. Campo's limited production. They are urging him to expand his operation so that they can export the necklaces.

A Traditional Potter

The family of Sr. Leopoldo Villota is also carrying on the Popoyán tradition of working with clay. Sr. Villota and his huge family occupy an old colonial house near the center of town. It is an irregular complex of buildings set around a large central court. His sons, daughters, and grandchildren have established their households, here, too, and share the facilities as one family. In the large, modern-looking, white-tiled kitchen, all the women cook together over a wood fire built under a section of the tiled counter stove, using pottery cookware. Coffee trees, bananas, papayas, mangoes, and other fruits thrive in the court. Señor Villota is extremely proud of his home. We drank coffee that was picked, roasted, ground, and brewed by Señora Villota and served in her husband's cups.

The Family's Training. Sr. Villota has been making ceramics here for 35 years. Originally he came from Pasto, where his father learned the potter's craft from a man whom they believe to have been the finest potter in Pasto,

Sr. Campo makes clay beads in several shapes and dips them in a borax-based glaze that has been mixed with a variety of coloring oxides and stains.

Sr. Campo's daughter makes finely incised handmodeled beads in fish, animal-head, and vase shapes. Two basic clays are used: one fires black and the other red.

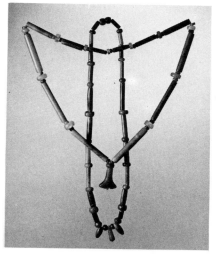

Colombia's bead tradition goes back at least 1,000 years, to when the Tairona Indians used carnelian and quartz to form a variety of handsome beads.

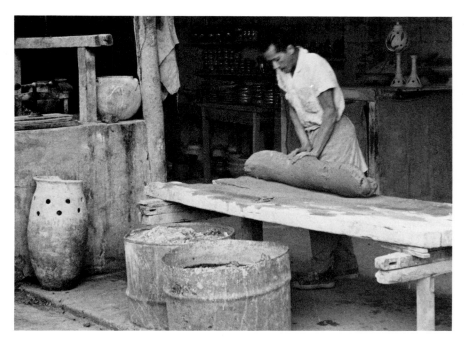

Metal barrel tanks are used to soak the crushed clay; then it is drained and kneaded. The clay humps used on the wheel are about one-third the size of the roll being kneaded here. Beside the wedging table is the glaze mill made to be used with the operator standing up. Its interior is the same as the mill in La Victoria, Ecuador.

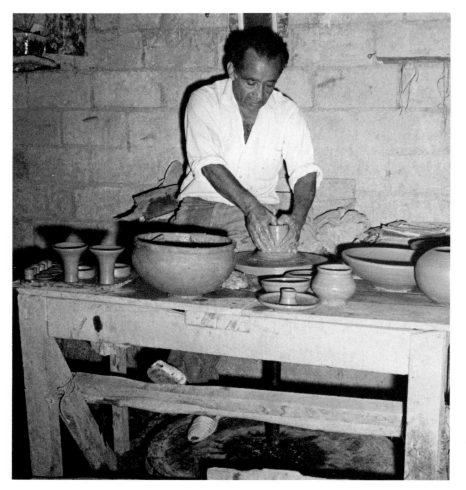

Sr. Villota throws the last piece from what was a large mass of clay. From the same hump he has thrown several bowls and many smaller parts to be put together as candleholders. Notice how this potter, like those in Peru and Bolivia, sits beside his wheel rather than straddling it.

Sr. Gerardo Luiso Garcés. Sr. Villota was taught by his father. Diego Herman Garcés, Sr. Villota's grandson, also works here. He does very fine wheel work and has studied ceramics at the same school Sr. Campo's son is attending, the government-operated SENA school for craftsmen located just a few kilometers north of Popoyán. Here, students from all over the country come to study handicrafts. Metalworking, woodworking, gem cutting, toy making, weaving, and ceramics—body and glaze formulation, wheel and other methods of forming clay, mold making, and kiln management—are taught.

The Clay. Sr. Villota's pale, buff-colored clay, to which nothing is added, is fine, pure, and very plastic, and fires to a hard, durable consistency. It is easily prepared by simply soaking in settling tanks, separating the few pebbles and other foreign particles by hand, draining and kneading. It is then ready for immediate use on the wheel.

Wheel Work. Most of the pottery is thrown off the hump by Pedro Ibarra, another workman in this cottage enterprise. Sr. Ibarra has great technical skill and a fine understanding of forms. His work is strongly reminiscent of the work from Breda, Spain.

The wheelthrown forms produced at this pottery are both utilitarian and decorative and are produced in sufficient quantity to supply the large city of Popoyán and several outlying community markets as well.

A Variety of Ware. Sr. Villota's family also markets the pottery made in Patía. Stacks of the deep-red Patía cooking pots are piled in one of the house's passageways. Popular items made at the Villota pottery are large, free-standing braziers, water coolers, tableware that includes handsome covered soup tureens, soup bowls, platters, plates, cups, cooking pots, pitchers, candelabra, large globular banks, huge wash basins, flower vases, and more. One notes the lyrical pulled handles and the typical fluted rims and incised wheel-banded lines. All of these pieces are coated with lead glazes in the most brilliant greens and yellows.

The grandson, Diego, also turns out braziers, flower pots, candelabra, tea sets, groups of round, wheelthrown houses, and other distinctive ware. He has begun a series of hanging candleholders. His work is easily spotted. It is clean, obviously schooled, precise, with feet set well back under the forms. At the present time it is also marked with strong commercial stylistic influences from the United

(Left) This footed bowl, coated with a copper-green lead glaze, has two rims: the inner one straight and the outer one fluted. Wavy lines on the shoulder and midway on the bowl repeat the fluted line.

(Below) The output from Sr. Villota's studio ranges from traditional *ollas*, *fuentes de baño*, and *maceteras* to modern lanterns, stoves, candelabra, and strawberry planters.

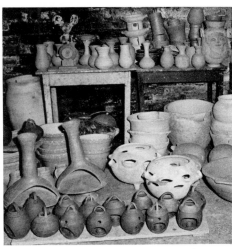

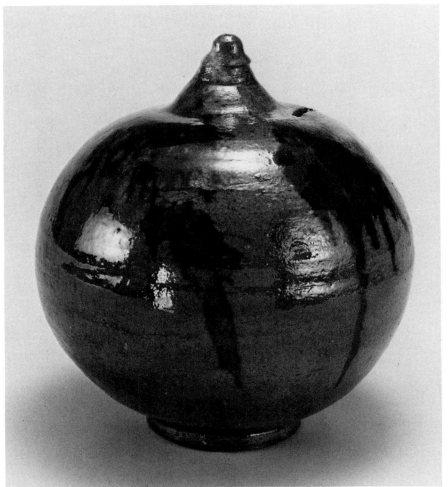

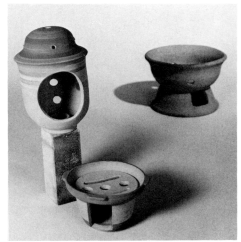

(Above) Sr. Villota's son makes unglazed ware, such as the brazier and lantern in the foreground. The pieces are banded in iron, copper, manganese, and cobalt oxides. The rougher brazier in the background comes from Sr. Villota's hometown of Pasto.

(Left) A globular wheelthrown bank has its counterparts in other areas of South America and Spain. This one is 22.9cm (9") tall and is covered in a rich green glaze with splashes of darker green.

States. He leaves his work unglazed, merely banded with stains of iron reds and oranges, manganese grays, kaolin whites, and cobalt blue.

Glazes.

Sr. Villota does little work on the wheel now, but has entirely taken over the glazing and firing, releasing more time for the others to work the clay. He makes his own lead glaze, which is not very different in composition from those found throughout South America. It is made of two parts lead and one part quartz.

The quartz is mined nearby and prepared by firing it in his kiln along with his bisque ware. The lead is obtained from discarded auto and truck batteries. Sr. Villota has built a special calcining kiln of brick to melt the lead. Copper battery parts and salvaged copper wire are put in an earthenware bowl and covered with yellow sulfur. This is placed in the kiln along

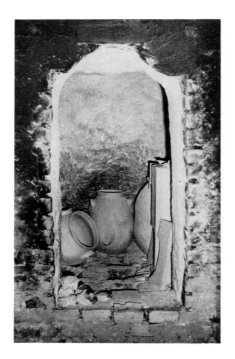

with the greenware during the bisque firing. The result is copper sulfate used for the green glazes. Yellow glazes are made from iron sulfate that he buys ready prepared.

Sr. Villota has the same glaze mill that we saw used in Ecuador. His calcining kiln was the first one we saw.

The Pottery Kiln

This kiln is made of brick with a large arched doorway that is bricked up for firing. Sr. Villota starts his firing by lighting a long log just outside the fire box. Gradually, it is inserted into the opening, and after a few hours smaller pieces of wood are used to raise the temperature. The firing lasts from 5 to 6 hours depending on whether it is for bisque or glazing. Sr. Villota reads the correct temperatures by observing the color of the kiln interior, and by viewing the brilliance of the glaze in his gloss firing. His grandson tells us that the bisque fires at

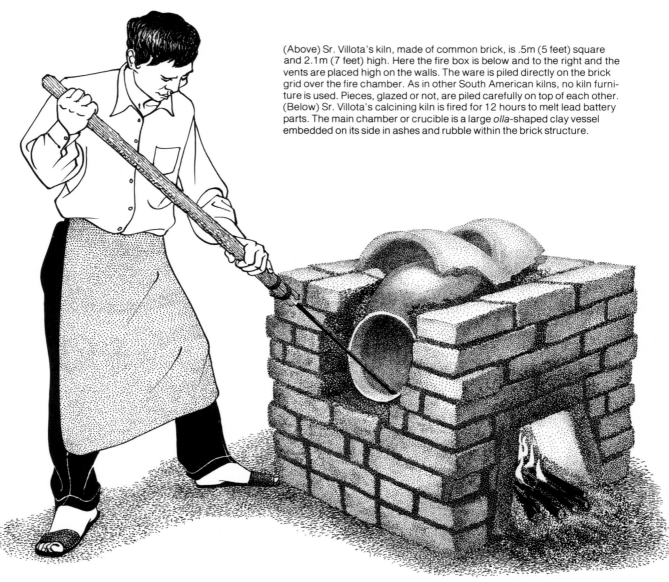

(Above) Sr. Villota's kiln, made of common brick, is .5m (5 feet) square and 2.1m (7 feet) high. Here the fire box is below and to the right and the vents are placed high on the walls. The ware is piled directly on the brick grid over the fire chamber. As in other South American kilns, no kiln furniture is used. Pieces, glazed or not, are piled carefully on top of each other. (Below) Sr. Villota's calcining kiln is fired for 12 hours to melt lead battery parts. The main chamber or crucible is a large *olla*-shaped clay vessel embedded on its side in ashes and rubble within the brick structure.

800°C. and the glaze at 900°C. to 950°C., depending on the quality of the glaze batch each time.

Marketing

Sr. Villota is not the only potter in Colombia who supports himself by his pottery alone, but he is probably the most proficient and successful we saw, supplying a large community that has no other nearby source. He tells us that his family quickly sells all that they can produce. The women in the family take turns managing the pottery stalls at the two principal markets in Popoyán. The ware is also trucked to other markets nearby.

New Possibilities in Popoyán

Diego is adding something new to the traditional Spanish background he comes from. The cobalt he uses is itself a surprising new note. A few of Sr. Campo's older molded and brightly glazed pieces are to be seen in Villota's workshop and are greatly admired by the Villota family. It is very possible that the sons from the two families, if their interest in ceramics is encouraged, could bring important changes to southern Colombian ceramics. Popoyán is a well-established university town, SENA is nearby, the city is gowing rapidly, and one expects that it would be a good environment in which new craft forms could flourish.

Santander

North from Popoyán, the well-paved Pan American Highway runs past Medellín to Porta Valdivia on the Rio Cauca. At this point the river becomes an important navigable waterway. The paved section of road will eventually be extended northward to meet the finished highway in the district of Córdoba. The part of the valley from Popoyán to Cali is narrow but filled with rich, black alluvial soil supporting an agricultural population. Large plantations of sugarcane are interspersed with lush pasture lands.

Santander is several hours' drive north of Popoyán. Two families of potters have settled here within this generation. They came originally from Ipiales near the Colombia-Ecuador border but were trained in Pasto. More and more we find that Pasto has sent out the best-trained wheel potters and has fostered the most able

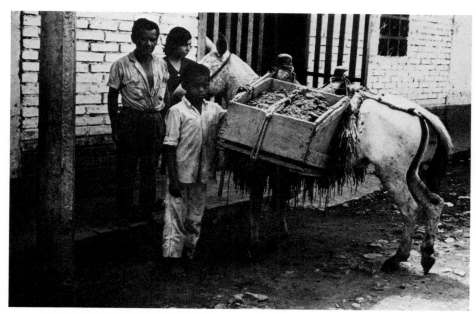

Two wooden boxes are tied to either side of the donkey's saddle. To unload the clay, the ropes around the boxes are untied and the bottoms drop off. This 12-year-old boy's job is to dig the family clay supply and bring it home.

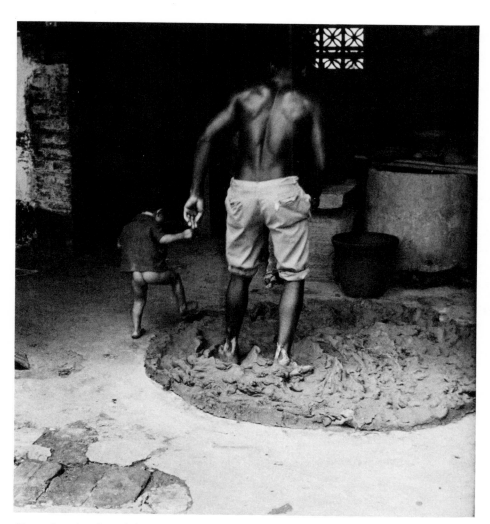

Clay and sand are kneaded with the feet to homogenize the mix. Children are brought up with the clay process as a central part of their lives and join in the work early. Here Sr. Peregrino's youngest son gleefully helps trample the clay.

glazing techniques in South America. In other parts of Colombia and in Venezuela we met potters who also came from Pasto! All are in that group we consider to be the finest craft technicians within the Spanish traditions.

Passing on the Potting Heritage

Peregrino Arébalo casually used the technique called throwing off the hump while chatting with us. He comes from the vicinity of Ipiales. His wife, Bertilda Ruis de Arébalo, also uses the wheel. Peregrino says with a chuckle that she is the boss here, and this may be truer than his joking suggests. She and her family are from Pasto, and it was in the workshop of her father and grandfather that Peregrino learned his craft. They employ a man who also uses the wheel. Another man helps with clay preparation and details of handwork.

You see here how a potter's children naturally grow up with the craft process as a part of their lives. An 8-year-old girl was polishing leather-hard ware with the bowl of a plastic spoon. We arrived as father and 12-year-old son were leading their donkey, loaded with clay, to the front door. At the doorway ropes were pulled, allowing the clay to drop out of the bottoms of the containers and pile up in the doorway. The son spent the next hour shoveling it up and into the yard enclosure. In the central court, a helper was trampling the clay, kneading it in a circular pattern with his heels.

Family Work and Living Area

This is a happy, busy family. Everyone is working, occasionally exchanging jokes and helping one another when things had to be moved or other work had to be done. Just inside the entryway is a roofed area with shelves of finished ware on display. A large table was loaded with handleless casseroles, and a son was forming and applying handles and setting the finished pots on the cement floor of the display area behind him.

On the left, under a roofed area against the wall, quantities of prepared clay wrapped in plastic are piled beside five wooden kick wheels. Peregrino works here at his wheel. Alongside the open display room are other walled rooms that contain the house proper with kitchen and sleeping quarters. Along the left side of the central court are other rooms used for housing, the storage of materials, and piles of finished ware.

The central open court with sunlight pouring down into it is like a great stage set. If we stepped off the concrete display entrance, we would have walked right down into the kneaded clay as it was being worked. Beyond, we walked carefully between rows of pots and bowls in all stages of drying. Raised garden sections are on either side of a walkway that leads to a raised platform at the rear. Up five steps is the kiln which occupies the central location.

Working the Clay

The clay is dried, pulverized, mixed with water, and kneaded with the feet. Red sand is added to open the texture of the clay. The wheel work, including beautifully made traditional tableware, bowls, candelabra, jars, flowerpots, and vases, is thrown quickly off the hump, footed, and glazed. Another line of work is made and polished to a smooth luster with metal tools while on the wheel. Other pieces are left "rustic," as they call unglazed ware. Sometimes the ware is turned a soft brownish black through the process of smoking the interior of the kiln by burning green branches in the fire chamber.

Glazing and Decorating

The most beautiful golden and golden-brown glazes in South America are made here. Peregrino uses the same techniques in preparing his

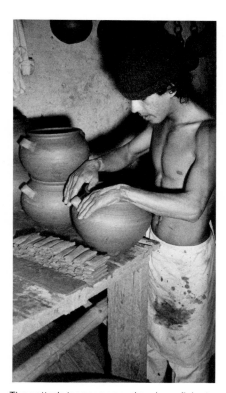

The potter's teenage son, already proficient on the wheel and skilled in all the other shop activities, will continue the family's successful business. Here he applies strap handles to dozens of identical *ollas*.

glazes as does Señor Villota. He makes the same quartz frit, but obtains his lead by melting down flashlight batteries. These also contain manganese, which helps produce the beautiful golden-brown tones of his glaze. The ware is glazed only on the inside or rims so that little of the ware is marred by kiln stacking. He does, however, suffer a lot of warpage due to the thinness of the ware, irregular stacking, and hot spots in the kiln. His most successful pieces are glazed footed fruit bowls and platters. A golden-glazed, round-bottomed *olla* produced here is similar to the round *ollas* found in Chordeleg and La Victoria, Ecuador. The glaze and the decorative band around the shoulder have the same straight-line border with wavy line within. Here the design is incised rather than painted. The two handles are applied horizontally on the design band rather than from rim to body as in the Ecuadorian bowls.

Contemporary Forms

The Arébalo family makes pierced hanging lanterns, long thin-necked vases, and other "arty" ware. These have a forced manner and are unimaginative in design. As in so many localities, the potters want to be contemporary and create new forms, but when they step away from the traditional variations in form, which are superbly handled, the work usually looks mediocre.

Marketing

This family sells all its ware to jobbers who truck it to the markets in and around Cali, as well as to large stores. They don't want to be bothered with marketing the pottery themselves and are content with this arrangement.

Another Santander Potter

Three city blocks away from Sr. Arébalo's establishment, near the Pan American Highway, lives Carlos Arturo Acosta. He learned to run a pottery shop and use the wheel from his father and grandfather, who also originated in Pasto. Carlos was born in Santander, where his father had set up his own family business. His father has since moved to Bogotá where he now specializes in making large planters. The walls in Carlos' house are covered with photographs and certificates awarded to his father for the good design of his pieces entered in departmental and national expositions. Carlos' uncle is a teacher of ceramics in a large correctional institute for boys in Cali. The school is well known for the quality of its ceramic instruction.

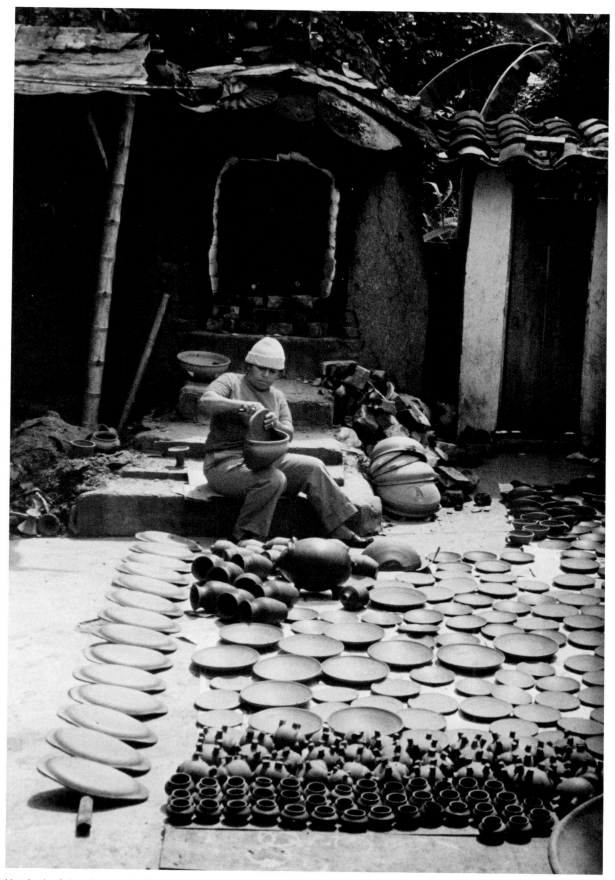

Hundreds of clay pieces, including plates, platters, bowls, small *ollas*, and piggy banks dry in the sunny courtyard. The kiln is centrally located, with the entrance raised about 1m (3½ feet) above ground level. Sra. Peregrino sits here with a small knife, trimming the irregularities on slab-and-wheel combined pieces.

It is interesting to see how these people from the Pasto region have spread out, carrying their fine craft techniques with them. A new generation is growing up now that will be well trained in the basic techniques and to whom it will be the most natural way of obtaining a livelihood.

Carlos does all the work in his shop. At 24, he has worked in ceramics for 7 years, and is just about able to support his family through his pottery. He tells us he could probably make a better living elsewhere doing something else, but this what he really wants to do.

His wife, a very quiet, pleasant woman, is descended from the black slaves that were brought into the valley by the Spanish colonists to work the sugar plantations. His children range in coloration from the black of their mother to the *mestizo* of their father and are typical of the large mulatto population that dominates the valley today. They are very young and, unlike Sr. Arébalo's family, have so far taken no active part in the family craft. His wife laughed when I asked if she worked with clay, explaining that she had never learned that skill.

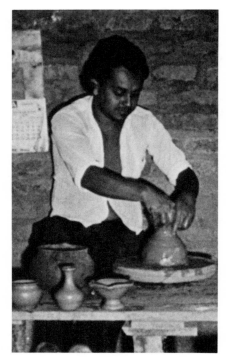

Carlos forms his pieces by throwing off the hump. His techniques and shapes of his pieces are like those by Sr. Peregrino. Both potters address their wheels from the side, as we have seen elsewhere in South America.

Making the Ware

Carlos prepares his clay and forms his wheel work very much like the other Santander family. The same traditional forms and the same "modernistic" pieces could be interchanged from one shop to the other without anyone knowing the difference. However, where the Arébalo family produces mostly glazed ware, Carlos only makes unglazed pieces.

After throwing his pieces, he lets them get leatherhard and then, using a chuck, places them upside down on the wheel. With a metal tool, he burnishes them until the outside of each piece has a soft sheen. He forms lids on the hump, leaves them attached until the clay is firm, then polishes them before cutting them free. Handles receive the same polishing. He has two wheels and uses both for this time-consuming method.

Firing for Red- or Blackware

Two kilns are also used. A large square one similar to Sr. Villota's is used for redware. For blackware, Carlos has constructed a tall, thin cylindrical kiln in which he can get a good smoky atmosphere. He uses

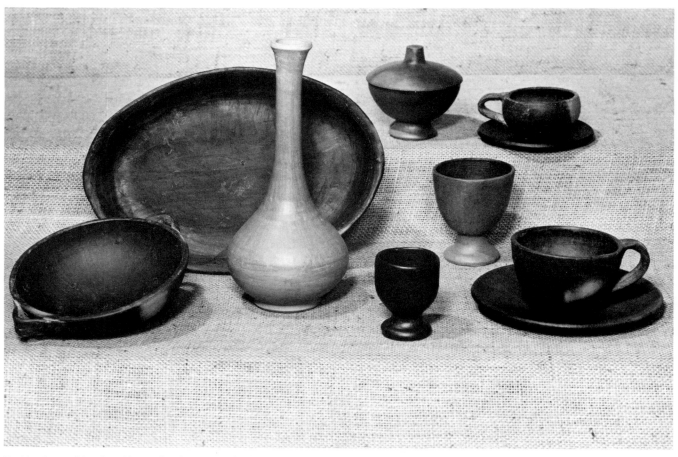

Besides the traditional cooking and tableware, the family makes a great quantity of "art" pottery. Pierced lanterns, wall-hung lanterns, and long-necked vases are common. They are finished either by burnishing the ware and leaving it natural or by glazing.

green branches for the reduction process, which leaves the clay a mahogany brown to rich black depending on the amount of reduction. Sometimes an unexpected patch of red clay remains where one piece prevents the smoke from coming in contact with the surface of another piece.

Marketing Utilitarian Ware

His most handsome pieces are low casseroles in various shades from red to black. He also makes attractive pitchers and handformed oval platters. Tableware in complete sets is made on commission. He fills many orders for these sets from people in Cali and other nearly communities. Carlos also sells to a trucking merchant who takes care of marketing the ware.

Guásimo, Caloto

We asked the families in Santander if they knew of any other potters in the vicinity. They thought for a while, told us they thought there used to be another family in the town itself, but that they no longer lived here. Then Señora Arébalo told us of a "world-famous" painter, sculptor, and teacher who lives about 5 kilometers (3 miles) away, in the town of Caloto, and that we should be sure to meet her. The paved road to Caloto passes through rich farmland and lush garden areas. Everyone we asked knew Señora Gambor and gave us the winding-through-street-after-street directions for arriving at her small villa. Her street is paved with stones with blossoming weeds growing between them much like an untended garden path.

Señora Gambor greeted us as if we were old friends and invited us into her pleasant colonial home where every room looks out onto a tree-and-flower-packed open court. Clay and wire baskets hang from the trees, laden with orchids or other exotic succulent plants. Although Señora Gambor's talents as a painter-sculptor could not measure up to her reputation, she proved to be an extremely pleasant and informative person. As the mayor of the town, she is greatly concerned with the people. She is deeply interested in colonial and pre-Columbian culture. She is principal of

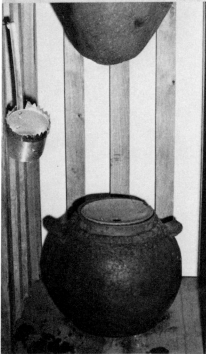

Water is placed in the large container where it seeps through the porous clay and drops into the container below. This filtering process is said to remove impurities from the water. The platter of plants on top is purely a decorative addition.

the private girls' school in the community which attracts students from well-to-do families. They come to enjoy the enlightened program of this school which reflects all of Sra. Gambor's interests.

The people of the community love and respect her. Everywhere she is cordially greeted. She has hosted Peace Corps volunteers and was intensely interested in our desire to learn more about the ceramics of South America. She owns a fine collection of pre-Columbian pottery of the nearby Corinto culture which she will only sell, intact, to a museum. In

her home, she uses many of the local ceramic products. A ceramic water filter and cooler, several large bowls and platters, and a collection of planters in her court and garden are examples of work made in nearby Guásimo, where she introduced us to several pottery families.

A Black Potting Community

Guásimo is a collection of some 30 black families, descendants of former slaves. About 20 of these families work from time to time in clay. The men are involved in agricultural pursuits, and only the women work at ceramic production. The people are poor, and the ceramics are necessary to augment the family income.

Here we witnessed for the first time a method of forming that we were to see used in a number of villages in the lower Cauca and Magdelena Valleys. The product in each place, however, is quite distinctive and easily recognized. The typical ware from Guásimo, we were surprised to note, is similar to ware we saw on the Ecuadorian coastal market at Boca de los Sapos, just south of Guayaquil, where there also is a large population descended from African slaves.

Working the Clay

The clay found near Guásimo is black, greasy, and nonplastic and cracks readily when formed in a ring. After a preliminary soaking, it is kneaded with sand on the same stone used for grinding corn. All the work is done in the shade cast by the overhang of the red-tile-roofed, whitewashed adobe houses. The yards are flanked by vegetable gardens and banana trees. In the yards are bowls drying in the sun and the few simple tools of the potter. (See illustrations and Color Plate 10.)

Firing

Firing takes place on the ground in each yard. A number of pots are placed in a circular mound on top of any available wood and covered over with wood branches and twigs. This is ignited and kept blazing with additional wood for about 2 hours, during which the clay matures to a deep brick-red color with the inevitable black patches from the smoke (see Color Plate 34).

Marketing

The Guásimo product can be found at the Cali markets, and we are told that Guásimo ware is sold at all the local markets in the smaller towns, such as Santander and Caloto.

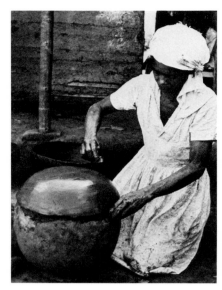

Prepared clay is placed on a piece of burlap spread on the ground and flattened with a series of karatelike chops to form a large, round *plancha*, or board. The *plancha* is draped over an *olla*. When firm, it is lifted off and left in the sun to set. Finally it is scraped with a *totuma* shell and smoothed and polished on the rim with water and a leaf.

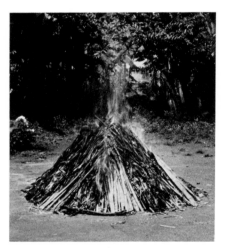

A simple ground firing is used in Caloto. Wood is piled on the ground, the pottery is stacked on top of it, and more wood is laid in a cone shape over all the ware. More wood is added as the firing progresses to keep the pottery covered.

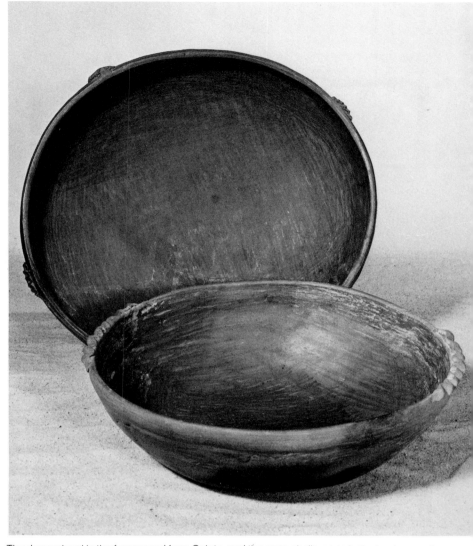

The deeper bowl in the foreground from Caloto, and the more shallow one in the background from Coastal Ecuador, are alike in many ways. Both appear to have been formed and burnished in the same manner. The handle treatment, using fluted coils attached to the rims, is also similar.

These shallow bowls, drying in the sun, have been coated with a red *greda* and burnished with a *totuma* rib. The color contrast emphasized by the burnishing marks while the piece is drying will not be apparent when the ware is fired.

Valle: Cali

From Santander to Cali is a short drive on smooth, well-paved roads. The capital of the Valle department is a modern, growing city with scarcely a trace of its colonial heritage. A sport and cultural center, Cali has two large universities, a music conservatory, and an impressive contemporary art museum, the Tertulia, which is the finest in the country.

Cali is the third largest city in Colombia and still growing, spreading from the valley out to the surrounding hills. It boasts a climate of eternal spring and, being situated at an altitude of approximately 900m (3,000 feet), as is most of the Cauca valley, probably has the most pleasant climate in all of Colombia.

Markets

The numerous city markets abound with the rich produce of the area. There are stalls filled with the valley's basketry, handcarved wooden bowls and utensils, and pottery, from all the towns north and south of Cali where it is produced. The ceramics range from the primitive crude ware made in Yumbo to the refined work of Santander.

Tourist-Office Gallery

Because this city is so important, the tourist office is large. The windows of the office show a fine display of the country's handcrafts. Inside is an impressive shop where the work is sold.

The director and store buyer of this gallery, Nubia de Bonilla, is herself a well-trained potter, whose work is in museums and private collections throughout the country. Periodically she visits craft-producing areas to encourage local craftsmen and to purchase high-quality work for the shop. The selection is made with sensitivity and understanding. She has a great interest and tries to be helpful to these people in every way, by buying the best work and suggesting improvements. As a teacher in surrounding communities, she tries to make people understand the value of *artesanías* to the country. She is also responsible for setting up the *National Crafts Exposition* held every August for the past five years. It was through Sra. Bonilla that we were able to locate several potters working unobstrusively in small towns north of Cali.

Yumbo

Concepción Domingas lives with her family just off the main street on a dirt road in this small industrial town, about 12 kilometers (7 miles) north of Cali. The townspeople appear to be a mixture of three main ethnic groups that have populated this valley—Indian, Negro, and Spanish.

Learning the Craft

Concepción told us that there used to be several families here working in clay but that now her family is the only one left. Concepción and her sisters were taught pottery by their mother, who was the first person in the family to make pottery. The mother became interested in claywork when she was a little girl watching a friend of her mother making pottery. She worked with the friend until she learned the necessary skills. When her own children were old enough, she taught the craft to them so that they could help her.

A History in Clay

They find their clay, sand, and *greda* locally, mixing it as in Guásimo. This area of the valley appears to be rich in clay deposits. A series of tomb excavations in the Cali vicinity, undertaken by James Ford for the *Institute of Andean Research*, uncovered many ceramic vessels. These attest to the common craft produced throughout the area in pre-Columbian times. Nothing is left of the small, isolated tribes who lived here; it is believed that either they were assimilated by the Spanish or died out. Whether or not influences from their pottery forms remain is hard to say.

The researchers found that the material used by the indigenous people was a mixture of clay heavily tempered with river sand. The work was formed using the coil system, but was often covered with a red slip and polished with a tool that could have been a smooth stone. Simple forms were characteristic, but the older *ollas, cántaros,* and pedestaled forms were far more elegantly formed and varied than similar shapes today in the vicinity of Cali.

Working the Clay

Concepción, joined occasionally by any of her three sisters, sits on the ground under the overhanging roof of the porch facing the garden and builds her pottery using the same techniques we saw in Guásimo.

She and her sisters make enough work to be able to fire approximately 80 pieces every 2 weeks. This would not lead one to believe that they spend a great deal of time at the potter's craft!

Firing

The clay vessels to be fired are mounded on the ground as in Guás-

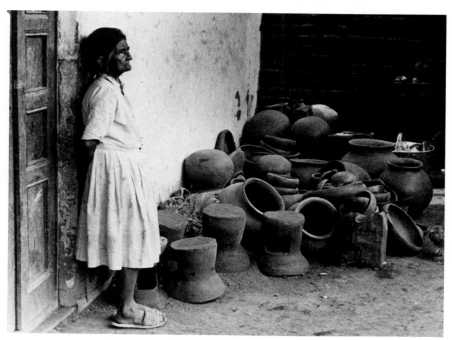

Sra. Domingas and two sisters, who work with her, represent the last family working with clay in Yumbo. Together they make enough ware to fire every other week. Here the results of one firing are stacked in front of the house prior to being shipped to market.

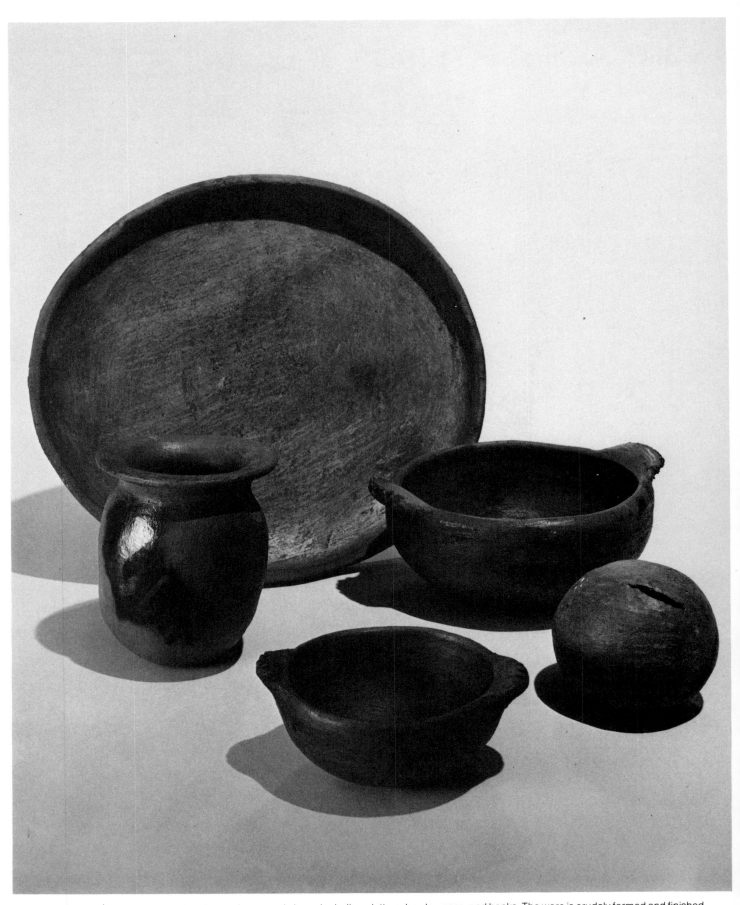

All the popular forms that the market demands are made here, including platters, bowls, vases, and banks. The ware is crudely formed and finished. The *greda* applied to the ware often crazes.

imo and covered with the same combustible material commonly used throughout southern Colombia—*guadua*, a thick, hollow-tubed plant, fast-growing, similar to bamboo, that burns rapidly with a very hot flame. They, too, fire the ware for about 2 hours, adding more *guadua* as the pots begin to show through the ashes.

Marketing

They market their ware over a large area. It is sold in the Cali markets, of course, but also in the nearby towns of Palmira, Ginebra, and even Cerrito, where another family of potters lives. The Domingas are able to supply any forms needed by the community.

A Roughly Made Ware

The pottery is the most crudely formed we have seen. The base clay is very course, due to the high sand content. They have no interest in achieving a smooth surface on their ware, which tends to be warped and most often out of round. There are very noticeable hollows where the surface has not been smoothed out. A red *greda* is applied to the surface, which is then slightly burnished with a stone. The rough base clay is evident even through the slip which, not fitting the clay body, often crazes.

These comments may sound derisive, yet the ware is successful. What rescues it from mediocrity is the honest approach and respect for the pot's function. This is pottery to be used every day by the people of the valley.

It is strongly sculptural in feeling, dependent upon basic forms, and obviously made with a no-nonsense approach to essentials. Lumps or hollows do not make the pot less efficient although possibly more difficult to clean. However, that doesn't seem to affect its salability in local markets.

The Variety of Ware

Sra. Domingas is able to produce whatever her market needs. Ware in all the common varieties and sizes is represented. The most impressive work here, however, is a series of wood or charcoal braziers. The base is a slant-walled cylindrical container with an irregular oval opening for the fuel, that seems literally to be torn out of the form. A flaring bowl is smoothed onto this base and rings of concentric holes are cut into it with no attempt to remove the remaining bits of clay. It is a sturdy, utilitarian piece, boldly declaring its use and the material from which it was formed.

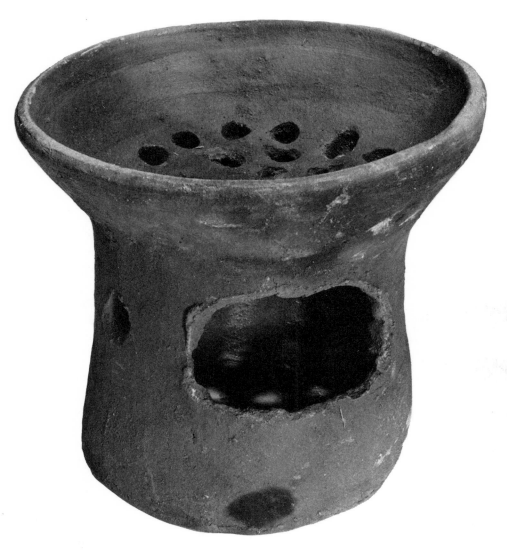

This roughly formed brazier is made in two parts. The lower cylinder is designed to hold a wood or coal fire. The upper, perforated-platter form will support a cooking vessel such as an *olla* or *tostadora*.

El Cerrito

Forty-six kilometers (28.5 miles) north of Cali on the Pan American Highway, we arrived at the small town of Cerrito. We pulled off the main highway, passed the railroad, and went to one of the last streets of the town, which was only a grassy lane. Here is the home of Diocelina Gualtero. Her house is made of fired brick and has a concrete floor—high standards, compared to many of the craftsmen's adobe homes we have visited.

Diocelina has 11 children; four help her with the ceramics. Her husband drives a horse cart and helps haul materials for her. These are all found nearby. Only one of her daughters helps her in forming the pieces. Three sons help with preparing the clay and *greda* and firing the kiln.

Magdalena Valley Background

She grew up not in Cerrito but across the central Cordillera in the Magdalena Valley, in the Department of Tolima where the largest and most sophisticated pottery center in Colombia is located. Diocelina, however, comes from the northern corner of Tolima, which is not known as a pottery area. Her parents were not ceramists, but she tells us that she had several neighbors who were. It was here, as a child, that she became interested in making pottery and worked with her neighbors until she was old enough to set up her own place to work. Her forming techniques are like those used in her hometown of Lerida and similar to her nearest craftsmen neighbors in Yumbo and Guásimo, of whom she knows nothing. Diocelina's work, however, is the finest hand-formed ware that we were to see in the Cauca valley.

The Claywork

Two rooms in the house are set aside for her work. She prepares her clay by soaking it. It is a very sticky clay and when she kneads it, she adds dry clay and sand to counteract the stickiness and to bring it to the proper consistency for forming. She drapes her clay over old *ollas*, lets them set, and then turns them right side up to finish them in a variety of forms. Her *greda* is a yellow-ochre color before firing and contrasts noticeably with the dark gray of the damp clay. She has brought her own river stones with her from Tolima to polish the *greda*, which easily acquires a soft sheen.

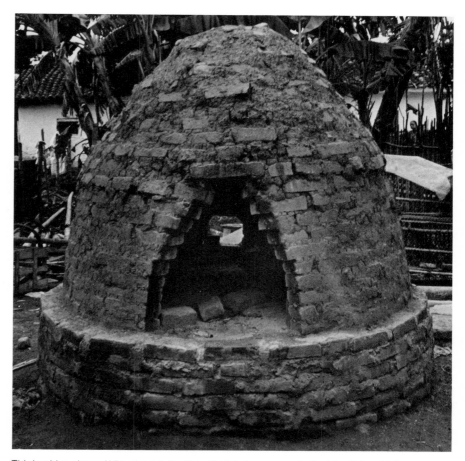

This beehive-shaped kiln, about 1.5m (5 feet) high, is common to the Magdalena Valley, yet this one is different as it is made of common brick. Besides the large opening for loading ware, there are three smaller ports, one opposite the loader port and the others on either side. During the firing, all four ports are left open and used to add more wood as needed.

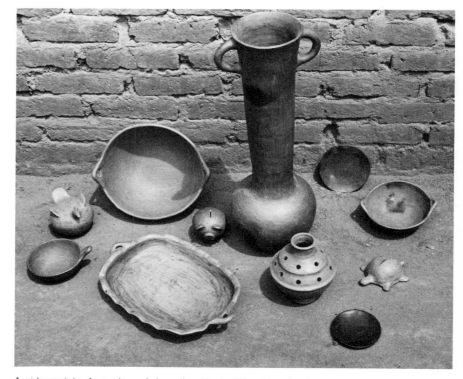

A wider variety of ware is made here than the traditional bowls, plates, and platters. Vases with elongated necks, perforated flower holders, and animal banks are made for the local markets.

Firing

Her impressive beehive-shaped kiln was constructed by her husband. It is sensibly built on a round brick platform that elevates the floor of the kiln about 46cm (18″) off the ground. Before the greenware is loaded, a layer of charcoal is placed on the kiln floor, then the ware, and over and around it, the wood. Depending on the size, Diocelina fires from 20 to 30 pieces at a time. The door is not bricked up and there is no top flue in this kiln which brings the clay to maturity in about 4 hours.

Blackware

Diocelina also makes blackware. She piles the small pieces that she wants black inside a large sagger that she calls a *tinaja*. She places the *tinaja* close to the kiln opening so that she can pull it out by forcing a board under it at the height of the firing. Out on the kiln platform, she throws sawdust into the loosely packed *tinaja*, and covers it with a metal can cover. The resulting smoke turns the surface of the ware a rich black. The *greda* she uses does not produce the brilliant surface found on the wares of La Chamba in Tolima, but her work, in both form and surface, is reminiscent of the pottery in the lower Magdelena valley.

The Pottery Forms

She forms all the traditional large water containers, *ollas*, bowls, flower vases, and pitchers. But she is influenced to try new things by what she sees now, as well as by remembrances of the forms that she grew up with in the Magdalena Valley. Her piggy and bird banks could have been produced in several communities across the mountains.

Marketing

Here is another woman who supplies all the utilitarian pottery her market needs, while tempting her public with new forms. Her work goes to markets in three large towns: Buga, Cali, and Palmira. An ample section of the *Museo de Arte Tradicional y Popular* in Bogotá is devoted to her work.

Buga

Throughout our journey, we noticed the various influences that are changing the traditional handcrafts in

This water filter is made in three parts. On the right is the filter itself, which when in place drips water into the basin-shaped bottom of the main section. The filter cover and cups for scooping up the filtered water are on the left.

South America today. Not since Spanish colonial times has there been such an influx of foreign influences on the continent. We found this most strongly in Colombia, and here, especially, we felt compelled to document many of the new trends which in the future could radically change the folk-craft picture, even in seemingly remote areas.

European teachers brought in by the government to instruct at established craft centers, Peace Corps volunteers bringing new techniques to craft villages, and even the inundation of plastic and aluminum products sold at the markets, all of these and more are increasingly bringing about major changes. Also, it must be noted that as a culture changes, its needs also change. The products at the marketplace will reflect the changes. Many once necessary handmade products are bound to disappear if the need for them diminishes. In many areas, the community of potters is dwindling, while in others, the potters have already died out. Pottery is still greatly in demand in many regions either because the traditional needs still exist, or because the potter has learned to develop new products and techniques.

The Training of a Solitary Craftsman

Sr. David Terrawa's history is similar to that of Sr. Campo, who became interested in pottery and developed his

craft through experimentation and inquiry. Sr. Terrawa, too, grew up in an urban environment. His family had no knowledge of pottery. Being an adventuresome young man, David left his small hometown, Buga, and joined the Colombian navy. He remained in the navy 14 years, traveling around the world. In all the experiences that his travel afforded him, he was most impressed by the pottery he saw in England and Japan. He was determined to quit the navy and to become a potter. He took a job in a ceramics factory in Bogotá, where he stayed for 6 months in order to learn as much as he could about pottery methods.

Sr. Terrawa's Studio

He returned to his hometown and set up a ceramic studio. To support himself and his family for the last 2½ years, he has been making an assortment of molded figurines, vases, and imitations of mediocre forms and ware. His equipment consists of a large assortment of slip-casting molds that he has made, one kick wheel that he uses only occasionally, and a rectangular, wood-burning brick kiln which he is constantly adjusting to achieve a more even firing.

He has molding and glazing tables and a large area of shelving for molds and ware in all stages of completion.

Tableware. Sr. Terrawa's main interest is in designing a contemporary line of tableware. He has fashioned slip

molds for a variety of freeform bowls, plates, and platters. The forms are well designed and further enhanced by beautifully textured glazes, which combine greens, golden tones, and browns with oil-spot or hairline patterns similar to the effects seen in Japanese glazes (see Color Plate 24). Sr. Terrawa expresses a great interest in using glaze effects. Knowing the toxicity problems inherent in lead glazes he will not use them, but instead uses a base of borax and nontoxic frits. These he colors with oxides of manganese, copper, chrome, and iron.

Water Containers. While experimenting with tableware and glazes, he produces another product for sale. He has borrowed the form and design of water coolers, water heaters, and water filters that are made in the city of Cartago, which is north of Buga. These are large, impressive forms similar to the stoves being made in Pomaire, Chile.

Hopes for the Future

After working for 2½ years on his own, David Terrawa still feels a great compulsion to continue his ceramic work and hopes to be able to succeed. He would like to build a gas- or oil-fired kiln in order to work in porcelain and high-fired glazes. His naturally good sense of design, augmented by his travels, is leading him to experiment more with good forms, but he feels limited in his technical abilities and is aware that he still has a lot to learn. He is struggling by himself and would be able to move ahead more easily with the help of technical advice. At present, he doesn't know how to get this type of assistance and proceeds through trial and error.

He has learned a lot in a short time. With persistance and training, people like Sr. Terrawa could bring new ideas in craft design to continue Colombia's rich craft heritage.

Southern Magdalena Valley

There are not many ways to enter the southern areas of the Magdalena Valley. Coming from the Cauca Valley, one must cross the formidable west-

ern Cordillera, which offers few passages through this high, rugged mountain range. Running east from Popoyán, poor but passable roads used as migration routes since pre-Columbian times are today still the only means to get from the Cauca to the Magdalena Valley. This section of the Magdalena contains the incredible San Augustin Park, with the richest find of ancient sculpture in all South America. It seems not to be as rich in ceramics as many areas to the north, east, and south, but much of the area is still unexplored. Quantities of pottery, jewelry, and other crafts have been found in nearby painted tombs of Tierra Dentro.

The Upper Magdalena Valley

The western Cordillera remains impenetrable from Popoyán, north to the Quindio Pass, which is opposite Bogotá. Here is one of the most important highways in the country, the main connecting link between the two river valleys and Bogotá. You descend by this highway, either from Quindio or the Bogotá plateau from elevations over 2,400m (8,000 feet) to the 300m (1,000 feet) level of the Magdalena Valley and quickly feel the change in temperature and humidity. It is hot, humid, and overgrown with lush, green vegetation. The river in the Upper Magdalena Valley, fed by numerous mountain streams and abundant rain storms, is an unnavigable torrent.

From the cross-valley highway, another good paved road cuts south along the river for about 240 kilometers (150 miles) to Garzón. To go further south, the traveler continues on dirt roads that branch westward to Pitalito and the San Augustin archaeological park, or southeast to Acevedo.

Of all the areas we studied, the Upper Magdalena Valley is one of the richest in contemporary ceramics.

Pottery. Basically, the same type of ware is being handbuilt throughout the region, with the methods gradually changing as you head south from La Chamba, the largest ceramic community in the country. Ninety-six kilometers (60 miles) north of La Chamba is Lerida, where Sra. Gualtera, now living in El Cerrito, came from. It is, according to her, a small village with several families of potters using basically the same techniques as in La Chamba. Girardot, Natagaima, and Timiná are other places in this region where pottery is being produced.

Pottery History. It is believed that the pre-Columbian culture of Calima and Quimbaya extended from the Cauca Valley over the Quindio Pass and pen-

etrated the Magdalena Valley. At El Guamo, only 12.8 kilometers (8 miles) from La Chamba, grave shafts with pottery were found. Blackware was made by several of the Indian tribes including the Quimbaya, Sinu, and Tairona. Although the ancient ware was all made with coils, and the methods we see being employed today are a combination of coil and other means, we wonder how many of the ancient techniques have been passed down to the scattered groups of families still practicing the potter's craft throughout the valley.

La Chamba

Today between 200 and 300 families are producing ceramics in the area of La Chamba. The village is a close-knit community of similarly constructed, whitewashed adobe houses with high-pitched, thickly thatched roofs that keep the interiors cool in this uncomfortably warm climate. *Guadua* or wire fences surround the house yards to contain the numerous pigs and chickens that wander about. Many of the houses have concrete floors and patios. The more well-to-do homes are made of concrete block and have high concrete-block or brick walls surrounding the property. Flowering trees are everywhere.

The main plaza is a soccer field surrounded by tall, grassy areas, a school, a modern church, and other buildings. It is pervaded by an air of somnolence. The roads are all dirt, and clouds of dust are sent up when the occasional car or truck goes by. Two buses a day connect La Chamba with the rest of the world through El Guamo. Two schools educate the children through the elementary grades, and many take the buses out to continue their higher education.

The central area of La Chamba appears to be a thriving community. The men work at agriculture, most being employed on the large *fincas*, or private estates, nearby that raise bananas, rice, cotton, or cattle. Some families have their own land and work it themselves.

The Co-op Center

The heart of the community is the *Artesanía Co-op Center*, set up and administered by the government office of the *Ministerio de Desarrollo Económico*. The center is a collection of high, thatched-roof buildings using

the local architectural style but constructed on a much larger scale. Red clay, concrete floors, and polished wood barriers set off the two main buildings that are used for display, sale, and storage of the completed La Chamba ware. The driveways are paved with cobblestone.

The director of the center showed us large, closed- and open-roofed classrooms where free courses are periodically conducted, sometimes by teachers from the national SENA schools, in woodworking, leather, and ceramic techniques. Courses in nutrition and health are also offered. There is no electricity in the village, but at the center a kerosene-burning generator runs from 6:30 to 10:00 P.M. each evening to operate the electric lights and a TV set located on an exterior patio. A large group of children and adults come to the center in the evenings to watch television, or just to bask in the light on the lawn and chat.

Everything possible is being done to establish a feeling of community, to prove to the people that it is their center and their cooperative. It is a truly new idea in Latin America, where government is generally suspect in the rural areas, and each person has few community or organizational feelings outside of his own family group.

Government Aid through Marketing. The government is aware of the importance of the folk craftsman, and is trying in several centers like this around the country to save and expand Colombia's craft heritage. Here it begins to work. The most important function of the center is that it acts as a collection point for the ceramics and as a doorway to expanding markets. From here work goes to the *Artesanías de Colombia* shops in all the large cities in Colombia and is collected for export all over the world. While we were there, a shipment of thousands of the La Chamba piggy banks and typical La Chamba tableware was being prepared to be sent to

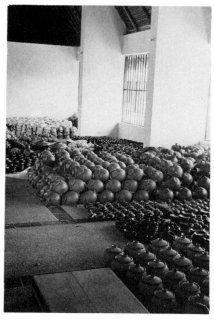

(Top) The *Artesanía Co-op Center*. (Above) La Chamba ware is made up mainly of lidded jars, piggy banks, soup bowls, and other tableware.

Italy. Buyers come to the center and take wholesale lots or place orders for what they want. Colombians from Bogotá make special trips to the center to purchase items for their homes. The center is also becoming a tourist attraction as word of the beautiful ware and reasonable prices is spreading.

Craftsman Participation. Each member of the co-op receives a number which is attached to the ware he brings in on consignment. He is paid twice a week for the work sold, a certain amount being held in reserve for special funds and to pay the local people who work at the center. A committee also selects the best work brought to the center to be bought for permanent display or to be sent to nationwide exhibits. This induces the craftsmen to continue making the work that sells best.

The majority of the community does not belong to the cooperative yet, but the number is growing and, with new orders coming in, the director is pushing to encourage greater participation so that the community will truly be able to establish itself as a thriving craft center.

It is a difficult task to convince a shy and retiring group of people that the uncertain conditions they have grown accustomed to can be changed for the better through their efforts as craftsmen. Ceramic production here, remains a cottage industry, although the *Artesanía Center* has toyed with the idea of encouraging the people to work and fire their ware in the center's kiln.

Men's versus Women's Work

All the actual forming of the work is done by the women, who laughingly chide that the men do not want to get their hands dirty with the clay. The men do, however, go out to dig the clay and bring it home for the women. If there are no men in the family, the women pay people to bring it to them; otherwise they dig it themselves and bring it home at no cost.

Preparing the Clay

The women pulverize the dried clay with a stone mortar, in the same way that they grind corn. Mixed with water it can be used right away. It is very black and sticky when too wet, and characterized by a very fine particle size. We are told that it works well as is for small pieces, but that for larger ware, sand must be added to the body.

Forming the Clay

The clay used to be formed over gourds, but now a set of old bowls is reserved on which to form the new work. We visited at the home of Señora Santas Prada, whose family and work patterns are typical of the area. She is a thin, small, energetic grand-

Señora Prada's Ware Production. Potters in La Chamba sit on the floor and revolve the *molde* with a toe while forming a pot.

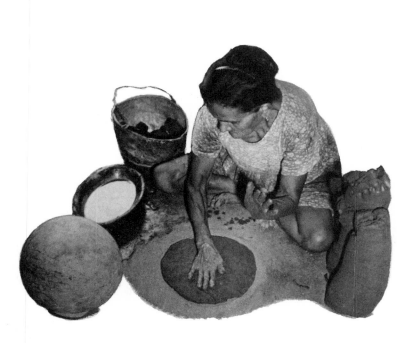

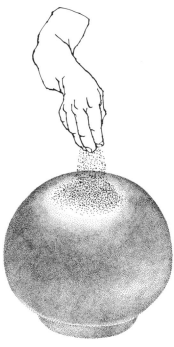

1. Señora Prada sits on the concrete floor of her pottery room. Sand is sprinkled on the floor and a ball of kneaded clay is slapped into an even *plancha* shape.

2. A globular clay form with a neck, quite like an upside-down *olla*, is used to begin forming the ware. First, sand must be sprinkled on the *molde* to prevent the *plancha* from sticking to it.

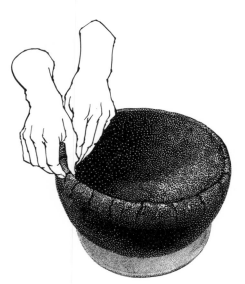

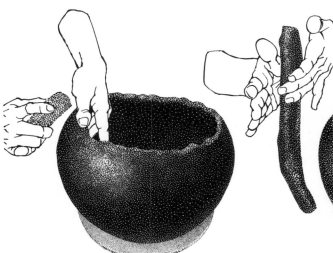

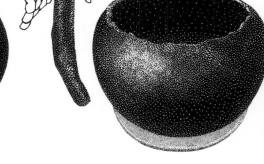

6. When the initial clay form has become firm enough to work on without distorting, it is taken off the *molde* and placed rightside up on a fired-clay bat. The potter tears the rim edge in vertical slits and cups the pieces inward.

7. With a corncob she smoothes out the slits and pulls the clay inward to further close the form.

8. The potter takes a lump of clay and squeezes it to a long shape and then, holding it vertically, she rolls it into a long, even coil.

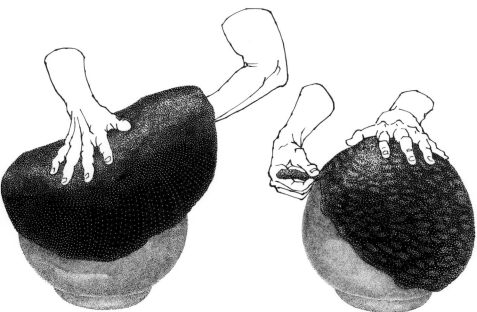

3. The large, thin *plancha* is deftly flipped over onto the *molde.*

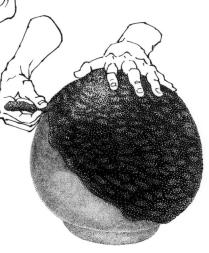

4. With her fingers the potter presses the *plancha* so that it conforms to the shape of the *molde.* She neatly pinches off the excess clay around the edge of the *plancha* and then smooths it back on to thicken the rim.

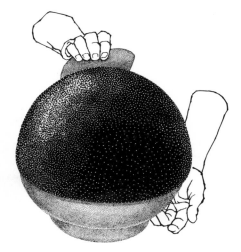

5. With a curved *totuma* rib and water, Sra. Prada evens and smoothes the surface of the clay.

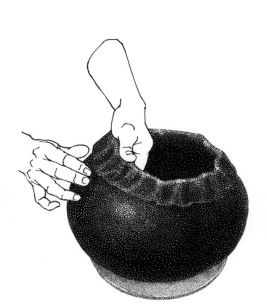

9. The clay coil is firmly attached to the neck opening and welded to the form both inside and out.

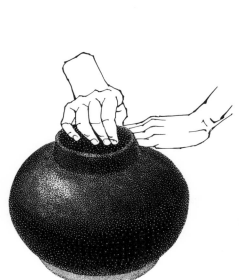

10. Another coil of clay is rolled and attached to form the pot's neck.

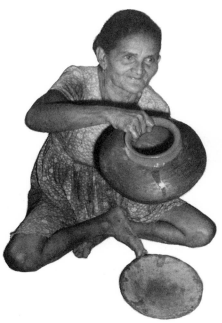

11. The final curve of the neck is made as the potter, supporting and turning the pot with her left hand, shapes the rim with her right hand. Here you can easily see how the potter's unusual sitting position enables her to use her big toe to help turn the pot while she is forming it on the clay bat.

mother who looks much older than her 50 or so years. She and her daughter Hermalinda produce a formidable amount of pottery including oval platters and casseroles and footed fruit bowls.

Hermalinda's sister and two daughters, Neita and Esmeralda, prepare the clay and apply the *greda* (see illustrations).

Surfacing the Ware

Esmeralda showed us how she applies the red slip which is called *greda* or *barniz*. They buy the especially fine-particle clay from people who live in a mountainous area on the other side of the Magdalena River, about 12 kilometers (7 miles) from La Chamba. Mixed with water, and the impurities removed, the red paste is applied to the damp ware with a small house-painter's brush. When the *greda* is dry enough so that it no longer rubs off on the fingers, it is ready for the final polishing (see Color Plate 32).

Small quartz stones that have rolled in the Magdalena riverbed until they have become round and smooth are gathered to be used to burnish the *greda*. A few passes over the surface, and the *greda* takes on a lustrous, wet, shiny look. Fingers and palms are also used in this polishing process. The La Chamba potters also make a ware that they call "rustic" which means that it is not covered with *greda* or polished. This ware is more likely to be found on the local markets, selling for less money than the polished pieces.

Community Working Relationships

The size and composition of the family determines the amount of pottery it can produce and the amount of money it can realize. A family like that of Sra. Prada does very well. They can produce a lot of pottery and they have plenty of help in polishing it, which is a time-consuming job. Hermalinda's husband gets the clay and helps with the firing. Some families must hire people to help polish their ware and the wages they must pay cut down on their profits. Other people with no kilns sometimes will offer to help a kiln owner's family in return for firing their ware. Sometimes the man of a family offers to help get clay and fire a kiln for a family lacking this masculine aid. Another woman might offer aid in polishing for the use of her neighbor's kiln. Many exchanges are possible, depending on family or that indispensible necessity, a kiln. Some people make ware and sell it in its crude form to others for firing. Some just make

the "rustic" ware because they cannot get help in polishing it.

La Chamba Kilns

Ernesto Habiles is known in La Chamba as a fine kilnmaker; he has made many of the kilns in use now, including the one owned by Sra. Prada. Generally the kiln is made of adobe in a beehive shape. It is usually located on a rise of land or on an earth platform, and a thatched roof lean-to structure is built behind and extends over the kiln to protect it from rain and wind.

Firing. Hermalinda tells us that they fire their kiln every 2 weeks. Four large *canastas*, each holding about 26 items, and 12 small *canastas* that hold about six pieces each are fired in one kiln load. Wood is piled all around the *canastas* and more is added as necessary. They fire from 1:00 P.M. to 3:00 P.M. as they had recently completed a firing and would not do another this week, we went to the home of Sra. Chela Sanchez to see her firing.

Although somewhat smaller, Sra. Sanchez' kiln holds eight large-sized *canastas* in each firing (see illustrations). This pottery is one of the few examples of unglazed ware we found in South America that will hold water without seepage through the walls.

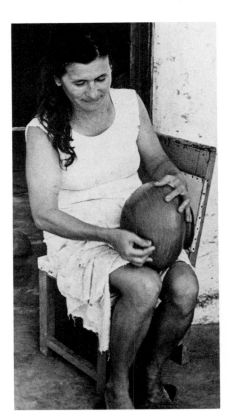

Hermalinda lightly rubs a small quartz stone over the *greda* to immediately produce a lustrous, shiny surface.

Fuel Shortage

Using wood as a combustible is a steadily increasing problem, as wood is becoming scarce in the area. It has to be trucked into La Chamba, and is comparatively expensive for people who can pay little for their materials, and who make relatively little profit on their product. Burro dung must also be purchased. This raises the cost of producing the more sought-after blackware.

Types of Ware

Over the last 20 years, the character of the La Chamba ware has been gradually changing because of its entry into the cosmopolitan and international market. More of the better, highly polished ware is being made, compared to the rustic, more utilitarian pieces made for local markets, which are well suited for storage, cooking, planters, etc. The external market has increased the demand for more tableware and decorative pieces. The polished traditional *paella* dishes and covered and uncovered casseroles in a variety of round or oval sizes are still the most popular items. Flower containers, candelabra, decanters, long-necked decorative pieces, braziers, plain and animal-shaped platters called *bandejas*, and the ubiquitous piggy banks have become very popular (see Color Plate 30).

All the ware we saw at the *Artesanías Center* and that being made in the potters' homes nearby was of high quality.

The same items are being produced from house to house, this being a community craft rather than an individual art form, although some potters are acknowledged to be better than others. There are many examples of poor design, copies of Chibcha Indian motifs in some cases, but on the whole, where the potters stick to variations of traditional and basically utilitarian ware, their product is exemplary.

Needed Aid

We are told that the potters are continually looking for new ideas at the expositions and in magazines and books. At the *Artesanías Center*, it is known that the potters need no training in their indigenous technical skills, but that good orientation in design—especially in the matter of new products—is sorely needed. It would be important to find teachers with a knowledge of La Chamba's ware-forming methods, who would have a deep respect for freedom of expression, with the ability to combine this with the knowledge of function and design.

Firing Unglazed Ware. The La Chamba kiln is made of adobe in a beehive shape, some 2m (6 feet) high. The entrance is about 1 square meter (10.8 square feet).

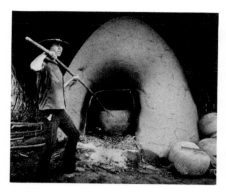

1. Ware is fired inside large earthenware *canastas* which are loaded into the kiln. Wood is piled around the *canastas* for firing.

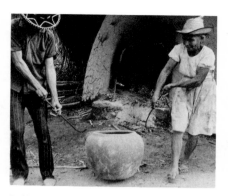

2. After being fired for about 2 hours, the *canastas* are removed from the kiln by means of metal hooks inserted into metal handles on the *canastas*.

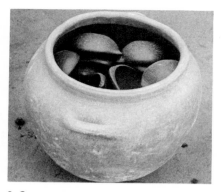

3. *Canastas* containing ware to be left red are set aside to cool.

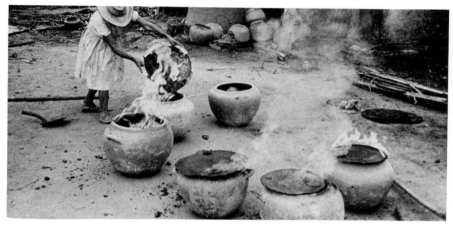

4. Reduction is induced by throwing dried burro dung into the hot *canastas*. A metal barrel lid is put on the top to confine the smoky, flaming atmosphere produced by the ignited dung.

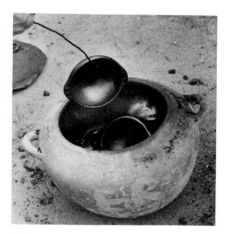

5. After a reduction firing, blackware is hooked from the specially treated *canastas*.

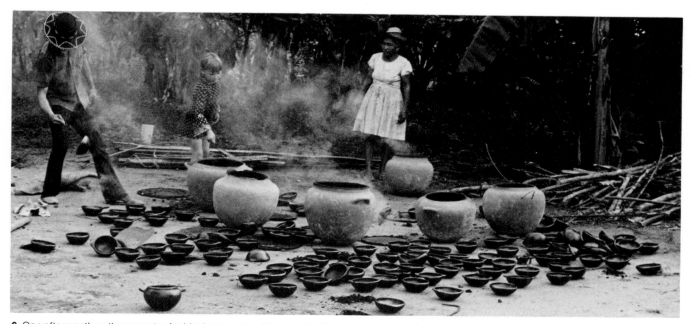

6. One after another, the *canastas* for blackware are pulled from the kiln, dung is shoveled in, and the ware is hooked out. If the lower ware has not been completely reduced, more dung is shoveled in the and the reduction is allowed to continue for another 5 minutes or so. Putting the hot ware directly on the ground does not cause any thermal-shock breakage, but we did see one goblet break when it slipped off the hook. No cracking or crazing can be observed in the slick *greda* surface, and the ware is a beautiful, lustrous black.

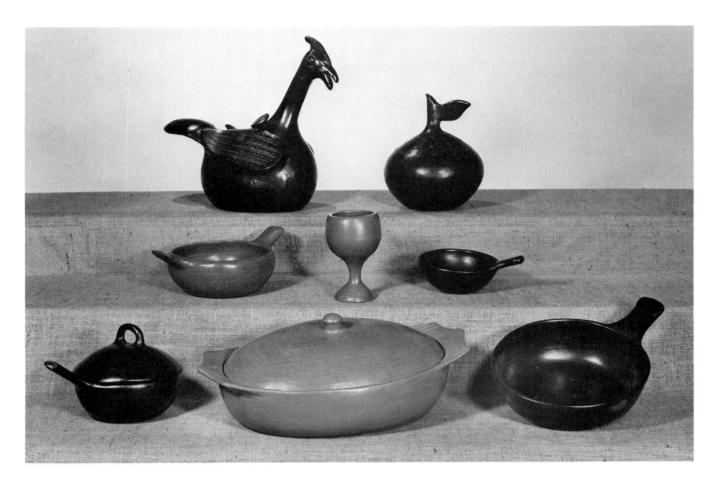

In the foreground is the more traditional tableware from La Chamba. At the top are example of decorative pieces, the bird designed as a beverage dispenser and the fruit form to hold wooden skewers with hors d'oeuvres.

Any suggestion that a change be introduced into their "cottage industry" is greatly resented, but *Artesanías* would like to see some modernization and commercial cooperation in such things as mechanized clay preparation and in firing procedures. With the growing problems regarding wood as fuel, they feel that communally operated kerosene-fired kilns would prove to be economically advantageous for everyone. It would especially help those who do not have kilns and those who have to go outside of the family for help in firing their own kilns. It would probably upset the present social structure of the village, but would certainly help to stabilize production and help secure good relationships among the villagers. The women could still produce their ware at home, while going about their family routines of caring for the children, the animals, the home, and the cooking.

Nearby Potting Communities

Other pottery areas in Northern Tolima are in Girardot and Lerida. Pottery techniques there are similar to those in La Chamba. To the south is Natagaima, a community existing in desertlike territory that proudly considers itself to be the only truly indigenous people in the valley.

Campo La Vega

Huila is the southernmost province in the Magdalena Valley. Until recently Tolima and Huila were one big province called "Gran Tolima," but the division into two districts was natural as there is some rivalry between the two areas. The more southern, Huila section, including the towns of Garzón, La Plata, Pitalito, and Acevedo, was said to have been settled by people coming over the eastern pass from Popoyán. The people of Huila consider themselves very industrious and jeeringly refer to the people of Tolima as being *opita*, a local term mearning backward, lazy, and having a slow, loose manner of speech. The La Chamba people especially resent the use of this term, as they consider themselves one of the hardest working people in the whole valley.

South of Neiva is Campo La Vega, a small community near the town of Campo Alegre. We were told that as many as 40 families here make ceramics. There is a brick factory with clay

mines where the women go to get their clay, carrying it home on large breadboards balanced on their heads. Their *greda*, as in La Chamba, is bought from people across the river. They also buy the white slip used in decorating.

Working the Clay

The clay is pulverized with a wooden club, then mixed with water and foot-kneaded. A grapefruit-size ball of clay is finger-pinched to make a hollow and then punched inside with the right fist while turning it in the palm and fingers of the left hand. Then it is thinned with a *totuma* rib, placed on a clay platter, and finished with coils of clay. The process is done the same way as in the more southern town of Pitalito (discussed later).

Women's Work. Melida Choa told us about the work. She forms the clay vessels here and has a niece who often helps her. Melida's mother is too old to work the clay, but she helps apply the *greda* and paint designs on the pots. Melida's sister Viviana lives next door and works alone because her daughter has another job and does not enjoy working with the clay. They made it clear to us that here only the women have anything to do with the clay, its gathering, preparation, and firing.

Combined House and Work Areas

The houses are of adobe with tile roofs and as many rooms strung out in a row as needed. Some are for sleeping and others for pottery storage. The houses and porches, that may face front or back, have concrete floors. The kitchen is a tile- or thatch-roofed open area with tables, benches, cooking area, and clay work area, all under one roof. Sometimes the kiln is set under this roof and sometimes off to the side. The work is done on the porches or under the kitchen roof.

Decorating the Ware

Greda is applied to the outer or upper surfaces of the ware and burnished with stones, but it never attains the luster of the La Chamba ware. A white-clay slip design distinguishes the pieces. This clay is mixed with water to a creamy consistency and painted on the ware with an improvised brush—a chicken feather. The skilled use of this primitive tool produces a thin, regular line. The design motif consists of curved lines repeated around the outer rim and sometimes around the shoulder of the pieces. Overlapping half-circles, concentric half-circles, and full curving

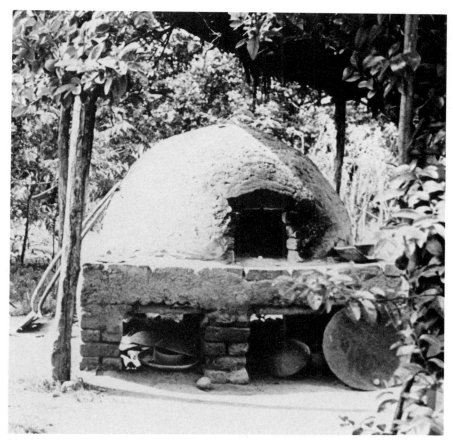

The Campo La Vega kiln is made of local brick, covered with adobe.

This tree ring is used around newly planted fruit trees. When set in the ground and filled with water, it keeps ants off the trees.

swirls are the favorite patterns. Often wider bowls will have swirling designs painted on the interiors. Round-ball banks with the addition of bird heads and tails will be treated with the same kind of design. When a fluted edge is made on a large, wide bowl, the edge fluting is incorporated into the line or design.

Kilns

The kiln is a low, igloo-shaped dome with an arched opening front and rear and a flue hole near the top.

Some kilns are raised off the ground on brick platforms and others rest on a mound of earth. Peace Corps volunteers who have been working with women throughout the valley have been encouraging them, as a back-saving device, to construct their kilns on platforms as it makes loading and tending the kiln so much easier. More of the women are accepting this advice.

Firing. The kilns are packed as full as possible with up to 30 or 40 pieces, depending on their size. Wood is placed on the floor, the pieces are stacked on it, and more wood is jammed around and over the clay pieces through both ports. The firing takes 3 hours, during which more wood is added through both doors.

Marketing

The Campo La Vega potters supply the two large nearby markets—Campo Alegre to the south and the enormous, bustling Neiva market to the north. You find many booths set up around a second-floor balcony in the new Neiva market building. At these booths, Campo La Vega pottery competes with La Chamba ware quite successfully, as they make many pieces for particular local uses.

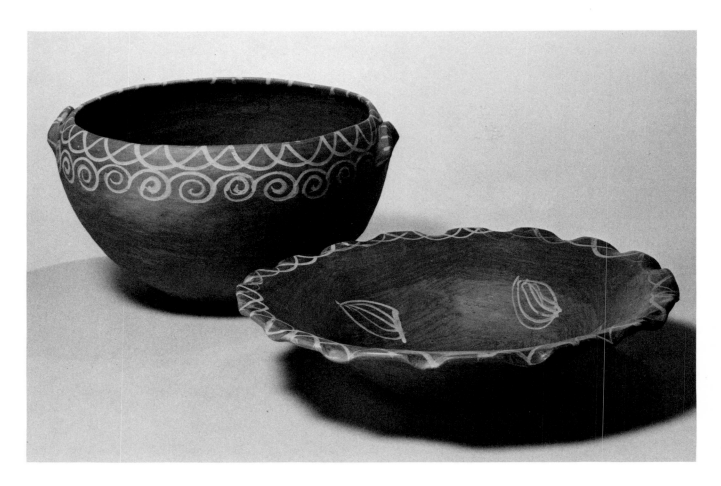

(Above) In the background is a *totuma*, a punch bowl made for a festive drink combining eggs, sugar, and *aguardiente*. In the foreground is a 41.8cm (16½″) diameter fluted bowl used as a serving dish.

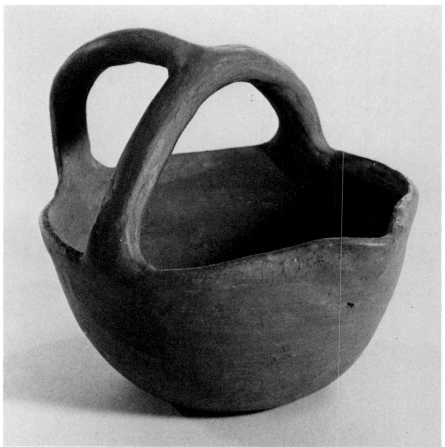

This pot is designed for melting and pouring lead weights for fishnets. The handle is constructed both for hanging over a fire and for pouring.

Claros

Garzón is the last town at the southern extremity of the paved roads. It is a large market town, being also located at the eastern end of the road leading from Popoyán. The market displays a huge pile of red-clay pots, decorated with white-enamel painted designs similar to those done in Campo La Vega, although not nearly as exuberant or sure in their application. There are three pottery families who supply this market. They live only 2 kilometers (1.2 miles) up in the hills to the east of the town, in the heart of cattle country. The tiny community where they live is called Claros.

Peace Corps volunteers have been working with the country people throughout the region for several years now and have been well liked for their generous help, understanding, and friendliness. Several years ago, it would have been difficult to meet these people as they were suspicious and afraid of strangers and apt to be hostile. Now, however, they are open, friendly, and eager to display their skills to those who show interest in and admiration of their craft.

The Last of the Potters

We visited Argémido Remón and his married sister, Susana, who lives with her young family in a house whose yard backs on his.

Susana and her brother told us how much they enjoy pursuing their craft, and although their children are very small now, they hope that they will want to continue the family tradition. They tell us that in years past there were many more potters, who have either died or moved away. The potters that are now working in Pitalito began here in Garzón.

Argémido told us that the men as well as the women in Claros have been potters for many generations. The learned from their parents, who learned from their parents before them.

The Clay

The area has an abundance of clay deposits. Argémido favors the clay found near the hydroelectric plant on the Rio Maja, about 2.5 kilometers (1.5 miles) from his house. The clay has particles of gold-colored mica flecked through it that shows up clearly after the firing. The red clay *greda* that they use is found on a hill nearby.

Working the Clay

When we arrived at Argémido's house, he had already been working for 2½ hours. In that time, he had produced 12 large pieces, both *bandejas*, or platters, and casseroles (see illustrations).

Argémido carries his freshly formed work to a shaded area on the porch where he leaves all the pieces together until they have become firm enough to lift and turn without deforming. At this point, the *greda* is applied and burnished with smooth river stones. The *greda* gives the fired surface a rich, warm color and a soft sheen which is smooth to the touch but cannot compete with the fine brilliant surface obtained in La Chamba.

Susana's Work. Susana works independently at her own home but carries her ware to her brother's kiln to be fired. When we visited, we saw over a dozen long, oval *bandejas* that she had made that day. She was putting the finishing touches on one large pot she had started early that morning. This impressive pot, used for storage of sugarcane juice, had been started in the same manner that her

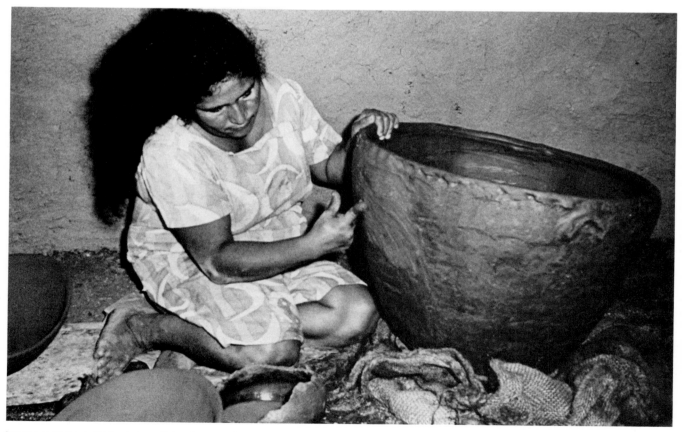

Susana applies small bits of clay with her finger and smoothes them out with a small, polished stone to even the irregularities on this large pot. It was made with coils, using the same techniques demonstrated by Argémido (see overleaf).

Forming a *Bandeja.* Angel Argémido works with one leg bent and the other stretched out in front of him. To make a 45.7cm (18'') diameter *bandeja* takes less than 15 minutes.

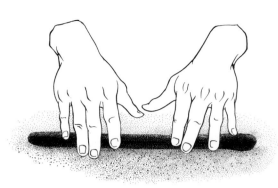

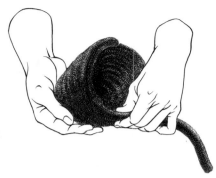

1. Argémido begins a pot by sprinkling sand on the concrete floor of his porch and rolling out long coils of clay.

2. The coils are initially formed in the potter's hands into a cone-shaped bowl.

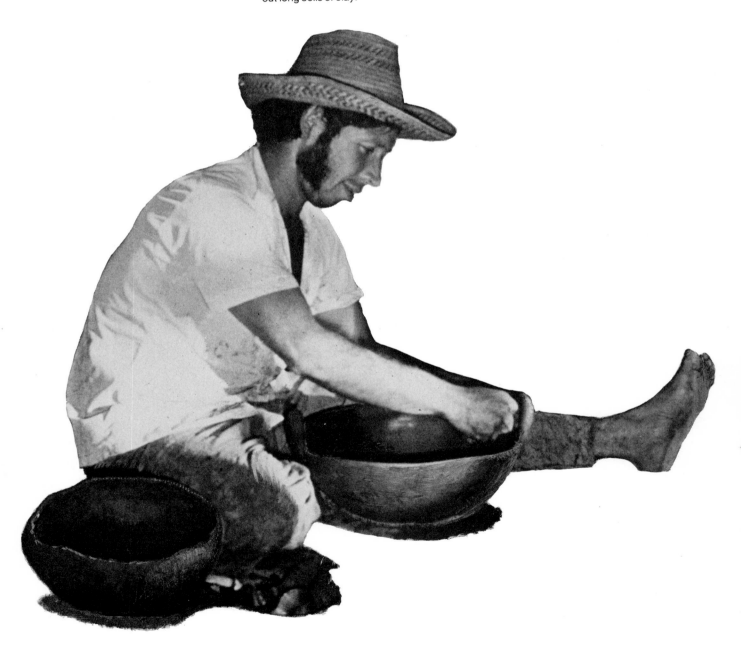

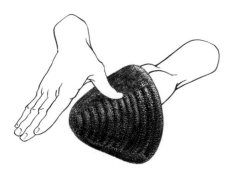

3. The coils are rubbed together both inside and out, while the potter supports and turns the pot in his hands.

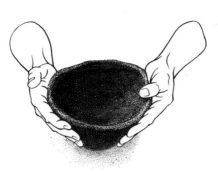

4. The smoothed coil pot is tapped on the ground to flatten its bottom.

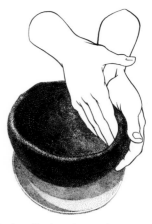

5. The bowl is placed on a clay platter which turns easily on the sand-covered concrete, as the potter, using finger pressure or a *totuma* shell on the inside, opens the form to make a wide bowl.

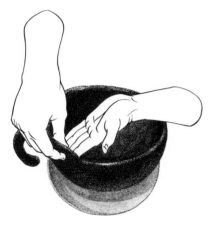

6. More coils are added and smoothed in to enlarge the bowl.

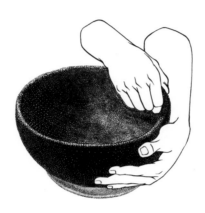

7. Angel turns the bowl with his left hand, while using his right hand to compress and thicken the rim.

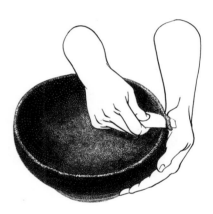

8. A thin *totuma* rib is used to trim any irregularities on the thickened rim.

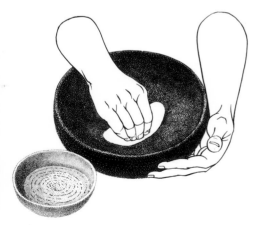

9. Water is sloshed over the inside of the bowl and slicked over the surface until it is smooth and even.

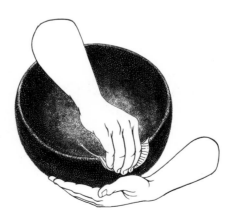

10. With a wet leaf he rounds and smooths the rim.

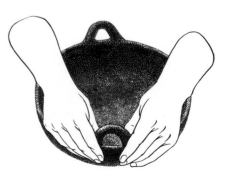

11. Handles are coils of clay applied directly to the outer rim surface and smoothed into place.

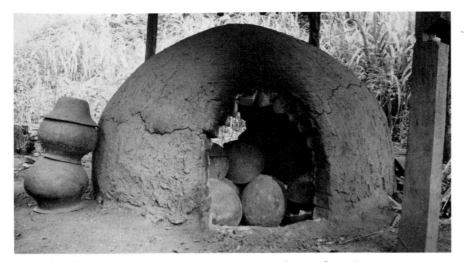

Argémido's kiln is similar to, but larger than, the kiln used in Barrera Contador.

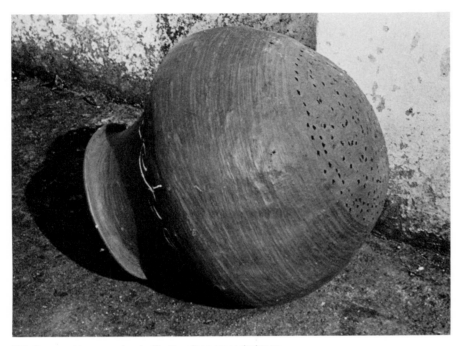

This flowerpot has a perforated bottom for proper drainage.

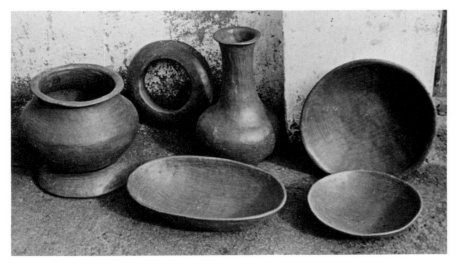

Oval-shaped platters called *bandejas*, plates, bowls, *floreros*, and ring-shaped tree protectors.

brother had demonstrated for us. However, it was made in several stages, as each successive section had to be set aside until firm before new coils could be added. By mid-afternoon, the finished height of 51cm (20″) tall and diameter of 61cm (24″) had been reached.

The Kiln

Argémido is very pleased with his kiln, which a cousin of his built for him 6 years ago to replace a smaller one. It is contructed of stones covered with adobe. It has a flatter dome than those in Campo La Vega, a front and rear entry, and no flues. The kiln, located in the back yard, is protected by a large, flat thatched roof held up by *guadua* poles.

Argémido tells us that they also make blackware by putting the pieces in large *canastas*, following the same process as in La Chamba.

Firing Schedule

Depending on the amount of work produced, they fire the kiln every week or every other week. A week's drying time must be allowed before a piece can be fired, so that greenware can always be seen drying in the sun or stacked on the porches. The kiln is loaded as in Campo La Vega and the ware is fired for 7 hours, during which time, more wood is added. Mostly *guadua* wood is used, which makes a very hot fire.

The Ware

The pieces made here are as varied as the market demands, including large sugar-juice containers, water jars, pitchers, vases, and cooking pots of all sizes. Many shallow bowls and flatter *tostadoras* are made for roasting coffee and grains. A cup of freshly roasted coffee is generally a welcoming gesture towards visitors throughout the valley, and much safer than the local fruit drinks which often are made with contaminated water. Another interesting form is a circular moat, made to be filled with water and placed in the ground around newly planted fruit trees to keep the ants off the fruit.

Marketing

Susana and Argémido put their ware in the hands of a stall owner at the market in Garzón who trucks, stores, and sells it for them when they are not at the market. She helps them establish a price for their ware and takes a certain percentage for her labor. They are good friends and have an amiable working relationship.

Acevedo

South from Garzón you travel on narrow, treacherous dirt roads that loop blindly, zigzagging up and down the steep sides of the river gorge. Along this one-way route, stopping places have been hollowed into the cliff so that one vehicle may stop and permit the approaching vehicle to pass. The government is just beginning a road-improvement project to make the area more accessible for tourism, since the famous San Augustin Archaeological Park is only about 96.5 kilometers (60 miles) away along this torturous route. A branch road terminates in a dead end at Acevedo.

Potter from Pasto

At Acevedo lives Peregrino Cuelton Chapuesgál, a potter highly skilled in the use of the wheel. He was born in Córdoba, Nariño, near Ipiales. Like the Santander potters, Sr. Campo from Popoyán, and others scattered throughout Colombia and western Venezuela, Peregrino learned his craft in Pasto. He was apprenticed to Ramón Santa Cruz at the age of 15 and worked in his shop for 15 years. For 21 years, Peregrino has been living in Huila. He knew that his old master, Sr. Cruz, died, but he did not know if the shop where they made mostly flowerpots and large earthen vessels is still producing.

For 20 years he has worked alone, except for his two sons, aged 12 and 14, whom he has trained to assist him, in his own shop in Acevedo. He was lured to Acevedo by a man who promised him work in a new shop here that made roof tiles and bricks. Before this, there were no factories of this sort in the lower part of the valley. After working for the man a short time, Peregrino decided to set up his own shop and work for himself. He supported himself by making drainage tiles and worked at the wheel when he had time, as this was what he truly loved.

A Family Workshop

Peregrino's home is named *Buena Villa* and he calls his shop *Cerámica Muñeca* (Doll Ceramics). The shop area is a partially roofed-over, 12m (40 feet) square courtyard. Against one wall are three wheels. Against another wall, as in Sr. Villota's shop, there is a calcining kiln for preparing lead battery parts. The kiln opening is bricked shut to build up heat, leaving 8cm (3") openings for vents. There is a smokestack to carry the poisonous fumes out of the yard.

Peregrino has nine children, four boys and five girls. The oldest son, 14-year-old Celimo, showed great interest in working with clay when he was 4-years old. He is now quite proficient at the wheel. Twelve-year-old Edelberto is just learning to use the wheel.

The two older boys, besides learning to use the wheel, are given two major responsibilities. They are expected to prepare the clay, which is dried and pounded with a 1.2m (4 feet) long club called a *masa*. After pulverizing the clay, they sieve it, soak it in water, and foot-knead it to make it ready for use.

Their other big job is to prepare glaze. The same grinding mill we have seen in Popoyán and in Ecuador is used here. The two boys take turns milling the lead with water. It takes 10 hours of grinding to prepare one batch. They grease their hands to avoid blisters as they turn the crank that is attached to a crescent-shaped grinding stone. The stone revolves smoothly in a well-shaped mortar of brick, stone, and cement. Copper sulfate made from copper electric wire is added to the glaze batch for greens, and rusty nails are used for the iron-oxide colors.

The Kiln

There are two kilns, a smaller and a larger one, for firing the ware. The large one is cylindrical, about 2m (7 feet) high with a domed top. It is built into a hillside, allowing wood to be put in on the lower level, while the ware is loaded on the higher side. A brick grate is built at ground level to hold the ware. There are two vent holes on the top of this kiln. This tall, thin cylinder is well designed for making blackware.

The smaller kiln is built like the large one and fires in the same manner, its capacity being about one-third that of the large kiln.

Firing. The kiln is preheated for 2 hours with small pieces of wood. Larger logs are introduced to increase the heat slowly. Firing takes a full 7 hours. For blackware, the pieces are stacked in the kiln very very loosely, and, as in Santander, green branches are put in the fire to produce a thick black smoke.

Tableware

Today Peregrino makes complete table services, mainly on special order. Many of the Peace Corps people and the towns people of Nieva order these sets from him. He makes up standard plates, soup bowls, cups and saucers, all thrown on the hump and glazed with brilliant copper greens and iron yellows. Of course, he uses the standard Pasto battery-lead glaze. His specialty is large Spanish baroque soup tureens and large, tall lidded jars with fluted rims (see Color Plate 22).

It is regrettable that Sr. Peregrino's talents were not discovered earlier by a greater number of people so that he could have been encouraged to produce more in this area. Like so many of his fellow craftsmen, when he works with the traditional Spanish forms and varies them, his sense of design and proportion is irreproachable, but when he strays from these established patterns to totally alien forms, all sense of design, form, and function seems to vanish.

He is constantly tempted to look for new ways to work and often falls into the trap of producing salable fad items. Because of this, he has neglected his own potential for developing new designs in the tableware field, where he excels.

Marketing

Peregrino makes his glazed tableware to fill the special orders he receives. Since many townspeople have admired this ware, he has also sent many of these pieces to nearby expositions, where they have sold well and won prizes. The tourist office features his ware, along with that from La Chamba and the studio of Sra. Vargas in Pitalito.

His glazed ware does not sell in the local markets. Several stalls in Nieva handle his "rustic" and new "modernistic" pieces, with mixed success.

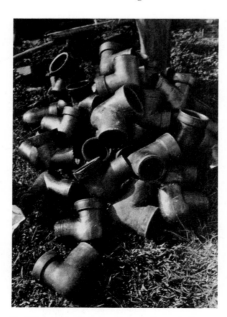

Sr. Chapuesgal makes these elbow drainpipes on the wheel. Each is made of one cylinder, which is cut and the pieces joined together.

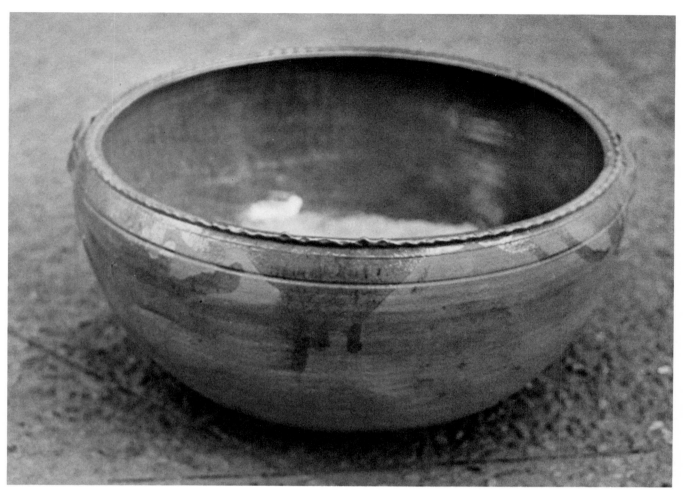

(Above) A 35.6cm (14″) diameter bowl made by Sr. Chapuesgal is glazed inside with a bright yellow lead glaze. A delicate fluted rim and a pair of horizontal handles have been added.

(Right) This soup tureen's body and lid have an undulating shape. The indentation on the body appears to be designed to carry the double curved handles. The glaze modulates from orange-brown to greens.

Pitalito

Pitalito is only about 32 kilometers (20 miles) from San Augustin, and although beautiful pottery in a large variety of forms is unearthed almost daily in the great archaeological park, very little of the early work is reflected in what is being done in the area today.

The closest work to it that we found is being made by a few families living in Barrera Contador, just outside Pitalito on the road toward San Augustin. The people here are making handbuilt ware for their local markets. Since Pitalito is famous for the commercial pottery of Sra. Vargas, it was merely by chance that we discovered the indigenous potters that work here. We saw a woman walking down the road, leading a small child by the hand and balancing on her head a large *olla* filled with water. We asked if she knew where the pot was made, and she pointed to a couple of houses down the road in one direction, and another house further down the road in the other direction, that we had already passed. Nothing would have indicated to us that potters worked here, and since we were not in the area on market day, we would not have been likely to see their ware. Again, the great question—how many places had we inadvertently passed where pottery is being produced?

A Kitchen-Pottery-Workshed

Señora Eugenia Las Plazas invited us through her home, which is very much like those in Campo La Vega, to see her work area, a long-roofed shed attached to the house and running its full length. One room of the house was piled high with stacks of completed ware which would be taken to the Pitalito market. The ware is sold only at this market or from the house.

The kitchen is a long wooden counter along one wall of the shed. Part of the countertop is lined with bricks upon which rest three bowls turned upside down and supporting a *teasto*, with fire underneath to roast the coffee beans. Over fresh coffee served in commercial white cups, we talked with Doña Eugenia and her lively family. Thirty large *ollas* were drying at one end of the shed. All had been made that week. At the other end of the shed near the kiln, which was still full of warm ashes, were 50 or more pots which had been fired that day.

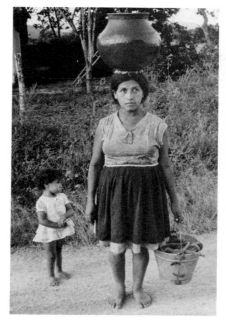

Water is carried home in an *olla*. A doughnut-shaped pad made of banana leaves cushions the round-bottomed pot.

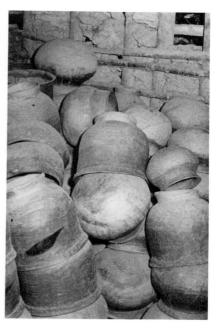

A pile of *maceteras* and *ollas* fills a storage room. The family will take them to the Pitalito market for sale.

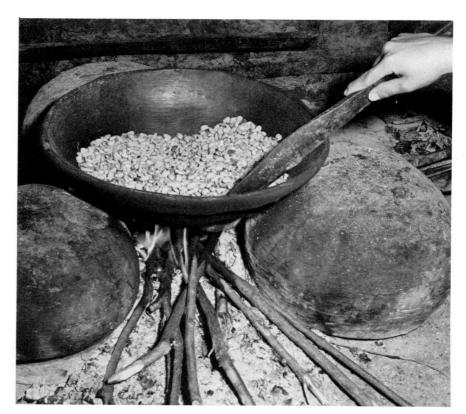

The platter for toasting corn is called a *teasto* here. The three pots supporting it would be pushed closer together to support an *olla* over the fire.

Handforming a Bowl. The pinch-pot techniques used here are similar to those of other communities nearby.

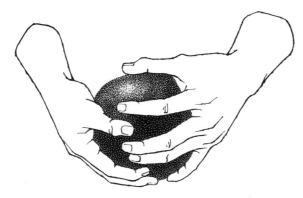

1. Angel squeezes and pats the clay into a ball about the size of a medium grapefruit, removing pebbles as he does so.

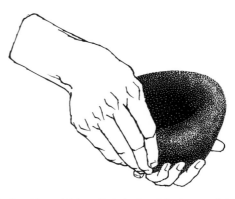

2. As if making a thick-walled pinch pot, he forms a fist-sized hollow in the ball.

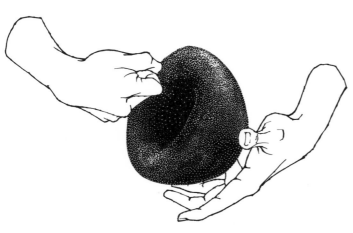

3. The bowl is tossed and turned in his left hand, while he punches the hollow with his right fist, thinning the walls and widening the form.

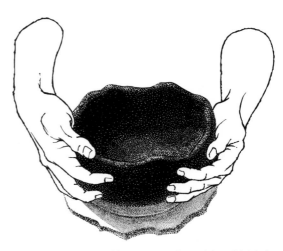

4. The roughly formed bowl is set on a pottery plate, which in turn is placed on a large shard. This will facilitate rotating the pot during formation.

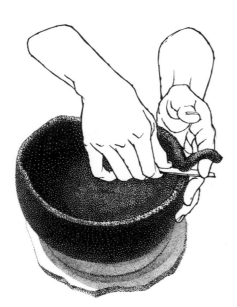

5. As in Claros, the pot is rotated and smoothed inside and out with a *tapara* rib. A thin, sharp piece of metal is used to trim the rim.

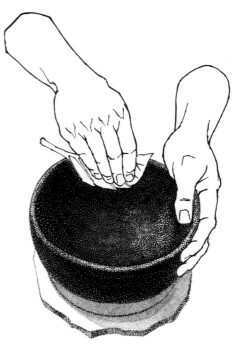

6. If the bowl were to be made larger, coils would be used. As in Claros, a wet leaf is used to round and smooth the rim.

Forming the Clay

Doña Eugenia and her daughter, Carlotta, make all the pottery here. Next door Rosana de Parra, her daughter, Blanca, and son, Angel, live. They also make pottery. They came over to talk with us, too. Angel offered to show us how their clay pottery is formed. Everyone laughed; it isn't every day that Angel will work with the clay. With great bravura, he grabbed the ball of clay his sister handed him—he worked standing up so he wouldn't get his pants dirty. He put down his coffee cup and began (see illustrations). The forming methods used here are identical to those used in Campo La Vega. From what I have seen, I would believe that these potters and the groups in Garzón, Campo La Vega, and La Chamba share remote community ties, because of the similarities of their work, their methods, and their kilns.

The Kiln and the Firing Procedure

Doña Eugenia's dome-shaped kiln is small, only about 1m (3.5 feet) high and about 1m in diameter. It has two ports and a small circular flue opening at the top. It is built right on the ground, next to her kitchen hearth. The firing methods are different than we have seen before, although the kiln is familiar. A wood fire is built in the kiln, and when it is very hot, a few pots are placed on the fire and more wood added to cover them. They are fired for ½ hour and then removed, and more pots are immediately introduced into the kiln.

Utilitarian Ware

We talked to them about which of the various forms they make are most in demand. They told us that these include the *teasto*, a large shallow bowl used for roasting coffee; the *bandeja*, an oval platter with or without handles used for roasting chicken and other meats in the oven and also used to serve salad; the *cazuela*, which has more vertical sides and two loop handles on the rim, used for frying such things as eggs and *plátanos*; the *olla*, used for rice, soup, and water; and larger water jars such as the one we saw balanced on the first woman's head. Plates, bowls, and pitchers are found among their tableware.

Vargas Muñoz Hermanos

Sra. Vargas, a trim, vivacious little woman, could be taken for a typical American suburban grandmother active in the crafts. Her work has brought her wide recognition in Colombia. Color photos of her pieces are reproduced on posters and in brochures, and her models of typical houses and costumed figures are displayed in store windows and shops all over the country. She and her married sons live in new American-type suburban houses in an area just outside the center of Pitalito's commercial section. From here, they commute to the factory and shop that she and two of her sons have set up in Pitalito.

Early Work

As a little girl, growing up in a *mestizo* family in Garzón, Sra. Vargas liked to play with clay. She tells us that she was always making little dolls out of clay, and that she enjoyed making dishes and other small things to use when playing with her dolls. When she grew up, she resumed her childhood pastime. About 20 years ago, she started making little model houses of clay with miniature people, animals, plants, furniture, everything needed to complete a small house scene, even to hammocks slung from tree to tree. People liked them, bought them, and showed them to other people, who in turn asked her to make more.

What started as a pleasant pastime turned into a profitable business. The little houses and figures won prizes at expositions. Tourist shops asked her to produce them in greater quantity. The items that she had made individually by hand are now produced in numerous press molds and then tediously assembled by hand and hand-painted with enamel paint.

The Barrera Contador *maceteras* have 19mm (¾'') holes around the base for drainage. Although its tulip shape is similar to its pre-Columbian predecessor, this one has a tall foot and a doubled-over rim added. Its surface finish cannot compare in overall quality with its earlier counterparts.

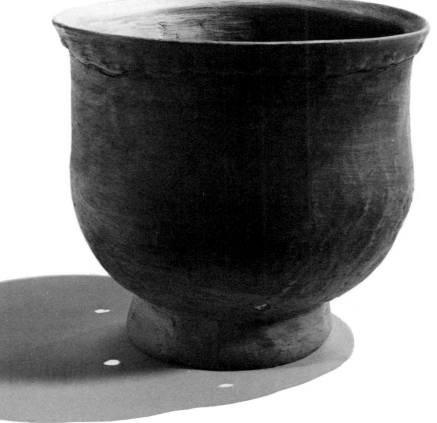

The Factory Work Today

The family moved to Pitalito 12 years ago. Sra. Vargas used to be helped with her production by her daughter, Cecilia, who now works independently in her home. Her sons Alfredo and Pablo do a great share of the work at the factory. Pablo worked in Carmen de Viborál for a while, learning the techniques of mold making and slip casting. All of the work done here now employs these techniques. Three young men and three young women are hired to keep up the production.

Hundreds of the tiny items are sprig molded. After firing, they are very carefully painted with tiny details and then glued together to form the scenes. Several typical rectangular and circular houses are made, and the size and amount of detail added make the piece more costly.

The piece that has brought Sra. Vargas the most fame is that of a dark-haired girl in a white dress carrying a basket of orchids. This model and groups of men with donkeys resemble the usual fare that one could pick up in any tourist shop. However, these

Sra. Vargas' sons have made several kilns for their thriving business. The small opening to the ware chamber in this kiln would make loading difficult if the pieces were not just piled in on top of each other.

are meticulously done, even to the tiny orchids that are individually molded and naturalistically painted.

Pablo and Alfredo are turning out a new line of slickly designed reproductions of what they consider to be a combination of modern design and Indian motifs. The pieces are stained rather than glazed, and the best that can be said about them is that they are technically proficient.

The Kiln.

A large, updraft wood-burning kiln of common yellow brick is soon to be replaced by a larger electric kiln. The brothers have built another wood-burning updraft kiln for their sister Cecelia who carries on the cottage craftsman's tradition of working at home where she can care for her young children and new home, as well as work in clay. In a pleasant roofed patio attached to her home, she makes the little houses and figures very much like her mother's. She also makes a lot of small, hand-modeled figures which could prove to be prototypes for new factory models.

(Above) Mold-made figures and baskets of tiny orchids have been very successful both in the domestic and tourist market. All the original models were designed by Sra. Vargas.

(Right) Carmen de Viborál does not use original dinnerware forms; rather, the handpainted designs give this tableware its interest. Yellow, pink, and green flowers decorate this soup tureen and platter, part of a complete dish set.

Northwest of Bogotá

To the northwest of Bogotá and due north of Cali runs the road to the Caribbean and the cities of Cartagena, Barranquilla, and Santa Marta. Along this route, we know of only three communities producing ceramics. Near Medellín is a center developed within century called Carmen de Viborál. Mompos in Bolívar is a community that is almost impossible to reach by road because of its isolation, and is really only accessible by plane. The other community is Lorica, again off the main roads, in the coastal lands of Córdoba.

Carmen de Viborál: Ceramics Factories

The story of Carmen de Viborál started in 1900 when a German con-cern began to build a ceramics factory in the city of Medellín. Two carpenters were employed to build the bench furniture for the factory. These men, who came from Carmen, were very interested in the ceramics plant, took note of how the operation was conducted and, returning to their homes, decided to set up a ceramics plant of their own, knowing that most of the raw materials necessary could be found near Carmen.

Now that Carmen de Viborál is becoming well known nationwide as a ceramics center, their original plant, run completely by water power, is in the process of being restored as a tourist attraction. Over the years more factories have opened in the area until now there are 14 larger ones and five or six smaller ones. It is hard to tell how many because they start up, fail, and others start from time to time. Each began by making molded and jiggered plain white bowls and plates. All the material necessary for white bisque ware is found nearby in mines and open pits which provide various grades of kaolin and ball clays, quartz, and feldspar. Lead oxide is im-ported from Mexico. The metallic oxides used presently are also imported.

Factory Expansion. The factories are expanding rapidly. The ware is sold out quickly and at fairly high prices. The gradual change from more primitive working methods to increasing mechanization presents an interesting study, especially in the largest and most successful factory, the Continental. Guillermo Rendón is now one of the owners and has been instrumental in its rapid conversion toward becoming more productive.

Spanish engineers have been brought in to develop new machinery for making the paste (which was previously trampled by horses) and to increase the plant's efficiency. Their 3.6m (12 feet) diameter, gas-fired, downdraft kilns are patterned after those in the original German factory in Medellín, Colombia.

Handpainted Dinnerware

Carmen de Viborál would still be known only as the country's source of cheap white tableware were it not for people like Señor Rendón. He is a

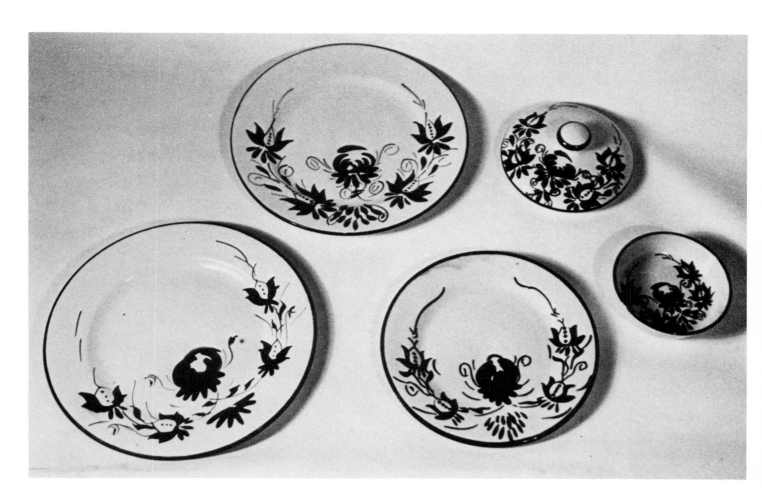

Like handwriting, a basic design will be painted differently by each decorator. Some will simplify the design, while others add flamboyant flourishes. Some paint a closely filled pattern, while others may spread the design out. Aficionados know the styles of the different painters.

salesman from Medellín. Every week he used to visit his sister who lived in Carmen de Viborál and became interested in the ceramic factories. When his sales office sent out Delft ashtrays with blue designs as gifts to the personnel, he noted the appeal of the design and wondered if handpainted work could be produced at the factories in Carmen. Six years ago he approached the factory owners with his idea and convinced them to try handpainted designs, offering to represent them in selling the ware. He opened a shop in the town plaza and began showing the ware in large cities.

An elderly man named Señor Pareja was one of the first to paint these designs. His early landscaped plates have already become collector's items. His flowers in pastel colors, whose stems meet at the center of the plate, became an instant success and called attention to the other original designs being produced here. The design painters are encouraged to try new patterns, and if a design proves successful, it is produced in quantity (see Color Plate 36). People in the cities regard the earlier pieces as being of great potential value because they are considered Colombian designs.

The dinnerware forms are still derived from Spanish models and it is

only the hand decorating on the ware that gives it any interest from the handcraft standpoint. Painters and designers are often enticed away from one factory by another. Sr. Rendón declares that he can tell this merely by looking at the painting on the different company's ware.

Lead-Glazed Ware

The ware from Continental is low-fired pottery. The maximum temperature is 955°C., and the lead glaze coating matures at only 593°C. Using a red lead caused serious health problems for workers and it has been replaced with a lead frit that they manufacture themselves, thus making working conditions safer for the 170 employees. Because of the lead glaze, the government will not permit general exportation of the product by the companies themselves. However, *Artesanías de Colombia* buys the greatest quantity of their output and exports it to Russia and Japan.

Future Expectations

Sr. Rendón looks forward to the development of a better product, the replacement of the lead glaze with more stable materials, and the production of high-fire ware. These changes

would enable Colombia to compete on the world market. His efforts are concentrated toward continual improvement of quality and design, and the controlling of quantity in order to produce a prestige item. To do this, more original forms than the present highly derivative ones will have to be developed. This should not be too difficult, considering the great progress that has been made in Carmen de Viborál in the past few years.

Lorica

Lorica markets its ware in an area of at least 389 square kilometers (150 square miles). The town, with approximately 12,000 inhabitants, is located in the north of Córdoba district on the stretch of land between Lake Charco Grande and the Caribbean. It is a hot, rainy, marshy area with poor, unpaved roads, but it is an important agriculture and cattle-raising region. Archaeologically, this area is noted for one of the oldest cultures in Colombia. The Momil people who lived in this area only began making pottery about 800 B.C. The old ware is mostly round-bottomed vessels. Some were made with flared feet so that they would sit level. The simplification of form and surface decoration, both incised and painted on these ancient pieces, is not seen in the contemporary ware, which is, however, well formed.

Driving northward through Antioquia along the Cauca River, we saw a woman balancing a large amphora-shaped water jar on her head. A ring of red cloth helped cushion and balance the round-bottomed pot. She told us she had bought the pot in Caucasia, a town near the Córdoba-Antioquia border. Traveling further north and stopping to see weavings in San Jacinto, Magdalena, we found several of the same water jars, and heard that they were from Lorica.

The Pottery Forms

In Cartagena, we located the man who markets the pottery from Lorica. He showed us a shack filled with pots in a great variety of sizes and forms, all from Lorica. The ware is handbuilt using coils and fired on the ground. The clay body is a reddish orange. The *greda* coating is burnished to a light luster, and is enhanced by handsome, dark fire marks. Some pieces have bands of incised, curved linear designs at the transition point between

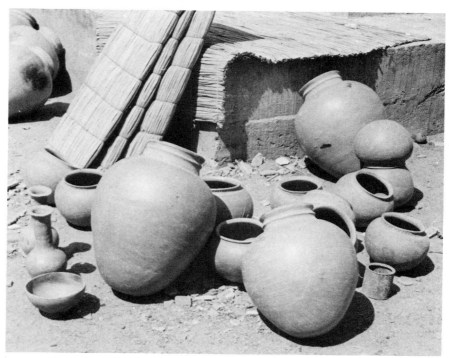

Lorica pots are built from coils. On most pieces the neck is thickened and emphasized with a prominent ridge below the lip. A looping line gives more emphasis to the upper area of the pot. Black firemarks spot the burnished surfaces.

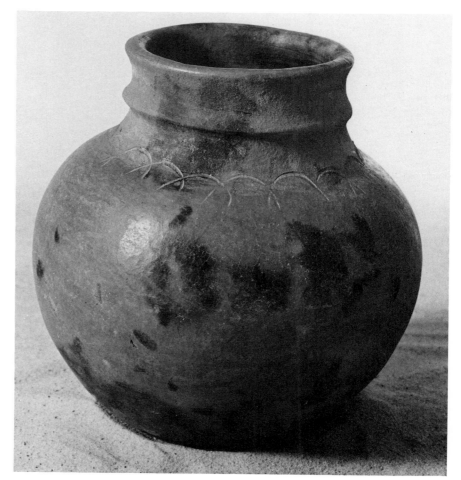

Ware from Lorica is found in many markets in northwest Colombia. The most common pieces are *cántaros* and *ollas*.

shoulder and neck. The majority of pots are different-sized water jars, spherical cooking *ollas*, footed bowls, flower pots, pitchers, and vase shapes. Most of the pieces have rounded bottoms except for a few forms where a footed rim has been added.

Boyacá: Ráquira

When the Spaniards reached the Bogotá plateau, they reportedly were very impressed with the Chibcha Indian culture they found. All that remains is some pottery and fine gold work. Two major groups lived here in the 16th century: one centered near Bogotá, and the other to the north, near Tunja. Little comparison can be made between the fine examples of pottery that remain from those ancient craftsmen and the numerous potters who are working today in the same territory.

There is today a high percentage of Indian blood in the population of Boyacá Department, and a few pottery-producing communities still exist. As in Indian populations encountered in several other South American countries, the women here have adapted the men's style felt hat to top off their costumes, which generally consist of cotton-printed dresses and handsome macramé-bordered black shawls. Usually, they go barefoot. The men wear standard factory-made pants, shirts, and jackets, but often one sees them wearing the locally made poncho, here called a *ruana*. Boyacá is more renowned for its weavers than for its pottery.

The Bogotá pleateau, where all of these communities are located, is between 2,400 and 2,700m (8,000 and 9,000 feet) in altitude, which means that the climate is generally that of a cool spring day and the nights are cold. There is abundant rainfall which keeps the hilly landscape a lush green, and is excellent for cattle and crops.

Ráquira became noted for ceramic toys and nativity figures that were sold to the people who journeyed to Chiquinquirá for the festival held there each December. Pilgrims, coming by the thousands to honor a picture of the Virgin whose faded colors were miraculously restored by a woman's prayers, purchased the ceramic souvenirs.

Ráquira's Artesanía Center

Artesanías de Colombia, hoping to increase and advance the ceramic production of Ráquira, has established a center in the village. The center has not had the great success of the one in La Chamba. This may be partly because the Ráquira village ware does not have the contemporary utilitarian qualities common to La Chamba.

The *Artesanías* personnel have built a handsome oil-fired kiln and have been teaching its use and the production of nontoxic higher-fired glazes. Potter's wheels are there, too, but we hear that the Ráquira potters do not like working at the wheel—we are told that they do not have the patience to learn this skill. So far, the local citizenry has not adapted the kiln or glaze ideas either. The school has had no noticeable effect in producing an awareness of good design. In fact, it can be said that in general, wherever

the center has had an effect, the designs have had a tendency to degenerate.

The most positive result achieved by *Artesanías de Colombia* in Ráquira is the recognition of the community as a ceramics center and the consequent sale of quantities of decorative folk ware from the community. The center probably has been influential in increasing production methods and in increasing the market for Ráquira products.

A permanent collection of the best Ráquira ware has been accumulated by the successive directors of *Artesanías de Colombia* and is on display at the center.

What is regrettable is that good design principles have not been taught, and that even the small selection of good ware at the center does not seem to inspire more of the same. Some of the village work is colorful and of interest as folk art, but the introduction

This impressive high-temperature oil-fired kiln is built on the patio of the *Artesanías Center* in Ráquira. This type of kiln has not been adopted by any of the local potters.

of foreign influences has made the work more vulgar and less meaningful. Shops in Bogotá are full of large, molded planters from Ráquira, with the insipid restylized Chibcha Indian face, decanters, ashtrays with the Chibcha motif, and such things as the ubiquitous hanging lanterns with poorly designed pierced openings and clay chains.

Two Groups of Potters

To discuss the Ráquira ceramics, it is necessary to note the division that exists between the potters from the countryside, or *campo*, who produce the utilitarian ware for use by local people, and the ceramists who create for the tourist trade and city dwellers. This duality can be seen most clearly in the marketplace.

Marketing Pueblo Viejo Ware. Most of the people who make the cooking ware live in Pueblo Viejo, a community in the hilly country between Ráquira and Chiquinquirá, a good 2 hour walk from the nearest road. The potters trundle huge bundles of ware on their backs to the road. Here the bundles are loaded on trucks, or on the tops of buses, and carried to the many area markets.

Often, as with other potters who live great distances from the village, an agreement is made with someone living near the markets to store the ware and sell it on market day. The same people can be seen on different days in different towns selling their ware.

Pueblo Viejo ware is found in the markets in Ráquira itself, in Chiquinquirá, in Tunja, the capital of Boyacá, and in other smaller communities.

The Sunday Ráquira market is set up in a dirt square in the center of town. On rainy days it becomes a very muddy and disagreeable place.

Everything is set up in rows and piles on the ground. The pots, which are wrapped in ferns and loosely knotted rope nets, are nestled in the ferns on the dirt. The town has become a Sunday attraction for people from Bogotá and other nearby towns. This is reflected in some of the pottery brought to this market. Some of the *campo* people were selling bird-shaped banks and fancy flasks along with the cooking ware.

The Pueblo Viejo pieces have distinctive characteristics that make it stand out from any other pottery we have seen. Its color ranges from light orange to pale grayish pink, and it is decorated with a thin, brown slip. The larger pieces especially have a very course, pitted texture with pebbles and particles of white clay and grog dotting the surface, and holes where they have been scraped away. The outer surface is scraped to form the proper contour and left with a texture of planes and ridges made by the forming tools. Several shapes predominate: the *olla*, principally used for cooking the rich vegetable and meat soups that are a staple of the area diet, two types of pots used for frying meat and *plátanos* and for toasting beans or corn, and pitchers (see Color Plate 12).

Pottery Shops in Ráquira

The streets that border the market square in Ráquira have a number of stores where one can buy the figurative and decorative ware made in the town. Streets running from the square are lined with the workshop homes of the town potters. The potters often have a room with shelves and cases of their ware set up at the street entrance, where they would like the tourists to step in, see their ware, and buy it. One seldom sees the *campo* type of pottery here. The shelves in different shops are filled with decorative figures that vary in quality and in the amount of hand versus molded work.

The few people that are making basically the same *campo*-type pottery, with some other styles of flasks, cups, saucers, bowls, some glazed in lead greens and yellows, tend to be suspicious of strangers. One woman told us we could enter her shop only on condition that we buy something. She let us see where she worked and reluctantly showed us her kiln, but warned us, seeing our cameras, that we were not to take any pictures. A neighbor of hers had died just days after a stranger had taken her picture, thereby stealing her soul. Another friend's kiln would never work right after someone had taken a picture of it and stolen its soul. This is not an iso-

Next door to the *Artesanías Center* is a typical wood-fired Ráquira kiln. Covered with shards and topped by a tile-roofed flue, it reflects the last cultural invasion, the Spanish conquest.

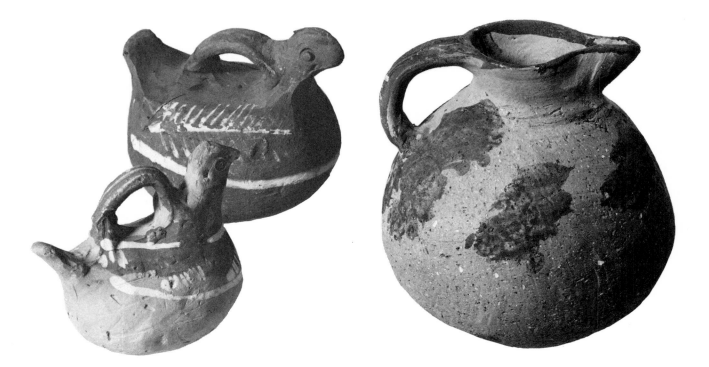

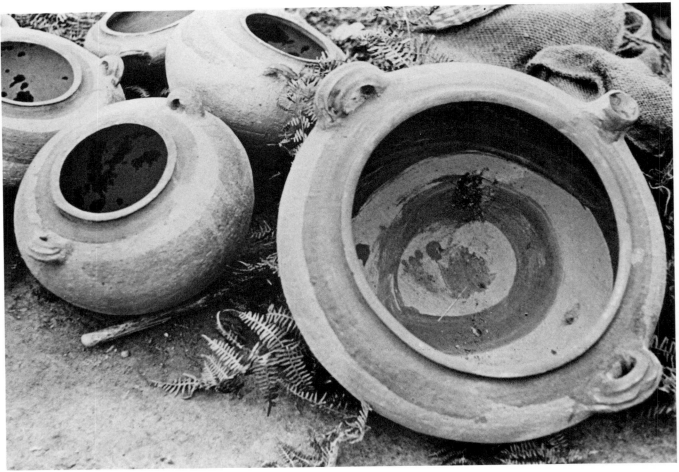

(Top left) Sculptural bird banks come to Rá-quira market from the *campo*. They are deco-rated in white and warm-brown slips on a base clay that varies from grays to pinks. The largest bird is 12.7cm (5") long.

(Top right) This modest-sized pitcher is 22.8cm (9") high. The same 7.6cm (3") diameter neck and spout would be formed on a pitcher double its size.

(Above) At the market a group of *ollas* and other pots is nestled in ferns on the ground. The 35.6cm (14") diameter pot on the right is designed for deep-fat frying. Two handles and a spout make it easier to pour the fat into storage containers.

lated example of the strong suspicion and fear of strangers felt by many people in remote areas of South America. We found it in Indian-dominated populations in parts of Venezuela, Peru, Ecuador, and Bolivia.

National Recognition

Several years ago, the town received national recognition for the small, sculptured Ráquira horses (see Color Plate 7). This sturdy, thick-necked, short-nosed animal was decorated with incised lines to represent the mane and tail and had tubular, pressed-ring incisions as eyes, nostrils, and reins. He was generally a molded piece with a few details and, occasionally, a couple of water jars done by hand and mounted on his back.

Today the popular item is an armadillo or tortoise bank. Thousands of them have been marketed by *Artesanías de Colombia*, both within the country and abroad. Many of the village shops are producing them and making their own molds with slight variations in the design on the animal's shell.

Reyez Suarez' Shop

We asked the people at *Artesanías de Colombia* for the names of several potters whose work was representative of current trends in Ráquira. The first person they all agreed we should meet was Reyez Suarez. He, we were told, is the man who dreams up most of the new, original ideas that everyone else in Ráquira ends up copying. The armadillo, the tortoise, and many of the ideas for nativity figures are said to have originated with him.

Reyez Suarez lives on one of the streets that leads to the main plaza. His display room was filled with figures on ashtrays, armadillos, and pitchers when we arrived. His workshop, like most work areas in Ráquira, is a courtyard with roofed porches around it.

Kilns

There are three kilns in the courtyard. The larger one is his, and the two smaller ones belong to his sons and a neighbor. All the kilns in Ráquira are wood burning, updraft, made of adobe with ceramic tile roofs and tall chimneys capped with ceramic tile. The shape can be cylindrical, square, or rectangular, and the fire box and entry to the kiln can be post-and-lintle construction, Romanesque, or gothic.

Original Decorative Ware

Sr. Suarez is very proud of his work and showed us the intricately de-

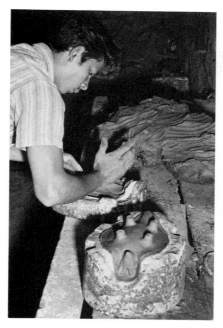

Here, Sr. Suarez's son presses clay into the bottom half of an armadillo mold. In the foreground, the bottom molded piece has been released from a mold and pressed onto the upper shell half while it still rests in the mold.

A potter sits on his porch brushing shellac over the bare clay surface of an armadillo. In the basket are the armadillos that have already been stained with shoe polish.

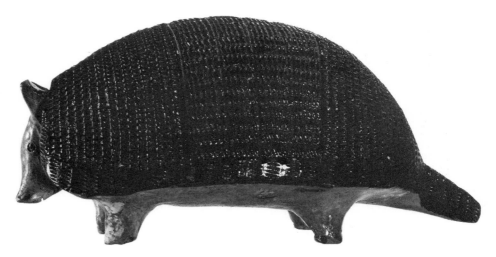

The popular armadillo bank is formed in a two-piece mold, painted with shoe polish, and shellacked. *Artesanías de Colombia* markets the armadillo throughout Colombia and internationally.

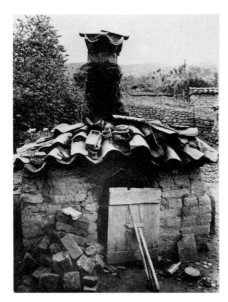

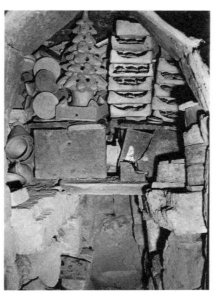

Sr. Suarez's kiln is made of adobe, stone, and brick. The wooden door is propped in front to protect the greenware inside from sudden rainstorms before the entrance is ready to be bricked up. The interior is about 1 cubic meter (30 cubic feet), and wood can be fed into it from openings on both sides.

Kiln shelves, brick supports, and saggers are used to stack ware in Sr. Suarez's kiln. These are devices he learned to use at the *Artesanías Center*. The Christmas tree will be glazed a bright green and wired for an interior light.

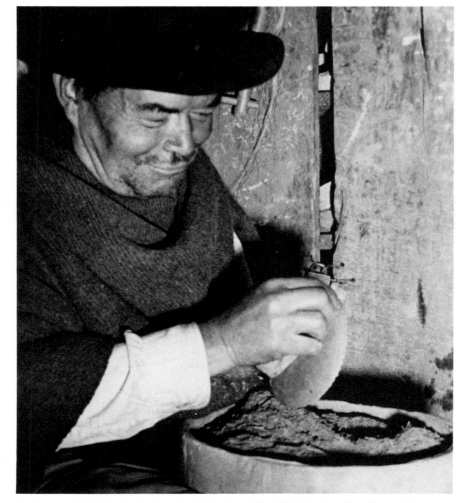

Sr. Suarez polishes the back of a sprig-molded medallion. Whether intentionally or not, the potter's good-humored face appears on many of the modeled figurative pieces he designs.

signed, hand-modeled figures he was making, the Chibcha medallions and other pieces. A new form he is quite pleased with is a penguin pitcher with a cap for a lid.

A Family of Potters

Sr. Reyez' wife makes pitchers in the same manner as those from the *campo*, except that she adds a rimmed foot to her pieces. They are two very amiable people, happy in what they are doing and quite pleased with their position in the community. While we were there, their son and daughter-in-law were listening to a transistor radio and pressing wads of clay into dozens of armadillo molds.

Pottery Shop of Sr. Lorenzo

Just two doors down the street from Sr. Suarez lives Rodrigo Lorenzo. He is a younger man than Suarez, and his children are all under 12. The oldest boy helps in the work, as does his wife. They have a tremendous output of large, molded planters with faces, chain earrings, and some with an all-over hobnail texture. These have a tendency to be grotesque, but he sells all he can make.

He is considered to be another town innovator, which seems to mean that when Peace Corps personnel were here he learned to make pierced, hanging lanterns and produces them in great profusion, too.

While we were there, the family was busy building up their stock of nativity figures for the approaching Christmas season. All the pieces in these groups are made in a variety of molds. The face is made in a sprig mold, the body in two press molds. Stands and other parts are molded. A lot of the accoutrements, including arms and hands, shawls and ponchos, are modeled by hand. Mary has a shawl over her head topped by a fedora hat; Joseph wears a fedora and a *ruana*, or poncho. The kings, however, are bearded and in what is considered oriental robes and crowns. The baby is molded on an Italianate figure, and the barn animals also look alien to Ráquira. The most animated figures in the groups are the locally dressed clay peasants who carry gifts of pottery, wood, musical pipes, chickens, and lambs.

New versus Early Ráquira Figures

On Sr. Lorenzo's shelves one finds among these more contemporary figures groups and single figures that are reminiscent of the older work that must have been done here before outside influences descended on Ráquira.

A tall, thin figure of a woman with

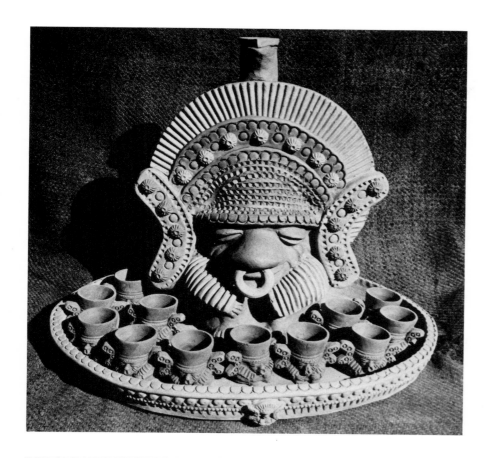

Sr. Suarez modeled this decanter, tray, and cup set. It is a combination of molded and handbuilt parts, decorated with sprig-molded pieces, pressed designs, and incised lines. The face is a self-portrait.

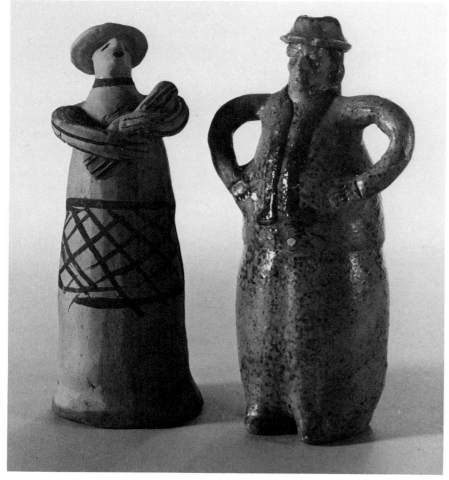

Two types of early-style Ráquira figures are made. The one on the left is completely hand-modeled, with slip-painted lines as an important decorative element. The glazed figure is also handmodeled, with a sprig-molded face.

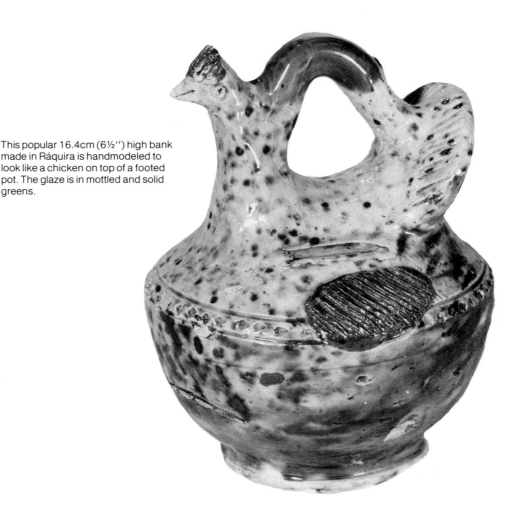

This popular 16.4cm (6½'') high bank made in Ráquira is handmodeled to look like a chicken on top of a footed pot. The glaze is in mottled and solid greens.

rudimentary head and arms, clutching a bundle of bread, has very little distinct modeling except for the hat on her head. It reminds one of the *bruja* figure from Ayacucho, Peru, even if it lacks the paraphernalia of witchcraft. Simple crosshatch lines and consecutive stripes of red slip are its only decoration. Other simple groups of plowmen and oxen or people feeding chickens and sheep are similar in feeling to the figurative groups we found in Huayculí, Bolivia, but not as imaginative or as well done. These groups are generally colored in the green, yellow, or brown common glazes, sometimes with interesting flecked textures.

Nativity scenes on a plaque, or farmyard and house scenes made on a dish shape, are made here as well as in other local shops. It is only after seeing the older ware made here before outside influences were imposed that one realizes how the work has deteriorated. The ware ranges widely, from the older community's simple, heart-felt works to the newer pieces that are too brash and commercial. In the nativity figures, for example, the intricately detailed faces, although interesting, are almost simian when compared to the more simple handmodeled faces of the Ayacucho nativ-

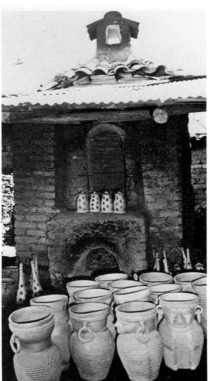

Sr. Lorenzo's large rectangular kiln is made of brick and topped with a tall, tile-roofed flue. Ready to be fired are his molded Chibcha-motif planters and pierced lanterns.

ity figures, which present an appealing expression of awe and wonder.

A Working Studio

Stepping into Rodrigo Lorenzo's courtyard, we passed rows of armadillos, tortoises, and large planters out drying in the sun. The older son was carrying planters to and from his mother as she rolled out clay coil earrings and applied them. Another boy was seesawing a length of burlap back and forth to screen the dry, powdered clay which fell in front of him in a large, sifted pile. Concrete settling tanks are nearby. Two large kilns dominate the yard, covered with corrugated-metal, shed-type roofs. One large, cylindrical kiln had dozens of figures and banks in front of it, ready to be loaded. The other, a large, rectangular gothic affair with arches and buttresses, was flanked with lanterns and planters.

Flowerpot Production

Miguel Suarez, brother of Reyez, lives directly across from the *Artesanías Center*. He has been in the production of flowerpots and planters for over a year and is very proud of a recently acquired press mold made in Ger-

many. It turns lumps of clay into commercial flowerpots as quickly as his daughter can dip the clay into a pot of oil, place it in the machine, and catch the released pot. Miguel prepares the clay, kneading and shaping it into piles of balls to feed the machine. Meanwhile, his wife presses wads of clay into the familiar figure-planter molds.

Toy Pottery

Martín Laurién has no kiln. His wife sits in the patio beside a large block of wedged clay and a pan of water. Her hands deftly and quickly form dozens of tiny doll-sized pots, each with handpulled handles. They will sell masses of this ware in the crude state for someone else to fire and sell.

Uneasy Future

In the yard of the *Artesanías Center* is an immaculate red-tile floor. On this is a large whitewashed, oil-fired catenary-arch kiln. On the other side of the wall, in a potter's muddy yard, is a cylindrical kiln with a dome-shaped top. Broken red-clay tiles are mosaicked into its surface and a tiled chimney rises about it. Most of Ráquira is figuratively straddling this wall, not having wholly left its traditional past, and is now moving clumsily towards a more technologically advanced future. Guidance in design-function orientation is sorely needed to help these people gracefully bring the integrity of their earlier work to their present-day attempts at tourist-oriented production.

Sogamoso

Northeast of Tunja, capitol of Boyacá Department, is the town of Sogamoso, called the Gateway to the *Llanos*, as it is the last large center on the paved road that runs on the edge of the great plateau. From there you move eastward over great cattle-grazing plains, down to the jungles of the Oriente. The Sogamoso market reflects the life of the region. Herds of cattle are driven or trucked here for sale. Mounds of raw wool take over a large part of the market. This is where the famed weavers of Nobsa come to select their material.

A Weaver's Market

Handwoven blankets and *ruanas* are piled in one section of the market. The

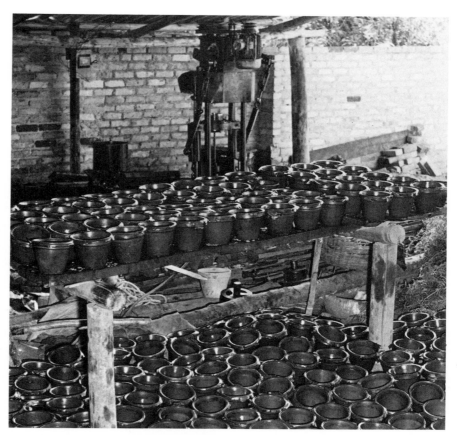

The first mechanized piece of pottery equipment in Ráquira is Miguel Suarez's German-made press mold. His production consists primarily of flowerpots made with this machine.

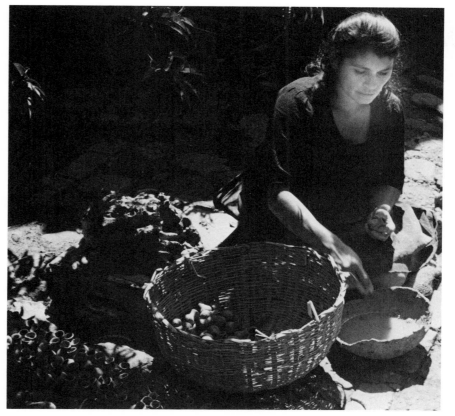

Toy pottery is sold both at local markets and as tourist items. Sra. Laurien deftly turns out hundreds of handformed cooking pots and tableware in miniature, many with tiny pulled handles.

traditional men's *ruana* in gray, black, and white natural yarn, woven in striped or checked patterns, are plentiful. The blankets and women's *ruanas* tend to be much more colorful. Saddle blankets and hemp bags for produce and pottery are among the other handcrafted items found in this market.

The Potter's Market

The pottery comes from three separate areas and all of it is sold by professional vendors—not by the potters themselves. Ráquira is well represented with its traditional cooking and storage pots. Another area represented presents smoothly polished, handformed redware, and the third type sold here is well-formed wheel ware in bright lead glazes or painted with enamels. The vendors were reluctant to tell us the source of their ware. We spoke to several of them and were given all the directions of the compass in answer to our inquiries. After several fruitless journeys, we were finally able to meet the potters who supplied this market.

Morca

Morca is only 12 kilometers (7 miles) out of Sogamoso. On a narrow dirt road that winds upward through beautiful grassy and wooded hills, you pass many home brick industries and small coke-burning operations. All the people we asked along the way knew where the potter Luis Antonio Angel lived. We were directed to a house perched on a green, well-grazed hill, far above the road and accessible only by a burro path. We arrived mid-afternoon to find the family at work.

We walked past rows of large *ollas* and *maceteras* placed outside to dry in the sun. All were exceedingly well-formed wheel pieces, rising gracefully to a swelling shoulder.

Sr. Angel was kneading clay on a stone wedging table set up on the porch of his workroom. His wife was in the patio in front of the porch, on her knees, pounding the dry clay into fine particles with a wooden club. Their daughter was taking care of household chores, and her two small daughters delighted in grabbing small sticks and helping their grandmother beat the clay. They were a friendly, gracious family and were pleased to

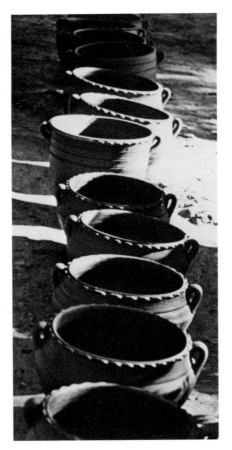

Rows of similar-sized *ollas* and *maceteras* recently formed on the potter's wheel are placed outside to dry. Neck, rim, and shoulder treatment varies on these pots.

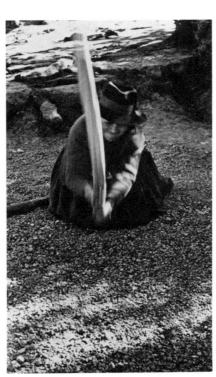

Sra. Angel uses a wooden club to pulverize the clay before it is soaked.

show us their methods and the few crude pieces they were working on for the next firing. All their finished work had been sold to the people who market it for them.

Wheel Production

Sr. Angel has a wooden kick wheel set in the corner of his adobe workshop, which is one of the rooms attached to the adobe-walled, tile-roofed house. He throws rapidly off the hump, his forms and techniques being similar to those we saw by all the potters who came from the Ipiales area! He told us he learned pottery techniques as a boy from his father, who was born here and had learned in turn from his father. Further than that, he does not know. Two other potters live in the Morca area, further back in the hills, and do not produce as much as he does, says Sr. Angel, but they too use the same wheel methods and produce the same type of ware.

The pieces produced here are mainly cooking pots, pitchers, soup bowls, coffee cups, and some plates and platters. The soup bowl is most important because it is the main individual eating dish. Flower pots, small piggy banks, and doll dishes are also made in great quantity.

Decorating the Ware

Most of the flowerpots and decorative toys are painted in enamel color—silver, blue, red, and yellow being favored. Soup bowls are glazed with a splash of plumbate in the bottom and around the rim. The foot is set way in and trimmed with a tool formed from a piece of band iron.

One of the favorite ways here to decorate coffee cups, goblets, and some larger pieces is with a simple flower design painted with red slip. This is then covered with a clear plumbate glaze.

A Two-Chambered Kiln

Sr. Angel's kiln is a strange one. From the front we saw two adobe, beehive-shaped sections, lined with brick and joined at right angles. Each has an arched doorway and above it a large, triangular-shaped vent. We went downhill to the back of the kiln which has a square adobe-brick room with a tile roof. The floor level of the room and firing chambers are below the ground level of the kilns. The wood for the firing is kept dry here, conveniently near the stoking chamber, which heats both sections of the kiln at once!

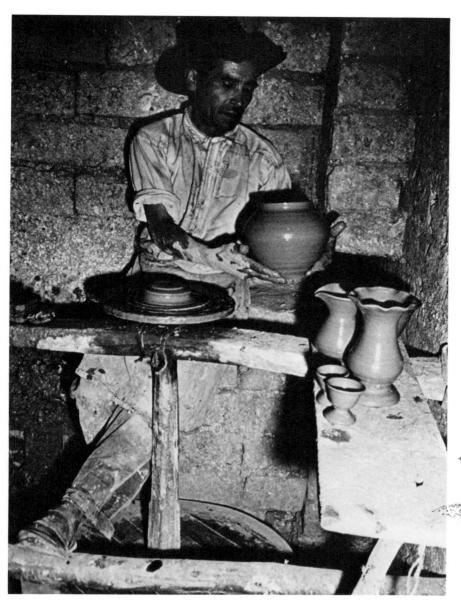

Sr. Angel sits to the left of his wheel shaft and throws off the hump. The ornate forms made here are similar to those made in Popoyán, Santander, and the Lomas Bajas area of Venezuela.

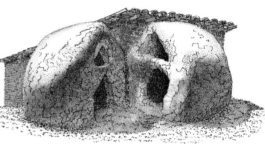

(Above) This unusual double kiln has two ware chambers, heated with one firing chambet whose port is below ground level on the back in a tile-roofed adobe building.

(Left) Soup bowls are a common production item in Morca. These are turned over and footed on a clay chuck. The yellow lead glaze is sloshed on the inside and allowed to spill haphazardly over the outside.

Tutazá, Tuaté

It was much more difficult to find the community that produces the redware for the Sogamoso market. We tracked down the vendor's storeroom, which was in the small town of Belén de Cerinza, north of Duitama. We asked directions for finding the potters whom they bought from and realized only after we had contacted the potters, why the vendors had had such a difficult problem in trying to tell us how to get there. We were first directed to the village of Tutazá, further north on hilly, narrow dirt roads. The people here are somewhat isolated and reluctant to look at or talk to strangers. It was finally through their lively priest that we came to know these shy potters.

Tutazá

Padre Luis Millen told us that the hills around Tutazá were loaded with thousands of people who make pottery, which may have been a slight exaggeration. He offered to take us to a few of the more accessible houses. Dressed in his long black robes, a black hat, and high-laced boots, this elderly gentleman led us on a strenuous hike through the hills and valleys that surround his village. From the one-way dirt road, the land sweeps down to low, narrow valleys. Rising sharply on the other side of the valley, the hills are dotted with small, natural-adobe-thatched-roof houses that look doll-sized from the road's edge. At 2,400m (8,000 feet), Padre Millen led us on a swift hike towards the houses. Sounds carry with remarkable clarity across these valleys and it was only necessary for the Padre to raise his voice slightly to notify people 400m (¼ mile) away that we were coming. Doors began opening and people popped out from behind houses to reply. One house stood in a recently excavated angle on the opposite wall of the lush valley. The naked red-clay soil contrasted sharply with the thick green turf. A wing was being added to the house. It was a simple operation. The clay under the turf was dug out, formed into bricks, and lined up to dry in the sun. In a few days, they would be laid up with clay to form walls.

The potter who lives in this house in the Vereda el Alizal, as this cluster of houses is called (a *vereda* is a foot path, or the complete route of traveling preachers), is named Filomena Gallo. She was pleased to see Padre Millen. The people in this *vereda* are so poor that the subsistence level is difficult to maintain. The women make and sell pottery as a necessary means to help provide food for their families. Filomena, a young mother with four children, smiled shyly and at the Padre's urging showed us her skills.

Filomena's Work Area

Filomena's house is set into the hill. Between the wall of the hill and that of her house is a 1.2m (4 feet) wide passageway that once contained the clay material of her house. We could sit on the grassy slope and touch the thatching spread on the thin sticks of the roof. In this passageway Filomena works. A large, flat stone raised about 46cm (18″) from the ground is her worktable. An old, broken pot holds her water-soaked clay. Her pottery clay is a medium gray, unlike the soil around her house, and is dug in another area.

Forming the Clay

Filomena took a grapefruit-sized ball of clay from the pot and, calling for

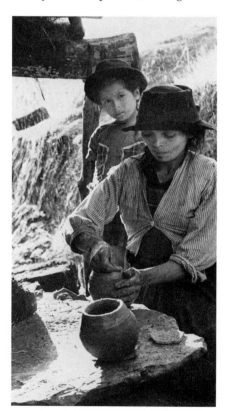

Filomena forms her pottery from a ball of clay placed on a pot shard. She turns and hollows the bowl with both hands, as if making a pinch pot. Wads of clay are added and smoothed with one wet hand, while the other hand turns the pot.

her daughter to bring her a bowl of water, she started to knead the clay in a hollow section of the stone. It took only a couple of minutes to raise a smooth 15cm (6″) high form. Filomena makes all her pottery this way, the largest cooking pots as well as small bowls and pitchers.

Prefiring Storage

She had no pottery to sell that day. The family had been very busy cutting clay earth blocks to make a new room, and she hadn't produced enough ware for a firing yet. She took us into her small house, a combination kitchen and sleeping room. Storage jars stood along one wall and sleeping platforms along two others. A ladder led up to a platform made of the same thin sticks that are used to support the thatched roof. This platform was loaded with her crude pottery, waiting here, protected from the rains, until the day she could fire it. Platform and pots were glazed with the greasy smoke that rises from her cooking fire below and filters up and out through the thatching. When she had enough ware for a firing, she would carry it to a depression hollowed into the hillside, cover it with wood and set it ablaze.

Other Tutazá Potters

We walked past another house where the woman is now too old to make pottery. She told us that her firing site had not been used for several years. At the next house we visited, chickens and pigs scampered about the yard and porch, indicating the greater prosperity of the people who lived here. This potter's clay was dry and it would be the next week before she would prepare it and begin a new batch of pots.

A Sporadic Work Schedule

Clearly, pottery making is not a seasonal thing in Tutazá. Rain is plentiful all the time and the growing season extends throughout the year. The women, who are the potters, work sporadically when they have time, producing enough for a firing and selling the whole lot to the market vendors who come to pick it up.

A Native Guide

The next day, Padre Millen brought Edwardo to our door early in the morning. Edwardo's wife is from Tuaté and he was on vacation now from a job and his schooling in Bogotá. He was glad to take us to friends of his wife's family who are part of a potting community back in the hills of the Vereda de Tuaté. Now we began

to understand why the Sogamoso merchants had such a difficult time explaining to us where to find the potters, and why some gave us one set of directions and some another.

Tuaté

Tuaté is between Belén de Cerinza and Tutazá. We took the road from Belén and went to within 5 kilometers (3 miles) of Tutazá. Here there is a parking station, just a slight widening in the one-lane road where a vehicle can park. From here, a gradually narrowing trail leads to the community called Tuaté.

The climate was like mid-May and we walked for two hours through a bucolic, green, hilly landscape. The path led through alleys between adobe walls built to separate one man's field from his neighbors. As the path dipped into valleys, we inevitably had to cross streams on stepping stones. Willows dipped their branches to the ground, cows grazed nearby, whitewashed adobe houses were snuggled into the hillsides here and there, and still we walked on through the hills. Finally, we approached an area where Edwardo pointed to a group of scattered houses, telling us that potters lived there. We came at last to a cluster of houses built close to the path. On houses built on the slope below the path, we could clearly see how broken pots were used to hold the roof thatching together at the ridge. On the uphill side, we faced porches hung with flowering plants, and patios and passageways lined with stones set on edge to make level areas. Everything was tidy and orderly, a neat hidden world. The people greeted Edwardo with a smile at each house we approached. Most of the people told us that they were not making pottery that day, that their clay was not prepared, and they directed us to houses where they knew that people were working.

Miguel Arala's Ware

At Miguel Arala's house we saw a large pile of finished ware stacked in a corner on his porch. It would be loaded on burros and taken out to the road to be trucked to town. Among the pots we saw *ollas* and other cooking pots, footed vases with wide, low bellies and long thin necks flaring out at the rim, soup bowls with a variety of handle treatments, coffee mugs, flowerpots, pitchers, ashtrays, and candelabra.

Miguel's mother does most of the pottery work, helped by her daughters. They had just finished firing this batch of pottery. The mother was out,

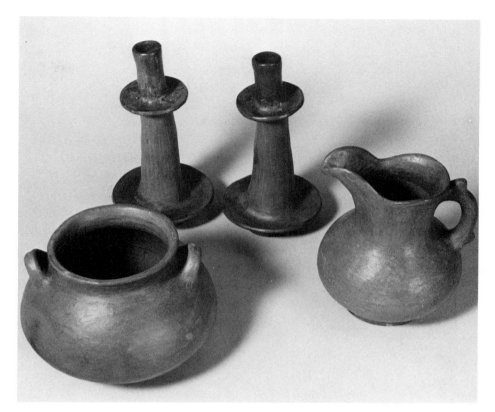

Many of the pieces show strong Spanish influences. The pitcher, with its knob-decorated handle and curved spout and rim, is a good example.

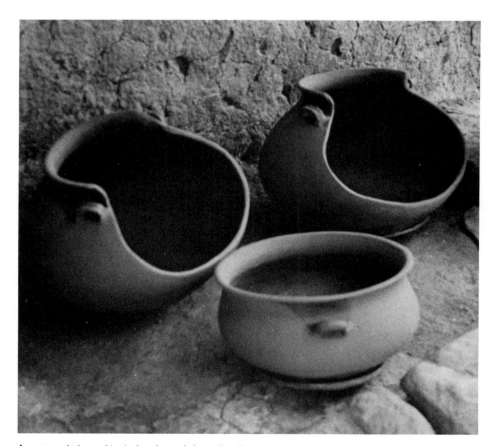

An unusual-shaped *tostadora* is made here. It is like an *olla* with a curved cross-section removed. Red *greda*, painted and burnished on the outside, contrasts strongly, when wet, with the black base clay of the interior.

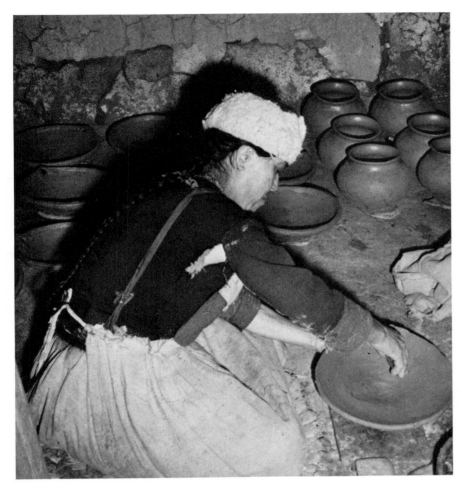

Gladys Diaz starts all her pottery with a ball of clay, even when making a shallow platter. She hollows the ball and uses a series of wooden ribs to form and thin the ware, adding daubs of clay to enlarge it. She then spins the plate with one hand while her other hand alternately sips into the water and smoothes the rim. On this platter form she pokes a hole inside the rim to serve as a handle or hole to hang it up.

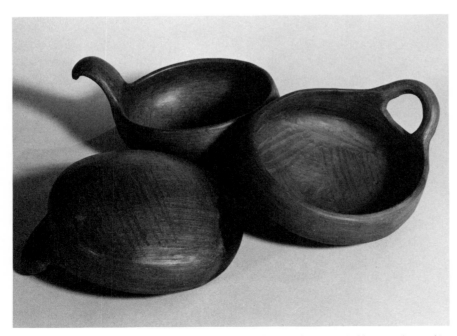

Soup bowls here, as elsewhere in South America, are the most important tableware pieces. At the leatherhard stage, a fine-textured *greda* is painted on the whole piece and burnished to a soft sheen.

and her daughters were catching up on the family wash, using a nearby stream and hanging the clothing on a barbed wire fence.

Tostadoras

Across the path Gladys Díaz was working at her house making *tostadoras*. Gladys worked inside her doorway on her knees. She wore a woolly cap on her head, rather than the usual felt one, and a homespun cotton apron to protect her skirt from the clay (see illustration).

The Clay

All the clay used here and in the Tutazá area is common in these mountains and everyone digs his own. Gladys told us that the red *greda* she uses is not quite as common. She buys hers from a neighbor in the valley who happens to have a very fine grade of it near her house.

Firing

Everyone fires in the same kind of hillside depression that we saw in El Alizal; sometimes potters share a firing site. The ware is piled on the ground and covered with wood, which is then ignited.

Continuing Heritage

On the wall of Miguel Arala's house was an old photograph taken in the 1930s showing potters at work and rows of pottery drying on the ground. Many other photos on the porch walls of other houses we visited are of sons and daughters who have moved away and are living in the cities or other pueblos. Some of the children do remain in the community and will be carrying on the potters' trade, along with cattle raising, as long as there is a demand for it. Gladys learned from her mother. As soon as her daughter is big enough, she will teach her to make pots. It is the tradition.

Similarity to La Chamba Ware

The work here is the most-polished and best-shaped handwork we have found in Colombia, outside of La Chamba. It does, in fact, bear a close resemblance to the work of that village. The forms of the soup bowls and *cazuelas*, the flare of the pitchers and vases, and the design concepts are very similar, in spite of the vastly different techniques the two areas use in forming and firing. Most likely the similarity in forms, which is highly Spanish influenced, goes back to colonial days when the Spanish style was imposed on the Indians' handforming techniques.

La Florida, Bucaramanga

We are certain that there are many more potters in Colombia and in all of South America than our investigation uncovered. It would be necessary to visit every town marketplace on its market day, and to explore the stalls in all the larger city markets to see how much local pottery is being made for the people who still use it. In this way, it would be possible to track down the location of the majority of group and individual potters who still pursue the craft. There are more of these people than one would suspect.

We did not explore every market and therefore came upon some potters in surprising, unexpected ways. The Bucaramanga market is one we missed. Bucaramanga is a large industrial city of 251,000 and the capital of Santander Department. It is only 198 kilometers (123 miles) from the Venezuelan border. We left the city very early in the morning heading south. At La Florida, a few kilometers outside the city, while driving past high roadside grasses, we noticed the early morning sunlight glittering on some objects alongside the road. Slowing down, we saw several bundles of partially glazed pots bound in sisal nets. On the other side of the road, a man, half bent over, was carefully picking his way downhill on a steep, narrow, winding path. A huge bundle of pots was balanced on his back. María de Palomina followed her husband with more pots. She and her young daughter were waiting for a truck which would come in a few minutes to take them to the Bucaramanga market. While we were talking, the truck arrived and the bundles were quickly loaded, the potter got on board, and all disappeared around a bend in a few moments. If we had passed by this place 15 minutes earlier or 15 minutes later, we would have had no idea that this potter, a very prolific and able one, lived and worked here.

A Diminishing Potter's Community

There are several potters in the area who bring their ware to the Bucaramanga market. This was a larger community of potters at one time. María was taught by an elderly neighbor here, who no longer makes pots. She has been practicing for about 10 years.

Kiln and Firing

Her kiln was built 2 years ago by a man who teaches in Bucaramanga. It is a rectangular, wood-burning type, built of brick with a tile roof and a capacity of about 1 cubic meter (30 cubic feet). She tells us that she fires for 7 hours, that she must buy her wood for fuel and her clay from people who live further down the road.

Sra. Palomina's Ware

Her ware was mostly large planters, all made by hand and decorated with bands of fluting at shoulder and rim. Some had wide necks, roughly brushed with sparkling lead glazes in yellows and browns; others were left unglazed. Tall, gently flaring shapes on high, flaring pedestals were also made as planters. These had fluting at the rim and at a point half-way up the pedestal. Nests of fluted-rimmed bowls were also in her packs, as well as some pots that looked as if they were meant as storage containers or cooking ware, since they did not have perforated bottoms.

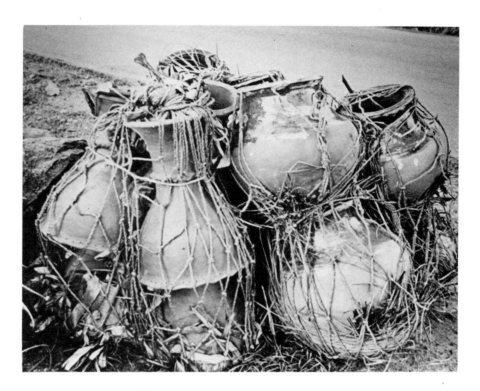

(Above) Pottery bundled in a rope net waits along the roadside for the truck to the Bucaramanga market.

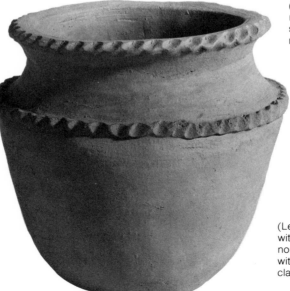

(Left) This *macetera* was made with clay coils. It is neither glazed nor burnished but decorated only with two additional fluted coils of clay.

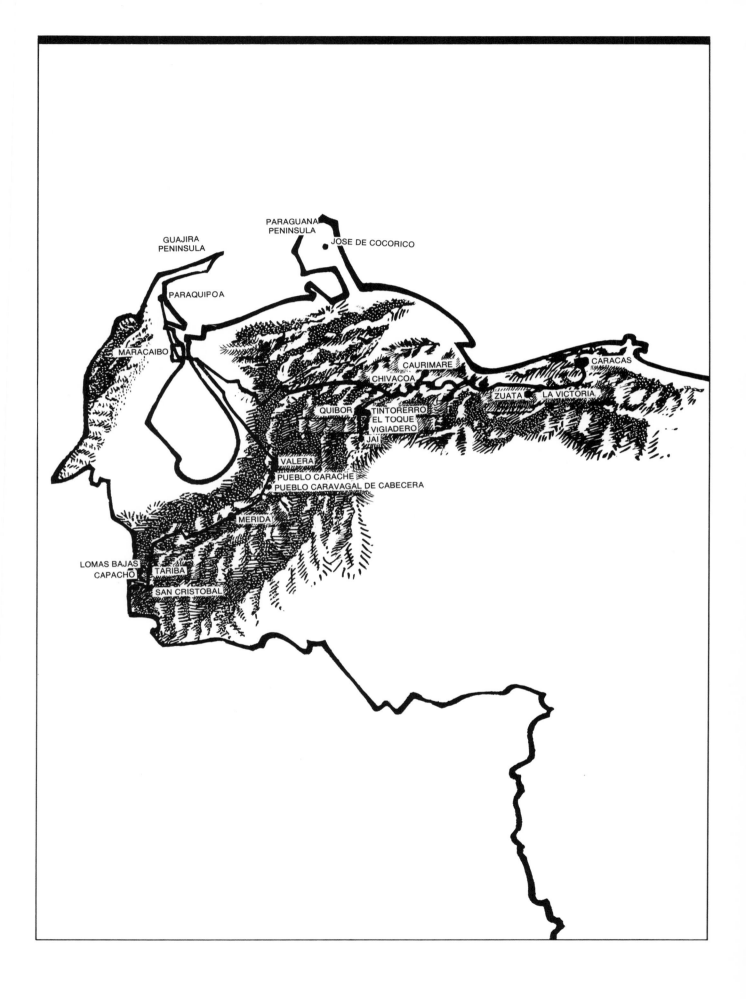

VENEZUELA

Dr. José Cruxent, the leading archaeologist in Venezuela, is the only person with positive information on where pottery is being made throughout the country. On his numerous trips to important archaeological localities, he has been careful to note where pottery is still being made and whether pre-Hispanic techniques are being used. His findings show that the craft is dying out. He feels that when the older people who are now making pottery can no longer continue, this aspect of the culture will disappear as surely as did those that preceded it.

In several of the areas that he suggested we visit, this had already happened. Three elderly women, who had been the village potters in the almost inaccessible village of Jai, could show us only a few pieces that they had made 2 or 3 years ago. None of the young people in this village had cared to continue the work, and utensils of aluminum, steel, and plastic were being used.

Colombian-Venezuelan Ties

Our study is limited in Venezuela to its western sector which, archaeologically, is closely linked with Colombia. There is no certainty about whether similar ceramic forms were carried from Colombia to Venezuela or vice-versa. It is said that western Venezuela has more early ties with Colombia than it has with its eastern half. The rich pre-Hispanic ceramic finds in the western sector bear affinities to the ware of the Tairona and Magdalena Valley cultures of northern Colombia, as well as to the Central American cultures of Panama and Costa Rica.

A ceramic form that bears witness to the existence of ties between these neighboring countries in past and present times is the flat clay frying pan-platter called a *budare*. This term is common today from the Valencia area in Venezuela, even to Ráquira in

central Colombia, where we heard some women refer to the flatter frying pans as *budares*. The history of this form links Colombia and Venezuela in their earliest ceramic phases, this platter being used throughout to make manioc bread before corn became the more common staple in the diet of this region. Today the pan is still used, but to make Venezuelan corn-flour cakes called *arepas* and as a general frying and toasting platter in eastern Colombia.

Spanish Influence

Dr. Cruxent noted that when the Spanish arrived in Venezuela, as in the rest of South America, they came in great strength with a will to completely subjugate the Indians. Seeing that the Indian women were fine potters, they tried training them to use the potter's wheels so they could produce the Spanish forms that the colonists were accustomed to.

Very few of the Indians could accommodate themselves to the wheel.

They did, however, take to the new Spanish forms and reproduced them using their own familiar techniques with local red clays rather than the white paste of Majolica ware. Cruxent tells us that Baron Alexander von Humboldt, traveling in Venezuela as part of his South American journeys in 1830, was surprised to see the Indians still making pottery in their own way, but repeating Spanish forms. He writes of this in his book *Voyage to the Equinoxial Regions*.

Even today in Venezuela, as in the rest of Latin America, the same Spanish techniques and forms are merged with local Indian traditions.

Introduction of Glazes

Before the Spanish conquest, no glazes were used; consequently the ware was not always waterproof. The Spaniards introduced lead glazes to make the native ware less porous.

Cruxent tells us that the first glazing was done here in the 16th century. The small towns of Cubagua and Población were forerunners, dating 1510 and 1524, respectively, for the first production of lead-glazed ware.

Kilns

Kilns were first introduced to make the curved clay roof tiles so common today. One finds thousands of small brick and roof-tile industries scattered throughout the South American countryside, continuing this Spanish-inspired production. The brick and tile kilns, whose style varied tremendously from place to place, were also used to fire glazed pottery.

West to East

We start by describing what we found in the western border department of Táchira. Here a present-day tie exists between Colombia and Venezuela, because of the migration of potters across the border.

Táchira Department

This is very hilly, low-altitude country. Táchira's capitol, San Cristóbal, is only 816m (2,720 feet) above sea level and 54 kilometers (34 miles) from the Colombian border. Looking around in the market, and in the line of shops along Avenida 5, we saw evidence of great ceramic activity in the area.

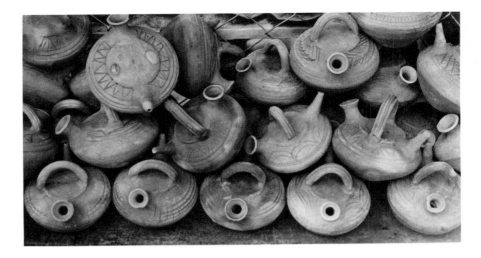

San Cristóbal Pottery Vendors

The shops sell a variety of cement planters, plaster work, wire bird cages, plant hangers, and wire baskets and, with all this, various types of garden ceramics, planters, clay water jars, cooking pots, and pottery for table use. Some of the shop owners make many of the items themselves and also buy part of their stock. One man who came here 15 years ago from Italy told us he had his own wheel and kiln here in San Cristóbal. Another man is from Lomas Bajas. He and his wife make pottery and he runs his own shop. The majority of shop owners told us they go to Lomas Bajas, Capacho, and San Antonio to buy truckloads of pottery to stock their stands.

Tariba Pottery Market

Across the river from San Cristóbal is Tariba, where there is another important market. There we saw a 12-year-old boy whom we had met the day before in San Cristóbal market. He is from Lomas Bajas and told us that all the pottery we see at this market, which is mostly planters, cooking pots, and platters, is from there (see Color Plate 8). He manages the pottery sales for his family at all the local markets.

Potter from Colombia

Just before crossing the river to San Cristóbal, we saw another stand where wire planters were sold. What attracted our attention, though, was an impressive brick-and-tile kiln halfway down the riverbank. It was a large walk-in type with a beautiful dome, topped by a vent. Buttresses had been built to sustain the walls, but having been out of use for several years, the stucture was beginning to disintegrate.

Luis Pinzón owns the kiln and the stand which his wife operates. He came from Colombia, near Ráquira, his wife tells us, 9 years ago. He enjoys working in clay and set up shop here.

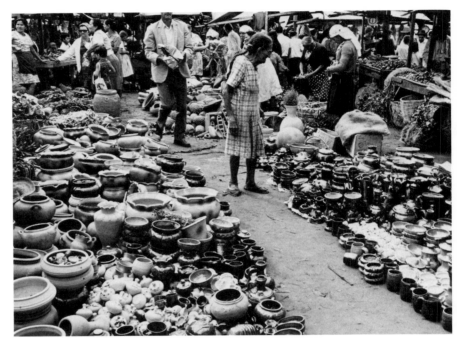

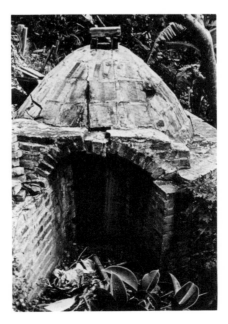

(Top) Wheelformed *pimpinas*, found piled in the Avenida 5 shops, are very similar to the Spanish drinking vessel called a *botija*. Unglazed, they are decorated at the shoulder with incised-line designs over a band of strong throwing ridges.

(Above) Tariba market is where housewives from the city and outlying areas come to buy groceries and other supplies. The pottery market is piled with glazed and unglazed ware from Lomas Bajas and Capacho.

(Left) An abandoned kiln on the river bank between Tariba and San Cristóbal has a ceramic-tiled roof. This side has a walk-in loading entrance. The kiln, which measures 3.1m (10½ feet) high, has a fire port on the opposite side which looks exactly like the one on Carlos Bolaños's kiln.

He was able to sell everything he made, but the work was very hard and he was not realizing much profit. Several years ago, he decided that it just did not pay enough and he went to work for a furniture builder in San Cristóbal, abandoning his kiln here in Tariba, but keeping the shop.

To see the pottery made in this area, Luis told us, we would have to go to Capacho and Lomas Bajas. Since he stopped, no one else is potting in the Tariba area.

Capacho

Capacho is only a half-hour's drive from San Cristóbal and we arrived there, too, on market day, to see the youngest Nieto boy managing his family's pottery sales. He laughed at seeing us again, and told us that if we were to go to Lomas Bajas, he would give us directions to his house so that we could see his family at work.

The market was representative of the area's production—handmade *budares*, oval bowls and platters, and wheelthrown work ranging from tiny doll dishes to huge *maceteras*. Most of the work was in natural clay. Some ware was gazed with plumbate and other mold work was covered with commercial glazes splashed on in lurid combinations of blues, yellows, greens, and browns. Some pieces were painted in enamels, others decorated with delicate white slip lines. Altogether, a wide cross-section showing the many possible ways of working clay was represented.

Mold Maker

In Capacho, there were two potters to visit. In the village itself was the workshop of Miguel Guivara. He, too, is from Colombia and told us he learned a lot of pottery molding techniqes at the Industrial Institute in Bogotá.

Mold Work

Miguel's work is technically able. He sculpts *maceteras* and vases like the Ráquira Chibcha imitations and makes many plaster molds to be filled with slip or with a clay of modeling consistency. Usually, wads of clay are pressed into the halves of two-piece molds. The molds are fastened together and placed on kick wheels where they are turned, while the molder smooths the clay on the inside of the mold.

Potter's Wheels

Miguel is very proud of the wheels he makes. They are wooden kick wheels of the same solid construction that we saw in the SENA school in Colombia and in the technical school in Tejar, Ecuador. Lomas Bajas potters purchase wheels from Miguel. He offered to show us how his wheel works, and although he can throw fairly well, this is not his method of work. The four wheels in his shop are used by him and his assistants only for mold work.

Simple Kiln

Miguel's kiln is the same tall, narrow cylindrical one that Sr. Acosta uses in Santander, Colombia, the top covered with pot shards. A pit is dug in front of the kiln below the level of the shop's earth floor. The wood is fed through this pit into the fire box. He says that everyone here reads kiln temperature by the color of the kiln interior, but he knows that their firing temperature measures between 485°C. and 650°C.

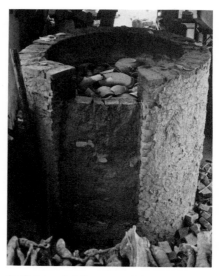

Sr. Guiveras's tall, narrow, 2.4m (8 feet) high and about 1.2m (4 feet) diameter, updraft kiln is made of common brick daubed with adobe. It is loaded from the side opening which is bricked up as the ware level rises. Shards cover the top of the ware. The firing port is on the opposite side.

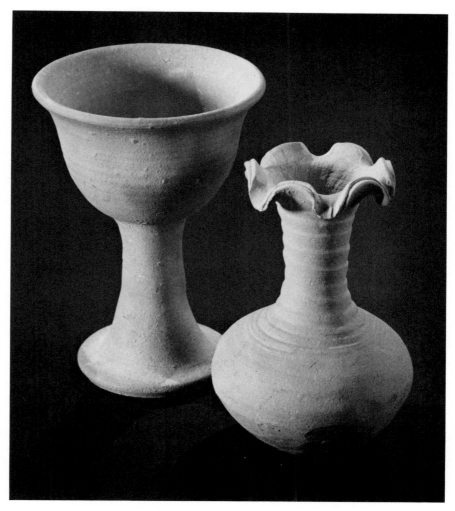

This goblet is 13.9cm (5½″) tall and thrown in one piece. The bottom of the bowl section is squeezed closed while the upper stem is collared in. The vase top shows typical Spanish-influence ornate treatment.

Wheel Work in Capacho. Carlos Bolaños demonstrates many of the methods he uses in throwing off the hump.

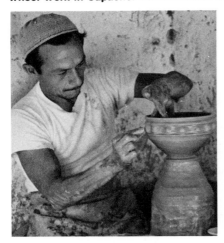

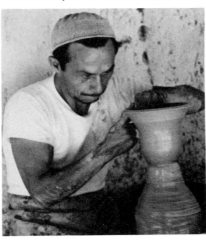

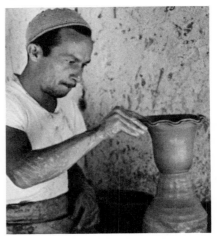

1. Bumped-out decorations on the shoulder of a pot are formed by pressing outward with the middle finger of the left hand and pinching the bump with the right hand.

2. While supporting the clay with the left hand, fingers inside and thumbs outside, the right forefinger is used to form a wide rim.

3. Having scored the wide rim with a wooden rib to form a double lip, both rims are fluted with the fingers of his right hand.

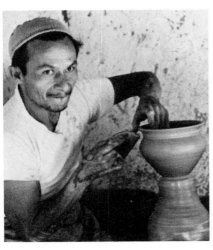

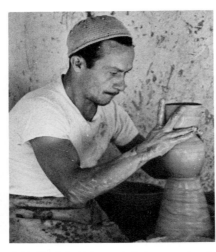

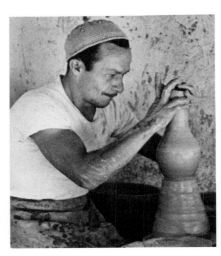

4. On another bowl, also destined to have a fluted rim, a wooden rib is used to firm and curve the flared lip.

5. Vertically held fingers help to support and squeeze the clay inward when necking-in a globular *florera*.

6. The right hand necks-in the upper section, while the left hand evens and compresses the rim.

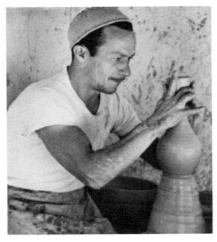

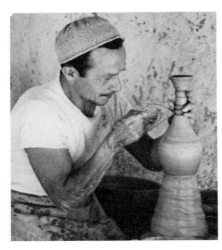

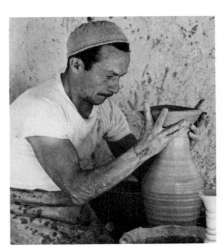

7. The middle section of the neck is narrowed to its smallest diameter, while one finger steadies and evens the rim.

8. With the tip of his wooden rib, irregularly spaced decorative notched bands are made on the neck of the *florera*.

9. The last of the clay hump is formed into a larger *florera*. Here the lower fingers apply pressure while thumb and upper fingers support the top section and guide it inward.

Potter from Popoyán

Carlos Antonio Bolaños is another potter from Colombia who is working now in Venezuela. Carlos comes from Popoyán. There he learned to make pottery by watching his older brother. His brother was making pottery in the city of Cali, Colombia.

Carlos has worked in Capacho for 4 years and established this pottery 1½ years ago. His main production is brick and roof tile. Six men are employed in this end of the business. One man only makes molded pottery, especially large planters.

Wheel Work

Carlos alone makes wheelthrown pottery. We have noted that many of the transplanted southern Colombian potters, and Carlos is among them, are superb technicians on the potter's wheel. Carlos wears rubber-tire-soled sandals to kick his wheel. He chats while he throws, and the forms grow under his fingers. He throws off the hump rapidly, hardly seeming to center the clay before it is drawn up (see illustrations). All his pieces are footed by placing the piece upside down on a clay chuck on the wheel and trimming with a metal tool.

Wheel and Tools

The flywheel on his wheel is an iron manhole cover. The shaft and head are made of steel, the supporting structure of wood. Carlos usually uses a series of wooden ribs to eliminate all finger ridges from his work, and a long needle to trim off irregular rims. His sponge, chamois, and a twisted cord to cut the pot off the hump are the same familiar equipment used by the American-trained potter.

Clay

Carlos modestly claims that one of the reasons he throws so effortlessly is due to the quality of his clay. It is a soft, orange color that is common everywhere in the surrounding hills. All one has to do is dig it, pulverize it, remove the few pebbles, mix it with sand and water and it is ready to throw—there is no need to age it, as it is naturally plastic.

Kilns

Carlos has two elaborate updraft kilns made of brick. The smaller one he uses for pottery. His large one, with gothic arches and buttresses, follows the style of many similar brick kilns in the area. Within an 8 kilometer (5 mile) radius of his pottery we have seen several brick industries going and a score more of abandoned, de-

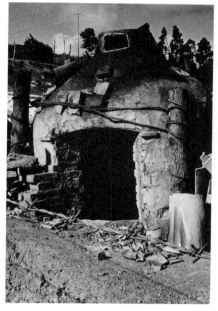

The smaller kiln is made of brick covered with adobe. There is a vent hole in the dome, which has been bound with heavy wire cable to help hold it together.

The fire port section of the kiln that Carlos uses to fire brick has 3m (10 feet) high Gothic arches leading to it. This type of architectural structure, like cathedral doorways, is common to the area's brick kilns.

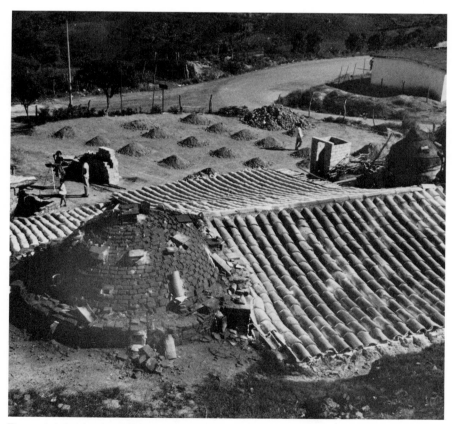

The vented circular dome of the brick-firing kiln rises through the firing shed roof. In front of the shed are rows of pulverized clay mounds ready to be mixed with water and used.

teriorating kilns that look like decaying castles in the green, hilly landscape (see Color Plate 15).

Design Sources

Carlos is always looking for new design forms. He looks in magazines and books whenever he can, but deplores the fact that there is very little available to him in pictures. He finds no source of stimulation to inspire him to try new ideas. Although he sketches a lot to get ideas for new forms, all the pieces we saw in his workshop were similar to the Spanish-styled pottery we had seen in Colombia.

Lomas Bajas

To get to Lomas Bajas, which in Spanish means "low hills," we drove very carefully along a steeply graded, narrow, winding dirt road. Slowly, we crossed dips in the road, paved areas of roadway made to carry mountain streams that fell across the roadbed. The hamlet is very secluded and in no hurry to adopt the advancements of the 20th century. The only level spots in the village are the house floors. In places the ground is dry, with rocky outcrops, while on the steep, short slopes semitropical plants and trees resembling long-needled pines grow in profusion. The atmosphere is pleasant and relaxed.

Everywhere pottery is being made—on the porches, in the front yards, behind the houses, in the shade of the trees. Between 70 and 80 families turn out thousands of pots every week.

Dwellings

In the central area of the village, the houses, which, are generally made of adobe or daub and wattle, are constructed in tight clusters, sometimes sharing walls. The more affluent have houses made of brick, and floors and patios of concrete. Closely spaced upright stick fences often mark property lines. The houses are built on the hillsides at random elevations, presenting a split-leveled appearance.

People

The women are very shy and suspicious of strangers. The men are more self-assured and outgoing. The men would invite you into their yards and homes and proudly introduce their wives. Only then were the wives willing to talk and discuss their work.

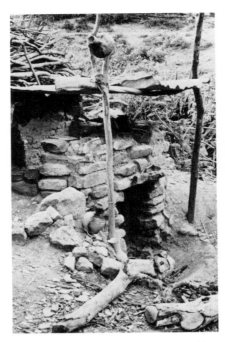

A more impressive kiln is made of brick with walls and roof erected to protect the entire structure. The fire chamber is built downhill, and the potter can stand on the uphill side to load her ware.

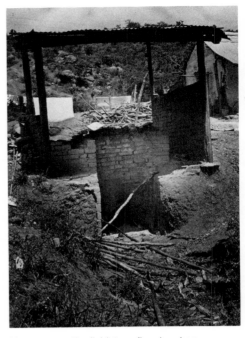

Here you see the fieldstone fire chamber, sheltered under a corrugated metal roof. The ware chamber is only about 1 square meter (10.8 square feet) inside. To the rear a pile of firewood is stacked for the next firing.

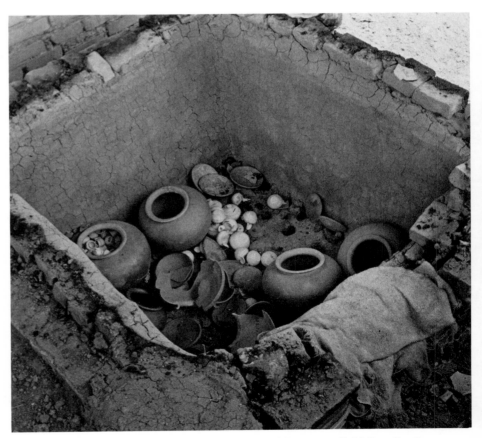

Ware is loaded through the top and piled on the pierced, adobe-covered brick floor. Small pieces are loaded inside the large *ollas* for firing. Shards cover the entire kiln top during the firing.

Kilns

Each family has its own kiln near the house, usually built into the protective slope of a hill. Kilns are generally made of field stone set in clay mortar. The open-topped kilns are covered with corrugated sheet metal to protect them from the rain. Sometimes a shed roof of corrugated metal is erected over the kiln. The shape is square or rectangular and varies in size, depending on the potter's needs.

Potter's Wheels

We saw the work of nine different families. In all but one only the women were involved with pottery making. Almost all of the families here use wheels, some very crude, rustic contraptions made by the husbands, who also make the kilns. A few wheels were the more carefully constructed products from the shop of Sr. Guivaras in Capacho. Several of the people using the old wheels expressed their desire to purchase one of his wheels some day.

Handwork Potters

A couple of the families we saw worked only by hand while sitting on the ground outside or just inside the doorways of their dirt-floored houses. To make the forms, these potters take daubs of clay and finger-shape and scrape them, then thin and finish the walls with *tapara*-shell ribs. These are the shyest people of all. They would answer our queries with monosyllabic retorts, turn their backs on us, and warn us not to take any pictures for fear that they would lose their souls. Children were rounded up and told to go into the house.

Nieto-Family Pottery

We stopped at the home of Eugenia Paveda de Nieto. Her youngest son, the one we had met at the markets, came out to greet us. He led us up a dirt-and-stone hill for several hundred meters to the house-shop compound which has a commanding view of the road and valley. Everything must be trudged up and down a zigzag path that looked suitable only for goats.

A large patio surrounded on two sides by house and workshop buildings also serves as a work area. The two other sides of the patio have low-masonry walls upon which one can sit and survey the valley. Two potter's wheels are set in niches under a tile roof alongside the patio. They are log-framed with wooden heads and fly wheels. A large storeroom for greenware and finished work is also on this

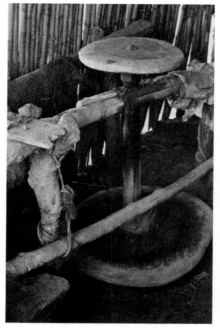

Almost all the pottery from Lomas Bajas is made on these irregular wheels. Flywheel, head, shaft, supporting structure, all are made of wood.

The more prosperous potters have purchased wheels from Sr. Guivara. The steady action of this wheel depends on metal bearings and working parts, and a sturdily constructed wood frame.

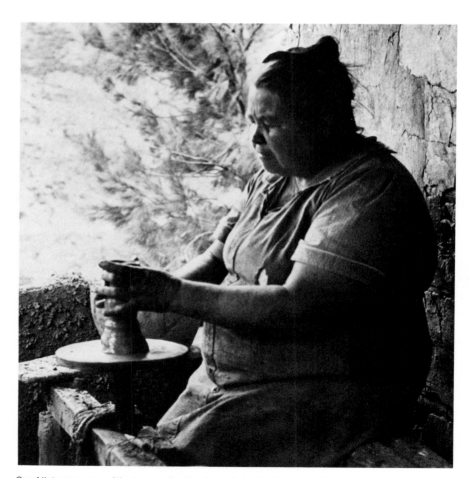

Sra. Nieto uses one of the two rustic wheels made by her husband. She throws both the Spanish-styled ware and the indigenous *ollas* off the hump. Where Sr. Bolaños sits to the side of his wheel shaft, the Lomas Bajas potter straddles the shaft.

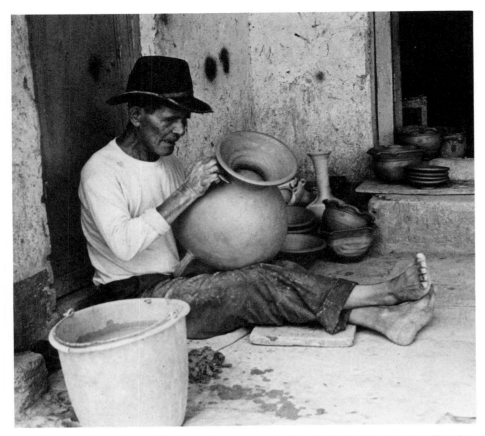

Ollas and *cántaros* have all the finger ridges removed with a *tapara* rib while they are still on the wheel. When they are leatherhard, the base is scraped up to midpoint and rounded. Sra. Nieto's father does the finishing *tapara* scraping, which makes the ware appear handformed.

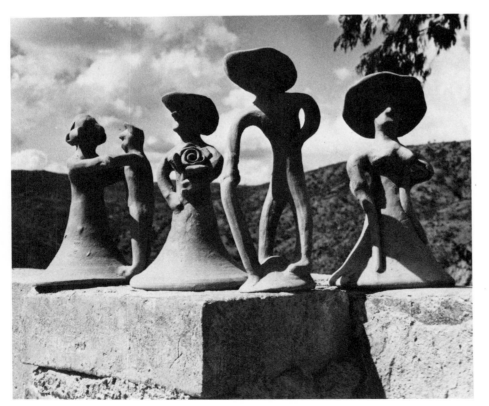

Here are a group of figures designed by Sra. Nieto's teenage son. The ladies' skirts are wheelthrown, but the rest of them and the male figures are handmodeled. They are strong, sculptural, good-humored forms.

side of the patio. On the other side, one step up, is a set-back porch under a tile roof, which is also a work area. From the porch, a door leads into the house.

Making the Ollas

When we arrived, the family was busily working. Señora Nieto was throwing small bowls and vases off the hump. Her older son also uses the wheel fairly well and is proud of his accomplishment. This is the only family in Lomas Bajas where we have met a son who wants to continue in ceramics. Señora Nieto's father was sitting on the porch floor and finishing the bottoms of handsome *ollas*.

Slip Decoration. When dry, the *olla* is decorated with circular lines in white slip. Around the shoulder a row of thin line spirals is deftly painted. Either large white dots or overlapping or just-touching sections of circles are the design motifs we have seen painted on the rims of this basic form. The *olla* is the most handsome pot we have found in the area, and the one with closest ties to earlier Indian ware (see Color Plate 35).

Glazes

Like many of the people here, the older son, Mario, told us they sell their ware either as natural clay, painted clay, or glazed. They use the term *alcolado* to describe a piece that is covered with lead glaze, made from a lead-sulfide compound. Cruxent notes that this term goes back to early Roman times and must have been brought over with the Spanish. The Romans used the term *alcohol* for the lead-sulfide galena crystals. This is the same substance that many of the women here use as a base for their glazes. The term *alcolado* is used in this area only, having been passed along by the Indians and *mestizos* up to today. The shopkeepers in San Cristóbal use this term, but nowhere else have we encountered it. In other areas, glaze is referred to as *plomo*, *brillo*, or *vidrio*.

Mario told us that the predominant glazes are made of lead sulfide, but that red lead for glazes was being imported from Colombia. Chemical colorants for blues, yellows, and greens were being smuggled in also from Colombia. These are very expensive and the potters must charge a lot more money for pots on which these colors are lavished.

Ware

The main products of the Nieto family are *ollas*, large planters, footed vases thrown in two parts, and many

smaller forms including pitchers, cups, bowls, plates, flower pots—many of the same types of pots made by Sr. Bolaños. For Christmas, molds of the nativity figures are used to produce this highly salable commodity. The figures appear to be molded from the plaster Italianate figures one commonly sees in all the city department stores.

Mario is modeling his own stylized figures and they are very good. He is just beginning this figure work and it will be interesting to see how far he takes it. He shows a good understanding of form and a gentle humor in these pieces, so much better than in the molded ones.

Handmade Ware

In the tightly packed center of Lomas Bajas we went from house to house to see the equipment and methods employed. The people who had no wheels made oval-shaped bowls, *budares*, and a special dish for feeding chickens. This is a high-walled narrow, oval bowl from 30cm (12″) to 76cm (30″) long with a series of large straps across the top dividing it into six or more openings for the chickens to eat the feed from.

Wheel Work

Those people who have wheels make all sorts of utilitarian ware, using traditional Spanish forms with taller or shorter necks, footed bottoms, frilled rims, and pulled handles. One interesting note is that the handles are pierced by a row of holes that look as if they were poked in with a thin knitting needle. These, we were told, were to prevent the handles from cracking during the firing.

Chicken Banks. Another popular form seen on the markets is a chicken bank. It resembles the Ráquira one in some respects and again one wonders if the influence of Colombian potters caused them to appear. These, however, are made on the wheel and have a flatter top than the Ráquira forms, which tend to build up taller in the center. A realistic head and stylized tail are handformed and attached. Unlike the Ráquira banks, these have no handle. They are glazed or painted and sometimes show a combination of both.

Pottery Heritage

The people here are very proud of their pottery heritage. They tell us that theirs is the peak of Venezuelan pottery making and that nowhere else in the country did the people learn to use the wheel or to make the kilns. They all tell us of having come from

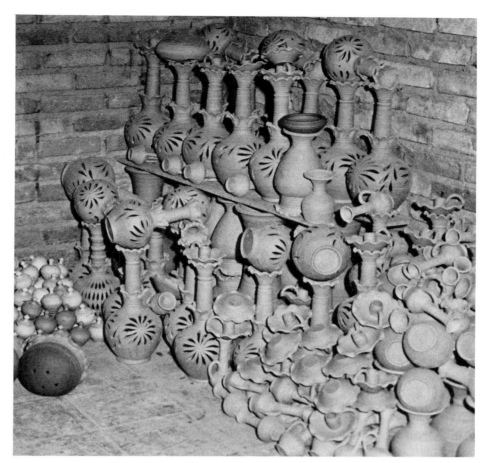

Decorative ware, with ornate Spanish shapes, is made by many Lomas Bajas potters. Here the pierced openings fit the rounded, fluted forms very well.

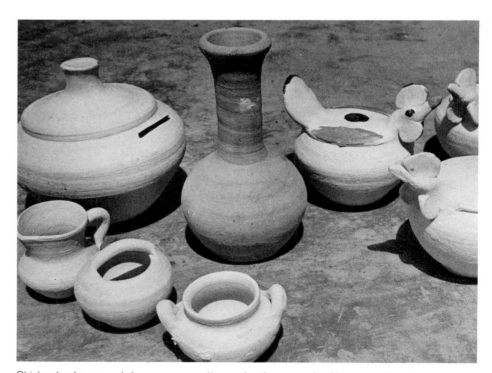

Chicken banks are made by many area potters, using the same wheelthrown and hand-modeled details. The banks will be painted with bright enamels. These globular banks have their own special form as all the potters make them appear to have removable lids. A few potters buy white firing clay to use on small pieces such as the banks and sugar and creamer sets shown here.

generations of potters, each person learning from her mother. Here we saw mothers and daughers, often working side by side, doing the handwork or throwing on the wheel.

Of the few archaeological excavations made in this area, one finds very little in common between the ancient shards that have been dug up and the work of today. The only similar form is that of the *olla*. In the past, red, black, and white slips were used to decorate the ware, and incised and applied designs embellished the forms. Today, only white slip is used, except where the more modern glazes and paints are employed.

It is interesting to see that the handforming process today is similar to the pre-Hispanic techniques. Cruxent found no evidence of coil building here, but rather surmised that the ancient pieces were scraped to form them as is done today. No polishing of the surface was done previously and that is not practiced here today either.

Mérida

The capital of Mérida Department also bears that name and is located in the Andes region of Venezuela. Mérida itself is at 1,616 meters (5,385 feet), on an alluvial terrace set among the highest mountains in the country. Venezuela's highest peak, Mt. Bolívar at 4,923m (16,411 feet), dominates the landscape of Mérida. Driving from Maracaibo, which is at sea level, to Mérida, one must cross Pica de Aguilla, the mountain pass at 4,050m (13,500 feet). At this altitude there are no trees and the chief botanical item is a plant called Monk's Hood. Its yellow blossoms are protected by furry green caps before they brave the cold to bloom in the incredibly blue, misty atmostphere at these exhilarating heights.

Indian Heritage

Several archaeological investigations were done in the Mérida area. The ware found showed that a mica-loaded clay had been used. It was formed by coiling and scraping with some polishing of the surface. The same clay, and much the same techniques, are still being used in this region.

Archaeologists have noticed the similarity of the ancient shards, burial shafts, and artifacts found here with those of the Chibcha Indians in the Colombian highlands.

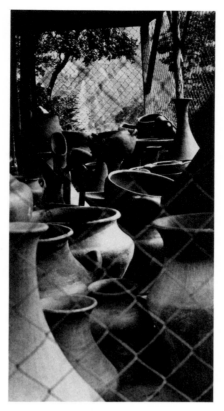

Thousands of pots made by Sra. Rodriguez are locked in a chicken-wire enclosure. Many kinds of pieces including *floreros* in all dimensions, *maceteras*, sieves, hanging planters, tableware, and sculptural candelabra are all made with coils, scraped, and lightly burnished.

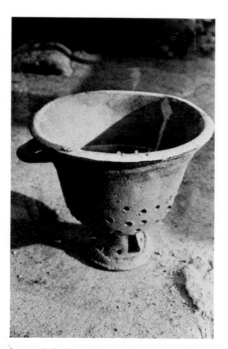

A gracefully formed brazier is designed to hold a large round-bottomed *olla*, a *budare*, or other cook pot. As suits the nature of the piece, the surface is not smoothed but has a coarse, sandy texture. The rim and walls are very even and well formed.

Sra. Rodriguez

We had been informed that a potter who lived in the nearby town of Ejido still worked in the old way. When we finally found where the woman, named Brucena de Rodriguez, lived, we were only able to talk with her daughter, who told us that her mother was gravely ill and did not want to see anyone.

A professor at the University of the Andes in Mérida had recently sponsored a one-man show of her work at the University galleries, and considered hers to be a singular, imaginative talent.

The daughter told us that her mother learned to pot from her mother before her, and she believed that they were descendants from many generations of potters. She herself learned to make pottery from her mother, but no longer cares to do it.

Clay and Work Methods

They get their clay from the nearby hills and bring it home in clay pots which they carry on their heads. All three generations of potters have used the coil method to shape whatever forms they made, using only *tapara* ribs to scrape and shape the clay. Firing takes place on the ground and the clay is always left its natural color.

Ware

A storage room right on the highway, with a cement floor and walls of poultry netting, contains thousands of Sra. Rodriguez's pots. The work ranges from tall vases, water containers, *maceteras*, down to little ashtrays and animal banks. There doesn't seem to be any form we have seen so far that she has not tried to do, or could not achieve. The work is very sculptured in feeling and seldom fails as good utilitarian design.

Valera

The road winding down through the Sierra Nevada from Mérida to Trujillo passes several important archaeological excavation sites. The digs in this area have shown that the pre-Columbian culture here used a red clay tempered with crushed rock, notable for the prevalance of mica fragments. The shards reveal that the pieces were made with coils of clay. Many of them are black because of reduction firing. Globular jars and bowls were the most common forms. The decoration

in the area, referred to as *betijaque*, has a superb patterning in black, red, and white slips of swirls, parallel lines in varying widths, dots, chevrons, and triangles—in all, a very rich, strong variety of designs.

Pottery at Valera Market

Valera, the largest city in the Department of Trujillo, has a permanent market set in a large, two-story concrete structure. A large section of the market is devoted to woven baskets, plastic pails, aluminum pots, and china dishware. One man, however, had a stall stacked with a red-clay ware which glittered in the sunlight because of all the mica particles in it.

The vendor was friendly and pleased to be able to tell us about the ceramics. A few years ago a lot more pottery was brought to this market for sale, but now many people prefer to buy products made of other materials. The clay *ollas, budares, paellas,* and large *floreros* are still in some demand—especially the cooking ware which, it is said, imparts the special flavor to the local traditional dishes.

There is still a group of people working in Pueblo Caravagál, La Cabecera, just 8 kilometers (5 miles) from Valera. Near Trujillo, Pueblo Carache is another area where a few people are still making pottery that is much more delicate and thin than the pottery from Pueblo Caravagál.

Ware from Caravagál

All the work at this vendor's stand is made by Isabel Perdoma from Pueblo Caravagál. All the traditional forms are here. We noticed particularly a variety of vases that seemed to embody all the variations possible for a necked vase with a globular base.

Work Procedure

Sra. Perdoma works on a wooden board. After mixing her clay to a workable consistency, she rolls the coils on the board. The ware, with smaller pieces set inside larger ones, is fired on the ground. Wood is placed under, over, and completely around the pottery and burns the ware irregularly. Some pieces are noticeably darker than others.

Slip Decoration

We hoped to see evidence that the beautiful ancient design practices were still employed and saw that Sra. Perdoma does decorate her ware with white slip painting. The designs seem superficial, having nothing in common with the shape they decorate or any feeling of continuity from the past. The most successful pieces are the *paella* dishes with coil handles applied horizontally and no more decoration than the dents of the rubbing tool or the shine of the mica.

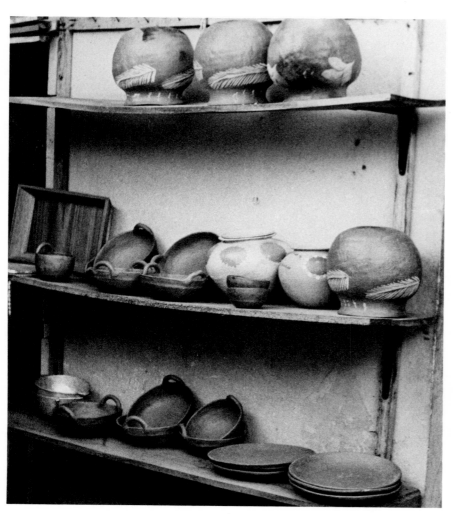

On the top and middle shelves here are Sra. Perdoma's decorated *ollas*. White slip is used to paint leaf patterns. Enamel paint, as in Tariba market ware, is used to paint flowers on the two *maceteras*. On the bottom shelf are *budares* and shallow *bandejas* with basketlike handles.

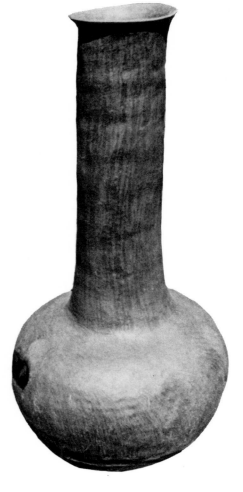

Tall, thin-walled *floreros* are sold by one vendor in the Valera market. This one, made with coils, scraped with a *tapara* shell, and lightly burnished, is .9m (3 feet) high.

Quibor Area

Quibor was a very exciting place to visit. Dr. Cruxent had told us that we would find several people working with clay, and that a large excavation was being conducted at present, right in the heart of the town. Dr. Lucena, the head of this archaeological investigation, would know where the potters lived.

We arrived on a day when Dr. Lucena was away from the area. There was a great cavity about 2.4m (8 feet) deep in the middle of the street in front of a convent. Skeletons were half-excavated. Bowls, stones, and other objects were cleaned and labeled, but had not yet been removed from the site. The digging was going very slowly as a careful record was being made of what was found at every level, and the position carefully notated. A few assistants were there and we asked them about the area potters. We were told that Dr. Lucena was going to visit Jai in the near future to secure pottery for a local bazaar to raise money for the excavations. We were given directions to the village and started out.

Jai

The trip proved an arduous one. The road steadily deteriorated and there was no way to turn around. Until a few days before, this road was only a burro trail. Bulldozers had recently worked it over, leaving it a mass of boulders, some of which had to be moved before we could get by. The trip down to the village would have been quicker and easier on foot.

It was here that we met the three elderly women who no longer made pottery. The story they told us was this: They used to produce a lot of pottery, but 4 years ago the last of them had stopped working. The other two had not made anything in the last 10 years, as they were really too old for this heavy work, and there was no longer any demand for their clay ware. Cruxent noted that when he had been here a dozen or so years ago, the women were using ancient pottery shards, ground up, as the tempering material for their clay.

During the night it rained and it was with great difficulty that we ascended the muddy trail out of Jai and back to Quibor. We met Dr. Lucena, who was surprised to hear the news of Jai, but said he could take us to another nearby area where he was fairly certain that, with any luck, we would find pottery being made.

Lara

The Department of Lara is a strange area. Parts of it are green and fertile, and then there are vast stretches of true desert with masses of towering cactus. One sees wide *quebradas*, or dry riverbeds, where occasional flash floods sweep through the hard, eroded earth, sand, and pebbles. It was to an area like this that Lucena took us in his jeep, over open fields and vast networks of trails. We visited women neighboring each other, but each in a district with a different name.

Tintorerro

Close to a *quebrada*, we saw two circles of ashes, each measuring some 3m (10 feet) in diameter. Piled nearby was a stack of green cactus wood. Several cracked and broken pots were scattered about. A house, whose yard was surrounded by a barbed-wire fence, was about 100 meters from these firing sites. Beyond the barbed wire, we could see several pyramids of upside-down pots. They were divided up in mounds of either large or small pots.

We called out a hello to the house, as there was no one in sight. After a few calls, a man came out, squinting at the brightness of the early-afternoon sun. When we told him we were interested in the pottery, he quickly informed us that he sold it only by the

Following the procedures of all Quibor area potters, Sra. Torres rolls out coils of clay to begin her pottery. In her hands she forms the coils into a bowl shape and rubs the coils together with her fingers. More coils will be added, and a *tapara* "spoon" will be used to thin and smooth the walls of the growing pot.

stack, each stack being worth about $6.60. Lucena explained that he would be coming back to buy a lot of it for the fair, but that now we were interested in finding out more about how the pottery was made. While we were talking, a large, smiling woman came out of the house. She had just washed her hair and had a towel over her shoulders.

We were introduced to Hilda Ramona Torres, who told us that she was the one who made all of the pottery, and that the man we were talking to only sold it for her. She was happy to tell us about her work and went to the house several times to bring out more examples of her pottery.

Pottery Heritage

Sra. Torres learned by working with her mother and her mother's friends. She thinks that her ancestors have lived in this area for some 300 years and that the women have been making pottery in the same manner as she does for that long. She told us that there are three families in the area who still make pottery.

The Clay

Her clay is found in abundance 1m (3½ feet) down under the flatland. The very best clay, she told us, comes from Jai, but the clay here, too, is very good. For decorating, a red clay and a white kaolin clay are dug from the nearby hills. Her base clay is peppered with small particles of white clay.

Coil Techniques

When we asked her how she made her pottery, she offered to show us. Her husband, who joined her after we started talking, dragged over a large piece of rusted sheet metal that she uses on the ground as a work surface. She went to the house to get her equipment—a bowl of water, a *tapara* "spoon," and a mass of clay (see illustration).

Finishing the Ware. After the form is made, it is allowed to partially dry in the sun. Then it can receive its final finish. In some cases, especially for the *budares*, a red slip is applied and then burnished. Although this is a widespread procedure, their way of doing it is unique. When the *quebradas* flood, many tree snails, which they call *molenares*, are washed down in the water. When the water again dries up, they collect the snail shells and save them to use as polishing tools. To apply the red slip, they moisten the red clay, rub the snail shell on it and then rub the *budare* surface with the shell. They have their own

word to describe this process, *empabonár*, also using it to describe a piece that has been polished this way as *empabonado*. The material used to *empabonár* is a wet paste of iron-saturated clay that imparts a rich color ranging from orange to russet on the clay surface.

Some pieces, such as the *budares*, are highly polished on the frying surface with strokes at right angles. This picks up the lighter clay underneath, producing a crosshatched surface. The jars, vases, etc., are not as highly polished. Sometimes the red slip coating is used on these and other times not. Sra. Torres delights in decorating her pieces with white-slipped linear designs.

Ware

One of our favorite pieces made by Sra. Torres is a *pimpina*, a Venezuelan word for earthenware bottle. Sra. Torres also makes many pitchers, vases, water jars, and cooking pots. Her vases have either thin or thick, long or short necks, and her larger pots have one or two handles made of thick, sturdy coils, well blended into the body of the ware. Many of her pieces are also decorated with rope coils of clay, these made with notches and overlapping ends as if in imitation of real rope. Most of her pieces are footed.

Vigiadero Potter

Inez Rodriguez is a thin, smiling, gray-haired lady who lives in Vigiadero. Her adobe house is whitewashed and painted with reddish brown branches from which grow fat leaves decorated with dots. Painted flowers grow beneath the trees, which are as tall as the wall.

Recent Firing

We were lucky to arrive at Sra. Rodriguez's home just as she had completed a firing. Across from the house, in a clearing among the cactus and scrubbly desert trees, was a still-smoldering ring of gray ashes. The greatest part had been raked to the side, exposing dozens of *budares*. Occasionally, one of Sra. Rodriguez's daughters would slosh water on the still-hot pots. This, we were assured, would not crack them but only make them stronger and less permeable to water. Why, they could not tell us, but they followed this procedure all afternoon.

Women Potters

Inez told us that she, too, learned to make pots from her mother. Her daughters in turn have learned from her, and her youngest daughter made

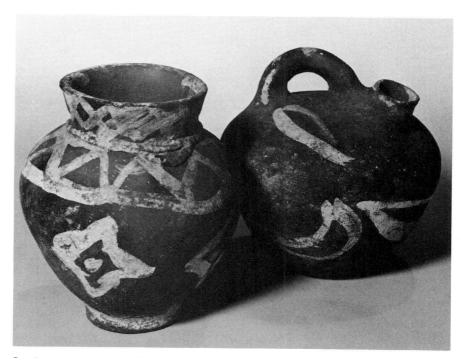

Small vases, pitchers, and *pimpinas* made by Sra. Torres are unburnished. However, she decorates her pieces with white slip lines representing birds, fish, or flowers, or with geometric patterns. Also, as in the vase on the right, she uses the ancient technique of decorating her ware with applied "ropes" of clay at the neck.

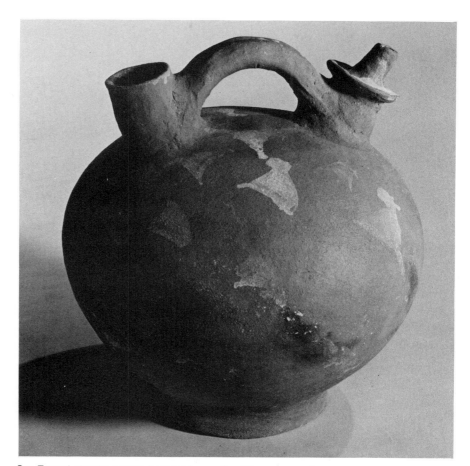

Sra. Torres' *pimpina* is a full, rounded form with a filling spout and a drinking spout. It is the equivalent of the typical Spanish *botija*, except that in this version the handle bridges the spouts. White slip bird motifs are repeated in a haphazard pattern over the unburnished surface of the vessel, which measures about 30.5cm (12") high.

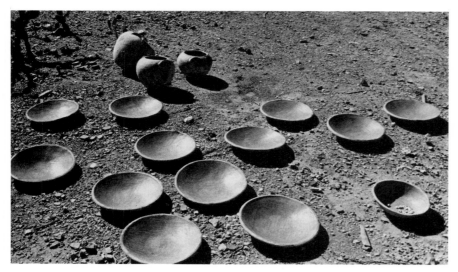

Sra. Rodriguez's *budares*, 35.6cm (14") in diameter, still hot from the fire lie glistening in the sun, having just been sloshed with water. Before firing they had been covered with *greda* and polished with a *molenare* shell, which also accounts for their bright sheen.

Decorative trees and flowers are painted on the pottery as well as on the adobe walls of Sra. Rodriguez's house. The word *ramera*, derived from the word meaning branch, is used to describe the painting of branches, leaves, and flowers.

all the pots in this firing. We sat in the patio shade with the flickering light and discussed the pottery situation. Inez said that she is too old for the strenuous work of potting, but she has been able to teach her girls all she knows about making the traditional forms used by the people in this area. Her daughter told us that everyone in the locality knows how to make the pots, and that almost every woman will take time about once every 2 or 3 months to make the pottery that the family will need. It is just part of the household chores, like cooking or washing the clothes.

Inez's daughter says that she could not make pottery for a living because not many people buy it anymore. Sometimes neighbors will buy some if they run out or cannot make it. Sometimes one family will make it one time and share it with a family who will make it the next time. Another working relationship is for one family to make one kind of pottery and another family a different kind and then they will trade. Although they will never earn a living by making pottery, they continue to produce it because they enjoy making it, they are making things that they will need, and anyway, "it is the custom."

Pottery Forms

We asked what the most important forms were that they made. The *budares*, of course, were needed to make *arepa*. Other pots are made to catch and store water when it rains. The men reminded Sra. Rodriguez not to forget to mention the pots used to ferment rice and maize for *chicha*. Then, there are the cooking pots and pitchers and vases.

Decorative Designs

We spoke about the painted pottery and noted that the designs on the walls were not too unlike those on the ceramics. A lively discussion broke out on the designs themselves which, we were told, all three girls worked on. What was the derivation of the designs? The girls said they made them up as they went along. We spoke of traditional designs and design patterns. Some believed that the designs were derived from the branches of trees. The women used the word *ramera* to describe the process of painting the design—the word comes from the word *rama*, meaning branch. This was embarrassing to the girls, for it is also the local term for whore.

A Firing in El Toque

Señora Leoncia Rodriguez, who lives in El Toque, had also just completed

her firing when we arrived. About 50 wide-mouthed, round-bottomed water jars had been pulled to the sides of the firing circle and were lying there cooling, the flecks of ash still dusting their surface. The jars were uniform, all being about 51cm (20″) tall, rising from a small, curved base to a wide, swelling shoulder. Then the curve flows almost horizontally to a 8cm (3″) high neck whose rim is folded over outside and terminates in a notched-rope pattern. The pieces are handsomely mottled in red and black from the firing.

Marketing Pottery

Leoncia does find it profitable to make pottery. She tells us she makes hundreds of pieces at a time (three or four large ones a day) and sells them all to one man who acts as her agent and sells them in Quibor or Barquisimeto. Sometimes she makes special orders for another man who paints them with enamels and sells them for more money than she makes.

Changing People—Changing Traditions

Like all the other women here, Leoncia learned from her mother and taught her daughters when they were small, but they have no desire to make pots. As she sees it, conditions have changed radically. Previously, all the area people had their own little farms and worked independently, growing more than they could consume themselves, and making many of the things they needed, including pottery. About 15 years ago, Italians, Spaniards, and Portuguese came from the Canary Islands and bought up all the area land. Water was brought down from the mountains to make great irrigation systems for their haciendas.

The local people have suffered recently from periods of draught. The hacienda owners employ airplanes to spray insecticides onto their crops. The insecticides are carried by the wind onto the sparse vegetation that the burros and goats of the *campesino* people feed on, so that many of their animals have died. All in all, hard times have made it more practical for the local people to hire out to the haciendas. They can make more money picking tomatoes than making pottery or growing their own food.

Leoncia does not like working on the haciendas and would rather make pottery even though it is harder work. Since even her daughters are not carrying on the pottery traditions, probably pottery will not be made here anymore after Leoncia's generation stops.

Archaeological Findings

The whole state of Lara and especially the land around Quibor has been explored for the extensive archaeological materials buried there. Several styles of pottery have been found, notable especially for its strong, well-executed decoration. All the shards found show evidence of having been coil built and scraped smooth, but not polished. Fine, slip-painted decorations and incised as well as applied embellishment were used.

Dr. Lucena is collecting pottery from this area dating from 750 B.C. to the present. There is a two-generation gap in the collection from the years 1770 to 1820. Hopefully, it will be filled. He is impressed with the fact that the same materials and methods have been used for so long. What is equally impressive, and at the same time puzzling, is why the craft has lessened in quality since Hispanic times, here as well as in the rest of Latin America. The pottery of the cultures remains, but one can only conjecture what became of the cultures themselves.

Yaracuy

Chivacóa is a town on the Pan American Highway between Barquisimeto and Valencia in the State of Yaracuy. At the crossroads is a large stand displaying wire, basketry, pottery, and cement products. You notice a lot of ware from the San Cristóbal area. The proprietor tells us that the shelves full of wheel-formed goblets, planters, *paella* dishes, bowls, and pitchers are brought by the truckload from that

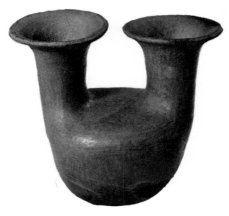

One of Sra. Ramirez's more imaginative *floreros*, on which red *greda* has been painted and burnished.

area. The only local pottery product that he sells is handformed ware made by a woman who lives nearby.

To find her, we took the road north from his stand toward the San Felipe airport. At the village of San Pablo, we asked for the village of Caurimare. The area is mostly under cultivation in sugarcane, and the flatlands are laced with small streams and irrigation canals. Caurimare itself is a small collection of homes where the cane workers live with their families. Some of the houses have cement floors. Walls may be combinations of adobe and cement, plastered stick lath, or daub and wattle. Roofs are all corrugated iron.

Señora Teresa Ramirez is the only person making pottery. We arrived at a bad time. She and her children were just recovering from a week's illness. She apologized for not being able to show us how she worked, as no clay was prepared. However, she vividly described her methods and we were later able to watch and photograph Petra Torrealba, who lives on the other side of Lake Valencia, but whose methods are similar to those of Señora Ramirez.

The Pottery Process

Sra. Ramirez and her young son dig the clay in a nearby field. It only has to be soaked and kneaded with sand to be a good working consistency. She forms her pots by daubing the clay on a saucer and scraping it to shape with a *tapara* rib. Sra. Ramirez has a patio of hard-packed earth. In one corner, a pile of dry clay covered by a loose piece of corrugated tin roofing marks her work area. She sits here on the ground to make her pots. She averages about four pieces a day. Firing takes place about once a week, about 20 pieces being fired at a time. The ware is piled on the ground with wood between, inside and over it, more wood being added as the pieces become exposed. Her firing lasts 4 hours. She expects to lose two or three pots per firing.

Marketing

The man who owns the stand at Chivacóa buys about everything she makes. She does not know if he wholesales it to anyone else or if it is all sold at his stand. She also sells quite a bit to people from her own and neighboring villages and presents some to friends as gifts.

Flower Vases

Sra. Ramirez's mother taught her how to make pottery, and during the 15 years she has been working on her

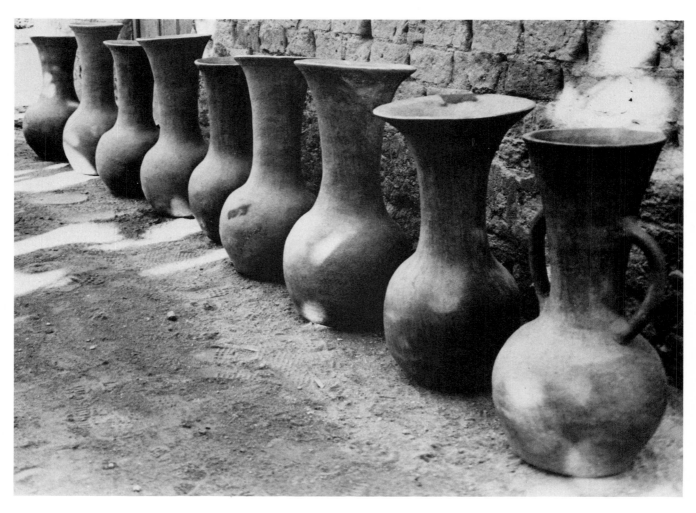

A popular form in Venezuela is the long-necked *florero*. Sra. Ramirez makes these using a sculptural process, placing wads of clay to build up the form, and scraping them to the proper shape with a *tapara* rib. Lips are always folded over to a double thickness.

own, she has developed a strong individual style. Her pottery stands out because of its thin, yet vigorous construction and the well-balanced relationship between neck and body. She has an innate sense of proportion, knowing for instance the best shape and the amount of flare necessary on a lip. This is just one of the many elements that, when knowingly combined, produce an elegant form. Her speciality is large, graceful *floreros*. She showed us about 16 that she had recently fired (see illustration).

Surface Treatment

All her shapes are finished by turning over the rim and roughly pressing slightly fluted ridges into the underside. The top outer flare is slightly flattened, but the edges are softly rounded. Some of her pieces are painted with a thin, red slip and lightly burnished, as one can see from the stripes left by the small burnishing tool following the form. There is a fine, sparkling mica scattered throughout the clay. The fire imparts a beautiful range of color from orange to black spotting.

Archaeological Finds

Cruxent has worked at several sites in this vicinity, one to the north at San Felipe, and the other just south at San Pablo. Both were rich in ancient shards. Some shards showed evidence of being coil made, others not. The decorations on these shards, in strong patterns of colored slip painting, have no equal today. The only real connection between past and the present pottery is the basic clay itself.

Aragua

On the east side of Lake Valencia is the Department of Aragua. Several archaeologists, including Dr. Cruxent, have worked here. He suggested we try to find a woman who was making pottery in the small town of Zuata near La Victoria. We asked at the Casa de Cultura in La Victoria, but no one could tell us where pottery was made. They did however point out the way to Zuata.

On a corner of the dirt main street in Zuata, a group of men stood talking. Approaching one of them, we asked if he knew of a woman in Zuata who made pottery. He acknowledged that he did, that she lived just around the corner, and that she was his daughter. "Around the corner" turned out to be a very badly eroded dirt road. Halfway up this road was the home of the Torrealba family.

The Torrealba Household

A green-painted concrete-block wall separated the garden from the road. To the left of the gate was a great mound of black clay, and to the right, a load of sand piled around a tree. This was a good sign that we were at the right home. We were greeted by a group of children who, on learning why we were there, ran to get their older sister, Petra Ramona Torrealba. She in turn invited us into the concrete-block house, introduced us to her mother, and then offered to show us her work and her workroom. The livingroom itself was a display room, for all along one wall was a row of tall, double globular-formed, long-necked *floreros*, each measuring 1m (3.2 feet) tall.

Beyond the livingroom is a long, semiopen room which Petra uses as an area for forming her ware. Beyond this room is the family courtyard, dominated by Petra's kiln and her clay-preparation area. Near the kiln grows a tall tree loaded with *tapara* fruits, from which Petra makes her scraping tools. Several large bird cages with a variety of occupants were suspended from flowering trees growing about the edge of the patio. The family wash was hung out. Obstreperous youngsters were running about.

In contrast, the entry court is a garden area with iron benches. Walls of concrete block border the path and are topped by Petra's planters in the shape of ducks and swans with open backs to take the plants. On either side of the front door are 1.2m (4 feet) tall oval jars made by Petra. Planters are attached high on the front walls to either side of the door. A few feet to the right, behind a hedge, pigs are grunting and snorting in their pen.

Petra Torrealba

Petra at 26 is the oldest of 12 children ranging in age down to the youngest, who is only 2. Her father has a farm and truck. He buys and sells whatever will bring a profit. He at one time bought and sold pottery made by Sra. Leonora Román, who lived here in Zuata. She is probably the woman

that Cruxent sent us to see. Sra. Román made *budares* and *botejones*, or large earthenware jars. When Petra was 12 years old, she would accompany her father in his truck, and she was fascinated by Sra. Román's work with clay. Petra began an apprenticeship with the woman, helping her with the clay and learning all the pottery procedures. Sra. Román had a daughter who also helped with the pottery, but she no longer works in clay. Sra. Román died a few years ago, leaving Petra the only person in the area who still knows the pottery craft.

Petra, as a child, also attended classes at the *Casa de Cultura* in La Victoria. She took instructions in painting and drawing there whenever it was available and had acquired some skill. Today she wants to try all sorts of things in clay. Whenever she can, she looks at the containers in the flower shops in the cities; she looks at magazines to get new ideas and draws all the ideas on paper before she tries making them. She has been potting now for 14 years and is still trying to learn how to do it better.

Working the Clay

Propped up on bricks in the backyard is a large, oblong wooden bowl. In this Petra takes the deep-gray clay that has been soaking in water, kneads it with the sand until it holds together well, and then brings it into her workroom. Ranged in rows on the floor are

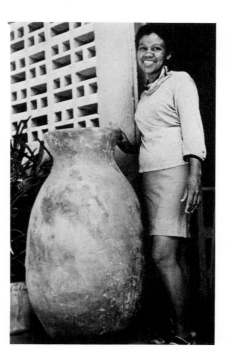

Petra Torrealba stands beside a large jar she made by a method best described as daub and scrape. The walls of this large vase are at least 2.5cm (1″) thick, making it extremely heavy.

fired clay bats about 36cm (14″) in diameter. On these Petra forms her ware. There is work in all stages of development here. When she begins the pots, the bats are placed on benches or on large bowls to raise them off the floor (see illustration).

Her larger pieces require between 8 and 15 days to make, and as long to dry. She makes a lot of *budares* and *floreros* and fires when she has enough to make a good load.

The Kiln and Firing

Sr. Torrealba built the kiln of adobe bricks. In this, Petra lays her vases on their sides and piles her *budares* and smaller pieces around them. Wood is piled under, inside, around, and over the ware. The wood is ignited and more is added as needed to keep the fire going for 12 hours. She starts firing at 6:00 A.M. and finishes at 6:00 P.M. The pieces remain in the kiln until the next morning.

Petra suffers over a 50% loss in firing. Often two out of four large vases come out of the firing cracked. This, we feel, is due to the excessive thickness of the ware and also to faulty firing. The firing is really little more than a ground firing in an enclosure. There is inadequate draft, and even the long firing time may not allow a high enough temperature to mature the inner layers of clay, causing the fractures.

Surface Finish

To reclaim what could be a terrible loss, she coats the cracked pots with a cement-stippled coating and sells them like that. Petra claims that many people prefer these to the plain clay. She also uses enamel paint to decorate many of her pieces, but does this primarily on order.

Marketing

Her father sells her work by the truckload to vendors in the markets at La Victoria, Maracay, and the capital, Caracas, all a short distance on the Pan American, which here is an excellent paved highway. Many people also come to the house to buy her ware and to order the special painted ones.

Need for Assistance

Petra loves her work and wants to improve it. She needs guidance to help develop her skills and design abilities. It is regrettable that there is no organization for craftsmen in Venezuela that could help a hard-working young woman like this to develop her talents and help her with the technical problems she encounters.

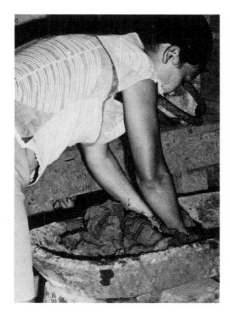

Clay that has been pulverized and soaked in water is kneaded with sand in an oblong wooden bowl. More sand is added until the clay will hold together well.

The kiln, measuring 1m (3.2 feet) wide by 2m (6.4 feet) long by 2m high, is nothing more than four walls and a metal roof. The doorway opening is about .5m (2 feet) wide and as high as the kiln. A grill made of latticed clay tiles is placed high on one wall to provide a better draft.

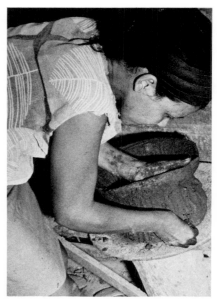

Petra begins a vase shape by daubing and scraping the clay. She works on a clay bat which is set on a bench or large bowl. When the form has grown taller, she will put it on the floor, walking backwards around the pot as she works on it.

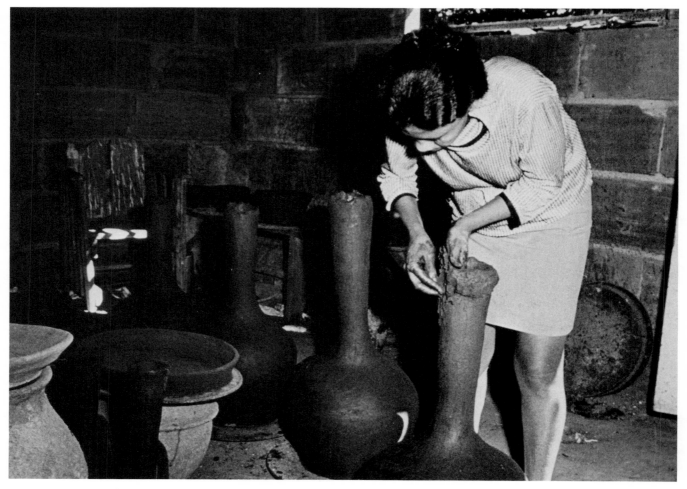

Petra works on many pieces at once, because of the sticky nature of her clay. Only a small amount of clay can be added; then it must be allowed to set before more is applied. *Budares* and *floreros* are ranged on her studio floor in stages of near completion.

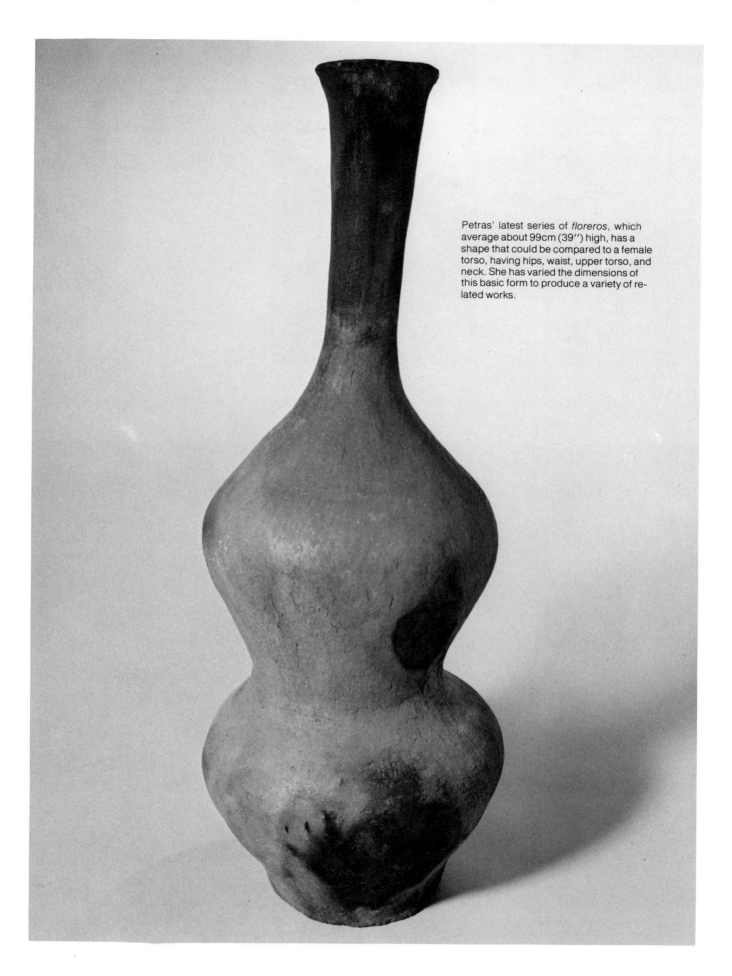

Petras' latest series of *floreros*, which average about 99cm (39'') high, has a shape that could be compared to a female torso, having hips, waist, upper torso, and neck. She has varied the dimensions of this basic form to produce a variety of related works.

Guajira

In Maracaibo, the *Museo de Belles Artes,* under the direction of Sr. Oscar D'Ampaire, recently set up a shop on its premises to exhibit and sell Venezuelan folk handcrafts. The most impressive of these are the textiles made by the Motelone and Guajira Indians. However, nothing is done to promote the pottery of the Guajira Peninsula, an area which is divided between the Colombian and Venezuelan governments. This is mainly because the pottery is not produced in quantity and is brought out of the area by the Indians only infrequently for sale in such markets as Paraquipoa.

The Guajira Indians, using the coil method and ground firings, produce a beautiful light-buff-colored pottery decorated with a red slip line. The line varies from a calligraphic curvy scribble to a more rigid series of double Xs and parallel bands filled with crosshatching or waves.

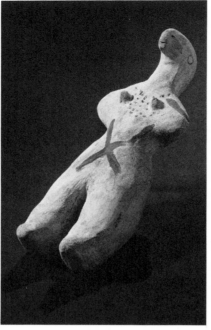

A votive figure, 19cm (7½") long, made of the same buff clay, is decorated with incised dots and red slip lines. The solid clay form is a stylized female torso with an animal head.

Making the Ware

Sra. Masula Maníl, a collector from Caracas and sister of Oscar D'Ampaire, spent a week traveling in the Guajira country. She watched an old woman making a pot with thin coils. To fire the pottery, the Guajira woman dug a hole in the sand and placed her wood there. One pot at a time was fired in this hole. A stick was inserted in the mouth of the pot from time to time in order to rotate it, so that it would fire evenly on all sides.

The pieces we have seen from the peninsula have the swelling shape of the calabash gourd and range in size from those that would carry ½ liter (1 pint) to some that have a 38 liter (10 gallon) capacity (see illustration and Color Plate 11).

The Guajira is a difficult area to penetrate, and the best work, we were told, is probably being done in areas where the white man has not yet been peacefully accepted.

The pottery, produced all over the peninsula, we were told, is made by the women to be used for cooking, eating, and storage.

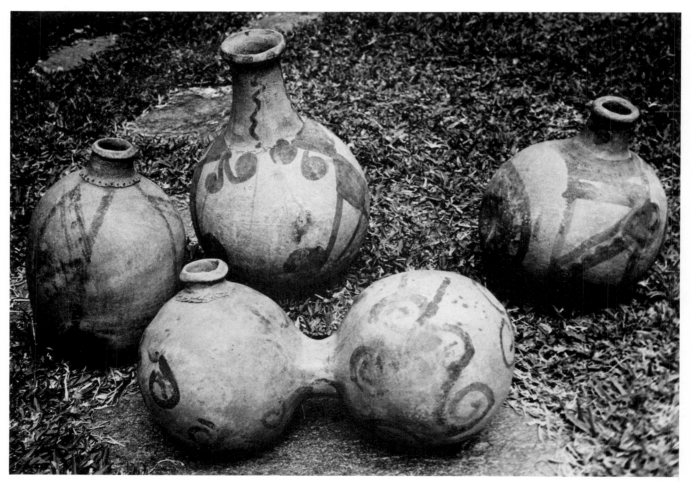

A variety of half-liter (pint) sized water containers show how the basic gourd shape can be changed by elongation, by combining forms, and by varying the length of the necks. The joint formed by the application of neck to body is seldom blended smooth. The joining area is further emphasized by a series of incised crosshatch lines or dots. Collection of Señora Masula Maníl.

Paraguaná Peninsula

We stopped at only a few of the many pottery sites in Venezuela. There are more, both in the western area where we were, and in the territory east of Caracas, which we never saw. There are small communities on the Paraguaná Peninsula, the most important being José de Cocorico. Once there were many potters here, but now only three women, all in their sixties, still work with clay. Since their daughters have no interest in continuing the craft, and no other member of the community is learning their skills, a beautiful, unusual type of pottery making will be lost.

The Claywork

The women go into the nearby mountains to get the different kinds of clay they use. They mix their clay on a long, flat board. They also use the board as the Amazon women do to roll out long, thin coils of clay. These are wound to make incredibly thin, even-walled pottery. A *tapara* rib is used to smooth out the coils. When the clay is almost dry, it is painted with either a cream-colored slip which fires white, or a yellow slip which fires red-orange.

We saw only about a dozen pieces made in José de Cocorico. There were carafes, drinking cups, vases, and bowls, all of them Spanish-influenced forms. The ware is carefully finished with a delicate, footed base (see Color Plate 17). Firing is done in a kiln similar to those in Lomas Bajas.

Decoration

All the pottery we saw was decorated with fine-line designs. A common element is an undulating double-lined band painted around the form, with flower and leaf designs incorporated into the wavy band. The deftly painted thin-line designs are done in cream or red-orange slip, contrasting with the earth-colored slip on the piece. After the final slip decoration, the entire piece is burnished with a type of seashell called a *caracola*. Through this coating, one can see the flecks of white clay that are peppered through the base red clay. This gives the surface an unusual speckled appearance.

Venezuelan Overview

We have found that there is less interest in the indigenous folkcrafts in Venezuela than in any of the Latin American countries we visited. Except for a few individuals in the major cities of Caracas and Maracaibo who are making great efforts to bring the work to the attention of the general public, craftsmen get almost no encouragement or support. Sra. Masula Maníl, one of the few people we found who shows a passionate concern for Venezuelan handcrafts, has done much to promote the handcraftsmen in the country. She finds it a very trying experience to convince the buying public, and the Indian craftsmen themselves, of the value of their art.

The indigenous people have been held in contempt for their backward ways and have been encouraged for centuries to emulate the Spanish traditions. Therefore, if they want to sell to the city dwellers, they do their best to make what they feel will please them. Sra. Maníl points to the example of zippers and buttons being used as closures on the more traditional-design, hand-crocheted Guajira bags. It is difficult to assure the makers that these types of closures do not suit their work, and that the bags look far better with traditional closures.

The indigenous textile craftspeople are being helped by exhibitions of their work, both in Maracaibo and Caracas. This has begun to awaken the Venezuelan public to their own folkcraft riches. It is hoped that this interest will spread to the pottery crafts.

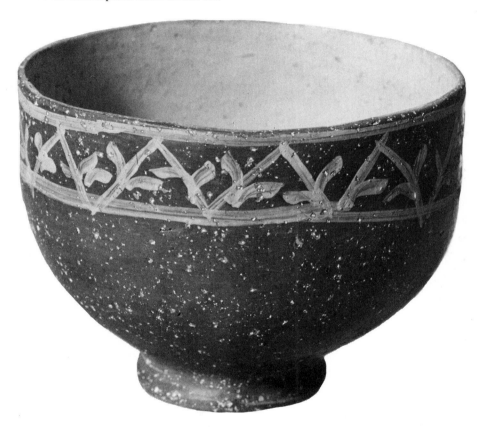

A thin coil-formed bowl, 13.9cm (5½″) in diameter, has a well-defined foot, adding to its delicate, light quality. The white clay particles of the body clay show strongly through the red burnished *greda* applied on the outside. The white slip design was painted on after the burnishing process.

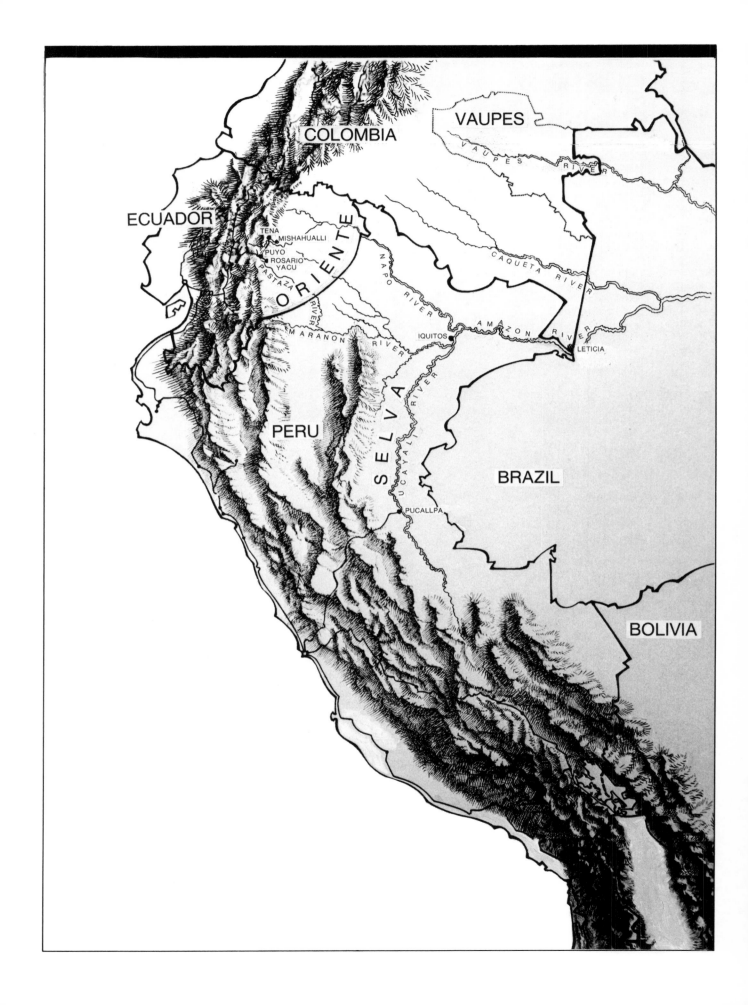

ORIENTE, SELVA, VAUPES

So far, we have described the pottery from areas in the Andes Mountains, in the valleys between, and on the coastal stretches to the west of those mountains. But what of the lands on the other side? In Colombia, Ecuador, and Peru, one descends rapidly down the eastern slopes of the mountains into that immense, humid jungle, traversed by few roads, the rivers providing the principal means of access. In Ecuador, the area is the Oriente; in Peru, it is called Selva; and in Colombia, it is Vaupes. Although fierce battles have been fought over the boundary lines separating one country's portion of the jungle from the other's, this is an area that really knows no national boundaries. It is one vast country all by itself.

Penetrating the Jungle

The Incas attempted, but were never able, to subdue much of this inhospitable region. The last stronghold, the legendary Villcabamba, was purported to be in this area, and several Inca ruins have been found. There are tales of others—mysterious cities with untold treasures that have been engulfed by the jungle—but little of this

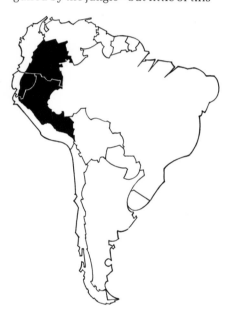

has been substantiated. The known treasure that lies here today is deep in the earth. Several oil companies have built landing strips and established drilling bases. Church missions have also made penetrations. But it is known that Indian tribes exist that have as yet not been contacted by any outsiders. In some places, fairly regular air flights deliver supplies to work crews and settlers. They fly out jungle products and sometimes craftwork.

Interarea Influences

The jungle regions, then, represent an area that up until recent times has received little outside influence. Because of this, jungle pottery bears little resemblance to that which is made elsewhere in these three countries. However, between the jungle people themselves, many similarities exist in materials used, processes employed, and the finished pottery product, regardless of national boundaries.

Ecuador: Oriente

We descended to the jungle regions of Ecuador from the city of Ambato, having learned that this was the least difficult way of approaching one of the more prolific jungle pottery-production areas. The following account should help illustrate the difficulty of encountering potters in the remote areas of the South American jungle.

Jungle Travel

A bus leaves Ambato early in the morning on a road of smooth hand-laid river stones. As the road begins to descend, it becomes a narrow dirt shelf cut into the side of the mountain ridge. The 4-hour trip is a swift descent past hundreds of waterfalls that cascade into the River Pastaza. The road ends at Puyo, a hot, moist jungle town. Several small villages where pottery is made lie within a 12 kilometer (7.4 miles) radius of Puyo: Río Chico, San Jacinto, Sarayacu, and Rosario Yacu. Pots are made at irregular intervals, and it is only by chance that an outsider will arrive at the opportune moment.

Makeshift taxis could take us a few kilometers towards these villages, but then we had to continue on foot for over 6 kilometers (3.7 miles) through dense jungle. In places, the jungle path was paved with slippery corduroy timbers, with boulders or just mud.

We spent half a day trudging along one of these jungle trails, crossing bridges that had rotted away so that only a single plank about 20cm (8″) wide remained. Fortunately, a cable stretched across the river provided a handhold and some security. Where there are no bridges, dugout canoes serve as ferries. We crossed the Napo River on a cablecar which consisted of an open wood platform 2m (7 feet) long and 1m (3½ feet) wide. It was necessary to stand and hang onto an iron pipe at about waist level. The platform, which rolled by force of gravity alone from the high shore on the Napo side to the lower one on the Tena side of the river, would not always reach the other bank. So, at times, much jiggling, hip swinging, and weight shifting was necessary to get close enough for someone on shore to grab a dangling rope and pull the heavy platform, that could have as many as eight passengers, to shore. Then as individ-

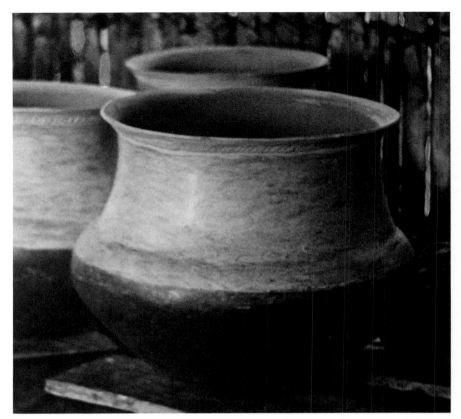

Large *mocahuas* have been made and prepared for decoration. The upper section is coated with white slip and the lower section with red slip. The entire outer surface is then burnished.

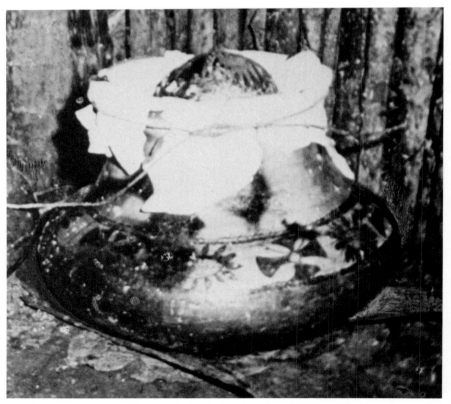

Mocahuas are used for cooking and storing the local *chicha*, which is a slimy concoction made from yuca roots. Banana leaves or cloth are tied over the top of the containers, whose flaring rim helps keep the covering tight. A bowl, which will be used both to scoop up the *chicha* and also to drink from, is placed on top of the covering.

uals jumping off would cause it to swing violently, we waited until everyone else had descended before we jumped off. The return trip was much slower. The rope attached to one end of the platform loops in and out of the river, but on the Napo side, it is fastened to a large cable reel. Two young men, who must have the world's most marvelously developed arm, shoulder, and back muscles, cranked the rope onto the drum and pulled the platform with its passengers to shore. The fare is one sucre, about four cents. A new concrete and steel bridge has been in the process of construction for several years and will eventually be completed. It will mark the end for the more picturesque present method of crossing.

The Search for Pottery Makers

When we finally arrived at the first village of San Jacinto, we were told that no one would be making pottery that day or the next. However, maybe an old lady at Rio Chico would be making pottery. Rio Chico is 5 kilometers (3 miles) away along the path going out the far corner of the village. We began climbing the slippery *palisada*. A *palisada* is a path on which debarked logs from 20 to 30cm (8″ to 12″) in diameter and a meter long have been laid crosswise. They are set next to each other at right angles to the path and are probably more negotiable with bare feet than with shoes.

After covering about a kilometer on this, we came to a clearing where a man was working. Two cows were tethered nearby. We hailed him and asked if this was the road to Rio Chico. "Oh no. You must go back to the village and take the road that goes out by the school." He came towards us with a machete in his right hand, repeating the statement. As he came to a large tree whose trunk was completely enshrouded with vines, he reached in among them with his left hand and brought out a shotgun. It was a little disconcerting, but he proved to be harmless and told us to follow him back to the village and he would direct us out the right road.

It was dark by the time we arrived at San Jacinto, so we had to return to Puyo and wait until the following morning before resuming our search.

In the morning, a Peace Corps volunteer stationed in Puyo introduced us to Rosita. Rosita is a loquacious lady in her sixties who operates a tourist shop called the "Toucan." She in turn introduced us to a taxi driver with whom we made an appointment to meet at 2:00 on Sunday afternoon. He would take us to a place along the river where potters dug their clay.

We arrived before 2:00 and were still waiting at 3:30, when a woman appeared with a daughter of about 8 or 9 and a son who could have been 12. The lady unwrapped four beautifully decorated bowls and offered them to Rosita. Rosita gave her 20 sucres for the lot and the trio left.

We went after them and tried to explain why we were there. The mother and daughter would say absolutely nothing. The boy told us only that they lived up the river and that his mother made the bowls. But beyond this he would say nothing and ran off, catching up with his mother and sister, who had continued walking. They went to the post office. We waited outside for them, but when they came out, they would have absolutely nothing to do with us.

The taxi driver never did show up. The rest of the day was spent in more fruitless attempts to locate working potters. Another night was spent in Puyo and then the following morning another lead sent us off to Rosario Yacu.

Rosario Yacu

Rosario Yacu is a soccer field surrounded by seven split-bamboo houses and a small adobe schoolhouse. Another house is set off from the field. In front, a young woman, possibly 17, with a child on her back and a long machete in her right hand, was watching us. We walked over to her and asked if pots were made there. She replied with a question, "Do you want to buy?" "Yes, we want to buy, but also to see how they are made." "My mother makes them. Follow me." We were led across the field to a house on the other side of the centerline.

We entered through a corner door into a room some 6m (20 feet) wide by 9m (30 feet) long. The floor was of earth. Beyond, a ladder led to an upper room. Directly across the room from the door, four large, gracefully shaped, unfired pots called *mocahuas* sat on boards. Above the pots, about 1.2m (4 feet) from the floor, was a rough board shelf. On it were several small bowls also in their crude state, but again, burnished. Some chunks of dried clay were there also.

Three beds of bamboo that resembled wide, long rectangular benches were attached to the walls. The outer sides of the beds were supported on bamboo poles about 7.6cm (3″) in diameter. There was no bedclothing. There were a few shelves in another corner. On the floor, near the far end of the room, three palm logs were equally spaced with their butt-ends together. At this meeting point, some ashes were smoldering.

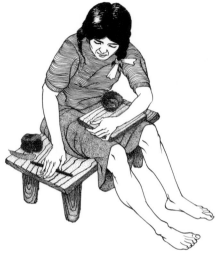

The potter sits with a board on her lap and rolls out thin coils of clay on the bench. The coils are pressed out very thin as they are joined together to form a bowl.

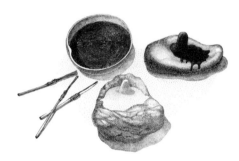

Large, medium, and small brushes are made from the potter's son's hair. Two stones with hollow depressions are used to prepare the slip. As a Japanese calligrapher uses his *suzuri* stone, the potter rubs her dry clay on the stone, dissolving enough to make the slip the proper consistency for painting. What appears to be white slip will fire black.

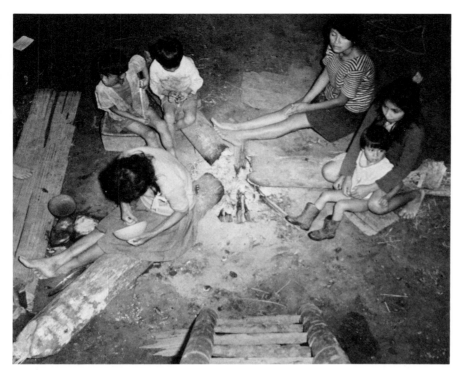

While her family relaxes around the smoldering fire, the potter begins decorating a small bowl. Her stones for slip and a gourd shell of water are beside her.

A girl of about 15 was folding up clothes and putting them into a small wooden suitcase on one bed. A very young man, who might have been her husband, was sitting on the bed and playing with a rusty shotgun.

On the other two beds sat three young women, each with a small child. There were also several other children from 2 to 12. An older woman, possibly in her late thirties or early forties, was sitting on one of the logs. She was obviously the mother. There were no other men present.

Our guide spoke to her mother in Quechua. The young woman then told us we could have one of the large pots for 100 sucres, but that there would be no firing today, that we must come back tomorrow. We tried to explain that we had come a long way and could not come back. The women conferred. The others also made comments, none of which we could understand. Then the older woman picked up a lump of moist clay from a pot full of clay and began to form the base of a bowl (see illustration). After a minute or two, she set the pot aside to allow the clay to set.

Decorating a Small Bowl. The mother called over a boy of about 5 and made him sit down in front of her on the ground. One of the other women handed her a large butcher knife. The boy dropped his chin onto his chest. The woman took a lock of his hair and started sawing away with the knife. It

seemed as if she were going to give him a haircut, but when one lock of hair was removed, the boy got up and left.

The potter put the lock of hair on a small stool hacked out of a log. She said something to the young man who had been playing with the gun, and he handed her a 25cm (10″) sliver of split bamboo that he had been scraping. She broke off about a third, scraping it some more with the knife. She then picked up half of the lock of hair and put it into her mouth to wet it. A girl handed her a spool of pink thread, from which she broke off a length. Then, after spitting into her right palm, she rolled the thread against the calf of her leg with the flat of her hand. While holding the lock of hair and bamboo together, she wound the thread around the hair tightly to form a crude brush. Then, she put it onto the stool, and, with the large knife, cut the end of the brush square. She then divided the rest of the lock into two parts, one about twice as thick as the other, and formed two more brushes. The potter then proceeded to decorate a small bowl for us (see illustration).

Firing the Bowl

From a corner she brought out a bowl whose lip had been turned in. The bottom had been broken out in a regular shape so that it now resembled a small automobile tire. She put the decorated bowl upside down into this

broken one, using it as a sagger (see illustrations and Color Plate 23).

Decorating a Large Pot

Her husband, who had just come home, asked me if I wanted to buy it. We told him that what we really wanted was one of the mocahuas. He asked which one, and I showed him. He said it could not be fired until tomorrow because there was no dry wood, and that he would go tomorrow to the mountain and bring home a load. We told him we could not return tomorrow. In the meantime, the woman had quietly carried the mocahua over to the fire and had begun to decorate it. She used the same decorating technique as on the small bowl (see Color Plate 16).

Obtaining Pottery Materials

The potter, relaxed by this time, had dropped her pretense of not understanding Spanish and answered our questions. She digs her own clay, which she calls mangalpa, at a spot along the riverbank that is 2 hours away by canoe. The clay is used moist, as she finds it. The colored slips and resins she buys from people in the village of Canelos who bring things to the Puyo market. She said that everything was very expensive.

Firing the Mocahua

When she had completed the decorating, she placed the pot upside down on the three logs over the smoldering ashes and threw several small pieces of wood onto the fire, without much effect.

The potter who had been moving quietly, disappeared. Her husband also left. She returned soon and started decorating another pot with curving lines. A half-hour went by, during which the potter had been working constantly. Her husband came back, breathing hard, his feet and the lower parts of his pants coated with mud.

The woman put down the pot she had been working on, picked up the one she had used as a sagger and another broken in the same way, and went out to the rear of the house. She returned immediately and, using two old dresses as insulation, picked up the freshly decorated large pot and went out with it. We followed. It was 2:10 P.M. She had set three broken pots about 1.5m (5 feet) from the house wall. On this tripod, she placed the mocahua, again upside down, and began stacking pieces of split bamboo against it on all sides, and over the bottom. She fetched a burning faggot and set the bamboo afire. It burned

Decorating a Bowl. Tools for decorating are improvised from readily available materials.

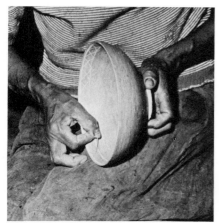

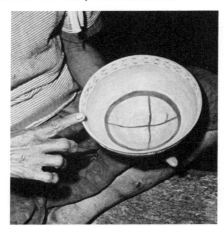

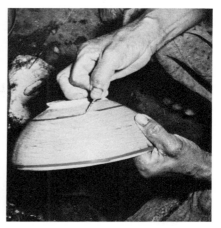

1. The interior rim design is started by drawing a parallel set of lines with the smallest brush. A crisscross pattern is drawn between these, and the shapes produced are embellished with fine red and white lines.

2. Once the pattern is established in the center of the bowl, the potter dips the tip of her finger in the white slip and rubs it on the rim. Then she fingerprints a pattern at the center.

3. The outside pattern is begun with two parallel lines banded around the bowl using the largest brush and red slip. The potter employs the knuckles of her fingers as a pivoting guide while she turns the bowl.

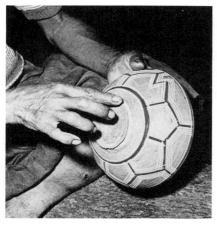

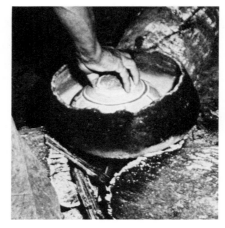

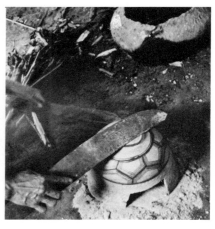

4. The red sawtoothed design is painted between the parallel lines. With the medium brush and white slip, the potter next echoes the stronger design lines. Last she paints a rim on the foot of the bowl with her fingers.

5. The junction of the three logs supports a small sagger used for firing the bowl. After an initial 10-minute drying period, hot ashes will be spread over the bowl with a machete, and the fire will be stoked.

6. After 30 minutes' firing time, the sagger is pulled off the fire, and a small stovelike bowl is placed over the sagger's hot ashes. The fired bowl is lifted out with two machetes and placed on the small clay stove.

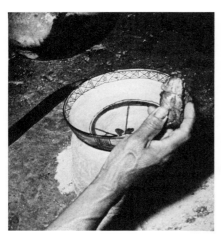

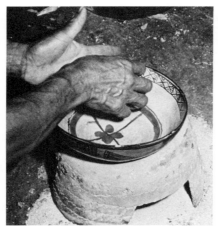

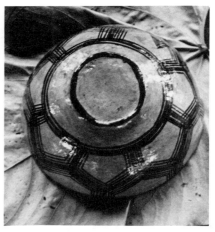

7. Immediately, the inside and then the outside are rubbed with a copal-type resin. Here you can see clearly the finger-pressed pattern of the coils as they were thinned and joined together to make the small stove.

8. The resin, gathered from a jungle tree, will melt and flow evenly over the surface of the hot bowls. In a few minutes it will cool, forming a hard surface.

9. The bowl is placed on a large leaf to cool and to set the lacquer surface. Without the protective coating, the painted designs would remain fragile and easily rub off.

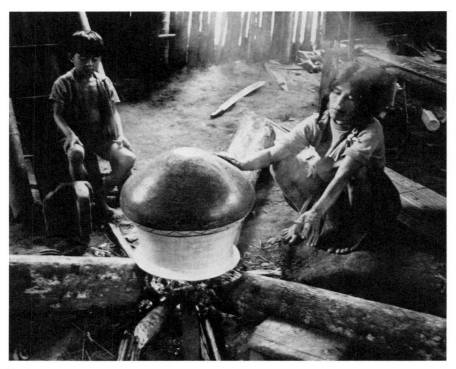

The large pot must be placed upside down over a low fire, indoors, to dry the piece well before it is fired.

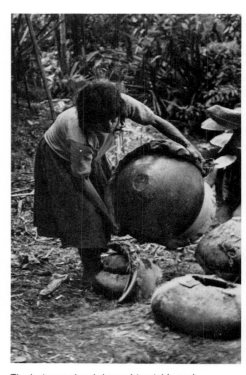

The hot *mocahua* is brought outside and placed upside down on three old pots.

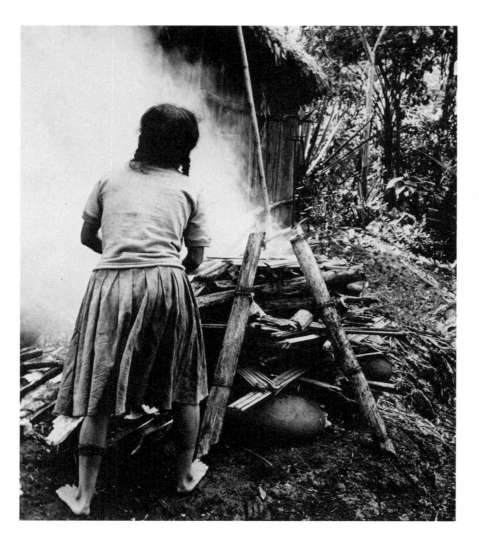

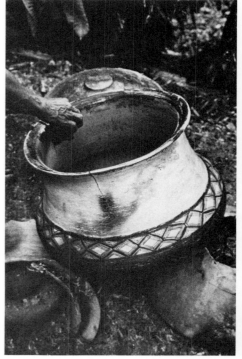

(Above) Because of the rapid firing, cracked pots are not an unusual catastrophe. The potter's husband brings some *pungara*, a black patching material, to help repair and coat the interior of the pot while it is still hot.

(Left) A carefully arranged structure of *guadua* wood is built under, around, and over the *mocahua*, covering it completely. Then a flaming faggot is brought from the house to set the wood ablaze.

furiously. The man reappeared and was greatly alarmed, as we were. The wind was blowing the flames toward the thatched roof. He grabbed a machete, hacked down several large branches from a nearby tree and stabbed them into the ground to form a windbreak. The flames went straight up, and the green leaves overhead turned black. The potter went back into the house, but the man remained to watch. All this had taken only about 10 minutes. By 2:25 P.M., the fire had reached its peak. We heard an ominous snap and knew that the pot had cracked. By 2:35, the fire was almost dead and the gray burned-out pieces of bamboo had dropped away to reveal the pot, now a beautiful red and almost white, with the strong red and black decorations and a good fire mark. There were two vertical cracks in the upper part and a horizontal one around the bottom. At 2:45, the woman turned over the pot and began rubbing resin over the outside. Her husband helped rub some black resinous pitch on the inside. This patching material, called *púngora,* is a substance extracted from a variety of jungle holly tree and is commonly used to repair the *mocahuas,* which crack quite frequently. We were all disappointed.

Bargaining

The woman silently carried the pot back inside and put it in the corner, then continued painting the other one. Her husband was quite sober, and told us we could buy the pot for 100 sucres. We told him we could not use a cracked pot. He tried to convince us that the resin makes them usable and that a former Peace Corps volunteer, who had worked in the area, had taken over a thousand of these pots back to the United States and that they were all cracked.

We offered to buy the small bowl. He said it would cost 20 sucres. "Ridiculous." He dropped immediately to 10. We hoped to return sometime and wanted to leave on good terms, so we agreed. He looked dejected. I told him it was just bad luck. This is the universal Latin American explanation. He repeated it. We shook hands with both of them and left.

Yumbo Cooking and Storage Ware

The Indians in the Puyo area are of the Yumbo tribe, and most of the women know how to make pottery. The Yumbo pottery shows great variety both in form and decoration, however, the *mocahuas* for cooking and for storage of *chicha,* which is made

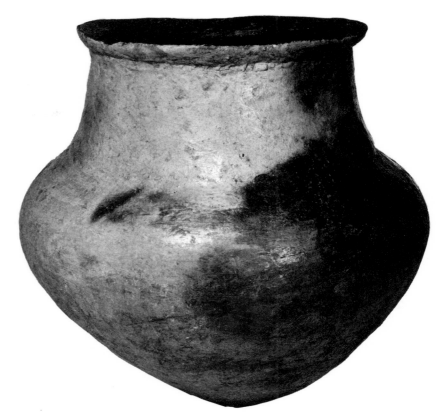

A *mocahua* meant for cooking has the same basic shape as those used for storage. However, the natural base clay is left uncolored, except for the marks made by the fire.

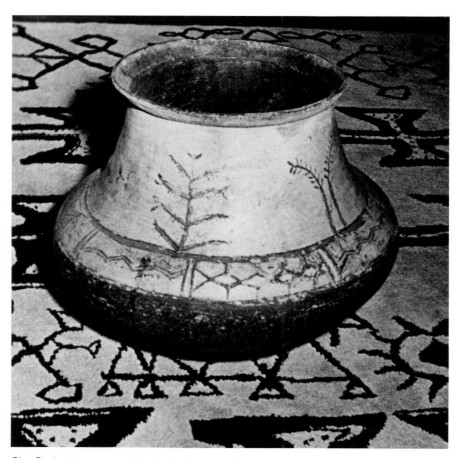

Olga Fisch adapts many of the designs found on Oriente pottery in her weaving. This pot was brought to her from the Puyo area some years ago.

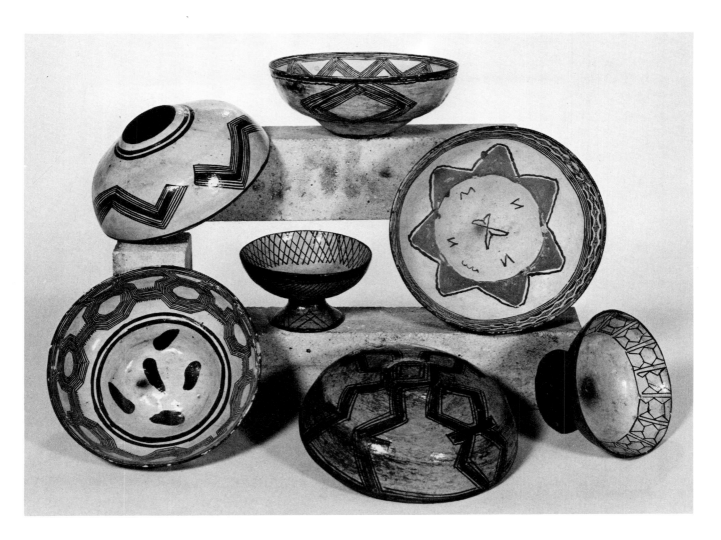

(Above) The Oriente potters seem to have an unending supply of original designs to use inside and outside their small *chicha* bowls. We have never seen two alike. All are decorated with black and reddish brown designs, usually over a white slip base.

(Right) Traditional Oriente slip painting is used to decorate this 30.5cm (12") long ceremonial horn. When blown trumpet fashion, it emits a satisfying piercing blast.

from yuca roots, all bear a strong similarity.

Chicha Bowls

Much more variety is lavished on the smaller bowls which are for drinking the *chicha*. The traditional form is like a footed bowl, the foot appearing as a hollow depression in the center of the larger bowl itself.

Possibly Spanish influence is manifested in the variety of other bowls and vase shapes that are also made for drinking *chicha* at special fiestas, or made for sale. A footed-pedestal bowl is made in the same sizes as the traditional *chicha* bowl. The vases are made in variations of the large *chicha* pot, but smaller and with a substantial flaring foot.

Jíbaro Pottery

The Jíbaro Indians, who live further south and border the Yumbo areas, produce pottery, some of which is indiscernible from that of the Yumbos.

Very little of this pottery makes its way out of the jungle. One sees it occasionally in specialty shops in Quito where it is brought by missionary groups who purchase it from the Indians. The ware is fragile, both because of its extreme thinness and its low firing, making it commercially unfeasible to transport in any quantity. This is regrettable, as it is one of the most sincere, indigenous, decorative products in South America.

Peru: Selva

The Swiss ethnologist Jean Christian Spahni has done an extensive study of pottery making among the Shipibo Indians around Pucallpa, located in the district of Loretto, Peru. In his book *La Ceramica Popular del Perú* he describes the procedures.

Clay Work

The Shipibo obtain their clay from river banks and transport it in their boats. Unlike the Yumbos of Ecuador who use their clay pure, this clay is mixed with the ashes from the burnt bark of two types of trees, *Licania utilis* and *Mimosa ucayali*. The former makes the clay a light color, and the latter colors it black. They also pulverize their broken pottery, adding the resulting grog to the mix, whose proportions are 50% clay, 25% ash, and 25% grog. The clay is left to soak over-

A ceremonial drinking container is made to lie on its side when not in use. Two unusual figures, painted in a sticklike style, have sculptured heads. Collection of Olga Fisch.

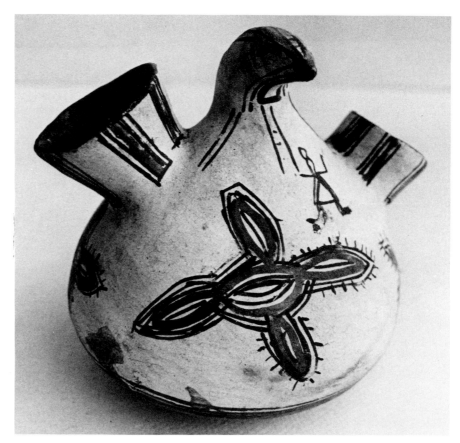

Chicha containers for festive occasions are formed in many unusual shapes. This one, made like a squat bird, has two drinking spouts placed like raised wings. Collection of Olga Fisch.

night, after which the other ingredients are mixed in. The coil method is used here, too, and the thin coils smoothed inside and out with gourd ribs. The Shipibo use a stone to burnish the clay after the ware has dried for a couple of days.

Shipibo Designs

Like the Yumbos, the Shipibo gather various colored clays to paint their designs. It is interesting to note that, throughout the jungle areas, the Indians manage to find the same types of clay to give them the black, white, and various shades of brown that they like to use for decorating. The Shipibo also use brushes made of human hair.

The precise geometric designs made by the Shipibo artist are like no other. One recognizes them immediately, whether painted on their textiles or on pottery. Made with a series of thicker lines delineating the main theme of the design, thinner lines, or lines of a lighter color are painted between the areas previously set out. Sometimes small rectangles and triangular areas are colored in. Rectangles, diamonds, and shapes that look as if they could be elaborate church cross-sections or other architectural plans are common, but the design used on one pot is not likely to be found again on another. Long lines with a crossbar toward one end are another design element commonly used. It is believed that all the elements of their designs once had a religious significance that is now forgotten, although the designs remain.

Backgrounds for the painting, as in the Yumbo ware, can be white, red, or natural clay, or a combination of these (see Color Plate 20). The shapes of the large *ollas* and *tinajas* are similar to those of the Yumbo. The bowl used for drinking is also of similar shape, but the sides are more vertical than the flaring upper section made in the Rosario Yacu area. Pots here, too, are not slip painted if they are intended for cooking. Those that are painted are treated with the same black resin for coating the interior and for repairs. The clear, shiny resin is applied over painted designs.

Firing

The firing methods practiced by the Shipibo women, who also make all of the pottery here, are identical to the

An 11.3cm (4½") bowl used for drinking *chicha* is coated with white slip and burnished. The linear design on most pots consists of a wide red line to break the surface into angular shapes.

Yumbo techniques. Small pots are fired on three upside-down pots. Here, too, the firing period is brief.

Pottery Types

The Shipibo make utilitarian ware designed for cooking, *chicha* preparation, eating, and drinking, and pitchers to carry water from the river. Spahni speaks of a female figure-vase decorated with their typical designs that he had heard about but never seen.

Colombia: Vaupes Area

In the Artesanía shops throughout Colombia, a large display space is given to the crafts from the Vaupes. Most notable are the natural fiber weavings of shallow, round baskets in intricate patterns, fiber carrying bags of all sizes and net patterns, hammocks, and a clever device designed to squeeze the poisonous juices out of manioc root, thereby making it edible. Handsome painted tapa cloth hangings and masks made of the same bark cloth also come from this area. Only occasionally can you find pottery from the region because of the difficulty of transporting these fragile pieces out of the jungle.

Guahibo Indian Ware

We have been fortunate enough to see several good collections of a type of female-vase vessel. These, we were told, are made by the Guahibo Indians who live northeast of Bogotá in the vast jungle areas that border the Rio Meta, for drinking *chicha*. Most of the figures stand with hands on hips, but we saw one with arms raised above the head, hands held together making a handle on the drinking pot. Again, we did not see any that were decorated alike. The design motifs are generally echoed lines of squares, diamonds, or triangles—straight-line geometrics.

Tucano Indian Pottery

In the *Museo de Artes Popular y Tradicional* in Bogotá, pottery is on display made by the Tucano Indians who live in the heart of the Vaupes area. The pottery is made in a great variety of shapes. We saw flaring bowls, goblets, platters, cooking pots, and vases (see Color Plate 3). The vases are made with a cylindrical base, a globular middle, and a cylindrical neck to match the lower section. A small drinking container is fashioned like a round gourd with a variety of necks, spouts, handles, or anthropomorphic figures added. The coil method appears to be used by the Tucanos to build their ware. Most often their work is left natural. Occasionally it is coated with clear or black resins after firing. We saw some pieces with designs very freely daubed with fingers using red, yellow, or white clay slip. However, this is done after the piece has been fired and coated with resin, so that the decoration rubs off at a mere touch.

Triangles, circles, series of dots, rows of lines, and even some fingerprint flying insects are used in repeat design around the forms.

Remote Jungle Potters

The best pottery, we were told quite often, is deep in the Amazon basin where few outsiders have penetrated and tribes live who have had little or no contact with the outside world. As is true with all the regions we visited, several years could be devoted to making a thorough study of the Oriente pottery and handcrafts. The small amount that is brought out stimulates one's desire to see more.

This festive *chicha* container is 29cm (11½'') tall. It has been made with coils of light-colored clay and burnished and appears to be coated with the same shiny resin we noted on the Ecuadorian Rosario Yacu pottery. The black linear designs represent decorative garments and skin painting.

Pottery Areas Data Chart

AREA	CLAY FORMING METHOD	FIRING	DECORATIVE TREATMENT	SEX OF POTTERS	POTTERY SEASON	TYPE OF WORK
PERU						
SIMBILA	stone and paddle coil	mound	slip coating stamped design	m f	August to December	utilitarian
OLMOS	mold	ground	incised mold	m	August to December	utilitarian
CHITA PAMPA	slab base coil	mound	none	m	August	utilitarian
MACHACMARA	slab base coil	mound	burnishing slip painting sprig mold fluting applied coil	m f	year round sporadic	utilitarian
CHECCA PUPUJA	slab base coil sculptural	mound kiln	slip painting slip coating applied coil glaze	m f	year round sporadic	decorative ceremonial tourist utilitarian
PUCARA	mold wheel	kiln	slip coating slip painting sprig mold glaze	m f	year round sporadic	utilitarian decorative tourist
AYACUCHO	slab coil sculptural	kiln	slip coating slip painting sprig mold burnishing	m f	year round sporadic	decorative ritualistic ceremonial utilitarian tourist
MOYA	slab base coil sculptural	kiln	slip coating slip painting burnishing	m f	year round sporadic	utilitarian tourist ceremonial decorative ritualistic
BOLIVIA						
CALCAPIRHUA	coil	pit	slip painting	m f	April to October	utilitarian
HUAYCULI	wheel sculptural	kiln	glaze coating glaze painting	m f	April to October	utilitarian decorative ceremonial
CHILE						
POMAIRE	wheel coil sculptural	kiln	blackware slip coating burnishing painting	m f	year round	utilitarian decorative tourist
QUINCHAMALI	sculptural	ground	blackware slip coating burnishing incised line	f	October to April	decorative utilitarian tourist
ARAUCA INDIAN	coil sculptural	ground	burnishing	f	December to March	utilitarian

I indicates insufficient information

AREA	CLAY FORMING METHOD	FIRING	DECORATIVE TREATMENT	SEX OF POTTERS	POTTERY SEASON	TYPE OF WORK
ECUADOR						
CHORDELEG	wheel	kiln	glaze coating glaze painting	m	year round	utilitarian
CORAZON DE JESUS	wheel	kiln	glaze coating glaze painting	m	year round	utilitarian
SAN MIGUEL	coil	ground	slip coating burnishing	I	I	utilitarian
PUNIN	coil sculptural	ground	slip coating burnishing	f	I	utilitarian decorative
TEJAR	mold coil	ground	incised line	m	year round	utilitarian
PUJILI	mold sculptural	kiln	slip painting painting	m f	year round	decorative utilitarian
LA VICTORIA	slab in mold coil	kiln	glaze coating glaze painting	m f	year round	utilitarian
COTOCOLLAO	slab in mold wheel coil	kiln	glaze coating painting	f	year round	utilitarian
COLOMBIA			slip painting			
POPAYAN	wheel handmodeled	kiln	glaze coating	m f	year round	utilitarian beads
SANTANDER	wheel	kiln	glaze coating burnishing blackware	m f	year round	utilitarian
GUASIMO-CALOTO	slab on mold coil	ground	slip coating burnishing	f	year round sporadic	utilitarian
YUMBO	slab on mold coil	ground	slip coating burnishing	f	year round sporadic	utilitarian
EL CERRITO	slab on mold coil	kiln	slip coating burnishing blackware	f	year round	utilitarian
BUGA	mold	kiln	glaze coating	m	year round	utilitarian decorative
LA CHAMBA	slab on mold coil sculptural	kiln	slip coating burnishing blackware	f	year round	utilitarian
CAMPO LA VEGA	pinched ball coil	kiln	slip coating burnishing fluting slip painting	f	year round sporadic	utilitarian
CLAROS	coil	kiln	slip coating burnishing enamel painting	m f	year round sporadic	utilitarian
ACEVEDO	wheel	kiln	glaze coating burnishing	m	year round	utilitarian decorative
BARRERA CONTADOR	pinched ball coil	kiln	slip coating burnishing	f m	year round sporadic	utilitarian

AREA	CLAY FORMING METHOD	FIRING	DECORATIVE TREATMENT	SEX OF POTTERS	POTTERY SEASON	TYPE OF WORK
PITALITO	mold handmodeled	kiln	painting	f m	year round	decorative tourist
CARMEN DE VIBORAL	mold	kiln	clear glaze under-glaze painting	m f	year round	utilitarian
LORICA	coil	ground	slip coating burnishing incised lines painting	I	year round	utilitarian
RAQUIRA	mold handmodeled	kiln ground	slip painting glazing	m f	year round	utilitarian decorative
MORCA	wheel	kiln	glaze coating glaze painting painting	m	year round	utilitarian
TUATE	hollowed ball coil	ground	slip coating burnishing	f	year round sporadic	utilitarian
TUTAZA	hollowed ball coil	ground	slip coating burnishing	f	year round sporadic	utilitarian
LA FLORIDA	coil	kiln	glazed applied coil	f	year round sporadic	utilitarian

VENEZUELA

AREA	CLAY FORMING METHOD	FIRING	DECORATIVE TREATMENT	SEX OF POTTERS	POTTERY SEASON	TYPE OF WORK
CAPACHO	mold wheel	kiln	glaze coating natural	m	year round	utilitarian
LOMAS BAJAS	wheel handmodeled	kiln	glaze coating natural slip painting painting	f m	year round	utilitarian decorative
MERIDA	coil sculptural	ground	none	f	year round sporadic	utilitarian
VALERA	coil	ground	slip painting painting burnishing	f	year round sporadic	utilitarian
QUIBOR	coil	ground	slip painting slip coating burnishing	f	year round sporadic	utilitarian
YARACUY	handmodeled	ground	slip coating burnishing	f	year round sporadic	utilitarian
ARAGUA	handmodeled	kiln	painting	f	year round	utilitarian
GUAJIRA	coil handmodeled	ground	slip painting	f	I	utilitarian ritualistic

ORIENTE SELVA VAUPES

AREA	CLAY FORMING METHOD	FIRING	DECORATIVE TREATMENT	SEX OF POTTERS	POTTERY SEASON	TYPE OF WORK
ROSARIO YACU	coil	ground	slip coating slip painting burnishing resin coating	f	year round	utilitarian
SHIPIBO	coil	ground	slip coating slip painting burnishing resin coating	f	year round sporadic	utilitarian

Bibliography

Adams, Alexander, *Plateau Peoples of South America*. London: George Routledge & Sons, Ltd., 1915

Artigas, J. Llorens and J. Corredo-Matheas, *Spanish Folk Ceramics*. New York: Watson-Guptill, 1974

Bennett, Wendell C., *Archeological Regions of Colombia: A Ceramic Survey*. New Haven: Yale University Press, 1944

———, *Excavations in Bolivia*. New York: American Museum of Natural History, 1936

———, *Excavations in the Cuenca Region, Ecuador*. New Haven: Yale University Press, 1946

———, *Excavations at Tiahuanaku*. New York: American Museum of Natural History, 1934

Colegio Alemán Humboldt. VI Curso 1971–72, *Artesanía Folklorica en el Ecuador*. Guayaquil, Ecuador: Cromas Cia, Ltd., 1971

Cruxent, José and Irving Rousd, *An Archeological Chronology of Venezuela*, Vols. 1 and 2 J.M. Washington, D.C.: Pan American Union General Secretariat, Organization of American States, 1958

Dockstader, Frederick J., *Indian Art in South America*. Greenwich, Conn.: New York Graphic Society, 1967

Duque Gomez, Luis, *Reseña Arqueologica de San Agustin*. Bogotá: Talleres Editoriales de Libreria Voluntad, 1971

Ford, James A., *Excavations in the Vicinity of Cali, Colombia*. New Haven: Yale University Press, 1944

Howard, George D., *Prehistoric Ceramic Styles of Lowland South America, Their Distribution and History*. New Haven: Yale University Press, 1947

Marshall, Andrew, *South American Handbook*. London: Trade & Travel Publications, 1971

Mason, J. Alden, *Ancient Civilizations of Peru*. Baltimore, Md.: Penguin Books, 1964

Meggers, Betty J., *Ecuador*. New York: Frederick Praeger, 1966

Osgood, Cornelius and George D. Howard, *An Archeological Survey of Venezuela*. New Haven: Yale University Press, 1943

Petterson, Richard, *Folk Art of Peru*. Claremont, Calif.: Pub. by Richard Petterson, 1968

Posnansky, Arthur, *Tihuanacu, the Cradle of American Man*. Locust Valley, N.Y.: J.J. Augustin, 1945

Reichel-Dolmatoff, Gerardo, *Colombia*. New York: Frederick Praeger, 1965

———, *San Agustin, A Culture of Colombia*. New York: Frederick Praeger, 1972

Rouse, Irving and José Cruxent, *Venezuelan Archeology*. New Haven: Yale University Press, 1963

Sawyer, Alan R., *Ancient Peruvian Ceramics, the Nathan Cummings Collection*. The Metropolitan Museum of Art. Greenwich, Conn.: New York Graphic Society, 1966

———, *Master Craftsmen of Ancient Peru*. New York: The Solomon R. Guggenheim Foundation, 1968

Spahni, Jean-Christian, *La Ceramica Popular del Perú*. Lima, Peru: Peruano Suiza, S.A., 1966

Steward, Julian H. and Louis C. Faron, *Native Peoples of South America*. New York: McGraw-Hill, 1959

Vicens, Frances, *Arteranía*. Barcelona, Spain: Ediciones Polígrafa, S.A., 1968

Von Hagen, Victor W., *Realm of the Incas*. New York: New American Library, 1961

———, *The Desert Kingdoms of Peru*. Greenwich, Conn.: New York Graphic Society, 1965

Weil, Thomas E., *Area Handbook for Colombia*. Washington, D.C.: U.S. Government Printing Office, 1970

———, *Area Handbook for Peru*. Washington, D.C.: U.S. Government Printing Office, 1970

Glossary/index

Edited by Sarah Bodine
Designed by James Craig and Bob Fillie
Set in 9 point Medallion by Publishers Graphics, Inc.
Printed and bound by Halliday Lithograph Corp., Inc.
Color printed by Toppan Printing Co. (U.S.A.) Ltd.

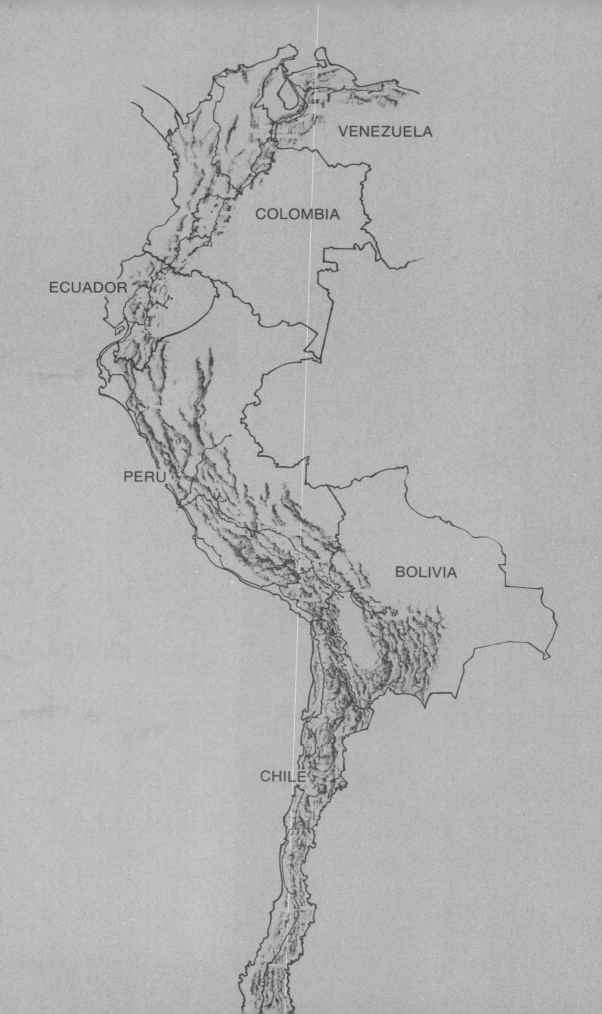